Modern Art: A Critical Introduction

REFERENCE ONLY

This exciting new textbook provides a comprehensive introduction to modern and post-modern art. Pam Meecham and Julie Sheldon bring together theory, history and the art works themselves to help students understand how and why art has developed in the modern period.

Modern Art: A Critical Introduction traces the historical and contemporary contexts for understanding modern art movements, and the theories which influenced and attempted to explain them, from futurism to abstract expressionism, and from Dadaism to conceptual art. It draws examples from a wide range of art genres, including painting, sculpture, photography, installation and performance art.

Individual chapters explore key themes of the modern era, such as the relationship between artists and the galleries which display their work, the politics of representation, the changing nature of self-expression, the public monument, nature and the urban, the 'machine aesthetic', performance art, and the nude. Illustrated with a diverse range of visual examples, from Manet to Damien Hirst, and from Rothko to Barbara Kruger, *Modern Art: A Critical Introduction* is a lively and accessible account of modern art and its histories.

Pam Meecham is a Senior Lecturer in Art and Design Education and Route Leader of the PGCE at Liverpool John Moores University. Julie Sheldon is Programme Leader of the BA and MA Art History at Liverpool Art School, Liverpool John Moores University.

UNIVERSITY OF WINCHESTER

Modern Art: A Critical Introduction

Pam Meecham and Julie Sheldon

First published 2000 by Routledge 11 New Fetter Lane, London EC4P 4EE Simultaneously published in the USA and Canada by Routledge 29 West 35th Street, New York, NY 10001

Routledge is an imprint of the Taylor & Francis Group

© 2000 Pam Meecham and Julie Sheldon

Typeset in Bembo by Florence Production, Stoodleigh Court, Stoodleigh, Devon Printed and bound in Great Britain by Butler and Tanner Ltd, Frome and London

All rights reserved. No part of this book may be reprinted or reproduced or utilised in any form or by any electronic, mechanical, or other means, now known or hereafter invented, including photocopying and recording, or in any information storage or retrieval system, without permission in writing from the publishers.

British Library Cataloguing in Publication Data

A catalogue record for this book is available from the British Library

Library of Congress Cataloging in Publication Data A catalogue record for this book has been requested

ISBN 0-415-17234-9 (hbk) 0-415-17235-7 (pbk)

For Doris and Barbara

Contents

Illustrations Acknowledgements Introduction		xiii xv
1	WHAT IS AND WHEN WAS MODERNISM?	1
2	MONUMENTS, MODERNISM AND THE PUBLIC SPACE	32
3	RETREATS FROM THE URBAN	61
4	THE FEMALE NUDE AS THE SITE OF MODERNITY	84
5	FROM THE MACHINE AESTHETIC TO TECHNOCULTURE	109
6	AMERICAN ART AT MID-CENTURY	136
7	SELF AND IDENTITY POLITICS IN PHOTOGRAPHY AND PERFORMANCE ART	168
8	THE MUSEUM OF MODERN ART	190
Bibliography		215 225 237

Illustrations

We are indebted to the people and archives cited in the figure captions for permission to reproduce photographs. Every effort has been made to trace copyright holders, but in a few cases this has not been possible. Any omissions brought to our attention will be remedied in future editions.

List of Figures

А	Adolph A. Weinman sculpting a cow	xvi
В	Damien Hirst	xvii
С	Some Comfort Gained from the Acceptance of the Inherent Lies	
	in Everything	xviii
D	Man with a Hat	xix
1.1	Cathedra	5
1.2	A Bar at the Folies-Bergère	6
1.3	The Development of Abstract Art	8
1.4	Nocturne in Blue and Gold: Old Battersea Bridge	13
1.5	Dante's Dream	17
1.6	The Painter's Studio	19
1.7	Nude in a Bath	21
1.8	Les Demoiselles d'Avignon	24
1.9	Green Reflections	25
1.10	`Untitled' I Shop Therefore I Am	28
1.11	Home Bright, Hearth Light	29
1.12	Mafia Victim and Pool of Blood	30
2.1	Moonwalker Statue	34
2.2	Monument to I. V. Stalin	35

X ILLUSTRATIONS

2.3	McDonalds, Prague	37
2.4	Industrial Worker and Collective Farm Girl	39
2.5	Lenin at Louny	40
2.6	Boulevard Montmartre: Afternoon Sunshine	41
2.7	Endless Column	44
2.8	7,000 Oaks	47
2.9	House	49
2.10	Vietnam Veterans' Memorial	53
2.11	GIs' Monument	54
2.12	Women's Monument	55
2.13	Korean War Veterans' Memorial	56
2.14	Lebanese Monument to Peace	57
2.15	The Legible City	59
3.1	Yellow Haystacks (or The Golden Harvest)	63
3.2	Wolf at the Door	65
3.3	Disks of Newton	69
3.4	No.398: Heavy Circles	70
3.5	Bird in Space	74
3.6	Interior of the Fourth Dimension	74
3.7	Trumpeting Girl in a Birch Wood	79
3.8	Landscape with Drunkards	82
4.1	Eve Babitz Playing Chess	85
4.2	Liverpool Art School Life Class	87
4.3	William Rush and His Model	88
4.4	Reclining Nude (Le Grand Nu)	89
4.5	The Client	90
4.6	The Origin of the World (L'Origine du Monde)	90
4.7	Woman in a Tub	96
4.8	Freedom and Change	103
4.9	Measures of Distance	104
4.10	Close Up	104
4.11	Etant donnés	106
4.12	The Dinner Party	106
4.13	Post-Porn Modernist	107
4.14	Family	107
5.1	Accords	112
5.2	Pittsburgh	114
5.3	'Machine Art' exhibition	115
5.4	Ballet Méchanique	116
5.5	The Rock Drill	118
5.6	Detroit Industry	119
5.7	Broadway Boogie-Woogie	120
5.8	Light–Space Modulator	122
5.9	Modern Times	125

5.10	Greyworld's Layer	129
6.1	Erased de Kooning Drawing	137
6.2	Harlem	141
6.3	Clouds and Water	142
6.4	My Egypt	143
6.5	Woman Carrying a Flag, Mexico	144
6.6	New Mexican Landscape	145
6.7	Flying Dutchman	148
6.8	Cathedral	158
6.9	Textile-Woven-Peruvian	160
6.10	Light Red Over Black	161
7.1	'Jackson Pollock'	169
7.2	Untitled Image #1	171
7.3	Breaking Test (Zerreissprobe)	178
7.4	Artifact Piece	180
7.5	(a) Property of Jo Spence? (b) Monster	182
8.1	Surrealist Exhibition	191
8.2	Forms Without Life	193
8.3	Walker Art Gallery	197
8.4	'Torpedo' diagrams of the ideal permanent collection of the	
	Museum of Modern Art	201
8.5	The Museum of Modern Art	202
8.6	The Archduke Leopold Wilhelm in His Gallery in Brussels	203
8.7	The Guggenheim Museum	209
8.8	Torqued Ellipses	210

List of Plates

I	Linen
H	The Execution of Maximilian III
III	Negative Form Monument
V	Lipstick Ascending on Caterpillar Tracks
V	Symphony No. 1, The Transcendental
VI	Intervention of the Sabine Women
VII	TechnoSphere
VIII	Robot Bodies
ΙX	The Peaceable Kingdom
X	A Score of White Pigeons
ΧI	The Messenger
XII	How Does a Girl Like You Get to Be a Girl Like You?
XIII	'Untitled' (All Violence is the Illustration of a Pathetic Stereotype)
XIV	Dial H–I–S–T–O–R–Y

Acknowledgements

The authors would like to thank the School of Education and Community Studies and Liverpool Art School at Liverpool John Moores University for supporting this project. In addition our thanks to colleagues for their practical support and encouragement, in particular to John Byrne, Colin Fallows, Neil Hall, Sean Halligan, Elaine Prisk and Ken Travis. Other thanks should go to Jindra Hubena of National Museums and Galleries in Prague, Nicola Taschevski, who acted as translator and photographic adviser, and David Ollerton. We are grateful to our commissioning editor Rebecca Barden at Routledge for her patience and confidence in the project. Finally our personal thanks to family and friends who have been forced to live with 'the book', especially to Joseph Ollerton and Colin Fallows.

Introduction

They come out of a tradition which has been very *talky*. The theory has bound itself into the work so tightly that it in fact generates another form.

(Laurie Anderson)

Even a cursory glance at the processes by which two art works are made, one at the beginning of the twentieth century - Adolph A. Weinman sculpting a cow in 1903 (Figure A) - and the other at the end - Damien Hirst in a field with a cow in 1997 (Figure B), demonstrates shifts in our understanding of what it is that constitutes, first, the artist and, second, art itself. Weinman and Hirst stand in a field, each with his bovine subject: Weinman fashions a small clay cow model, probably to be later cast in bronze, demonstrating the requisite manual skills to accomplish the task and achieve a convincing likeness of the real thing. Hirst, ninety or so years later, seems implicated in a related set of concerns. In the 1996 Some Comfort Gained from the Acceptance of the Inherent Lies in Everything (Figure C) Hirst's now-familiar dead animal motif is the focus. Unlike Weinman's art work, however, Hirst's requires the skills of the taxidermist and the aquarium builder. Each work is a 'readymade' of sorts (in the sense that Marcel Duchamp had first coined the term to describe existing objects that he would redesignate as art objects). Apart from its title, Figure C would not, at first sight, look out of place in a Natural History Museum. Closer scrutiny of Hirst's piece reveals not randomness but a strictly ordered, if unscientific, pattern: twelve glass tanks contain the bodies of two cows (A and B), each divided into six segments, those of cow A alternating with those of cow B. The title of the piece, moreover, underscores Hirst's philosophical (as opposed to zoological) ruminations.

The juxtaposing of Weinman and Hirst's work demonstrates something of both the continuity and the ruptures within twentieth-century art. The way we make art, as well as write and talk about it, has shifted. What we attempt in this book is to show

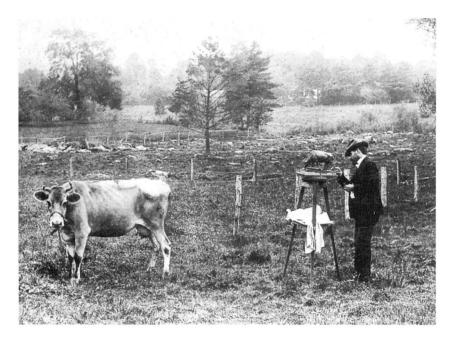

Figure A Adolph A. Weinman sculpting a cow, 1903

how changing ways of making art and changing ways of writing about art belong to a broader climate of change. Theoretical discourses - such as poststructuralism, feminism, Marxism, postcolonialism - often drive contemporary art practice. Of course, this is not to say that Weinman's work is not theoretically driven; it is, but its theoretical co-ordinates map a different terrain. We will see how theory and art practice are linked, even in cases in which no link is evident or acknowledged.

For the student of modern art and art history, an inspection of the literature reveals 'disciplines' torn between theory and practice. There are numerous anthologies of art which bring together the received authorities of the twentieth century. And there are other overviews of modern art which chart the 'story of art' (linear histories which divide modern art into a chronology of the dominant historical '-isms' - impressionism, expressionism, cubism, surrealism, etc.). But these illustrate our point: literature on the subject of modern art often founders either because it surveys the art of the period in terms which serve to isolate that art from the contextual factors that contribute so vitally to its intelligibility, or by presenting historical accounts of the period which have little or no connection to the works of art that readers may encounter. Although the genealogy of art can afford important structural lessons, this book has little concern with the chronological ordering of the art of the modern period. We prefer that the history of art should be thematically driven: we try to uncover 'significant' moments in the critical analysis of art and to consider art works as responses to the changing contexts of its production, consumption and evaluation.

The main aims of this book, then, are to locate modern art in its varied contexts; to look critically at recent developments in theoretical enquiry; and to indicate how art practice and theory may be usefully integrated.

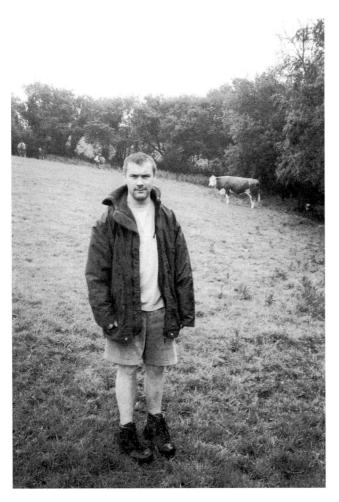

Figure B Damien Hirst. Photo: Johnny Shand Kydd. Courtesy of Jay Jopling/White Cube, London

Art history as a discipline has undergone considerable revisions since the 1960s and has been compelled to re-evaluate the status of what it calls 'knowledge' – partly fuelled by massive social upheavals. As Figures A and C illustrate, what we think of as being art has changed over the course of the last century. Similarly art history (the way in which we classify and evaluate these works) has changed: there has been a drift within the discipline towards a broader understanding of visual culture; and art history's importation of literary and linguistic theories from other disciplines over the last thirty or so years has changed many of the basic premisses on which the discipline has rested. We do not after all, it seems, actually know art history. By this statement we use the word know in the sense that the eighteenth-century philosopher Immanuel Kant thought of knowing – that is as having an a priori cognitive structure. To return to our illustrations, the grounds upon which we know Figure A are not the same as the knowledge required to understand Figure

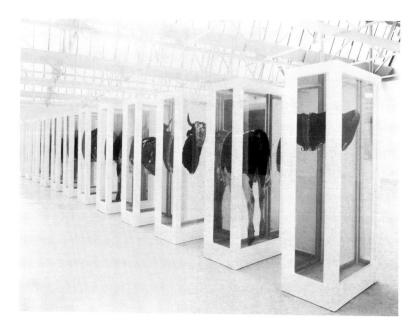

Figure C Damien Hirst, Some Comfort Gained from the Acceptance of the Inherent Lies in Everything, 1996. Courtesy of the Saatchi Gallery and Stephen White

C. We no longer *know* art history, we suggest, because our conceptual frameworks for creating and solving problems appear to have multiplied.

Since the 1960s the human sciences have turned to language as a model for understanding culture in all its forms. One characteristic of contemporary art history has been its extensive use of non-art-historical texts. This assimilation permits connections between material which is apparently unconnected or diverse - drawing upon sociology, anthropology, linguistics, film and popular culture. It may be difficult to accept the relevance of theories which address subjects other than the agenda of art history, but the fact remains that such theories have gained credence in the discipline in recent years. On the whole, visual art theorists have found it more difficult than have their peers specialising in literature and film, for instance, to accommodate poststructuralist ideas. That is to say, poststructualist concepts apparently are more readily applicable to written 'texts', as they are encoded in the same textual practices, than they are to works of art, which in relation to language present a different set of problems. The encroachment of text, for example from its incorporation in cubist collage early in the twentieth century (Figure D) to the entirely text-based images of artists such as Jenny Holzer in the 1990s, is matched, as Laurie Anderson has observed, by the increasingly 'talky' nature of modern art practice, exemplified in the observation 'mimimal art, maximum explanation'. As well as the increasing presence of text in art, it is important to grasp the sheer scale of the convergence of art with what is called 'textuality' over the last thirty years, a symptom of just how far contemporary thought is linguistically orientated. Hence the often-quoted poststructuralist maxim that unless you can articulate something it does not exist, and therefore we are all constructed 'in and by language'; or, to put it simply, 'you are what you communicate'.

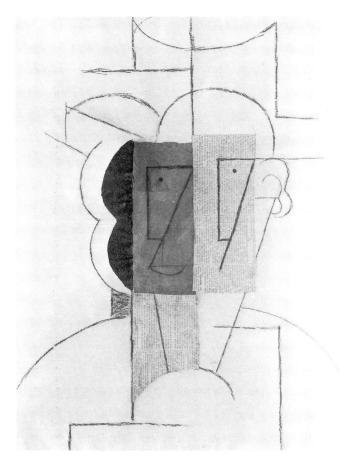

Figure D Pablo Picasso, Man with a Hat (after 3 December, 1912). The Museum of Modern Art, New York, Purchase. Photo: © Sucession Picasso/DACS 1999

Meanwhile, the assimilation by art-historical studies of literary theory and sociology has introduced a whole new vocabulary into the art historian's lexicon. A comparison of the entries to be found in a dictionary of art from the 1970s with those in a more contemporary dictionary reveals just how many terms have been imported from discourses such as race, gender, semiotics and psychoanalysis, and how even familiar words ('intention', 'representation', 'materialism') have acquired a layer of specific art-historical/cultural studies' meaning that is quite distinct from everyday usage. Even the style of writing about art has changed. A relentless tickertape of theoretical exposition is poured out featuring phrases such as: 'offering a reading', 'mapping the trajectory' and 'interrogating the image' to describe a methodology far removed from the apparent simplicity of nineteenth-century doctrines of 'truth to nature' and 'beauty is truth'.

One hundred years ago the relationship between art and language was very different. Art critics used colourful language (poetic equivalence) in their attempt to recreate in words the thrill when looking at works of art they held in high

regard. These were not, by and large, professional art historians but interested amateurs and 'men of letters'. 'Connoisseurship' required art historians to use language which either investigated the art object (usually through archival research) or made philosophical points about art in general (often in terms of quality, beauty and morality). Underlying the central tenets of 'art appreciation' lay a sincere belief in the power of art to enhance, uplift and improve human life. In the democratic revolutions of the early twentieth century, connoisseurial 'art appreciation' came to be seen as both reactionary and elitist, a powerful representative of class values. Presented independently of socio-political, economic or historical context, connoisseurship was supported by notions about aesthetics which acted as criteria about what did and did not constitute good taste.

The formulation of principles of taste and beauty in art implied that 'beauty' (in itself a loaded concept) resides in the art object and that 'taste' is the viewer's capacity for appreciating the beautiful. Increasingly with modern art, where beauty is often redefined or irrelevant, the services of an art critic are required to intercede with and to define the work's quality, and to establish parameters of taste. Ironically, the early twentieth-century insistence on the capacity of art to 'speak for itself' did not undermine the presumption that in certain viewers (usually white, male and middle-class) the capacity to appreciate artistic beauty was innate. This notion of a timeless faculty for the recognition and appreciation of 'great' art pervaded the diverse discourses that passed for art history, which, as in most of the humanities, were fixed upon western culture and the output of male artists. So art history became the history of individual men whose genius was determined by their unique 'essence' which was capable of transcending conditions of time and place and 'spoke' to those possessed of the proper aesthetic sensibility - or 'taste'. However, the radical shift in understanding of personal identity as somehow immanent to, but also differentiated from, the body to something that is preconstituted in and by language ('you are what you communicate') has undermined many such 'commonsense' givens. This is not to suggest that there are no continuities or that, as Weinman and Hirst jointly demonstrate, we have altogether dispensed with the values of the past. However, as a general view, modern art and its histories have been, and still are, subject to quite substantial revisions.

In recent years art history has dispensed with the kind of overt connoisseurship we have just described, and to such an extent that we are often shy of using words like 'quality' and 'beauty' in case our professional authority is mistaken for amateurish enthusiasm or, worse, elitism. Instead of appreciating art in terms of its quality and beauty, we will talk about 'reading' works of art (although what we actually mean by 'reading' is an endeavour altogether different from the conventional sense of the word). We do not necessarily read a narrative or interpret the story of a work of art even though this might still play a supporting role in our analysis. Often narrative elements are missing or are subordinate to what we call 'modern' in art works; or the claim, made on behalf of the modernist art work, that it is 'a thing in itself', and not an adjunct to narrative, inhibits such reading. So if 'reading' works of art is not solely a matter of uncovering content, then 'reading' has to be understood within a climate of contingency. By and large, we 'read' art works by putting them in one or other context or measuring them against one or other theory of art. This inevitably means that theory — as, for example, it is assimilated by Hirst — comes

out into the open, even to the extent that, occasionally, it seems as if art works have to be, from the outset, theoretically accountable.

This growing tendency towards declaring the theory under which you labour, a practice that grew largely out of Marxism, has spawned a new set of cultural gurus who lend their names to diverse theoretical positions. We have seen how the history of '-isms' has been superseded. Somewhat perversely, we have to acknowledge that there has been a trend simultaneously towards '-ians': Freudian, Greenbergian, Lacanian, etc., which foreground a particular methodology or act as a working example of how theory is applied. These theories, individually and collectively, tend to confound rather than confirm the grounds on which much of the confidence of the past was based. These theories have radically altered our understanding of the staple of art history – its roll of great artists and its canon of 'masterpieces'. At best, this has resulted in a broadening of the canon to include works by previously marginalised artists and art forms – in part the outcome of a collapse of divisions between 'high art' and popular culture. At worst, it has resulted in 'indifferencism' – a sense of anything goes and an academic inability to define quality.

So why should we pay attention to theory? What we have been calling 'theory' is actually a summation of all kinds of shifts in thinking about art that have taken place since the Enlightenment, although there is a growing tendency to ground theory in 1960s and 1970s poststructuralism. Theory can take different forms, positions, methods and practices – some of which do not naturally combine, some of which confusingly overlap, while others again are simply irreconcilable. All the same, theory has become something of a dogma in all arts and humanities' disciplines in recent years. There is, however, a good argument to say that theory has, and always has had, its place: it is simply that it has never before been incumbent upon us to acknowledge that we are all, knowingly or unknowingly, in thrall to one or other theory.

It would probably be fair to say that for art history, as an academic discipline, the acknowledgement of the importance of theory, from the 1960s onwards, has been part and parcel of a general receptiveness to poststructuralist and postcolonial theories. This in itself was a reaction to the particular kind of art history (connoisseurial liberal humanist) we discussed above. Art history was almost the last of the disciplines to reevaluate its procedures. Art historians remained blinkered to the pivotal changes of the 1960s – such as the civil rights and women's movements, gay rights and the declarations by the former colonies of their independence. Ironically, perhaps, even historians in thrall to varying degrees of theoretical Marxism resolutely failed to acknowledge the artistic contribution of groups identified as 'other'. As the Guerilla Girls, an anonymous feminist collective, have pointed out, even Pliny the Elder, Boccaccio and Vasari acknowledged more women artists that ever did Meyer Schapiro or T. J. Clark, two of the major twentieth-century Marxist art historians. As late as 1983 Norman Bryson wrote:

It is a sad fact: art history lags behind the study of the other arts ... while the last three decades or so have witnessed extraordinary and fertile change in the study of literature, of history, of anthropology, in the discipline of art history there has reigned a stagnant peace . . . at an increasingly remote margin of the humanities . . . little can change without a radical

re-examination of the methods art history uses – the tacit assumptions that guide the normal activity of the art historian.

(Bryson 1983: xi)

It is very revealing that in the partial shake up which followed, it is phrases such as 'untheorised' and 'unreconstructed' that came to describe the old art history – even in relation to the formidable scholarship of Erwin Panofsky and Ernst Gombrich. Of course, to claim enlightenment at the end of the twentieth century at the expense of the 'naive' art history of a former age would be undeniably smug. At the same time, it would be reductive to dismiss the all-singing-all-dancing new art history as just a wink in the direction of 'political correctness'. Even though theory has injected the new art history with a suspicion of such 'totalising' ideas as 'great art' and 'old masters', as a discipline art history is more fragmented than ever before. Any notion that the old art history has been swept aside by a torrent of radicalism needs to be tempered with the acknowledgement that blockbuster exhibitions of Picasso and Monet, and monographs on 'geniuses' of art, remained buoyed up because of the support they received from institutional practices.

All the same, the new art historian, just as likely to be sited in the cultural studies' department as in the art history faculty, considers art in significantly disparate terms from those of his or her forebears. The new art historian will, for instance, probably be sceptical of the ideological construction of 'the artist' and will openly acknowledge that trying to uncover the artist's intention (as a received formula for uncovering the meaning of an art work) is a fruitless and passé enterprise. He or she is unlikely to hold original art works in any great esteem — in fact the 'aura' of the original art work has been replaced by self-reflexive debates about authenticity per se. The new art history argues that 'man' is a construct of social and historical circumstances, that 'he' is not an autonomous agent of historical change. Feminism, lesbian and gay criticism, and postcolonial art history, have cumulatively shown how the claims to universality that used to be made on behalf of literature, music, art and culture are bogus. There is no such thing as human nature through which the human 'essence' is expressed, only a process of 'subjectification' which, as we will see, is part of the push and pull of the art of the modern period.

In a nutshell, then, what has come to operate under the aegis of postmodern theory, in all its shapes and forms, has issued us with several warnings: at its most extreme, that everything is contingent and nothing is absolute; that truth is always provisional and partial, and that 'reading' a work of art is a local, relative and unstable endeavour which will be inevitably revised by other 'readers'. The plurality of theoretical approaches in which all positions are 'open and equal' has given us a plurality of conceptual frameworks – histories for history, truths for truth. What goes, then, is the quest for the definitive, abiding, universal interpretation of the unique work of art – once the foundations for art-historical enterprises.

But why should we pay such attention to a set of theories that make art history more complicated? The growth of theory to its current predominance has coincided with wholesale re-evaluations not just of art but of what it is to be human in the twentieth century. Whether theoretically denominational or polysemic, 'theory' frames the mindset of the present time. Just as it has become unfashionable for academics to produce speculative historical overviews or to identify overarching

patterns in history, the history of art is now a set of histories – each conjunctional, local and discursive. The 'postmodern condition' or the 'crisis of confidence' of recent years has entailed some fundamental reappraisals of the kinds of 'facts' each discipline used to take for granted. As we have seen, the idea of the history of art as a history of great individuals had been steadily undermined, but thought-provoking writings, such as Roland Barthes' essay 'The Death of the Author' (1968), have dealt a blow to some of the unreflective adulation accorded to artistic genius. As Barthes put it, 'everything must be disentangled, nothing deciphered'.

At the same time, the French philosopher Jacques Derrida described a 'decentred' intellectual universe. The old art history (and Derrida is writing principally about metaphysically loaded systems of language) used to place (white, bourgeois, heterosexual) 'man' at the centre of things. Anything that deviated from this centre was 'other' or marginal. But Derrida's universe contains no fixed centre and offers no assurances for art history of an artist at the centre of an art work whose intentions, emotions and desires are recoverable by us, the trained viewer. Derrida was ushering in a host of interpretations which would never stand as facts in a decentred universe.

Parallel with the demotion of guaranteed facts, there have been a number of apocalyptic texts announcing the demise of history: Hans Belting's *The End of the History of Art?* (1984); Fukuyama's *The End of History and the Last Man* (1992); and Arthur C. Danto's *After the End of Art: Contemporary Art and the Pale of History* (1997). Danto identifies the pop artist Andy Warhol as the artist who, in the 1960s, single-handedly overturned the modern movement. According to Danto this heralded the end of art. The kind of rampant pluralism we experience today, in which contemporary art can be video art, installation, superrealism, abstract painting, is what he terms 'post-historical', and others might call simply postmodern.

Chapter by chapter

Chapter 1 introduces the key debates that underpin the period covered by this book. As the title – 'What Is and When Was Modernism?' – suggests, any certainties around modernism have been rendered unstable, especially since the 1970s and the arrival of a new term 'postmodernism'. The seemingly monolithic 'universals' of modernism – genius, essentialism, truth – have been called into question and subsequently revised. This chapter seeks to locate modernism in a set of practices and debates, and to open up the terrain to contemporary thinking. Many of the key terms and debates that take place throughout the book are introduced.

In Chapter 2 we concentrate on the changing nature of the public monument. Drawing on a wide range of older and contemporary examples, we explore the changing nature of public spaces and the function of monuments as visible manifestations of the changing relations of power and display.

Chapter 3 offers an alternative view of mainstream modernism – as fundamentally pragmatic, optimistic and urban. Examining a number of artists who 'retreated from the urban' in the modern period, we see how modernism has had a difficult relationship with the spiritual and the mystical agendas of some of its key protagonists. Here we consider how and why some artists removed themselves from the city as the site of their modernity and chose instead to create from 'the interior'. We

consider and question the claims of artists who used 'primitive' subjectivity and 'rural simplicity' as the basis of their quest for greater self-expression, and investigate the overlapping of the notions of 'subjectivity' and 'creativity'.

Chapter 4 considers why the female nude played so prominent a part in the making of modern art practice. The primacy of the female nude as a motif of modern art, from Courbet to Kruger, is examined. The chapter considers some of the significant moments in the incorporation of the female nude into modern artistic practices and frames them in terms of more recent feminist and theoretical perspectives. Debating the politics of representation, pornography and 'the gaze', Chapter 4 pulls together various theories of representing the naked and the nude which have valorised modernist aesthetics.

Chapter 5 is an examination of modernism and postmodernism's uneven relationship with technology. From the mechanolatry of the 'machine aesthetic' to the current fascination with the 'cybersublime', we probe the push and pull of art and science. This chapter demonstrates the tensions between artists and the technological developments of the post-industrial world, considering in particular those artists who have embraced the machine and now locate their creative practice in the most recent technological developments. Considering the impact upon art, architecture, music and film we look specifically at 'holistic' art projects such as Dada, futurism and movements affiliated with the 'machine aesthetic' – Russian productivism and the Bauhaus, purism and De Stijl. We consider the nature and function of utopian art projects. According to dominant modernist history, the 'machine aesthetic' was fundamentally anti-expressionist, anti-mystical and anti-romantic individuality. We look also at some of its contradictions, considering how some artists reconciled the 'machine aesthetic' with a continuing sympathy for spirituality and mysticism.

Chapter 6, on American art, starts from the premiss that while it is no longer possible to view New York as the centre of the art world, Europeans were in thrall to its critics, its museums and its art practices until well into the 1970s. The cult of abstract expressionism ricocheted around the world. In accounting for the dominance of post-war American art, this chapter raises a series of debates around quality, critical endorsement, museum practices and Cold-War politics.

Chapter 7 looks at the role of the performance artist in late twentieth-century art practice. Starting with an examination of the role of the artist's body in the production of works of art and finishing with an examination of the artist's narcissistic obsession with questions of self and identity, we chart the development of the body politic in the post-war period. The chapter looks at the changing nature and function of self-expression and considers some of the ways in which artists have used their bodies as sites of political and social discourse. We explore the nature and significance of performance and body art, predominantly in the 1960s and 1970s, using recent theories of the body and the self, and identity politics.

Chapter 8 shows how the museum and gallery of modern art has been crucial to the development and dissemination of the art we call 'modern'. We explore the perceived monumentality of the gallery space and look at the work of those artists who have courted the gallery system and those who spurned it. Technological changes which have opened up the possibility of bypassing conventions such as curatorship, are considered, as are notions such as the 'original' work of art and the 'authentic experience' as prerequisites for the consumption of modern art.

WHAT IS AND WHEN WAS MODERNISM?

If I'm going to have a past, I prefer it to be multiple choice!² (The Joker)

In the 1980s, Sherrie Levine brought together in composition two of the icons of modern art by photographing Alfred Stieglitz's photograph of Marcel Duchamp's Fountain. To present, as a work of art, a photograph of a photograph of an art work raises critical issues, especially if we are mindful of the 'status' of the original: Duchamp's Fountain — a urinal turned upside-down — is a 'ready-made'. Levine's photograph acquires its postmodern credentials through her acknowledgement of (what, not so very long ago, would have been seen as) her flagrant plagiarism. Levine's photograph is emblematic of modernism's uneasy relationship with its objects of desire and helps us to locate a disruption in the confidence of the modernist trinity — authenticity, autonomy and originality.

In the Introduction we introduced the term 'postmodernism'. The prefix 'post' suggests something that is over, after the event. However, 'postmodernism' can mislead if we understand it to act as a style label or to define the current situation, particularly if it suggests a clear break or severance with something called 'modernism'. As indicated by the case of the 'modern' Duchamp and the 'postmodern' Levine, many of the defining characteristics of modernism seem to continue as defining conditions of postmodernism. These continuities sometimes make the two designations seem almost indistinguishable.

The postmodern period is often defined in relation to the political turbulence that characterised the late 1960s, 1968 being seen as the watershed. Student unrest, anti-Vietnam-War demonstrations, the civil rights' and women's movements are cited as the social forces that ushered in postmodernism. Loss of confidence in a single authoritative political voice extended to the arts where rapid changes led to a questioning of the adequacy of the dominant tradition – modernism – when faced with the competing demands of previously marginalised groups.

During the century preceding the tumult of the 1960s the arts appear to have been engaged in an essentially optimistic project inclined towards progress. Modernism, as a movement or at least a loose confederation, is a set of ideas and beliefs about art produced in the modern period. It was, broadly speaking, the cultural outcome of *modernity*, the social experience of living in the modern world.

The received genealogy of modernism

Transformed as it was by industrialisation and urbanisation, culture since the mid-1800s has been marked by a self-consciousness and a restlessness that single it out from the less changeable pre-industrial world. Change, a dynamic constant in the modern period, was embraced by those who would be modern, as a marker of advancement.

Looking broadly at the arts – at, say, music, dance, the novel, poetry and the theatre – there appears to have been a common motivation in the late nineteenth and twentieth centuries to redefine the boundaries of what constitutes the particular specialism of each discipline. In general terms, what became known as modernism was synonymous with overhaul and change, even abandonment. Artists, musicians and writers renounced traditional art forms during the nineteenth century in what E. H. Gombrich calls a 'permanent revolution' (Gombrich 1950: 395) followed by a 'search for new standards' (Gombrich 1950: 425). It is not that more 'conservative' forms of music, dance, art, etc. disappeared, rather that they were not synonymous with *the modern*, although just why remains a contested issue. After all, if something happens during the *modern* period how can it fail to be *modern*? These and other questions are fundamental to an understanding of the developments of art generally designated *modern*.

Leaving aside for a moment the difficulties of definition, examples of what came to count as 'modern' in music, to take one art form, included the early experimental works of Eric Satie and Claude Debussy, and the work of the Austrian composer Arnold Schoenberg (1874–1951). In searching for new musical forms Schoenberg all but demolished traditional harmonic structures and abandoned what had constituted melody and the eight-note scale to eventually construct twelvetone (or note) music.³ In the 1950s the American composer John Cage, one of Schoenberg's pupils, experimented with 'chance music' and even 'created' a musical piece that consisted of silence across 4 minutes and 22 seconds – arguably the sonic equivalent of Kasimir Malevich's *White on White* paintings. Cage made music of non-musical *sounds* and ostensibly removed or diminished the traditional role of the composer. Musical notation also did not conform to traditional expectations.

In literature, Gertrude Stein redefined the sentence, at a time when many were abandoning poetry and literature's 'realism' and traditional narrative structures, constituting a denaturalisation of language. Although not in tandem with literary change, architecture abandoned centuries of stylistic tradition and ornamentation. At the same time, there was a tendency to make redundant the traditional notion of dance as the enactment of a story set to a musical score; this was purged in preference for purely functional movement. Theatre meanwhile abandoned both its traditional role as a vehicle for cathartic release and the conventions of staged illusion to become consciously theatrical and self-referential. From the early avant-garde Russian theatre

to the experimental theatre of Weimar Germany and Italy in the 1930s, the discipline underwent radical attempts to make visible, often self-consciously, its *form*. Exponents of drama, such as Bertholt Brecht, concentrated on theatre as theatre and employed techniques to remind audiences that they were watching an illusion, an artifice. The audience would be coerced to watch the production through the intellect, not the emotions. In some cases this involved the removal of the theatre to non-theatrical spaces, such as cafés and streets.

Even the newest art form, film, patented in 1895 by Auguste Lumière, soon split into mainstream and experimental arenas. Early avant-garde cinema of the 1920s tended to reject literary ideas and conventional narratives, and to concentrate instead on the possibilities of the medium of film itself, utilising montage to disrupt audience expectation of seeing a 'slice of real life' on the screen. Splicing together composite images, filmmakers like Hans Richter – a member of Zurich's Dada, an anarchic confederation of writers, musicians and artists – disrupted traditional narratives and audience expectation of the 'real'.

No art form was unchanged by modernism but the degree and depth of change seems, in the visual arts, to have been especially extreme, involving the abandoning, in some of its forms, of centuries of craft, technical skill and even knowledge. Modern art is usually measured, in the imagination of the public at least, in terms of how unlike the object depicted it actually is. For example, cubism is very little like its object, and abstract art, not at all. Before the modern period artists were praised for their attention to detail and the lifelikeness of their work: apocryphal it may be, but the notion of good practice can be summed up in the tale of the Greek painter who painted on a wall grapes that looked so 'real' that birds actually pecked at them. The modern period is marked by redefinition of art's function in depicting as 'real' a representation of the world of appearances. Fountain (1917) by Marcel Duchamp (1887–1968) is more than lifelike: indeed, it was actually 'real' – a ready-made urinal, but a urinal masquerading as art. Paradoxically, denying the status of a piece as art was one way of guaranteeing that status, as happened, for instance, with Marcel Broodthaers' 7 This Is Not Art or René Magritte's This Is Not a Pipe.

At times it is difficult to see just what it is that characterises 'art' in the modern period. The skills traditionally associated with sculpture are clearly absent from the work of Duchamp and Broodthaers, yet the repeated reproduction of the works in art books testifies to their importance in art history. Modernism in art seemed to be implicated in a kind of crisis about its own objects of desire, which is to say that artists fetishised objects perceived to fall outside of the traditional remit of art. At the same time, there was a requirement to self-consciously interrogate art's own internal, usually formal, functions. This imperative gave the modernist movement a seemingly undisputed status in identifying the only 'significant' art of its time.

A return to ready-made art might clarify the issues. As early as 1914 Duchamp had installed 'ready-made' objects, such as bottleracks, hat stands and bicycle wheels, into the art gallery. By 1917 the most famous of these ready-mades – Fountain, the urinal – had entered art history as an iconic object. Duchamp asked whether art was just what he said it was, when he anonymously attempted to exhibit the inverted urinal, signed 'R. Mutt', at a New York Independents' exhibition. Perversely, it became art, precisely because it was rejected, particularly since Duchamp complied with the rules laid down for the open submission of art works. An anti-institutional

stance, a climate of spirited opposition and a conscious breaking of boundaries seem to have been prerequisites of modernist art. This tradition was established with Salon des Refusés (Salon of the Rejected) in Paris (1863) when the French impressionists, in a defining moment, defiantly displayed art works rejected by the official Academy. To have one's work summarily dismissed from an orthodox institution subsequently became the sign of a serious enterprise, and a mark of modernism. It is important to note that co-option into what was increasingly the modernist revolution was often retrospective, and puzzled many artists whose radicalism went only as far as the paint-brush. Duchamp's inverted urinal, Fountain, unseen by the public, was, however, validated by an authoritative photograph taken by the American modernist artist, photographer and gallery-owner Alfred Stieglitz. To enter the pantheon of modernist icons art works in the modern period did not need to be actually made, exhibited or even to exist, often achieving celebrity through notoriety and fame through infamy.

Painting was equally marked by a form of iconoclasm. To the uninitiated, Kasimir Malevich's paintings *Black Squares*, exhibited at 'The Last Futurist Exhibition in Petrograd: 0, 10', in 1915, can be puzzling. All content but for the paint seems to have been evacuated from the canvases, and yet the paintings have been the object of sustained historical and curatorial interest. Although the look of paintings and sculpture had certainly changed compared with, say, a Vermeer or a Donatello, just when and why remains contested. To pick up a point which we raised earlier, the net results of what appear to have been artistic abandonments were cultural forms that were principally experimental and innovative. As abiding principles, although simplistic and crude when we examine the course of twentieth-century art, they are a fair indication at least of what the practitioners of modernism thought it to be and of how it differed from what had gone before.

The examples by Duchamp and Malevich provide also an indication of a central paradox within modernism. If innovation, originality, an autonomous art (art that refers only to itself) and a 'critical distance' (art that is a critique of orthodoxies) were programmatically central to modernism, then all that could be accomplished seems to have been achieved before the end of the First World War. If the iconoclasm of these two works could stand as a marker for modernism as early as 1915–17 what more could be achieved? If, in addition, postmodernism is taken to mean a rejection of notions of authenticity and originality, why had another fifty years to go by before modernism supposedly burned itself out? The two works stand in mutual tension. Duchamp's 'ready-made' was a rejection of his former painting practice, and certainly the early Russian avant-garde, of which Malevich was a member, had by the 1920s all but abandoned easel painting. As Raymond Williams (1989: 69) points out, if real 'renunciation', abandonment of tradition, was supposed to have taken place, then there appears to be have been no decision by most painters (Duchamp being a major exception) to give up *paint* as a medium.

For the most part, traditional histories of art structured around movements and '-isms' such as impressionism and post-impressionism or abstraction and post-painterly abstraction, privilege painting and sculpture. Even where artists, like the Russian constructivists and futurists, designed clothes, made music, designed furniture and made films, it is with their paintings and sculpture that we are made primarily familiar. The reproducible arts of photography and printmaking still remain, by and large, categorised as lesser arts. This hierarchical approach to art's histories has helped

sustain the exclusivity of the '-isms' approach. It has excluded, in part because of the often transitory and ephemeral nature of the works, much of Dada, and missed out Fluxus and situationism. Surrealism is often limited to a hagiography of repetitively familiar European names. The 'domestic' arts of quilt and lace making and embroidery are entirely absent from canonical modernism unless incorporated into a painting or sculpture for their formal beauty. The examples we have chosen are indicative of what Williams identifies as 'the machinery of selective tradition'. Although coming out of modernism from their respective '-isms', Duchamp and Malevich are still 'old masters of modern art' and a cultural manifestation of male, white, bourgeois privilege, despite Duchamp's anti-bourgeois stance and Malevich's revolutionary credentials.

The version of modernism that dominates art history is concerned largely with painting, while sculpture is seen as a second-order art form. Put simply, the dominant modernist tradition maintains that the demands of 'specialisation' and 'purity' required painting to be rooted into its 'own area of competence' defined by the American critic Clement Greenberg as 'paint' and an orientation towards flatness. Barnett Newman's monumental *Cathedra* (Figure 1.1), almost seventeen feet across, complied with high modernism's imperatives: to explore the medium of paint and attain flatness. Could it be that, far from the radicalism that we believed modernism to be, in its painterly manifestation at least, it was a form of conservatism after all? Or does radicalism lie in the ability of artists to critically assess the medium through the medium itself?

When was modernism?

The answer to the question 'When was modernism?' is not a simple matter of establishing dates. It depends in part on what modernism is believed to have been. If it is merely a continuous series of stylistic changes then, in some sense, the issue is either very simple – beginning with Edouard Manet's 'unfinished' canvases of modern life in the 1860s such as *A Bar at the Folies-Bergères* (Figure 1.2) and finishing

Figure 1.1 Barnett Newman, Cathedra, 1950–51. Courtesy of the Stedelijk Museum, Amsterdam. Photo: © ARS, NY and DACS, London 1999

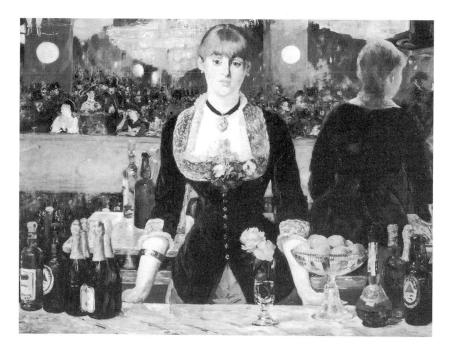

Figure 1.2 Edouard Manet, A Bar at the Folies-Bergère, 1882. Photo: John Webb. Courtesy of the The Courtauld Gallery, London

somewhere around American abstract expressionism in the 1950s – or else extremely vexed. That we should attempt to answer the question posed here at all would have seemed peculiar 200 years ago. In the eighteenth century history and fiction were kindred forms and history was regarded as a literary art; both possess a narrative structure, that is, both tell a story. The emphasis on narrative gave rise to a way of writing about the past as a story in chronological order of events. One of the great scholarly enterprises of the age was the systematic periodisation of the past to order, sequence, classify and impose dates upon history. Currently an understanding of our own relationship to the past is tempered by a 'crisis of confidence' in understanding the past through empirical data. Although we may now feel that history is something we 'make up as we go along', the result of such systematic scholarly activity was the structuring of a discipline of art history that developed through its own principles of periodisation: there was Medieval, Renaissance, Baroque, Rococo or their local equivalents.

Such an enterprise left twentieth-century art history with a legacy of fixed chronological boundaries, a structure to which it initially subscribed, adding supplementary movements and '-isms'. The history of art is replete with survey books featuring separate chapters dealing with the various '-isms'. This in itself has created a quandary. What should be the object of study in the modern period, particularly given modern art's own fractious relationship with its objects of study? Is a chronological survey of '-isms', although the most popular way of working through the period, the only way of understanding modern art? Should art works be central to

the 'curriculum' or should the curriculum be structured around artists, 'the sensitive antennae of society' (Barr 1975: 5), political events or the changing zeitgeist? If around art works, then which do we select to study?

General surveys tend to treat modernism as having an exclusively French nucleus. Even when Spanish and Dutch artists are mentioned, they seem to have been coopted into French culture and a modernity that is sited in Paris. In acknowledging this emphasis we might look beyond the narrower margins and begin a history of art with a broader look at art's position within a cultural framework and not as a separate sphere of activity divorced from the social. Where the social dimension impinges on traditional histories of art is usually at the level of biography: artists' biographical details may shed light on artistic activity but also on art's social context. Art history as a history of '-isms' combined with edited highlights of the lives of artists does, however, tend to focus attention on the salacious and the tragic, often substituting romantic ideas of individual struggle for any real engagement with the social and political framework.

A systematic approach

By the 1920s, the empirical model of scholarly activity required by modern art, as it became increasingly 'difficult', was felt to need some kind of genealogy. Alfred H. Barr Jr, scholar and founding director of the first modern art gallery, the Museum of Modern Art (MoMA) which opened in New York in 1929, created a nownotorious schema for modernism. Barr's attempt to define an historical trajectory for modern art adorned the cover of the catalogue for the Museum of Modern Art's 1936 exhibition 'Cubism and Abstract Art'. It is emblematic of the difficulties facing those who attempt definitions in the current age of resistance to overarching defining characteristics. Barr's schema was provisional, and although he did later rework the plan he made no major revisions. The schema's narrow boundaries and its assumptions about which works are valuable, and on what grounds, has led to charges of 'historicism' - constructing a history that is implicated by contemporary values - and 'teleological thinking' - constructing a system as if art inevitably progressed towards a 'natural' goal (Figure 1.3). Barr's diagram charts a trajectory that flows from post-impressionism through cubism and expressionism, the machine aesthetic and surrealism, to two forms of abstraction: on the left, non-geometrical biomorphic abstract art typified by Wassily Kandinsky, and, on the right, geometrical abstract art represented by the Dutch painter Piet Mondrian. While compelling in its apparent logic and clarity, having the authority of a scientific diagram, Barr's schema has always been problematic. First, it contributes to the schism between 'conservative' practices and a perceived radicalism by aligning itself with technically 'progressive' practices. Second, it evacuates the social and political agendas that often informed the movements identified in favour of a deracinated art. In many ways the grid was emblematic of the dominant view of modernism flat, repetitive, non-figurative, ordered and bordered. It may be emblematic of one definition of modernism, certainly familiar if we follow the line of art's need to purify and orientate itself towards flatness, but it is important to grasp that modernism, though used to label/define certain art works, is also a set of ideas and beliefs about

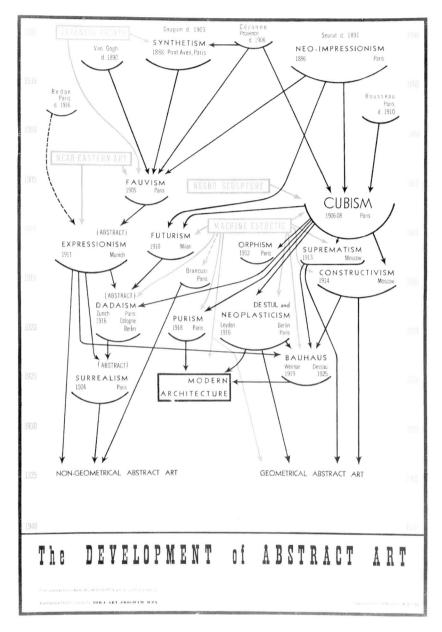

Figure 1.3 Alfred H. Barr Jr, The Development of Abstract Art, 1936. Photograph © 1999 The Museum of Modern Art, New York

art works and as such, we will see, is unstable and often deeply subjective. Moreover, the dynamic, ever-changing, practice of cultural activity in the twentieth century, the sheer diversity of cultural response to modernisation, should mitigate against any homogeneous and totalising outcome, which Barr's schematic approach seems to endorse.

Were we ever modern?

Writers often locate the onset of modernity in the eighteenth century. Thierry de Duve identifies in the writings of Roger de Piles and Abbé Dubois a significant shift of emphasis in the notion of individual subjectivity characteristic of this period. De Duve maintains that *taste* is an important factor in the ideology that supports modernism, and he identifies a movement from a kind of collective idea of taste to a notion of taste as determined by the individual. It was during this period that the emphasis on *feeling* as the basis for judgements of taste emerged. This is not to say that a highly formed sense of self had not existed prior to the eighteenth century; however, put crudely, the agency of the individual began to encroach upon the position previously occupied by God. To raise the question 'Were we ever modern?' is, therefore, to enquire not only about dates but about reconfiguring notions of the individual.

The eighteenth-century Enlightenment, often called the Age of Reason, promoted an opposition to the authority of the aristocracy, the traditional repository of morality and taste. The French writer Denis Diderot (1713-84), responsible in part for Encyclopédie, the first published encyclopaedia, was opposed to the classical rules of beauty and believed, more democratically, that beauty resides in ordinary and every-day entities. He rejected the belief that breeding is the basis for taste and instead emphasised experience. More important for our purposes is the collapse of confidence in seventeenth-century doctrines such as the 'Divine Right of Kings' and the challenges to aristocratic values. As we will see, 'lived experience' was to be pivotal for the prime movers of modernism, critics and writers who, like the nineteenth-century French poet Charles Baudelaire and the Edwardians Roger Fry and Clive Bell, and latterly Clement Greenberg and Michael Fried, valued engagement with the 'here and now' over any acquiescence to the extant classical order. The German theorist Jürgen Habermas located the origins of the modern period in the Enlightenment, in his influential paper 'Modernity - An Incomplete Project' (1990). He saw modernity as a continuation of the belief in an 'illuminating' age in which enlightenment was an attitude to problem solving, sustained by trust in the power of logic to solve problems rather than by belief in a deus ex machina.

The Enlightenment project was profoundly influential, providing the litmus paper for both the American and French Revolutions. While its philosophical ideas reached every sphere of social life, it is its relationship with the arts that interests us here. Enlightenment philosophers believed that through a combination of science, technology and an autonomous art (art as a self-governing sphere of activity) all things, including nature, could be conquered and all social problems solved. Art was therefore seen as an implement with which to improve, both morally and socially, the condition of humanity. This was in stark contrast to the earlier function of art which, according to de Duve was:

to honour the dead, serve the Church, ornate bourgeois interiors, placate taste . . . but its function was never programmatically . . . to exert critical vigilance over the ethical realm. Once it appears in art works, this very function of critical vigilance – precisely because it is new – radically

severs them from their pasts; it forbids anyone to valorise art forms that failed to make the same break on their own.

(de Duve 1996: 432)

In part then, the art works that became identified with the term *modernism* contained some kind of moral imperative – an idea we will return to throughout this book. This is not, however, a transparent issue. The moralising tendencies of Victorian art, based largely on notions of self-improvement, were not directly equatable with the moral high ground that modernists occupied. What de Duve identifies has been described as a 'critical distance' (art that is a critique of orthodoxies). As we will see, the moral was often evacuated from the aesthetic programme of modernism, but, paradoxically, in order to engage in an act of pure aesthetics, was somehow to lay claim to another moral high ground.

The greatest legacy for modernism has been the construction of the notion of the artist-as-genius. It is possible to discern the legacy of the eighteenth- and nineteenth-century Romantic movement in the heroic (if short-lived) stage of the early avant-garde. Alienation and rejection were essential elements in the formation of artistic sensibility in Romanticism. The movement required a new form of subjectivity, one that we will examine more specifically in coming chapters, that at least in part opposed classicism's emphasis on order and restraint. The Romantic artist became identified, at least in myth, with the Byronic phrase 'mad, bad and dangerous to know'. Restraint was not the order of the day: landscape art in particular exalted in 'sublime' tragedies, and disasters abounded, with incipient industrialisation eroding the edges of nature. Facets of Romanticism were 'adopted' by the avant-garde: in particular, rejection of conventions, resistance to institutionalised forms of regulation, and emphasis on the individual.

This moment of rebellion is notable because in earlier epochs certainly no-one expected Vermeer or Rembrandt to be technically innovative, to contribute to a manifesto or to declare the grounds of their 'critical distance' from the established order or status quo to create in *their* art. We may have come with hindsight to value Rembrandt's ambiguous relationship with the worthy burghers of seventeenth-century Amsterdam, but that is not to view his art as advanced or in opposition to the dominant order. Early modernism, however, was marked by an avant-garde that looked for radical political transformations through artistic innovation and experimentation, and the declaration of that radicalism in print. In the case of the Italian futurists, a manifesto could conceivably precede any art work. Filippo Marinetti published the first manifesto on futurist painting before any significant body of work had been produced. The declamatory nature of the manifesto is important in establishing an intervention in mass 'consciousness'. It is a statement of intent — the reverse of the private diary and letter form used by earlier artists.

Formalism

There is often an assumption that an 'artistic death knell' ushered in the modern movement.⁷ For some, like the American critic Clement Greenberg, it was important to establish that modernism, within the parameters of his own definitions, was

in a continuum with the past. Greenberg saw modernism as an historical reality, referencing the unsettling effect of photography on artistic practice in mid-century France (the first daguerreotype, a combination of printmaking and photography, was made in 1839) as part of the crisis that precipitates such dramatic changes in the way art looked and what its function should or could be. This is not, contrary to modernist opinion, the first time that painting had been in crisis. In fact, history painting had come under threat in the eighteenth century when the introduction of mirrors into artistocratic homes resulted in the mass removal of 'old fashioned' painted panels in favour of increased reflected light.

Greenberg is definite about dates and, perhaps more importantly, the way in which modernism manifested itself: the form that the works took. His writing does tend to suggest that modernism, after all a concept or tendency, was in some way self-defining, with a will of its own. Nonetheless, for Greenberg,

Modernism showed itself more clearly at first in terms of technique, technique in the most immediate, concrete sense. That is how Manet broke with the recent past more momentously than did any other contemporary in his or any other arts. Not that he broke with all tradition. Harking back to a more distant past in Spanish painting, he found himself inspired to leap into the future.

(Greenberg quoted in O'Brian 1986: 30)

Of course it is the look of the modern painting that is startling. The distortion of colour, the rejection of naturalistic conventions and the blatant rejection of the classical conceptions of the heroic in favour of the mundane still have the ability to disarm the viewer. Hung side by side with an academic work, Natalia Goncharova's (1881–1962) Linen of 1913 (Plate I) with its distortion of scale, unheroic subject matter and antinaturalistic composition, has so little resemblance to its academic counterpart that it is easy to assume that technical change and innovation, an emphasis on formalism, was all that was important in the works designated 'modern'.

The conflation of terms generated, wittingly or not, around Clement Greenberg, often obfuscate the period. 'Formalism' and 'art for art's sake' are two terms often conflated in writing about modern art. Rarely are sustainable definitions attempted (and not without reason). Attempts to cite modernism with a capital 'M' as an indicator of the type of modernism associated with Greenberg can be misleading. Greenbergian modernism is perhaps closer to a relatively useful definition of a dominant and defining history of modernism, that both defined the past and influenced the working methods of artists anxious for critical acclaim. Greenberg's work was based on formalist critical tendencies, rooted in the theories of, among others, Clive Bell and Roger Fry, but the whole of modernism or indeed Greenberg's theories should not be co-opted under such a blanket term. Formalism, rather than a proclivity like modernism, better suggests the way in which works are read or subjected to aesthetic evaluation by the artist or viewer. Formalism is principally an approach that emphasises line, colour, tone and mass at the expense of the significance of subject matter. It gives no clues as to the social context of art works. At first sight this is an apparently 'easy' theory of art, although it underwent several transformations, between 1912 and 1950, in response to the perceived direction of the modern movement in painting and sculpture. Developed between 1912 and 1914 by the English painters and art critics Clive Bell and Roger Fry, formalism privileges the aesthetic response as mediated through sight alone. Visual sensibility is a prerequisite of art appreciation, and a genuine aesthetic experience is both self-sufficient and disinterested. The strength of the approach is that there can be a formalist response to any item or artefact from any culture or period. However, there is also a philosophical dimension to formalism, harking back to the Enlightenment philosopher Immanuel Kant (1724–1804) and, through him, to Plato. In brief, this is a system of aesthetic judgements and values which have their own internal intricacies, whereby beauty is not scientifically measurable but is appreciated through 'feelings' and 'aesthetic pleasure'. The crucial and defining feature of Kantian aesthetics is that aesthetic pleasure is disinterested: that is, the aesthetic response transcends the corporeal. This aesthetic can obscure Formal art appreciation as it often resorts to exclusivist ideas about painting and sculpture which are highly philosophical.

Given the apparently open agenda of formalism, it is curious that so little art finds its way into the pantheon of great works as defined through the process, described by Clive Bell as an engagement with 'significant form' (Bell 1982: 67–74). By this he meant that art works of quality can be identified through their formal properties which act as the marker of their significance. We saw in Alfred Barr's schema (Figure 1.3) how exclusive the canon of 'great works' could be. Certainly it seems that the emphasis in modernism on the 'aesthetic response' has been exclusive rather than inclusive. If we return to the work of Duchamp, and apply a formalist agenda, it becomes easier to see why works such as *Fountain* were so marginalised. Kantian aesthetic responses can only accommodate partial readings of modernism, and *Fountain* was 'distasteful'.8

This approach in the modern period is not exclusive to Bell, Fry and Greenberg. The symbolist painter Maurice Denis maintained in 1890, that 'a picture . . . before being a battle horse, a nude woman, or some anecdote – is essentially a plane surface covered with colours assembled in a certain order' (Denis 1890: 94). Perhaps the difficulty here is in maintaining a formalist 'eye'. Just how long can mere looking be sustained without recourse to other questions about what an art work is about, without reordering those works into some kind of subject matter with social, not aesthetic, considerations? Be that as it may, one of the compulsions of early modernism seems to have been to abandon subject matter in favour of form.

Modern art and its objects

Modernism has become synonymous with specific modern paintings – the 'old masters of modern art', Cézanne, Monet, Picasso, Pollock. Although actual examples may be referred to as quintessentially modern, modernism is also a set of ideas and beliefs about those works, and so needs to be distinguished from the works themselves. These *works*, in what constitutes a canon of modern art, were themselves identified through a process of selection and validation that was considerably different from the academic procedures of the established academies of art in the nineteenth century. One sense of modernism, as we have seen, tends towards rejection of the values of the academy, perceived by a new generation of artists as conservative and

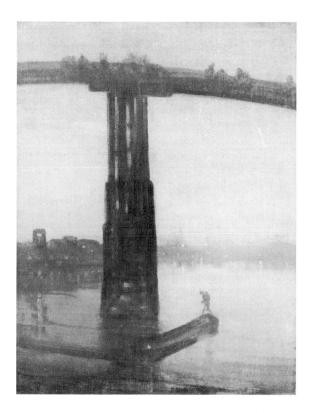

Figure 1.4 James Abbott McNeill Whistler, Nocturne in Blue and Gold: Old Battersea Bridge, c. 1872–75. Courtesy of the Tate Gallery, London

repressive, and implicated in bourgeois notions of moral correctness as somehow corresponding to exactitude and 'finish' in a painting. For instance, Ruskin's attacks on Whistler's hurried *Noctumes* (Figure 1.4) were not merely attacks on incompetent painting: he saw their lack of verisimilitude as a moral affront. Manet's 'unfinished' and rather dishevelled canvases were not just poor painting (that could easily be accommodated) but were a fall from moral grace.

In *The Birth of Modern Painting* Gaeton Picon writes of a earlier break with the past, in 1863:

When the Salon des Refusés – the Salon of the Rejected – opened in Paris on May 15, 1863, it was as if History were staging an event which, in the order of painting, would show all the signs of a break with the past and a new beginning. . . . It was a drama with several leading characters but with one outstanding hero: Manet; and for which *Le Déjeuner sur l'Herb* – whether applauded or booed – might have supplied a title. (Picon 1978: 7)

The passage is important as it raises several spectres. For many social historians in the 1970s and 1980s, the language of heroism and the presumption of a heroic rupture

with the past contributed to the mythologising of art history's past. ⁹ It is an indication of the radical debates (particularly under the aegis of the so-called new art histories) that have opened up the terrain of traditional art history, and which were written largely from a Marxist viewpoint. In fact, although rarely so credited, John Berger was also writing critical, not celebratory, connoisseurial art history as early as the 1960s. Marxism permeated the new writing's seminal works: T. J. Clark's *Image of the People: Gustave Courbet and the 1848 Revolution* (1973a) and *The Absolute Bourgeois: Artists and Politics in France 1848–1851* (1973b) altered the terms by which art history would be written. Clark stated his method in his Introduction, entitled 'On the Social History of Art', to *Image of the People*:

When one writes the Social History of Art, it is easier to define what methods to avoid than propose a set of methods for systematic use. . . . So I begin by naming some taboos. I am not interested in the notion of works of art 'reflecting' ideologies, social relations, or history. Equally, I do not want to talk about history as 'background' to the work of art. . . . I want also to reject the idea that the artist's point of reference as a social being is, a priori, the artistic community. . . . Lastly, I do not want the social history of art to depend on intuitive analogies between form and content . . . that the lack of firm compositional focus in Courbet's Burial at Ornans is an expression of the painter's egalitarianism, or that Manet's fragmented composition in the extra-ordinary View of Paris World's Fair (1867) is a visual equivalent of human alienation in industrial society.

(Clark 1973a: 10-11)

The newer art histories do seem to be permeated with a set of puritanical negatives, but their aim has been to prise art from its esoteric rest home and push it back towards some form of social relevance.

The strength of the Marxist approach was its acknowledgement of the subjective nature of historical reconstruction. The assumption of a 'disinterested history' and, crucially, the assumption of a 'disinterested aesthetic' above and beyond the contingencies of historical reconstruction were laid bare by Marxist, socialist and feminist art historians. The central tenet of Marxist art history (and it is only fair to point out that there are many shades of Marxism – Leninist, Engelsian, Althusserian – named after its various exponents) is that art is influenced by the social and political circumstances in which it is produced. But the degree to which the social and political conditions in which a work of art is made *actually* influences that work is controversial. Some (these are often called 'vulgar Marxists') argue that a work of art is the passive product of any given socio-economic situation, while others credit art as having greater autonomy in the face of what they see as more distant socio-economic events.

Marxism deconstructs the centrality of the 'artist as hero' – in the crowd but not of it – in modernist discourse. The modernist artist is the anti-academic, anti-traditionalist who breaks the boundaries and revels in the refusals. There is, however, plenty of evidence to suggest that Manet and many other artists craved official approval. The relationship between artist and authority and, crucially, display opportunities, patronage and galleries is a constant irritant in twentieth-century avant-garde

culture. The gradual assimilation of oppositional art into institutional orthodoxy represents one of the failed utopias of the modern period. The collapse of the Eastern bloc combined with the poststructuralist rejection of totalising beliefs has contributed to a collapse of confidence in Marxism as a tool for analysis. However, it would be premature to dismiss the strength and rigour of the Marxist contribution to art history even as the light fades on the utopia that it seemed to represent.

To return to Gaeton Picon's 'one outstanding hero' – Manet: Picon centres the modernist tropes – innovation and rejection – around the artist. It is unlikely that a book on the Renaissance or the Baroque period would start with the artist. For other periods, innovation, originality and authenticity were not isolated in the gifted individual whose subjectivity, through some notion of self-expression central to modernism, would reveal the truth about the age. This construction of the artist as hero is a primary marker of the modern period. The art works that would be *modern* art are defined and subjected to validations of a specific kind. If T. J. Clark and the feminist social historian of art Griselda Pollock wanted new ways of reading seminal modernist canonical works like Manet's *Olympia*, other dissidents preferred Raymond Williams' approach to modernity and its objects – an approach characterised by analysis of the relationship between popular culture and fine art.

In traditional histories of modernism, the process by which an academic genre painting such as William Frith's *Paddington Station* is not included within the category of the modern, in contrast to Monet's paintings of railway stations which are, does not take place naturally nor is it a procedure that can be attributed to some abstract notion of the modern as somehow self-selecting. The procedures of selection are within given discourses supported by institutional validations, even when apparently oppositional. Merely re-reading the original canon from a Marxist or a feminist perspective does not diminish the canon itself.

What emerges from the debate is the nature of the quality of and the confidence in the 'disinterested aesthetic', and what the objects of study should be. Should art works be at the centre of art history? Equally at issue is the specific designation of the canon. 'Modernism', as we have witnessed, has a hierarchical basis which privileges high cultural forms and practices, and excludes graphic design, commercial and industrial photography, and film. To ask meaningful questions about modernism, then, is to ask questions about cultural value.

Avant-gardes

The only modern art of significance and quality is avant-garde art, and any art that is satisfied with exerting functions that predate modernity (placating taste for instance) loses its value as well as its critical function simply by being retarded, retrograde. When push comes to shove, Rodchenko is an artist and Bonnard is not.

(de Duve 1996: 432)

The term *avant-garde* has been mentioned in various contexts. It holds a crucial if ambiguous, even contradictory, position in relation to cultural practices in the late-nineteenth and twentieth centuries. Although current confidence in it has been

shaken, in the avant-garde remains an important (if fictional) feature of modernism, especially in terms of its inclusions and exclusions. 'Familiar' problems of the avant-garde have been identified by Hal Foster as '... the ideology of progress, the presumption of originality, the elitist hermeticism, the historical exclusivity, the appropriation by the culture industry, and so on' (1990: 5). Foster's set of negatives is a concise deconstruction of areas once considered inviolable. A shift in 'feeling' for avant-garde culture seems to be manifest in the now not unfamiliar tone of Foster's statement. In general, the public may not have liked the work of avant-garde artists, but there was a broad general agreement that it was progressive and original, even authentic. Its position was assured, and even if remote its very hermeticism, its 'otherworldliness', did not necessarily mark it off as 'elitist'.

The history of the avant-garde is not transparent. The avant-garde itself (and it was often self-defining) is notorious for mythically obscuring its own history. This is in part a consequence of the artist's often woebegone if sometimes heroic attempt to both court official recognition and yet stay beyond the confines of orthodox sanctification. The strategies devised by artists, writers and musicians to establish themselves in opposition to the dominant order make up some of the most interesting artistic skirmishes of nineteenth- and twentieth-century art.

The avant-garde is of course a military term and, as such, is instructive in setting the conditions of artistic endeavour since the late nineteenth century. A relatively new term, it singles out an important difference in modern art practice from what went before. The term suggests an element of danger, certainly of risk, a military metaphor applied to western cultural practices. The advanced guard went into battle first. The rest, crucially in modern art terms, followed or rather pejoratively 'brought up the rear'. By these terms, Monet led with his railway station and Frith was pensioned out of the army altogether. It has, however, become all too apparent in the late twentieth century that the legions did not follow the avant-garde. But this is to jump ahead. At least in artistic terms, to be 'in advance' was to be innovative and original. But what did it mean to be original and innovative in the mid-nineteenth century? Industrialisation brought with it major social upheavals across the western world. England was industrialised earlier than were her European counterparts.

One response to such apocalyptic changes can be found in the works of young English artists who made up the Pre-Raphaelite Brotherhood. Formed in 1848, a date at which some commentators suggest the avant-garde gets into its stride, the work of this grouping could constitute a radical practice. It was, after all, sufficiently 'anti-establishment' to constitute a critical relationship to society, its relationship with modernity was complex, and its imagery was technically, visually and symbolically innovative. It had the right critical connections. In 1928, Roger Fry, subsequently associated with the formulation of the aesthetic response in relation to post-impressionism, wrote an important essay of introduction to the art collection at the Lady Lever Gallery, Port Sunlight, which is, however, unfortunately not available as a purchasable publication, being part of the Gallery's 'reserve'. In this essay Fry stated that 'it was against the trite sentimentality, the trivial facetiousness, or merely theatrical effectiveness of the motives which were current among the painters of the mid-century that the pre-Raphaelites raised the standard of revolt' (emphasis added). All the characteristics which seemed to ensure entry into avant-gardism were in place: revolt, genius and, what Fry defined as, 'seriousness and conviction' - a kind

of pictorial moral high ground. Fry identified crucial elements in the Pre-Raphaelite rebellion, particularly in the quality of Dante Gabriel Rossetti's 'poetical inventions, [and] the freshness and intensity of his themes'. Ultimately however, Fry 'conceded' that even Pre-Raphaelitism, 'the one distinctive and original movement of the period, fits readily enough into the Royal Academic conception of painting'. Fry acknowledges the Brotherhood's opposition to the Royal Academy but finally, with regret, condemns the works as *illustrative*. So rebellion alone, even against the academies, is not enough, at least not for critics like Fry. He required a sense of the pictorial, not of the illustrative, saying of Rossetti: 'he never showed himself a painter in the proper sense, his expression was laborious and heavy handed'. So although Fry's admiration for the Pre-Raphaelites is clear, the grounds of his disapproval comply with that estimation of the avant-garde that requires technical innovation of a certain sort. Whatever a proper painter is, Rossetti, for Fry, was not one.

There must be a rejection of 'illustration', and as Fry was to say of the American symbolist James McNeill Whistler, there must be instead, 'a *direct* expression of imaginative states of mind'. The dominant account of Pre-Raphaelite works sees them as a retreat, not an advance, into the mythic past – an indulgence in the face of the reality of 'dark satanic mills' and Dickensian squalor. Whistler's work, on the other hand, seemed more connected to the 'here and now'. Pre-Raphaelitism can too easily seem like a mawkish antidote, even a panacea, to the modern world, for those knowledgeable enough to draw on Dante, Malory and Keats (Figure 1.5). As we will see in Chapter 3, one of the defining aspects of modernism was its relationship to the *imagination* – the ability to realise an alternative to the present, to the morass of industrialisation. An engagement with modernity need not have resulted in the seemingly monolithic French model. The Pre-Raphaelite technique

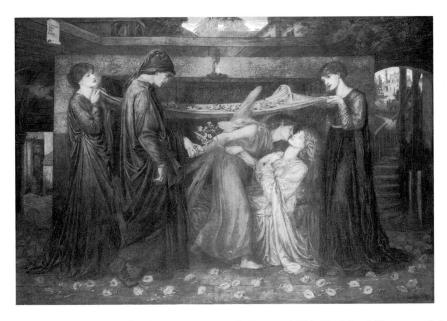

Figure 1.5 Dante Gabriel Rossetti, Dante's Dream, 1871. Board of Trustees of the National Museums and Galleries on Merseyside (Lady Lever Art Gallery, Port Sunlight, Wirral)

was deliberately archaic, not 'unreflective' illustration. The movement was also programmatically self-conscious, one of the modernist tropes. At the risk of sounding jingoistic, the influence of British art on European art in the nineteenth century was considerable. John Constable is often cited because of the enthusiastic reception of his works by the French impressionists; the Pre-Raphaelites were, however, associated with a symbolism which did not come to dominate art-historical writing, at least that of the American and British persuasions.

The Brotherhood fails to enter the avant-garde, as it is defined in the Baudelairian sense of an engagement with modernity that requires paintings of modern life to be symbiotically linked to a new means of representing those living in an industrial age. Arthurian legends or the morality tales of life under capitalism were not enough. It was necessary to somehow be of that age and show it through its technical innovation as well as its subject matter. This apparent lack of technical innovation in painting is echoed also in the debates over the radical nature of the writer Charles Dickens. On what grounds, Raymond Williams (1989) asks, is the radical 'realism' of Dickens marginalised against the achievements of James Joyce, Franz Kafka, Virginia Woolf and T. S. Eliot? What were the grounds for privileging those who 'denaturalised' language over others who reflected it like a mirror? Avant-garde artists equally rejected what they perceived to be art that mirrored the world. However, it would be wrong to assume that the 'appearance of things' is a simple mirroring of the world, because even mundane things can assume symbolic or allegorical connotations in works of art. It is simply that Barr's belief that artists were 'bored with painting facts' often belies the complexity of representation.

In *The Politics of Vision* (1991) Linda Nochlin maintains that the term 'avant-garde' was first used in relation to art by the French utopian socialist Henri de Saint-Simon in the 1830s. Crucially for the early avant-gardists, social revolution was inextricably linked to the arts. The arts were not confined to the realms of the aesthetic alone. Nochlin (1991: 2) quotes D. Laverdant's 'De la Mission de l'art et du rôle des artistes' (1845):

'Art, the expression of society, manifests, in its highest soaring, the most advanced social tendencies: it is the forerunner and the revealer. Therefore to know whether art worthily fulfils its proper mission as initiator, whether the artist is truly of the avant-garde, one must know where Humanity is going, know what the destiny of the human race is . . .'

This is a far cry from the requirements of academic technical competence in the subtle modelling of human flesh, careful gradations of tone and the privileging of line over colour – to recall a classical past. Artists must now have a serious mission and a futuristic social insight beyond that of most mortals. This version of avantgardism finds its apotheosis, according to Nochlin, in Courbet's major work *The Painter's Studio* (1855) (Figure 1.6). However, the essential element in avant-garde culture – that of alienation from bourgeois norms – does not make an appearance until Edouard Manet and the writers Flaubert and Baudelaire. Many have argued that Manet's *A Bar at the Folies-Bergère* (1882) (see Figure 1.2) combines the commitment to social and technical radicalism of Courbet with the isolation and alienation necessary for the advancement of what we have come to know as avant-gardism.

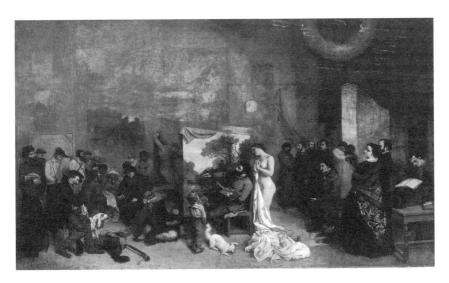

Figure 1.6 Gustave Courbet, The Painter's Studio, 1855. Paris, Musée d'Orsay. Photo: © RMN – H. Lewandowski

In Manet's work irony and the irreverent reworking of art-historical sacred cows (e.g. Giorgione's pastoral idyll *Concert Champêtre*, Titian's *Venus D'Urbino*) coalesce to create wilfully ambiguous paintings that, according to the dominant version of avant-garde cultures, set the standard for avant-garde practices to follow. Even at this juncture, however, the level of social or political commitment in Manet's work has been contested. Manet may have been isolated from his bourgeois roots but he never attempted, at least not through his art, to overthrow the established order, although there is plenty of evidence to show how disaffected he was from Napoleon III's Second Empire and its imperialist initiatives.

In a series of five works begun in 1868 (Plate II), Manet shows the execution of the Emperor Maximilian, Napoleon's puppet ruler, abandoned in one of Napoleon's less successful colonial 'interventions', this time in Mexico. Manet drew heavily on contemporary accounts of the execution, changing details in the works as more information was relayed through the newly laid transatlantic cable. Manet appears to have worked obsessively on the series until the following year. The series is critical of Napoleon's failure to save Maximilian from execution by Benito Juárez's Mexican Liberal troops. It has been suggested that the soldier loading his rifle to complete the coup de grâce is a portrayal of Napoleon; in addition, the troops resemble French rather than Mexican soldiers. Unlike other paintings of the execution, the series was the subject of severe censorship. The lithographic stones, which would have yielded wider public access, were confiscated and the works were never shown in France in their entirety. In spite of Manet's clear political agenda and his attempt at a major modern history painting, one of the losses of avant-garde practices, the American critic Clement Greenberg felt able to state that 'the lasting shock [of the series] had to do with his handling of the medium and that alone. . . . Similarly, the Impressionists, coming in Manet's wake, caused shock or scandal by nothing other than the way they used paint' (Greenberg quoted in O'Brian 1986: 31).

This is an important issue in relation to avant-garde culture. The social and political commitment in Manet's work is crucial in establishing an avant-garde agenda. The modernist claim is that Manet's work was a 'pretext for painting', that his commitment to politics was, at best, secondary to the 'act of painting', a claim made even more extremely in Greenberg's writing where the content of the work is disregarded in favour of paint handling alone. There is enough evidence, however, to suggest that Manet's paintings were no mere formal exercise – that he had an explicit political agenda. The ambiguities that appear in his work are accounted for, at least in part, by the need to evade the censors – not because he was concerned over charges of incompetent painting or indulging his pleasure in paint, but because the content of his work was inflammatory. Manet may have been alienated from the bourgeoisie, but in this particular instance he was supporting a liberal—bourgeois opposition (united in its condemnation of Napoleon's ill-conceived ambitions). ¹⁰

In his essay 'Modernist Painting' (1982), Greenberg continued to maintain the position that 'content should be avoided like the plague'. In addition, he wrote of a new emphasis on flatness and what he termed 'opticality'. Greenberg declared: 'Manet's paintings became the first modernist ones by virtue of the frankness with which they declared the surfaces on which they were painted' (1982: 6). There is here a significant shift in emphasis, from what appear to be the concerns of Manet in the 1860s to the preoccupation of a critic writing a century later. It does highlight the difficulties faced in recovering artists' intentions, but also the difficulties of separating present concerns from those of the past.

The tensions in Greenberg's writings are indicative of the polarities that have characterised many of the histories of art produced over the last fifty years. How do artists reconcile the twin commitments of what appear to be separate spheres of activity – the aesthetic and the political?

Another example might be pertinent. Until recently Pierre Bonnard, the French painter of interiors and nudes in the bath, had an assured position within the avantgarde. However, the grounds on which the debate has been staged have shifted again. At just the point when avant-garde culture has gained institutional and public acclaim, the historians of art have pulled the rug from under the avant-garde. Bonnard is not to be considered avant-garde because the designation was, according to de Duve and others, bogus in the first place. It has indeed proved difficult in the nineteenth and twentieth centuries to successfully combine the political and the aesthetic, especially when there seemed also to be a requirement for innovation and originality. De Duve's identification of the Russian constructivist artist-designer-photographer Aleksander Rodchenko's Human Pyramid as the work of an artist and the French painter Pierre Bonnard's Nude in a Bath (Figure 1.7) as not, is not, although axiomatic of a particular tendency, an illustration of the difficulties of classification within avant-garde culture. Traditional art history would include Bonnard for his technical innovations and largely marginalise Rodchenko for his politics and photography. De Duve ironically highlights the issues surrounding classification, insisting rhetorically,

You are not a historian of art; you are a historian of the avant-garde. Such is the name of the practices that alone interest you. The name of art and the consensus that it begs are nothing but the retrospective

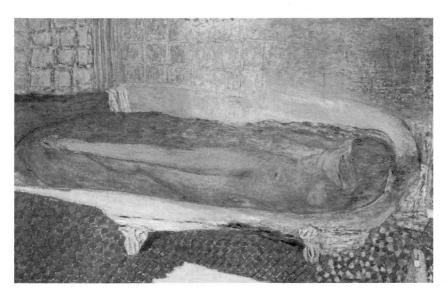

Figure 1.7 Pierre Bonnard, Nude in 'a Bath, 1937. Musée d'Art Moderne de la Ville de Paris, Paris, France. Courtesy of the Bridgeman Art Library. Photo: © ADAGP, Paris and DACS, London 1999

sanction of these practices. It makes them autonomous, and in so doing alienates them; it endorses them, and in so doing drains them of power; it affirms them, and in so doing negates their negating impetus.

(de Duve 1996: 20)

Aesthetic autonomy

The linking of the terms 'autonomy' and 'art' is a modern phenomenon, a result in part of the supposed loss of innovations in painting with the invention of photography, but also a response to the increasing commercialism of modern life under capitalism. In brief, this autonomy can be seen as the detachment of art from the realm of the social. Peter Bürger points to the central paradox in trying to explain art as an autonomous activity that exists outside of the social world because to refer to art's independence requires 'you . . . to refer to autonomous art's position within society' (Bürger 1984: 35). In this sense, Bürger continues, 'to suggest autonomy is a historically conditioned phenomenon turns into a denial; what remains is mere illusion'. Autonomous art, then, not only contains this central paradox but, as a construction of bourgeois society, the historical development of the avant-garde ironically precludes any possibility of an autonomous art. Hal Foster identifies this elitism as a problem within avant-garde culture that attempts to create a hermetic world, simultaneously 'revealed and obscured', sealed off from the social. This is to arrive at the position we identified earlier: although we can see that art works are positioned and even constructed within bourgeois norms, can they be reduced to them? Is there no possibility for art to transcend the conditions under which it was validated and consumed? It is important to grasp that, while art works are undoubtedly formed in relation to social and aesthetic discourses, the variety of artistic responses to modernism would suggest that artists are not merely passive reflectors of dominant social and aesthetic discourses. In particular, the work of the international groups of surrealists, with their productive use of Freudian and later Jungian notions of the unconscious, stand as a riposte to the reductive theories that made art merely a reflection of bourgeois values. Through a strategy of 'making strange' the everyday, the surrealists hoped to force a re-evaluation of bourgeois norms.

For some theorists the question of autonomy is a thorny one. Terry Eagleton cautions us:

From Romanticism to modernism, art strives to turn to advantage the autonomy which its commodity status has forced upon it, making a virtue out of grim necessity. Autonomy in the worrying sense – social function-lessness – is wrenched into autonomy in a more productive sense: art as a deliberate turning in upon itself, as a mute gesture of resistance to a social order which, in Adorno's phrase, 'holds a gun to its head'. Aesthetic autonomy becomes a kind of negative politics.

(Eagleton 1990: 370)

For Eagleton the only way out is to reject the aesthetic to make art against itself, an avant-garde strategy that will become a familiar one over the course of what follows.

Avant-garde and the relationship to bourgeois culture

Put simply, by Raymond Williams in *The Politics of Modernism*, 'hostile or indifferent or merely vulgar, the bourgeois was the mass which the creative artist must either ignore and circumvent, or now increasingly shock, deride and attack' (Williams 1989: 53). All avant-garde movements were anti-bourgeois and yet all were assimilated by the structures of bourgeois society. As T. J. Clark put it: 'Bourgeois society is efficient at making all art its own' (Clark 1973a: 6–7). The relationship of modern art to the bourgeoisie is further complicated by the historical divisions within the bourgeoisie between 'petite' and 'haute', not unlike the English distinctions between lower- and upper-middle class.

These historical distinctions arose in France, following the demise of the aristocracy as a force to be reckoned with after the revolution of 1789. The triumphant
bourgeois revolutionaries, perhaps displaying a characteristic insecurity in the face
of aristocratic 'taste', either quickly assimilated or formed (depending on the
extremity of your position) the potential for an 'acquisition of taste' in modern art.
The haute bourgeoisie saw themselves as the arbiters of taste and the artistic heirs
of the system of patronage. Having 'taste' at this point required a flirtatious but not
dangerous liaison with bohemianism – a kind of frisson without the discomfort. The
successive '-isms' of nineteenth- and twentieth-century art, predicated not on levels
of skill that could be acquired but on art forms that required a new form of sensibility in order to be 'understood', were the perfect vehicle for protection against

the philistinism of the lower orders. It is notable that, by and large, even in terms of the north—south divide in Britain, the mill and ship owners preferred the 'skilled' paintings of the Pre-Raphaelites and late-Victorian aesthetic movement to those of the 'incompetent' French school of daubers favoured by the sophisticated upper-middle class in London. Roger Fry described the painter Sir William Orchardson as 'a man of refined but trivial sensibility' (Fry 1928). Wealth during industrialisation was no longer adequate as a distinguishing feature of social class. The new rich had the money to differentiate themselves from the working class, but this was insufficient to impress. This is, of course, a fairly crude level of reasoning though, as we saw in the Introduction, the sensibilities required of the new art, extolled in the theories of Clive Bell and at a more sophisticated level in Roger Fry's work, instead of giving universal access to all became the privilege of a certain class.¹¹

The rapid move through the '-isms' of canonical art history, then, becomes a prerequisite of taste and avant-garde culture is a necessary absorption of styles by the dominant fashion. The remove from so-called objective standards of competence required a level of critical substantiation and, crucially, spokesmen to identify the real 'challenges' in art. Members of the educated upper-middle class, confirming their status and power, were willing to act as a discriminating high-priesthood in these matters. Pierre Bourdieu's Distinction - A Social Critique of the Judgement of Taste (1984) adds weight to this version, in which the avant-garde continually redefined advanced art in opposition to popular taste. His work suggests that avant-garde cultures and the elevation of certain art works, whether in literature, music or the visual arts, represent the class struggle fought out in the cultural arena. He identifies a bourgeois strategy that accumulates what he calls 'cultural capital', a force which continually moves taste beyond the reach of working-class audiences. The challenging visual language of high-art icons, such as Picasso's Demoiselles d'Avignon 1907 (Figure 1.8), demonstrates the point precisely. As far as avant-garde culture is concerned, there is a built-in time-lag between critical reception and popular acceptance. The acquisition of cultural capital is dependent upon an avant-garde: currently, where there is arguably no single avant-garde, this strategy becomes increasingly passé, since the 'shock of the new' rarely achieves its aim.

Two avant-gardes

There was a period, however, when an avant-garde had greater cultural caché and therefore more to lose. Raymond Williams identifies the complexity and vulnerability of avant-garde culture:

We have then to recall that the politics of the avant-garde, from the beginning, could go either way. The new art could find its place either in a new social order or in a culturally transformed but otherwise persistent and recuperated old order, all that was quite certain, from the first stirrings of modernism through to the most extreme forms of the avant-garde, was that nothing could stay quite as it was: that the internal pressures and the intolerable contradictions would force radical changes of some kind.

(Williams 1989: 14)

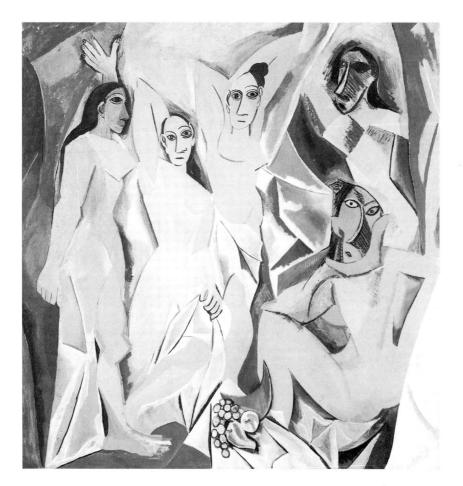

Figure 1.8 Pablo Picasso, Les Demoiselles d'Avignon, 1907. The Museum of Modern Art, New York, Purchase. Photo: © Sucession Picasso/DACS 1999

Two avant-gardes are discernible (although the polarities do not always hold): on the one hand there is the avant-garde designated by its 'pure opticality' – its exponents being Roger Fry, Clive Bell, Clement Greenberg and Michael Fried; and on the other hand there is the avant-garde of Dada, surrealism, futurism and constructivism. Both are basically utopian art projects, but although their aims were the same their objectives were very different.

Dada, an anarchic confederation of writers, musicians and artists, began in Zurich in 1915. Its roots had been in the revolutionary art of the early Russian avant-garde, and it went on to inspire 'branches' in New York, Berlin, Barcelona and Paris. Implicit in the sheer variety and scale of their art (simultaneous poems, cabaret, noise, music, posters and paintings, illustrated in Marcel Janco's painting of an evening at *The Cabaret Voltaire*), Dada demonstrated a commitment to personal and political revolution. The term 'revolution' has lost much of its currency in the late twentieth century, applied as it is to processes as diverse as the manufacture of hair conditioner, or triple beef-burgers. In Zurich's Spiegelgasse, however, Dada's 'revolting' Cabaret'

Voltaire was in good company. The exiled Lenin, Russian leader of the Bolshevik Revolution, plotting revolution on a grand scale, lived across the street. Politics and art were inextricably enmeshed in Dada literary and polemical manifestos and anti-manifestos.

Hugo Ball (1886–1927) was a leading Dada protagonist at the Cabaret Voltaire, and his *Gesamtkunstwerk* (complete art works achievable through cabaret) was a vehicle for Dada's engagement of the bourgeois in a war of attrition. Hans Arp wrote:

The bourgeois saw the Dadaist as a loose-living scoundrel, a villainous revolutionary, an uncivilised Asiatic, with designs upon their bells, safe-deposits and honours. The Dadaists thought up tricks to rob the bourgeois of his sleep. . . . The Dadaist gave the bourgeois a whiff of chaos, a sensation like that of a powerful but distant earth tremor, so that his bells began to buzz, his safe-deposits wrinkled their brows and his honour developed spots of mould.

(Quoted in Richter 1965: 37-8)

The fate of much avant-garde culture is glimpsed by Hans Arp in 'Dadaland':

Revolted by the butchery of the 1914 World War, we in Zurich devoted ourselves to the arts. While the guns rumbled in the distance, we sang, painted, made collages and wrote songs with all our might. We were seeking an art based on fundamentals, to cure the madness of the age, and a new order of things that would restore the balance between heaven and hell. We had a dim premonition that power-mad gangsters would one day use art itself as a way of deadening men's minds.

(Quoted in Richter 1965: 25)

Meanwhile, Monet at Giverny was coping with the noise of the guns while painting waterlilies (Figure 1.9). It is a moot point which of these avant-garde strategies has been the more effective. In terms of art history the 'selective machinery of tradition'

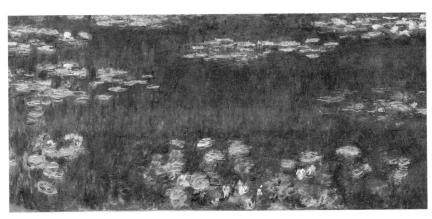

Figure 1.9 Claude Monet, Green Reflections (detail), c. 1916–26. Paris, Orangérie des Tuileries. Photo: © RMN

(to recall Williams) valorised Monet's formalism (and evacuation of politics) while reducing Dada to the antics of naughty schoolboys.

An additional contradiction of avant-garde culture is its distant relationship to the masses. André Breton, leader of the surrealist movement, wrote in 1929 in 'The Second Surrealist Manifesto' that 'the approval of the public is to be avoided like the plague'. In surrealism the revolution of the psychic self, the inner world, was symbiotically linked with revolutionary Marxism. The surrealist's difficulty with political commitment was connected to the ease with which revolutionary techniques, formal experiments that would reveal the inner world, were appropriated as mere experiments or else rejected as separated from their politics. Surrealist automatist practices, like frottage, grottage, decalcomania and montage were innovative but easily neutralised of any radical potential. In essence the surrealist quandary mirrors the avant-garde's precarious existence.

Radical art in terms of innovation was not seen as the only option to social revolution in the modern period, and it is a misreading of avant-garde culture to always see it as a break with the past, in spite of claims made by avant-gardists themselves. Lenin and Leon Trotsky recognised the achievements of bourgeois art forms, although they acknowledged its essentially conservative nature. A complete rejection of previous art forms was not therefore necessary. In *Literature and Art*, published in 1923, Trotsky states: 'Artistic creation is always a complicated turning inside out of old forms, under the influence of new stimuli which originate outside of art' (quoted in Timms and Collier 1988: 179). Lenin rejected new art forms advocated by both the Proletkult, a confederation of workers and factory art clubs producing art by and for the people, and the constructivists, employed in the same project, but using an abstract visual language in favour of building on existing bourgeois orthodoxies.

Antonio Gramsci, working in Turin in the early 1920s before Mussolini's rise to power in 1922 and prior to a decade in prison, organised the Institute of Proletarian Culture which bore affinities to the Proletkult in Russia. Gramsci also acknowledged the dynamism of bourgeois individualism, but advocated a redirection of that energy to mass culture. The rejection of the idea of continuities in favour of the modernist tropes of disruption, rejection and alienation was part of a strategy of social renewal. The continuities are, however, there, even if unacknowledged by many.

Commodity

There are some people for whom the mere mention of art and money in the same book . . . is high treason, a hanging offence. To them it is as if money were a form of fiscal defoliant; set it among the fragile flowers of the art world and in next to no time you will have a wasteland.

(Watson 1992: xxiii)

The co-dependence of art as art and as commodity is a pronounced feature of modernism. There are two aspects to this co-dependence: first, that modern art has tended to depict the commodification of culture (for instance, *A Bar at the Folies-Bergère*); and, second, that art aspires to the condition of commodity. Peter Watson's observation,

overblown perhaps, nonetheless highlights a prominent feature of nineteenth- and twentieth-century art, a feature that has at times either bedevilled art practice or been embraced by its practitioners and public alike. As we have seen, avant-garde culture contains several paradoxes: one is the instrumental effect of art markets on an art that aims to be autonomous and 'free' but at the same time remains in thrall to the novelty factor of an art world hotfoot in pursuit of the new and unfamiliar.

One of modernism's more 'heroic' constants has been to evade commodity status and to risk, or celebrate, a retreat from the world. From the Russian Proletkult movement through Dada, surrealism and the situationist international to abstract expressionism, there have been attempts to evade the controlling mechanisms of market forces. Abstract expressionism, it has been argued, attempted to remove itself from the political arena and market forces, at the level of routine analysis, by retreating into the aesthetic. The critic Greenberg acknowledged the ambiguous position the avant–garde would need to maintain with its patrons. After all, even painters need to eat. However, he declared that artists would need to remove themselves from the commercial world, and frequently from the social world also, in order to survive, and that this in itself was an act of heroism. The visual outcome on the canvas of this retreat was a rejection of direct reference to the real world. Greenberg stated:

Retiring from the public altogether, the avant-garde poet or artist sought to maintain the high level of his art by both narrowing and raising it to the expression of an absolute in which all relatives and contradictions would disappear, and subject matter or content becomes something to be avoided like the plague.

(Greenberg 1939: 35)

This utopian idealism that seeks to protect art from commodification becomes in its turn another heroic failure.

With the possible exception of 'gift culture' – which is usually relegated to the realm of 'primitive' economic forms, and therefore the academic preserve of the anthropologist, or else is marginalised to the periphery of 'sophisticated' capitalist western economics – the nineteenth and twentieth centuries have been marked by the total assimilation of cultural activity with the orbit of commodification. As early as 1900, the German philosopher Georg Simmel, writing in *Philosophy of Money* acknowledged the inability of culture within a capitalist society to evade commodity status. Modern capitalism, he believed, would reduce all human creativity to the vicissitudes of the market place (see Simmel 1978).

Ever since the impressionists in the 1860s rejected the official Salon as the only financial market place and created an alternative art market with a dealer system, artists have both rejected (Duchamp) and embraced (Warhol) the process in about equal measure. As both the desired object of exchange value, and increasingly since Manet's A Bar at the Folies-Bergère with its conspicuous display of new mass-produced consumer goods, such as bottled Bass beer as part of the imagery of modernism, the commodity has permeated art practice and display. Currently, postmodernism's easy 'embrace' of commodity culture seems, at times, to be at the level of the apocalyptic – for instance in Barbara Kruger's 'Untitled' I Shop Therefore I Am (Figure

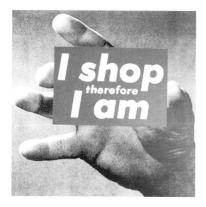

Figure 1.10 Barbara Kruger, 'Untitled' I Shop Therefore I Am, 1987. Courtesy of Mary Boone Gallery, New York

1.10), an embrace that seriously undermines the earlier modernist claim that a 'critical distance' was essential to its operations.

The commodification of art is evidenced by the purchase of Louise Jopling's Home Bright, Hearth Light (1896) (Figure 1.11) from the Royal Academy by Lord Leverhulme for use as an advertising image to promote Sunlight Soap which he manufactured. In the 1990s the clothing multinational company Benetton has run various advertising campaigns which have generated controversy for their aestheticisation of violence, death and human suffering. Benetton's imagery blurs lines that used to exist between art and advertising. Such imagery, unlike Home Bright, Hearth Light, generates controversy because it has nothing whatever to do with the product advertised. Benetton's use of Mafia Victim and Pool of Blood does not even approach selling by any reference to the product (Figure 1.12). Such is the force of commodity culture that a tasteful logo and unconnected image can sell clothes around the world.

Where is the avant-garde now?

Hal Foster has commented on the failure of the avant-garde:

For Bürger the historical avant-garde also failed . . . the dadaists to destroy traditional art categories, the surrealists to reconcile subjective transgression and social revolution, the constructivists to make the cultural means of production collective – but it failed heroically, tragically. Merely to fail again, as the neo-avant-garde does according to Bürger, is at best pathetic and farcical, at worst cynical and opportunistic.

(Quoted in Foster 1996: 13)

Robert Hughes writing in the *Sunday Times Magazine* in 1979 felt confident enough to announce the death of the avant-garde.

This sudden metamorphosis of one of the popular clichés of art-writing into an unword took a great many by surprise. For those who still believed

Figure 1.11 Louise Jopling, Home Bright, Hearth Light, 1896. Lady Lever Art Gallery, Port Sunlight, Merseyside. Courtesy of National Museums and Galleries on Merseyside

that art had some practical revolutionary functions, it was as baffling as the evaporation of the American radical Left after 1970.

(Hughes 1980: 18)

Other writers have sought to bury modernism. They point to things like the so-called technological revolution, the reappropriation of avant-garde strategies by the world of advertising and the supposed collapse of art into pure commodity as evidence of the demise of modernism – and as themselves markers of postmodernism.

However, announcements such as Hughes's concerning the 'death of the avant-garde' are premature, according to others. If modernism has ultimately failed, then what happens to all its relics, *Fountain*, for instance? Contemporary art practice has found various uses for avant-garde culture. The first easily visible manifestation of the avant-garde's loss of purity came in postmodern architecture with the wholesale

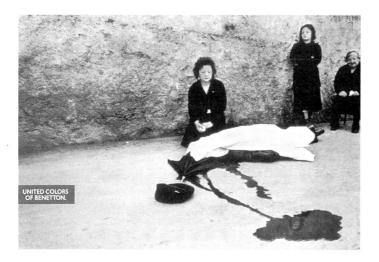

Figure 1.12 Benetton advert (Mafia Victim and Pool of Blood), Courtesy of Benetton

importation into one building of previously autonomous styles. Returning to Sherrie Levine's photograph of Stieglitz's photograph of Duchamp's *Fountain*, her acknowledged plagiarism is representative of the next stage in the reassimilation of modernist strategies into the postmodern. It may be seen, on one level, as postmodernism's partial acknowledgement of the failure of the totalising tendencies of modernism, and of totalising tendencies in general. The whole notion of a universal modernism has been found wanting. However, as Suzi Gablik argues, in relation to Levine's 'duplicitous' strategy, postmodern art 'becomes the cheerful orchestration of collapse, the cracked mirror of culture where products must continually replicate other products, where artists become the authors of somebody else's work' (Gablik 1991c: 36–7).

The triumph of postmodernism, at least in the west, has been a Pyrrhic victory. Postmodernism's crisis is the crisis of confidence in the function of art and culture at the end of the twentieth century. One of the gains of postmodernism, however, has been its recuperative aspect. It allows for artists and historians to explore in the wider margins works and strategies neglected or dismissed by modernism. It allows also for local and specific art works that take account of cultural diversity and celebrate difference. Its other gain, a dismissal of hierarchies, has come at the expense of a sense of overall purpose. A loss of confidence in the unitary self and a unitary expression has opened up a space that takes account of cultural diversity and celebrates difference. In terms of the work generated under the rubric of postmodernism, Faith Ringgold's *Dancing in the Louvre* (1991) is a celebration of black people's intervention in to western art history. But it is a celebration also of the cultural diversity of art practice itself. An amalgam of formal fine–art practice (painting) and domestic handicraft (patchwork fabric), Ringgold's work of art is eclectic at the level of both subject and medium.

The strength of the modernist project was its sense of purpose, which gained in the face of opposition – part of its dissenting tradition of antagonism and alienation. The difficulty now, at least in western culture, when art seems to have fused with commodity, is that rebellion lacks caché. As a consequence, art has arguably

been deprived of its energy, and certainly its utopianism. In the next chapter we look at modernism and postmodernism again, this time in terms of public spaces, monuments and sculptures.

Notes

- The question 'What Was Modernism?' was asked by Harry Levin in the title of an essay first published in 1960. The chapter title, 'When Was Modernism?', refers to Raymond Williams' essay (1989) of the same name.
- 2 Batman: The Killing Joke (© 1986; published by Titan Books, 1988).
- 3 The new system of composition sometimes referred to as dodecaphony was developed in 1921. The system utilised twelve notes of the chromatic scale in which, potentially at least, each note was of equal importance.
- 4 18th century Romanticism, it should be remembered, had claimed some drastic revision of what constituted art.
- 5 Jules Michelet and Jacob Burckhardt in the second half of the 19th century are usually subsequently credited with 'inventing' periodisation, building on Enlightenment thought.
- 6 See for instance the works by Ernst Gomrich, David Britt, H. W. Jansen. The recently published (1997) Tate Gallery series *Movements in Modern Art* includes editions on Minimalism, Realism, Surrealism and Modernism.
- 7 Catriona Miller claims as do many others that, 'it was the mechanised murder of the Western front which consigned the old nineteenth century order to oblivion.... But the artistic death knell had been sounded some ten years earlier' (Miller 1996: 159). She cites Fauvism (1905) and Cubism (1907) as the 'two vital sparks which kick started modernism into existence'. These two seminal dates 1905 and 1907 refer to two art-historical events: in 1905 the Fauves, the group of artists including Derain, Matisse and Vlaminck who exhibited their work at the Salon d'Automne in 1905; and in 1907 Picasso painted the proto-cubist work *Les Demoiselles d'Avignon* (see Figure 1.8).
- 8 There is only one mention of Duchamp in Charles Harrison's latest book, on modernism (see Harrison 1997).
- 9 See the 1982 seminal social historian of art's Open University course 'Modern Art and Modernism'.
- Notable writers such as Victor Hugo and Emile Zola wrote in defence of Manet's works and against Napoleon III.
- 11 This, in spite of the political allegiances of Fry and company, who came largely from a socialist background which included, for some, working with the WEA (Workers' Educational Association).

MONUMENTS, MODERNISM AND THE PUBLIC SPACE

For the sake of a single verse one must see many cities, men and things. . . . One must be able to think back to roads in unknown regions, to partings one had long seen coming . . .

(Rainer Maria Rilke)

The power of the metropolitan development is not to be denied. The excitements and challenges of its intricate process of liberation and alienation, contact and strangeness, stimulation and standardisation, are still powerfully available. But it should no longer be possible to present these specific and traceable processes as if they were universals, not only in history but as if it were above and beyond it.

(Raymond Williams)

It is just possible that in the twenty-first century the west's attachment to cities will seem, at best, eccentric and, at worst, an aberration. However, since nineteenth-century industrialisation cities have been the focus of accelerating communication, social transformation, revolution and reaction. Increasingly, it seems, the technological revolution makes where we live irrelevant to our working lives: the global village is accessible with a touch of a keyboard. Modernism was played out against a predominantly urban backdrop, driven by the migration to the cities during industrialisation, its rapidly changing social relations transforming artistic production, consumption and display. Artists' responses to modernity and all the technical and economic changes that were wrought in its wake, as we have seen, have not been uniform. Although the city was central to modernism it had as its 'other' the countryside; and, for many artists, it prompted extended explorations in 'exotic' and 'primitive' locations. It is one of the ironies of modernism that, although an urban phenomenon, it had a symbiotic relationship with nature. Its 'offer' of authenticity (as we see in Chapter 3), while deeply romantic in concept, could propose an alternative to the modern urban world.

The city

Received modernist art history has for the most part placed Paris at the centre of modernism, although latterly Singapore and Tokyo have been identified as its postmodern successors. Beyond the actual physical spaces of global cities lies another metropolis – the virtual city and the disembodied encounter with Cyberia. This chapter will explore artists' and historians' responses to the changing realities that cities have presented. It begins by looking at the often neglected memorial monument of the civic square and the public place. If the equestrian statue of the Renaissance square, with its harmonious relations of scale and proportion, seems unproblematic to the tourist in search of history, the European monument in the nineteenth and particularly the twentieth century strikes a somewhat discordant note.

Many of the works we will look at have been designated realist. It is worth noting at the outset, however, that what we understand as realistic in a work of art is always culturally determined. Whether we know it or not, we are bound by a tacit understanding which determines for us whether works look correct or real. This is not a question merely of familiarity, although familiarity unquestionably plays a part. Our perception of nature itself is culturally determined and informed by pictures and sculptures. The monument's realism in the nineteenth century, contributed to our understanding of reality itself. The rapid transformation of our understanding of 'the real' in the late twentieth century is echoed in the transitory and often ephemeral nature of the monument in the modern period. The monument, or memorial monument, acts as a lexicon of shifts in cultural practice. It is therefore an important site of a culture's rites and rituals, which contribute to a collective or at least 'collected memory' (Young 1993: xi). However, the privileging of the individual subject within modernist art practices enabled a shift from public to private in which the monument's primary function was subject to revision. For instance, when the monument is displaced or removed, the formation of historical memory is fractured; and when modernist art practice moves from the public domain to the private sphere of individual contemplation, the notion of a public monument loses some of its cultural privileges.

On monuments and memory

In September 1996 Michael Jackson's monumental *Moonwalker Statue* (Figure 2.1) temporarily towered above the River Valtava in Prague, emblematic of Jackson's 'History of the World' tour. The statue stood in front of the faltering timepiece, the metronome, erected to mark the passing of the Cold War and the re-entry of Czechoslovakia into Europe. The site's former incumbent had been the statue of the Russian leader Joseph Stalin. The socialist realist monument (Figure 2.2) popularly referred to as 'Stalin and the Bread Queue', had been removed in 1963, following Nikita Kruschev's de-Stalinisation programme of the 1950s. These changes are significant in charting, in the modern period, the fugitive state of the monument – usually a signifier of solidity and stability. The ideologies represented by monuments, and, crucially, their modes of representation, are what concern us here. The simulated-bronze statue of Jackson may, on one level, seem to signify a return

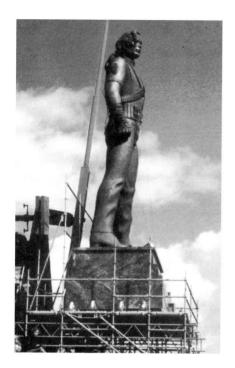

Figure 2.1 Moonwalker Statue, temporarily in Prague, 1996. Photo: Pam Meecham

to the unreconstructed kitsch that Stalin's statue used to represent in western terms. The term *kitsch* was a modernist indictment for much socialist realist work – a term of approbation used by Clement Greenberg in his 1939 article 'Avant-Garde and Kitsch' (Greenberg 1985). The term *realism* itself, the accurate recording of visual appearance in the world, became an impediment to truth-telling in the modern period. Socialist Realism, the official doctrine for all the arts in Russia from 1934 onwards, cannot be *real* by modernist criteria. It is marked twice in its 'regressive' anti-modern tendencies: once by its dependence on previous bourgeois art forms and again by not merely recording the visible world but actively constructing a partisan realism – an optimistic art of, and for, the masses.

At the same time, kitsch is a form of parody widely used in postmodern practice, especially by artists critiquing established notions of taste. As we saw in Chapter 1, taste was the principal criterion for establishing quality within modernism, and to subvert modernist notions of taste is a typically postmodern device. For instance, both Barbara Kruger's *Family* (1997) (see Figure 4.14) and Jeff Koons' huge puppy made of flowers which embellishes the entrance to the new Guggenheim Gallery in Bilbao used 'bad taste' in an ironically knowing way. Of course, Michael Jackson's statue might operate at the level of parody – as an ironic spin on capitalist reworkings of socialist realism – or it might be simply an unwitting pastiche.

The statue of Jackson in heroic posture and pseudo-military regalia mocks notions of authenticity (its creators could make no claim to formal innovation); and in its iconoclasm it re-configures the function of the monument in western culture. The statue bears more than a passing resemblance to socialist realism, but could be

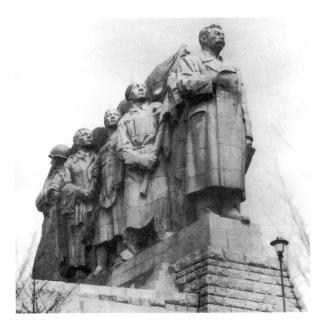

Figure 2.2 Otakar Švec, Monument to I. V. Stalin ('Stalin and the Bread Queue'), 1955

said to stand in triumphant antagonism to it. The statues of Stalin and Jackson seem to stand as binary opposites – for the demise of the totalitarian Soviet bloc and the economics of Communism and for the triumph of liberal free-market economics. Combined, the two statues raise the question of the changing nature of public art. As we will see, in direct contrast to earlier public art that represented a perceived consensus, under late capitalism sculptures in public spaces seem to occupy a position of ambivalence – either in conflict with dominant values or complicit in the blurring of boundaries between public, private and corporate.

Postmodernism has been seen positively by critics like Francis Fukuyama as the 'masterstroke' of capitalism, ushering in a utopian age of the consumer.2 Moonwalker Statue can be seen as emblematic of post-Marxism and a harbinger of a global advanced capitalist society in which the ideological battles symbolised by the Berlin Wall would have no place. Culture, as we enter the new millennium, becomes the ultimate commodity. This commodification, however, is now explicit. That is to say, by and large, under modernism art works often disguised the economic activities of capitalist society. Nowadays artists often make the culture-commodity relationship overt, particularly in works like Barbara Kruger's 'Untitled' I Shop Therefore I Am, which was emblazoned on carrier bags. Of course, the statue of Michael Jackson, too, is a monumental advertising campaign. The relationship of advertising to art was part of the pop art phenomenon in the 1960s and has been most recently recycled on U2's 1997 'Pop Mart' tour. In the 1960s Andy Warhol used packaged consumer goods made into multiples to critique art's original status: an anti-purist aesthetic. Currently the utopian promise of happiness through consumerism is bolstered by many formerly radical art techniques. 'Appropriation' and 'quotation' are recurring themes within postmodernism, evidenced in recent advertising campaigns

where the combination of once-radical techniques such as montage, collage and documentary-style photography make surrealist-like images that fuse art and commodity with technical brilliance.

Even such an obvious juxtaposition as two statues representing Jackson and Stalin bears witness not only to the cult of the personality, instigated under Stalinism in the 1930s and revamped as the cult of the pop star, but also to postmodernism's fragility. The triumph of capitalism, the crumbling of Communism, and the creation of a new consumerist Eden have been lauded as historical inevitabilities. To suggest a historical programme that is both purposeful and intentional is to impute to 'history' – in the sense of the passage of time – a motivation of universal scale. It also is an indication of a confidence in the present such as may reflect only a partial view of the new world order. While the former Soviet Union and its satellites rarely used corporate advertising, like other cities of the world, they now have a new set of monuments – the signs of the mega-corporations like Benetton and Coca-Cola which advertise under the banners of 'The United Colours of' and 'We Are the World'. The new monuments around the bloc are now the ubiquitous yellow arches of McDonalds.

The arrival in the early 1990s on Wenseslas Square (the site of the 1968 Russian invasion of Czechoslovakia and of the Velvet Revolution of 1989) of McDonalds (Figure 2.3) registers a new utopia, the globalism of the multi-national and the homogenising of cultures. John O'Neil identifies this process not through the 'yellow arches' alone but through the loss of the specific to the generalised.

Defamilized meals – the ultimate goal of McTopia – constitute a further step in the democratisation of American taste that begins with the infant addiction to sugary foods. . . . The result of such gastronomic levelling is that America is the only country in the world where the rich eat as badly as the poor – a demonstration-effect that serves to underwrite the globalization of McTopia.

(O'Neil 1993: 137)

Under this rubric, the familiar yellow arch of McDonalds becomes synonymous with a 'democratic' levelling, which is of course profit led and assumes, as its accessory, an unthinking, passive consumer. However, in spite of the seemingly negative aspects of the global village, it can be argued that consumers including those within so-called subcultures are not just passive recipients but have the capacity to create a 'critical distance' – in the modernist sense of the term.

The rapid social transformations that have taken place in the east and the west since 1989 signify radical changes that blur the boundaries of many previous sedimented beliefs. Jackson's *Moonwalker Statue*, along with the 'cultural imperialism' of Coca-Cola and McDonalds, call in question many certainties, not least the status of kitsch and high art's relationship to advertising and new technologies. It has been argued (mostly by Marxist critics) that art's search for the 'holy grail' of originality will result in its own annihilation — and the fusing of art and advertising is just one manifestation of this. Modernist attempts to avoid commodification may seem futile but the nihilistic view that total commodification has been inevitable may well be premature. Even to pose this question, is an indication of the difficult terrain which the arts have traversed since the nineteenth century.

Figure 2.3 McDonalds, Prague. Photo: Pam Meecham, 1997

In 'Moscow', written in 1927, Walter Benjamin commented (1979: 203) on the visible absence of monuments in the streets of Moscow, saying that Moscow was village-like, 'augmented by landscapes', compared with other European cities where 'there is hardly a square . . . whose secret structure was not profaned and impaired over the course of the nineteenth century by the introduction of a monument'. The nineteenth-century monument's artistic role is usually overlooked in favour of its public role, and the two are rarely conflated. Located in prominent positions, and as official monuments lacking avant-garde credibility, they have little artistic currency. Official monuments, such as those of monarchs and heads of state, and war memorials, are significant visual expressions of state values subordinating artistic ones. However, they do more than simply mirror those values: they contribute to their very formation. That is to say, monuments help to fix the memory – not only recording what and who is remembered but also the form that those memories take. The form of the monument in the twentieth century becomes crucial in this respect.

Agitational monuments

Ironically, these important signifiers of state values displayed in urban public spaces have become so familiar as to be all but invisible to passers-by, though their power has not been lost on those in authority. A memo written in 1918 by Lenin suggested that those without work could usefully be employed clearing discredited Czarist

monuments from the cities (Lodder 1993: 19). The Russian film-maker Sergei Eisenstein, acknowledging the propaganda potential of the ruined monument, shows the destruction of a statue of Alexander III³ by revolutionaries in the opening sequence of his epic film *October* (1927–28). Even though iconoclasm has a long history, the pulling down of the monument is as important as is its erection in the modern period. The act of 'dismembering' Alexander III's monument, after all no more than an act of vandalism, was enough to register in the audience the changed political order brought about by the fall of the Romanov Dynasty. It registered also Eisenstein's belief that all art is ideological, and none more so than sculpture. The primacy of monuments and monolithic sculpture in the new Communist epoch was acknowledged and debated. Monumental forms to immortalise the new regime, part propaganda, part utopian, were needed to replace the fallen symbols of the autocratic regime.

Broadly speaking the new monuments were pluralistic in form and content, experimenting both with avant-garde forms and more traditional academic art practices. Lenin had originally requested non-permanent monuments to the revolution. In his 1918 'Plan of Monumental Propaganda', Lenin had advocated transitory and accessible works not made of granite or bronze. The works were not intended for contemplation and relaxation but were to be temporary street art, an agitational art, part of the vibrant celebration of a proletariat revolution. The pluralism associated with the early, honeymoon, years of the revolution did not survive for long (although the polarisation of avant-garde versus totalitarian socialist realism has been overstated). Generally however, by the mid-1930s, socialist realism, the official state art that celebrated the 'reality' of the revolution, had solidified the monument to the proportions of Vera Mukhina's towering (24-metre) Industrial Worker and Collective Farm Girl - two idealised figures, holding hammer and sickle aloft (Figure 2.4). It is a commonplace observation that totalitarian regimes monumentalise their ideologies, but monuments throughout the west also represent dominant forms of power and celebrate the values of government.

The place of the monument, as we have seen, is no longer assured – those of the recent past being the most quickly removed. It is one of the disquieting characteristics of the modern period, seen most concretely (but not exclusively) in the removal of the monument, that our relationship to the past has been eroded. Eric Hobsbawm identifies this as living 'in a sort of permanent present lacking any organic relation to the public past' (Hobsbawm 1994: 3). The remaining monuments that celebrated Marxism were hastily removed from the former eastern bloc after 1989, although amnesty was granted to those of war heroes who had fought against fascism. Some statues were recycled but most, unless destroyed or melted down, are consigned to warehouses or aircraft hangers – like *Lenin at Louny* in the Czech Republic (Figure 2.5) – to await possible rehabilitation in a social realist theme park.

Tatlin and the unrealised monument

Ironically, it is the monuments that were not completed – those which act as countermonuments and 'unrealised projects' – that western art history valorises. Tatlin's constructivist tower, described by Mayakovsky as 'the first monument without a

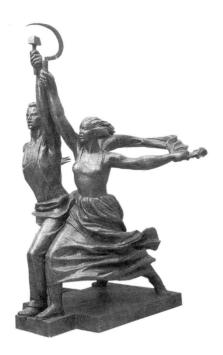

Figure 2.4 Vera Mukhina, Industrial Worker and Collective Farm Girl, 1935. Courtesy of State Russian Museum, St Petersburg

beard' (Lodder 1993: 90) was never built. It survives, however, in various guises. Vladimir Tatlin's dynamic constructivist *Monument to the Third International* (the organisation formed to oversee the International Socialist revolution), which should have rivalled Eiffel's Tower, was aborted at an early stage – emblematic in many ways of the revolutionary socialism that Stalinism interred. The proposed 300-metre-high monument constituted an attempt to synthesise formalist innovation with revolutionary politics – an entirely different type of structure 'uniting in itself a purely creative form with a utilitarian form' (Punin, quoted in Lodder 1993). The monument of three revolving glass and steel structures in spiral form should have housed a suspended cube, a pyramid and a cylinder. The structure would then have functioned as a communications network for the revolution: at once, an assembly hall, an administration centre and a radio station with the capability of projecting revolutionary watchwords on to the clouds. The massive construction would have straddled the River Neva in what was then Petrograd.⁴

The critic and avant-garde apologist Nikolai Punin, writing in defence of Tatlin's monument, argued against the use of classical and Roman sculptural forms to celebrate the new order: because of their connotations of heroic individualistic posturing and their static quality, 'thinkers on granite plinths' could not represent the proletariat. Geometric shapes, Punin maintained, were more appropriate for the people. The spiral form in particular (even prior to the Revolution) had become a useful symbol for socialist monuments (see Lodder 1993: 25). Although such abstract forms were held to be universally accessible, Lenin infamously thought Tatlin's tower resembled a huge coffee grinder. John Berger does point to the paradox of abstraction and the social conditions

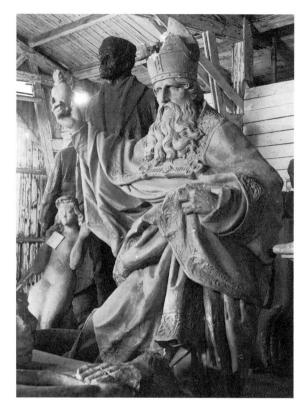

Figure 2.5 Lenin at Louny, Czech Republic, 1997. Photo: Pam Meecham

of the time, asking 'what can Tatlin's Monument to the Third International mean to a peasant with a wooden plough?' (Berger 1969: 46). The continuing presence of Tatlin's tower in art history books (usually as an elegy to 'a world gone wrong') is the real reason for its survival in memory. That the structure could ever have been built is a matter of doubt, but its presence is a testament to its very lack of monumentality – it serves as witness to a failed modernist and political utopia, a salutary if nostalgic lesson for the west.

In the west

Tatlin's work was part of a general rejection by modernist artists of both the form and content of the nineteenth-century monument. The anthropomorphic (human form) monument, in particular, lost its place in the city. Within early modernism there was a scaling down of sculpture and painting as part of the move towards the private consumption of art. Sculpture became the equivalent of the easel painting – portable, intimate and collectable but 'hardly heroic' (de Duve 1993: 25).

Those modernist artists in the twentieth century who were in opposition to official culture held an ambivalent position on the monument's 'life' in the public domain and to its status as 'official' art. Placed above eye-level, usually on a plinth,

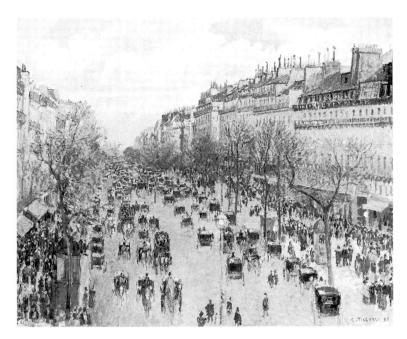

Figure 2.6 Camille Pissarro, Boulevard Montmartre: Afternoon Sunshine, 1897. Courtesy of State Hermitage Museum, St Petersburg/DACS

the monument was positioned, both physically and symbolically, in relation to the space (often a city square) which it was to occupy. It is worth noting that, with a few exceptions, the plinth or pedestal of traditional sculptures no longer held the avant-garde artist's interest. Whether in the city, or latterly in the works of Robert Smithson and Christos' works in the vast tracks of desert or canyon, the sites used often ruptured the previously symbiotic relationship between sculpture and location.

The change from public to private artistic contemplation by the 1890s had made it difficult for artists to register the conditions of modernity from the monuments of grande boulevards. The stuff of impressionist painting had been the fleeting glimpse of la vie moderne rather than the solid statue. Paris had been transformed under Napoleon III in the late 1850s by the building programmes of Baron Haussmann. The spectacle of the city could be viewed from the new vistas opened up by the huge boulevards (Figure 2.6) which created open spaces in which to view monuments.

Significantly, the monumental for the impressionists, with notable exceptions like Pissarro's paintings of the statue of Henry IV, could be found not in the Place de la Concorde and the Arc de Triomphe, but in the icons of modernity – the railway stations (the cathedrals of the age) and the Eiffel Tower. The new monuments were such edifices as the Crystal Palace, the riveted wrought iron structures of industrialisation and Baudelaire's new 'heroes of modern life' – the marginalised and transgressive populace of modernity, ragpickers and prostitutes. The wide boulevards offered increased shopping and leisure facilities, public parks and modernised bars but they also displaced large sections of the Parisian population. These people themselves supplanted the old heroic statues as the new corporeal monuments,

inevitably 'fleeting and ephemeral'. The new edifices of international exhibitions and shopping arcades were the subject of endless paintings, and they registered just how far modernity was marked by the new consumerism and 'conspicuous display'. The downside of modernity, however, was registered by the entirely unmonumental – the detritus of shopping arcades, brothels and bars, inhabited by the urban underclass. Fragmentation and alienation quickly entered the visual vocabulary of artists associated with early modernism.

In Europe in 1850 the rural population still outnumbered the urban population. However, cities began to absorb the population from the countryside and to attract people from other nations. Cities therefore became the focus of modernism partly because the émigré had been absorbed into the city. For the modernist poet Rainer Maria Rilke, creating a single verse was resolutely connected to the subjective nature of modern experience found in the restless life of the émigré. The solitude of poets such as Henry David Thoreau and Emily Dickinson could be countered by the modernist imperative to experience the vibrancy of the new cities. The internationalist, in a distinctly undomesticated affair, found the alienating experience of cities, roads and regions central to the modernist diaspora. The artist, poet, writer was the antithesis of domesticity and, with only a few exceptions, modernism was a largely masculine affair. Modernism had as its lead player the 'rootless cosmopolitan', who was often literally stateless or committed to internationalism and a rejection of national boundaries. The fixed monument that bore a relation to the architecture and squares of the city and its national culture no longer seemed the appropriate form for the artist to work with. In its 'fossilised' traditional form, the monument failed to tell the truth about the conditions of modernity which seemed to be such an imperative for modernists. 'Truth' became a modernist trope most famously with Cézanne, who wrote to Emile Bernard in 1905: 'I owe you the truth in painting and will tell it to you.' Rilke, confronting what he saw as the 'colossal reality' of Cézanne's paintings, said: 'the good simple truthfulness, it educates you; and if you stand beneath them as acceptingly as possible, it's as if they were doing something for you' (Rilke 1991: 50).

The truth, however, is not easy to define when subjectivity is its basis. In many respects the homelessness of the monument mirrors the modernists' sense of rootlessness. The quest for truth could not be located in the permanent. Modernist artists increasingly transgressed boundaries and borders in what appears to have been an intellectual, physical and spiritual restlessness.

Sculpture and the public

What we have outlined so far demonstrates how the near-invisible street monument can act as a barometer of changing social and artistic relations, and as such is an important social site. Modern sculpture, outside of the monumental, was held in lower esteem than painting. The American artist Ad Reinhardt's quip that sculpture was 'something you bump into when you back up to look at a painting' is not without some cruel substance. Whilst Michelangelo had considered sculpture to be the only real art and painting was something for women, modernism tipped the balance towards painting. Modern sculpture's relationship to painting prior to

the minimalist challenges of the 1960s was of only secondary order. Modernism is usually explained in relationship to painting. Even Clement Greenberg's essay 'Newness in Sculpture' largely discusses sculpture for what it was not, i.e. painting (Greenberg quoted in O'Brian vol 2, 1986: 60).⁵ Abstract painting did have an equivalent in sculpture but it was largely unsuccessful. Apart from the 'ready-made' which could be considered analogous to chance or 'automatism' in surrealist painting, it was difficult to translate the concerns of modernist painters into sculptural equivalents.

For Leo Steinberg, 'flatness was the analogue in art of the experience of modernity' (Batchelor 1997a: 16), leaving sculpture in Reinhardt's no-man's land: acting as a controlling mechanism for the circulation of the public around the gallery space. Modernism has found sculpture difficult to accommodate within the tropes of individual expression. Subjectivity seemed easier to render in paint. And modernist painting lent itself effortlessly to private contemplation, while sculpture remained an important carrier of public rites and anthropomorphic statues its most acceptable manifestation. It is one of the paradoxes of modernism, then, that its quest for universals resulted in an art that was so unpopular with the general public that, as Albert Elsen has observed, 'in terms of international public acceptance, no modern sculpture has ever matched Bartholdi's Statue of Liberty' (Elsen 1974: 155).

The new sculptures of, say, Constantin Brancusi and Barbara Hepworth became increasingly remote from public places by seeking autonomy – becoming objects of aesthetic contemplation independent of state ideological 'interference'. Sculpture, until the move back to the public sphere in the earthworks of the 1960s, found its peripatetic home in the new galleries and modern museums – especially in their sculpture gardens and touring shows. Much of Brancusi's work, for instance, was bequeathed to the French nation, and remains in his studio where it is displayed for our contemplation. Of course, there were modern artists who worked in public places, but the extent to which the parameters of their project had changed is remarkable. If the modernist monument was more like a private symbol intervening in a public space, then of what could the monument be a public reminder?

The heroic public monument had received a much needed fillip in the nine-teenth century through the work of Auguste Rodin (1840–1917). Fundamental to his work was a sense of the overtly 'public'. However, the artists who aspired to modernity rejected Rodin's 'theatricality' and his 'restless surface' (Hamilton 1984: 463) in favour of a constant tenet of modernism – 'direct' simplicity. The Romanian artist Constantin Brancusi (1876–1957) worked from primitive, folk and children's art. Simplicity, he believed, defined a sculptural syntax that was unencumbered by past conventions. Like many of the early modernists, Brancusi utilised the work of peasants, children and primitives as if they had no past or present and could therefore be representative of an originality outside of their own local histories.

Brancusi's monumental totemic sculptures were 'direct carvings' – intuitively formed in the spirit in which, he believed, African tribal masks and Romanian folk art were made. Brancusi sought an authenticity that neo-classical sculpture seemed to lack. His obelisk-like structures were often more primeval than primitive. In sculpture the use of the 'primitive' (always problematic in a post-colonial age) did not enter the vocabulary of sculpture as it had that of painting. 'Expressive' painting that exaggerated and distorted to gain effect in sculpture was interpreted as simplicity,

drawing on the formal vocabulary of African carving. In 1918 Brancusi produced Endless Column, the first in a series of works usually roughly carved from wood. In the 1930s variations were built in Tirgu Iiu, Romania. The almost 100-foot tall Endless Column of 1937 (Figure 2.7) was thought of as a mystical ladder, being part of what Brancusi described as a search for the 'essential core of visible matter'. He explained: 'what is real is not the external form, but the essence of things . . . it is impossible for anyone to express anything essentially real by imitating its exterior surface' (Hamilton 1984: 462). Brancusi, like many other artists, was expressing the age-old metaphysical question of what lay at the heart of the cultural form - its essence. To this end he simplified forms - in the case of the column, to repeated. rhomboid, six-surface, modular structures. The fifteen complete modules and two half-modules were moulded from a carved wooden shape and then cast in iron and 'threaded' on to a square internal steel column. The original finish of highly polished golden brass soon deteriorated, but initially at least shone a bright yellow. Brancusi's search for essentials through elemental forms like eggs - a motif for 'self-contained perfection' and creation – became a private contemplation on the form of the sculpture itself: a far cry from the public declarations of nationalism embodied in the heroic statues like Liberty.

To generalise, modernist sculptures eliminated visual hierarchies in a move akin to high modernism's 'all-over painting' typified by Jackson Pollock (see Figure 6.8). Brancusi's sculpture rarely had a centre and a periphery; in spite of the height of the columns, the individual blocks do not appear to diminish. The sculpture is viewed as a whole and, since contemplation was the primary objective, any tactile element was of secondary importance, or irrelevant.

Figure 2.7 Constantin Brancusi, Endless Column, 1937 (50–134–993). Courtesy of Philadelphia Museum of Art. Photo © ADAGP, Paris and DACS, London 1999

The essence

'Essence' designates the set of properties considered to be definitive of something – animal, vegetable, mineral or a work of art – qualities that constitute 'the specific whatness of something' (Eagleton 1996: 97). These essences, however, are not always readily observable properties: as Herbert Marcuse put it in 'The Concept of Essence', essence is 'an isolation of the one true Being from the constantly changing multiplicity of appearance' (1968: 43). This metaphysical concept 'essence' has come under attack from a number of quarters: from Marxists, who think that essentialism is a romantic fiction; from new art historians, who think that essences are unstable; and from post-structuralists, who conclude that 'things' are not of an (ir)reducible nature. However, to write off essentialism altogether would be premature. Terry Eagleton has said of postmodernism's antipathy to essentialism, largely within social relations:

There are indeed reductive, falsely eternalizing, brutally homogenising uses of the concept of essence, and they have wreaked especial havoc in the fields of gender and ethnicity. Essentialism there means something like 'reifying to an immutable nature or type', and has been a potent weapon in an arsenal of the patriarchs, racists and imperialists, even if it has also been brandished by some feminists and ethnic activists themselves. But if every concept which can be deployed for radical ends was discarded because it was used against them, the discourse of radicalism would be threadbare indeed.

(Eagleton 1996: 103)

'A criterion for whether a city is modern: the absence of memorials' (Benjamin 1979: 487)

There is another issue we might consider – the changing status of decoration under modernism. The German arts and crafts school Bauhaus was enormously influential in the 1920s and early 1930s. Founded in 1919, it developed a radical programme of integrated arts. The increasing specialisation of architecture in particular, however, resulted in the separation of the disciplines into 'purist' camps. The austerity and uniformity of much modern architecture made sculpture superfluous. The geometric ordering of the city under architects and planners like Le Corbusier⁷ might admit a sculpture but it would take an abstract, mystical, often eastern, form. In general, then, decoration became outlawed as buildings without ornament were seen as works of art in their own right. Adolf Loos went so far as to associate decoration with crime. By association, then, sculptural adornment so popular under art nouveau was rendered obsolete. New York's modernity, for instance, can be registered in the dearth of its monuments: the city's buildings stand as substitutes. By the middle of the twentieth century, the individual identity of cities was replaced by an international style more suited to corporate capitalism than civic authority.

This is to emphasise only one aspect of modernism, but nonetheless artists who have worked on fixed sites for public commissions have run the gauntlet of artistic populism. Often viewed merely as an adjunct to an urban space, public sculpture

is required to conform with public or corporate taste – what Robert Morris called despairingly 'urban decoration for urban sites'. In some cases, for instance Richard Serra's *Tilted Arc*, the subject of an ignominious court case and removal, or Rachel Whiteread's *House*, also the subject of controversy and removal, the public work's primary function seems to be the debate it generates.

The community

The conceptual artist Joseph Beuys (1921–86), also a founder-member of the German Green Party, worked on monumental projects that draw together some of the issues about art in public places looked at so far. Conceptual art was another attempt by artists to avoid the straightjacket of commercialisation and the conformity of gallery art. Often 'dematerialised', the final art product was sometimes irrelevant. New public art outside of the gallery is something of an oxymoron since ironically most art collections are public. However, the term is used to designate art that, although increasingly difficult to define, is in a public space. Conceptual art often took the form of interventions into public spaces using non-traditional material, text, video, billboards, hoardings.

Beuys' 7,000 Oaks (Figure 2.8) project was developed for the International Quintennial art exhibition 'Documenta X' held in Kassel, Germany. Atypically, the mutability of this monument is inbuilt. 7,000 Oaks exists in different locations, in different cities and transfiguration is a crucial element in its conception. Talking of 7,000 Oaks Beuys stated:

[M]y point is that . . . these 7,000 trees . . . each would be a monument, consisting of a living part, a live tree, changing all the time, and a crystalline mass (basalt columns) maintaining its shape, size and weight. This stone can be transformed only by taking from it, when a piece splinters off, say, never by growing. By placing these two objects side by side, the proportionality of the monument's two parts will never be the same. We now have six and seven year old oaks, and the stone dominates them. In a few years' time, stone and tree will be in balance and in 20 to 30 years' time we may see that gradually the stone has become an adjunct at the foot of the oak or whatever tree it may be.

(Quoted in Demarco 1982: 46)

7,000 Oaks is, then, an organic monument, implicating the public in Beuys' ecological agenda. Beuys' work was part of a wider attempt to return art to the community and make of art something accountable.

Permanent commissions for public spaces have encountered difficulties beyond the requirements of pleasing public taste and meeting civic budgets. Just what we celebrate of the past, or of the future, is no simple issue. The need to commemorate the past is strong, and the memorial monument is still part of most countries' culture. The difficulty in a pluralistic age is how we represent 'others'. The term 'the other' was used by Simone de Beauvoir writing in 1949, to clarify the position of the female in relation to the centrality of the male – 'he is the subject, he is the Absolute – she

Figure 2.8 Joseph Beuys, 7,000 Oaks, Kassel, Germany. Photo: Pam Meecham, 1997, © DACS, 1999

is the other' (Beauvoir 1949: 16). This term has subsequently been used to designate the marginal group in relation to the dominant order. This awareness of power relations has contributed to a loss of confidence in shared universal values which previously assumed a totalising, universal, human nature. Sculptors of monuments which are commissioned to speak for others, then, are placed in an unenviable position.

The counter-monument

Horst Hoheisel's 'Negative Form' Monument to the Aschrott-Brunnen, 1987 (Plate III) is an apposite example of the counter-monument: an acknowledgement of the inability to speak for the other. In 1908 a civic monument for Kassel was funded by a Jewish industrialist. The Aschrott-Brunnen monument on City Hall Square was originally a 12-metre-tall neo-gothic pyramid fountain surrounded by a pool. It was destroyed by members of the National Socialist Party in 1939. The reasons for rebuilding this monument after the war are complex. Memorial monuments usually celebrate triumphs rather than the state's decimation of cultures and peoples. Hoheisel's solution was a design that made explicit the relationship between the present and the past. The monument was not designed merely to replace the previous

structure. In making the form a 'negative monument' Hoheisel hoped to relate the present to the past as the only way of understanding both. The negative monument acknowledges the destruction of the first. Like many other memorials to the Jews it reinforces through its negation of the monument the remembrance of absence. The spectator stands on the flat site of the monument and listens to the periodic fountain that flows down around the inverted pyramid. Hoheisel stated:

I have designed the new fountain as a mirror image of the old one, sunk beneath the old place in order to rescue the history of this place as a wound and as an open question, to penetrate the consciousness of the Kassel citizens so that such things never happen again. That's why I rebuilt the fountain sculpture as a hollow concrete form after the old plans and for a few weeks displayed it as a resurrected shape at City Hall Square before sinking it, mirror-like, twelve meters deep into the ground water. . . . The pyramid will be turned into a funnel into whose darkness water runs down.

(Young 1993: 43)

For Hoheisel the need to tell the truth could not be represented by a simple reconstruction or replacement of that which was destroyed. His counter-monument was designed as an allusion to the original and as an illusion, forcing the spectator to confront the former's absence.

Other memorial monuments to the Jewish people have raised the spectre of remembered loss. In Berlin a site reserved for a memorial to the Jews is still, after ten years of debate and considerable cost, not yet scheduled for completion and seems increasingly unlikely to be so. It seems that public mourning and the commemoration of the recent past are as problematic as the debate around what form the monument should take. To portray the Holocaust abstractly – the preferred option of Richard Serra's and the architect Peter Eisenman's design of a colossal 'garden' of stone pillars – raises issues around the need to mourn or commemorate within a perceived realism. Although many of the memorials to the First World War contain figures, few artists attempting to work with the Holocaust have chosen anthropomorphic monuments despite hostility to the idea of 'abstracted' mourning.

Christian Boltanski's *Missing House* registers that which was 'lost' as an imagined space. The fate of Rachel Whiteread's memorial to the Jews *The Nameless Library*, to be built on Judenplatz in Vienna, has proved equally labyrinthine in concept and execution. If Whiteread's work is constructed, it should comprise 266 square metres of concrete – a white rectangle. The sides of the structure will contain impressions of thousands of books, and embedded in the structure will be the names of the concentration camps where Jews were interred in the Second World War.

The commemoration of specific cultural groups, often subcultures or groups outside of the dominant class is a preoccupation of many contemporary artists. Whiteread's *House* (Figure 2.9) was a memorial to another community, in this case the relocated working-class population of Bow in the East End of London. *House* itself was consigned to memory (or at least to photographic and video records) when the concrete caste of the interior of a terraced house was removed in 1995. *House* and *The Nameless Library* can be seen as part of what has been characterised as a

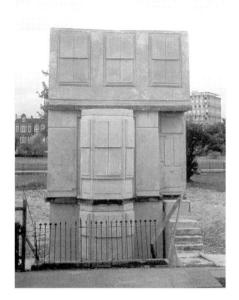

Figure 2.9 Rachel Whiteread, House, October 1993–January 1994. The 1993 Beck's/ Artangel commission. Photo: Sue Ormerod. Courtesy of Artangel

melancholic postmodern 'sense of loss'. In her castes and imprints, Whiteread fashions the presence of an absence. The proposed monument to the European Jews 'lost' in the Holocaust would have borne witness to their loss. Although problematic and a cliché of learning, the debates that fuel the controversy over what constitutes a suitable monument to lost communities are likely to be the only lasting legacy.

These examples illustrate a major debate in twentieth-century cultural practice: what kinds of monuments can be built and, more crucially, what forms can they take? James Young (1993: 11) maintains that:

the fundamental dilemma facing contemporary monuments makers is [thus] two-sided and recalls that facing prospective witnesses in any medium. First, how does one refer to events in a medium doomed only to refer to itself? And second, if the aim is to remember, that is refer to a specific person, defeat, or victory, how can it be done abstractly?

The issue for the modernist memorial monument is its very self-referentiality. Does the modernist insistence on the autonomy of the art work necessarily lead to its political irrelevance? And, conversely, does mimetic illusionism – the anthropomorphic statue – always fail as art? But there is an ambiguity here: Whiteread's *House* looked like an 'abstract' sculpture, with geometric shapes bearing scant resemblance to the physical world. Yet it was also the caste of an actual house and therefore *real* in a very concrete sense (both literally and metaphorically, as it happens). Although by no means unproblematic the term 'realism' in its post-war manifestation came to be associated

with the 'thing itself'. Broadly speaking, to refer to a work of art as 'realist' meant that it added to the world of things, it was not just illusory or a reflection of things already in existence. These works required an engagement with an invented (imagined) realm, although it was nevertheless predicated on an engagement with the ordinary and the mundane.

It can, of course, be argued that the failure of the permanent monument in the twentieth century is simply a manifestation of the collapse of shared values: cultural diversity and pluralism will not admit of a universal vision shared by all. The debate around the British Monument for the Millennium would tend to support this view. That, however, would be to simplify the significance of the monument to the process of the *formation* of unified values, even if 'the common memory' is illusory.

Artists at war

Art isn't supposed to be practical, but when it is it's great.

(Lippard 1990: 118)

It is a common observation that most public monuments celebrate violence or incorporate an aggressive element. The depiction of the conqueror and the vanquished is an important element of western public monuments: even the caryatids that adorn civic buildings were to the ancient Greeks representations of a defeated nation. Unlike their European counterparts, eighteenth- and nineteenth-century American monuments often celebrate the virtues of the 'common man' rather than those of the state. However, in trying to create monuments to the American Civil War (1861–65), artists had become familiar with the divisive potential of the memorial that cannot represent a victor. That is, in attempting to reunify a divided country, granite and stone reminders of one side's success are tactless. The American war in Vietnam raised this spectre again, but at a time when artists were increasingly preoccupied with the 'self' and an art constructed around notions of private contemplation.

The 1950s were marked by an increasing tendency among artists to engage in an art of 'monumental vision' and making 'cathedrals of ourselves' (Barnett Newman) an art of individualism. If art had become increasingly centred on its own practices, the Vietnam War was a watershed for many artists previously disengaged from political activities. The legacy of McCarthyism and the anti-Communist 'witch hunts', as we will see in Chapter 6, had contributed to an unprecedented retreat to the studio. The Vietnam War re-opened the debates started in the 1930s around the social responsibilities of the artist. The monuments that were created around this war, however, were largely the inverse of traditional monuments.

Lucy Lippard has argued that Robert Smithson's earthwork at Kent State University in 1968 became an 'unintentional monument' when the National Guard opened fire on anti-Vietnam War demonstrators. Smithson's work, although political only in the sense that works cannot be in the world and not be political, became the focus of anti-Vietnam protests and a photograph of the work was exhibited as an anti-war poster. The work consisted of an abandoned woodshed on the university campus that Smithson partially covered with earth creating an 'ambiguous grave-

ruin' (Lippard 1990: 20). The symbolic resonance of the work altered as the killings at Kent State became the focus for anti-war activism. It mobilised many artists who were politically active but engaged in 'abstract' art practices that seemed inadequate to express the anger and grief felt at the US government's involvement in the war in Vietnam. The Peace Movement, often under the aegis of The Art Workers' Coalition (AWC) was active not just in the making of art works that brought the war to public attention in a critical non-celebratory way: they exposed the institutional collaborations that simultaneously funded the museums and art galleries and the military–industrial complex.

As well as Smithson's 'unintentional' monument, there were several monuments that commemorate conflict. The Los Angeles 60-foot *Peace Tower* was a temporary collaborative piece initiated in 1966 by the Artists' Protest Committee. The tower, built by Mark di Suvero and Mel Edwards, consisted of 400 panels by artists from all over the world. The artists were some of the best-known then working, including Judy Chicago, Philip Evergood, Robert Motherwell and Ad Reinhardt. What is interesting about the collaboration was its synthesis of diverse art practices from figurative to non-objective art. Its also worth noting that the tower is rarely written about, despite its enormous significance to the period. It was intended to stay as a visual analogue for the war, to be removed only when the war finished.

As we have seen, monuments are not always realised; many of Claus Oldenberg's (born 1929) plans for monuments referencing every-day consumer goods⁹ fall into this category. Oldenberg's work is part of a much broader rejection of abstract expressionism that we look at in greater detail in Chapter 6. Suffice it to say that pop art involved an explicit if sometimes ironic engagement with consumerism, illustrated by Oldenberg irreverently producing a plan for replacing the Statue of Liberty with an electric fan, and for huge trowels and clothes pegs to be placed in unlikely places. Pop art directly challenged what was increasingly seen as abstract art's esoteric retreat from the world.

Oldenberg's first constructed project was *Lipstick Ascending on Caterpillar Tracks* (Plate IV) for Yale University, placed in position on Ascension Day 1969. It had been commissioned by students and was situated near the official war memorial on Hewitt Plaza. Yale, until then a bastion of male privilege, had just become coeducational, and the introduction of the lipstick on campus was knowingly anarchic. For Oldenberg it was reminiscent of Tatlin's tower and should have incorporated a telescopic element. Most of Oldenberg's monuments have not been permanent and have incorporated change-movement and sometimes metamorphosis. In this case, however, graffiti and erosion through weathering wrought unwanted changes, and it was removed in 1970.

The traditional monument has tended to confound gender politics. That is, the female is often used to represent what she does not possess – justice, liberty, equality. The female form as monument, typically either classically robed, therefore historically unsited, or unrobed and so socially unspecified, has been the allegorical repository of state values that often excluded the female. The monument, as we have seen, also contributes to the formation of state values. Allegory, as Marina Warner points out, has a double intention, conveying one meaning but also saying something else. Of Parisian monuments she comments:

[O]nto the female body have been projected the fantasies and longings and terrors of generations of men and through them of women, in order to conjure them into reality and exorcise them into oblivion. The iconography appears chiefly in public commissions and in the edifices where authority resides because the language of female allegory suits the voices of those in command.

(Warner 1985: 37)

The very visibility of the female form in public statues is paradoxical given that it was used to reinforce patriarchal values.

In terms of the Vietnam War, Oldenberg's monument made use of a common motif, that vanitas of appearance, the lipstick, to subversively analyse the transience of human existence and the erroneous confidence placed in technological order and the machinery of war. The use of the female form or of associated female 'ephemera' in anti-war works reintroduces the figure into art at a time when it had seemed conspicuous by its absence. Oldenberg's Lipstick, in its first incarnation, had been a huge plastic inflatable. Max Kozloff points to the inherent radicalism of Oldenberg's work: 'one thing sculpture is quite simply not allowed to be, if it has any pretensions to the mainstream, or any claim to historical necessity, is soft' (Kozloff 1967: 26). Subsequently reworked in a metal case, the retractile lipstick conformed to phallic symbolism. The missile was conflated with male sexual aggression; but, ambiguously, the lipstick too became a weapon. In this sense, the lipstick both conforms to the use of the female form as a clichéd repository of patriarchal values and subverts it. Significantly in this period the Women's Movement, in part arising out of the activism of the Peace Movement, established itself as a major force in western art practice. 10 Oldenberg's monument also breaks the rigid anti-chromatic format of most western public sculptures and monuments. The absence of colour, the concentration on black, grey and at best bronze, is remarkably uniform throughout the western world. Public taste seems to require a denial of colour: a chromaphobia.

This is in part gender-related. The nineteenth-century writer Charles Blanc identified colour with femininity which he considered of a secondary order to the more 'masculine' design or drawing. There is a long history of colour being subordinated to 'purer' disciplines like drawing and, more pertinent to the subject under consideration, sculpture. Colour is often related to sensuousness, eroticism even, and therefore in a culture burdened by a legacy of censoriousness and hierarchies is regarded as a sign of frivolity. Colour has also acted as a marker of the primitive or, in pop art's case, a populism associated with bad taste. David Batchelor states 'to this day 'seriousness' in art is usually available only in shades of grey' (Batchelor 1997b: 2). Oldenberg's *Lipstick* is therefore transgressive precisely because it blends serious intent and playful imagery. It transgresses the etiquette expected of traditional war memorials – the social site of violence made visible. Traditional war memorials often use the female form to embody abstract notions such as peace, justice, liberty, though Oldenberg's use of the lipstick to stand for the female is also a piece of pop irony.

There are further works to consider in relationship to the memorial monuments to the Vietnam War. Maya Lin's *Vietnam Veterans' Memorial* in Washington, DC, was dedicated in 1982 (Figure 2.10). The memorial was a belated tribute to

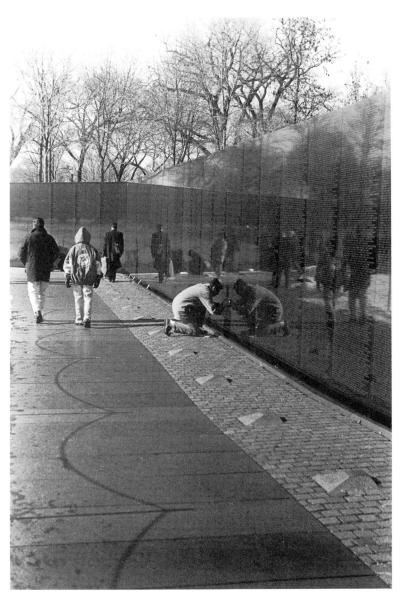

Figure 2.10 Maya Lin, Vietnam Veterans' Memorial, 1982, Washington, DC. Photo: Pam Meecham, 1999

the soldiers in combat (hostilities ceased in 1973), who found themselves in an uneasy, even hostile, relationship to the country for which they had fought. The monument is a V-shaped low wall of polished black granite that reflects back the image of the viewer. It is an earthwork which appears to descend into the ground and is partially buried in the soil. Carved into the granite are the 58,135 US casualties' names listed according to date of death. Coincidentally, Maya Lin is an Asian-American who anonymously won the open competition to design the monument

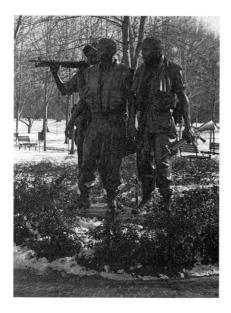

Figure 2.11 Frederick Hart, GIs' Monument, 1984, Washington, DC. Photo: Pam Meecham, 1999

when she was a young graduate at Yale University. The significance of this monument registers some of the changes that the history of monuments have made manifest. We have seen that modernist works have been largely unsuccessful in combining the public and private spheres, but Lin's work is an exception. It has not remained isolated and unexplained or remote from the community. Its apparent self-referentiality - it has no illusionistic devices or decorative features - has been overcome and it stands as a successful 'interactive' abstract work: the monument is touched, has rubbings taken of the names and is a repository for gifts. The monument is not a celebration of war. It does not glorify but literally inscribes the cost of war. In this crucial sense, then, the memorial monument has 'critical distance' creating an ambivalent relationship to the dominant order. The new art of the public space may offer the possibility of a new critical relationship for groups marginalised by the central contradictions of a public art. The issue of Maya Lin's sculpture, however, highlighted the official ambivalence to abstraction's ability to be read in different ways. The fact that it registered as an anti-war monument subjected it to official censure. Placed near Lin's work is Frederick Hart's bronze figurative work of three GIs (Figure 2.11). His more traditional rendering of the heroic figurative monument was erected as if to act as a counterbalance, to compensate for the Lin monument's lack of specificity. As an index of postmodernism, a newer bronze group, also overlooking Maya Lin's monument, features women in the auxiliary war-time service supporting wounded soldiers (Figure 2.12).

The collection of memorial monuments to war multiplying in Washington, DC, is not just an act of remembrance: it is part of the attempt to recover retrospectively the histories of people written out of memory. The Korean War of the 1950s has been largely absent from significant memorial sites. So the late arrival of a Korean

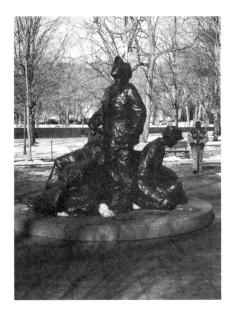

Figure 2.12 Women's Monument, Washington, DC. Photo: Pam Meecham, 1999

War Veterans' Memorial (Figure 2.13) in the 1990s, positioned within sight of Maya Lin's Vietnam memorial, raises several issues. The Korean War Veterans' Memorial looks at first like a compromise between variant forms of the Vietnam memorial. Its large black wall, like Maya Lin's work, reflects back the image of the viewer, but closer inspection reveals the etched images of military personnel. In addition it features traditional anthropomorphic statues in front of the wall, positioned as if crossing a field of combat. Each soldier is realistically rendered in lead but the effect of the material is to give the figures a ghostly pallor: their ethereal presence is reinforced by their images reflected on the black wall. The monument's representation of a moment frozen in narrative, with a platoon leader appearing to shout instructions to the radio operator at the rear, confounds any reading of the work as a traditional symbolic monument. Instead, the Korean War Veterans' Memorial is a life-sized tableau of a moment of war, seen through the prism of Hollywood war films.

We have seen that most public monuments have the – overt or covert – theme of violence. The graphic representation of violence in the twentieth century has presented a set of complex issues. Armand Fernandez's monument to the recent conflict in the Lebanon (Figure 2.14), erected outside the Ministry of Defence building in Beirut, unusually incorporates actual instruments of war. Layers of tanks are contained inside a ten-storey concrete structure, the gaping holes in the concrete revealing glimpses of weapons, while the tanks' guns protrude from inside the monument. The 5,000-tonne assemblage uses real Soviet tanks, contained in what resembles a shelled building but is actually a composite of sandbags and concrete, in effect combining the destructive weapon with the destroyed. Like Maya Lin's abstract work, the *Lebanese Monument to Peace* appears to reference modernism's tropes such as monumentality, ready-mades and industrial processes. However, it is one further example of the kind of solution to the ongoing problem of 'representing the unrepresentable' which inverts

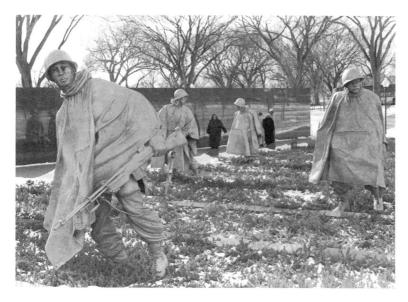

Figure 2.13 Korean War Veterans' Memorial, 1995, Washington, DC. Photo: Pam Meecham, 1999

several conventions of the traditional war memorial. Fernandez saw the work as a *momento mori* and a continual reminder of the catastrophic consequences of war.

The formation of unified values in a postmodern age, however, is perhaps neither desirable or possible, and so the potentially democratic idealism of the public monument has proved elusive. The cultural move from an autonomous and independent sculpture back to the public sphere inevitably raises the spectre of popular culture. The *Moonwalker Statue* of Michael Jackson, while in part mythic, bears at least some relation to an actual person, even if Jackson's self-aggrandisement literally as well as metaphorically has reconstructed that person.

The fate surrounding the statute of Rocky Balboa, the fictional boxer played by Sylvester Stallone in the *Rocky* film series (1976–85), is pertinent here. The film prop is a larger-than-life bronze of the working-class boy made good – the apotheosis of the American dream. In the film, the statue is displayed on the steps of the Philadelphia Museum of Art which contains the major collection of Duchamp's ready-mades. Marcel Duchamp, as we have seen, questioned what constituted art and art's relationship to the space in which it was displayed. The ensuing battle, therefore, over whether a functional piece of work, like the film prop made by Thomas Schomberg, could be an art work had illustrious parallels in high art. The museum authorities wanted the work removed after the filming was completed despite the statue's enormous popularity. It was eventually removed to a sports stadium.

Regardless of its status as 'art', the statue of *Rocky* functioned not as iconoclastic avant-gardism, as in Duchamp's *Fountain*, but as popular culture. Its appeal as an icon of the 'common man' triumphant made it the second-largest tourist attraction in Philadelphia after the Liberty Bell (Senie and Webster 1992: 231). The partisanship the statue evoked undoubtedly polarised the debate to one of elitism versus

Figure 2.14 Armand Fernandez, Lebanese Monument to Peace, 1996, Beirut. Photo: Elaine Prisk, 1997

popular culture. But the issue of how a fictional character can function as a contemporary monument is unresolved. Unframed by art's validating institutions, the status of *Rocky* as art is not assured. The elision of the divisions between high art and popular culture is one of the much-vaunted ambitions of postmodernism. However, overcoming the distinctions between art and non-art may prove more difficult in fact than in theory.

Virtual reality

With the television image – the television being the ultimate and perfect object for this new era – our own body and the whole surrounding universe become a control screen.

(Jean Baudrillard, quoted in Foster 1990: 127)

We began this chapter by looking at the city as the locus of modernity. As we enter the twenty-first century our experience of the city has become increasingly complex. While not everyone travels, no one who watches television stays entirely at home. We experience other places through the medium of the screen, and

arguably the modern monument is now the movie. Although Laurie Anderson's *Blood Fountain*, the proposed 50-foot monument for murder victims, was on a grand scale, we experienced it as a small video projection which superimposed the blood-pumping work onto Columbus Circus in New York.

Artists' current preoccupation with new technologies is part of a tendency towards a virtual, rather than a direct, experience of creating art works. It might be useful to recall that for Brancusi and his peers the direct experience of carving was crucial to the authenticity of what was produced. Since new technologies are eminently reproducible and do not possess the same inherent claims to originality, the authentic experience has now shifted to the beholder. Jeffrey Shaw's The Legible City (Figure 2.15) is an interactive video installation. Here the dematerialised experience of the city is ciphered through a notion of virtual reality. The viewer is the participant who maps the terrain of the city by cycling through New York courtesy of a real-time animated computer graphic projection that functions by means of electronic sensors. The screen contains text storylines by different people in Manhattan, from taxi drivers to Donald Trump. By cycling across storylines new texts can be made, and each cyclist creates a new reality. The bike ride around virtual Manhattan (a screen that corresponds to a map on the bike indicates the cyclist's actual location), by being interactive, combines several notions of the real and of virtual reality.

The extent of the impact of mass media on our perception of reality has been difficult to assess. However, the theorist Jean Baudrillard holds up the example of simulacra to show how our sense of self has altered in the modern world. Put simply, a simulacrum is an identical copy without an original. We cannot, so the theory goes, separate out our reality from the means of *representing* that reality. The impact of digital imaging and the organisation of information (its transmission and retrieval), and the way that we learn, is therefore in and through simulacra. Of course, these theories have implications extending beyond the visual arts. Baudrillard cites an historical shift which suggests that we in the west no longer produce things, machines or materials – we just manufacture information.

In art terms the influence of Baudrillard has been complex. When Baudrillard attacks modernist 'sacred cows', such as 'authenticity' and 'originality', some artists have 'retreated' to art that refers to art. These are works that have a currency only within discourses of art, and therefore art becomes only about art and requires a knowing audience (*Vik Muniz*, in Chapter 6, makes more sense when you know about Hans Namuth's famous film footage of Jackson Pollock at work). Baudrillard's theories have become an endorsement for a form of self-reference which can be viewed as socially irresponsible – although he is ambivalent about the shift that he himself has registered. At its most nihilistic, postmodern culture recycles fragments of the past characterised as just 'playing with the pieces' (Storey 1997: 165). As John Storey maintains, if Walter Benjamin claims that mechanical reproduction has destroyed the 'aura' of the art work, then Baudrillard argues that the 'very distinction between original and copy has now been destroyed' (quoted in Storey 1997: 126). This process is easy to see in film, of course, where to make reference to an original print makes little sense. There are only copies, no original.¹¹

There have been calls to 'boycott Baudrillard' (Wheale 1995: 62) and to resist those claims that reduce 'all our experience to the thinness of the television screen',

Figure 2.15 Jeffrey Shaw, The Legible City, 1981-91. Courtesy of the Artist

since we are not 'passive victims of a mediated information flow' (ibid.). However, the Baudrillardian collapse of certainties has precipitated a crisis in our understanding of representation and realism. For Baudrillard, in the universe of simulation, 'reality becomes ambiguous, paradoxical, certainly undecidable – so it no longer has a use-value, one can no longer say, "this is real, this is rational, this is true" (Williamson 1996: 308). Baudrillard (1988, 1993) explores the relationship between fantasy and reality most accessibly in his references to America's notion of itself and to Disneyland. Disneyworld, with its sanitised environment and its lack of urban detritus (vagrants and litter), simulates an American utopia. Baudrillard claims that Disneyland is presented as imaginary so that we can believe in the 'real' America. And this, he argues, is not real either. It is not a question of false representation of reality, but an 'act of concealment'. The real is no longer real, we are constantly told: in fact, it is simulated, and so we need an act of fiction (Disney) to convince us of our reality.

To make sense of reality, then, we refer to fiction as if it were reality (Rocky's statue conforming, in part, to this). But the issue is more complex than the mere escape from reality into fantasy. The fantasy exists – and Disney is only one of myriad fantasies – in order to convince us of the 'realness' of our own lived experience. Storey maintains that it is 'not a retreat from the 'real' but the collapse of the real into hyperrealism' (Storey 1997: 165). Hyperrealism, then, is a characteristic of postmodernism, although it is not consistent in its manifestations. What is real in the Baudrillardian sense is a dissolution of the fantasy, Disneyworld, into the every-day reality. We may well be engaged in a 'false realism' (Jameson) since postmodernism is rarely consistent in its manifestations. In the cities of the Pacific Rim, in Singapore and Tokyo, the parody and pastiche of western culture produces another set of realities.

Notes

- 1 Most of the histories of modernism were written after 1950 at a time when the teleological approach instituted by Alfred H. Barr was further endorsed, for instance in John Rewald's *History of Impressionism* (1973).
- 2 The End of History and the Last Man (1992).
- The subtitle reads 'Alexander the Third', though it is referred to by Rosalind Krauss (1977: 7) as 'Nicholas the Second'.

- 4 What is now called St Petersburg was called Petrograd after the Bolshevik Revolution, and later Leningrad.
- 5 Clement Greenberg did promote the sculptor David Smith. A major issue to emerge in recent years is the natural erasure of paint from Smith's work under the guidance of Greenberg's 'taste'.
- 6 'Flatness' found its sculptural equivalent in 1960s' minimalism.
- 7 Le Corbusier's 1920's plan to rebuild the centre of Paris allocated more space to some of the city's monuments.
- 8 Whiteread's work is notorious for simultaneously winning the prestigious Turner Prize at the Tate and the K Foundation's prize for the worst piece of art that year.
- 9 Modern artists often sought newer materials with which to record modernity, and so stone became a casualty of modernism, its very permanence an impediment. Lewis Mumford noted that 'stone gives a false sense of continuity, and a deceptive assurance of life' (quoted in Young 1993: 20).
- 10 See particularly Martha Rosler, *Untitled*, from 'Bringing the War Home: House Beautiful' (1969–71).
- Baudrillard means that once a print of a celluloid film is copied and circulated for screening, it has no original. Of course, these days we view videos of films on our television screens, whilst organisations such as the BFI (British Film Institute) are currently trying to retrieve any surviving 'original' prints of celluloid film.

RETREATS FROM THE URBAN

We have substituted for the idea of 'nature seen through a temperament', the theory of equivalence or of the symbol: we asserted that the emotions or spiritual states caused by any spectacle bring to the imagination of the artist symbols or plastic equivalents. These are capable of reproducing emotions or states of the spirit without it being necessary to provide the *copy* of the initial spectacle; thus for each state of our sensibility there must be a corresponding objective harmony capable of expressing it.

(Maurice Denis)

ALTHOUGH MANY APPEALS HAVE BEEN made to the reasoning of Maurice Denis to support the purely aesthetic ends of artists' formal concerns (see Chapter 1), his idea of 'plastic equivalents' for 'emotional or spiritual states' will be our focus in this chapter. The notion that artists' authority rests in their firsthand experience of the thing that they are making into a work of art has always been open to question: for instance, no one expected the artist to have first-hand knowledge of ancient battles, of Diana bathing or of the creation of Adam. It was the artist's ability to approximate the spectacle that was valued. However, for modern artists the capacity to invent spectacles that they have not experienced is less significant than the artists having actually experienced the things (and in particular the emotions) that they make the object of their art. Denis' call was for art works which correspond to 'states of our sensibility' - not by representing the 'spectacle' or the cause of the sensation but via 'plastic equivalents' in colour and form. This has then to be seen in the context of particular shifts which combine to privilege the artist as someone whose authority resides principally in his or her capacity to express interior moods and beliefs. Denis' painting Procession Beneath the Trees (1892) is, like much European symbolist art, darkly atmospheric, its elongated ghostly 'soul-figures' conventional illustrations of the spirit.

In this chapter we look at how artistic authority in the modern period is grounded in a notion of the artist's unique experience and particularly in his or her

'inner world' of feelings, impressions and sensibilities. We look at how the personal journeys of the artist's imagination (both physical and mental) became so important to modern – especially non-figurative – art in relation to the search for spiritual meaning. The image of the artist venturing out (or inwards), risking their senses (and sometimes their sanity) in order to experience the limits of the imagination is very much part of the rhetoric of modern art. It is often attended by the notion that a physical retreat (usually from the urban environment) permits a psychic 'rebirth' of the artist. But it is attended also by the notion of a retreat that is mystical rather than physical. As we will see, the communion of peoples and their religious beliefs may be loosely characterised as mystical, although precisely what that entails depends upon whether one's system of belief is Buddhist, Christian, Hindu or something else. However, as we will see, a number of artists from the late nineteenth century onwards renounced conventional religious systems or sought out alternative spiritual experiences.

Imagination and 'the fiction of the self'

Because no two people have the same intellect and senses, we cannot find the truth in representing things as we see them; they will always be distorted.

(František Kupka quoted in Henderson 1983: 105)

As defined by Raymond Williams, the imagination is 'mental conception, including a quite early sense of seeing what does not exist as well as what is not plainly visible' (Williams 1988: 158). The *imagination* was classified as a category of knowledge in Denis Diderot's (1713–84) *Encyclopédie* and it became the prime site of knowledge in eighteenth-century Romantic notions of the poet (such as Blake and Coleridge), even though it remained of secondary importance for scientists.

The imagination, however, played a less significant part in the notion of the artist until the modern period. What is significant for our purposes is that when artists do start to privilege the imagination, it is in a spirit of opposition. For Charles Baudelaire (1821–67) the imagination, 'the queen of the faculties', was diametrically opposed to the doctrine of 'truth to nature' and signalled the right of the artist to pursue 'his' fancies (Baudelaire 1965: 155). Baudelaire divided artists into two camps: the realists and the imaginatives. The realist seeks to copy nature, the imaginative, to 'paint its own soul' (ibid.: 162). Baudelaire's separation of 'nature' (the external world) from the 'soul' (the internal landscape) was very much part of the philosophical dualism we examine below. But for the present the salient feature of the imagination is the way in which, under modernism, interiority assumes superiority. The imposition by artists of form on their imaginings and the evolution of a personal iconography – either a unique signature style or a recurring set of motifs – is crucial to the modernist concept of art.

The perceived differences between art movements such as impressionism and symbolism (although Baudelaire's distinction pre-dates both) mark the differences between 'external' and 'internal' for the modern artist. Paul Gauguin, whose career spans both impressionism and symbolism, criticised the Parisian impressionists for

being 'shackled' (his term) by their attempts to render impressions of nature – haystacks in different atmospheric conditions, Sunday outings along the banks of the River Seine, flowers in a vase. The impressionist pursuit of nature is summed up by Cézanne who is supposed to have said, in awe, of Monet, 'he was only an eye, but my God what an eye'. Gauguin, however, had no truck with the impressionists' privileging of 'the eye' of the artist. On this matter he was fundamentally at odds with the impressionists because he believed that his 'internal eye' was more important than his physical or external eye. Gauguin used the phrase 'working from memory' to describe his method: nature may well have been the starting-point for his art, but his imagination had the last word. In order to tap his imagination, Gauguin consorted with different experiences of nature – at Pont-Aven in Brittany (Figure 3.1), in Arles and finally in Tahiti. Gauguin's belief in the power of imagination over observation signalled (if you believe in modernist sea changes¹) a shift in thinking about the making of art whereby, in order to nurture the imagination, the body had to be exposed to new experiences.

Similar sayings, in which the imagination is privileged, can be found among the writings of Gauguin's contemporaries: Edvard Munch's well-known dictum 'nature is transformed according to one's subjective disposition', and Gustave Moreau's 'I believe only in what I do not see and solely in what I feel', are typical of the rhetoric of the fin-de-siècle. The otherworldly and introspective themes that characterised the symbolist movement were part of the fin-de-siècle mind set. Many ponderous 'cycle of life' schemes saw artists asking profound questions: Gauguin's Where Do We Come From? What Are We? Where Are We Going?; Picasso's La Vie;

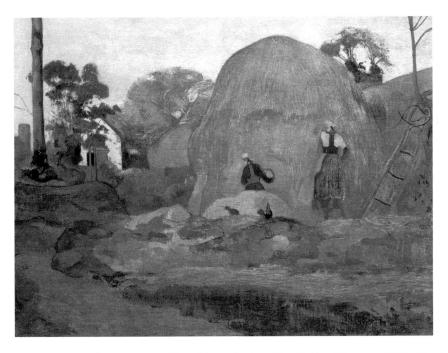

Figure 3.1 Paul Gauguin, Yellow Haystacks (or The Golden Harvest), 1889. Musée d'Orsay, Paris. Photo: RMN

Munch's Frieze of Life; and Klimt's Beethoven Frieze. Although beginning in literature and poetry, symbolism became both a style and a source of subject matter for the visual arts around the 1890s. In Alfred Barr's 1936 schema (Figure 1.3) symbolism plays a pivotal role, but in terms of modernist art history it is viewed as something of a cul-de-sac. The dynamism of the 'modernist project' – within the narrow parameters of formalism – is apparently undermined by symbolism's eclectic blend of literary content and narrative. At a time when, we are led to believe, the overwhelming impulse of artists was towards a purposeful 'purification of the medium', the symbolists seem quirky and old-fashioned. Moreover their interest in quasimystical thought was somewhat arcane and remote from the hubbub of modernity.

To go any further with the notion of retreat into the interior landscape we need to examine how the notion of 'the self' and, in particular, consensual notions of 'the artistic self' have been reconfigured in the modern period. In general terms, notions of selfhood came under review. The idea of the self - as unique, unitary, separate and distinct from every other self - is a privilege of modern society, one that not all cultures share: in fact many cultures have no equivalent word. The notion of 'self' is thus historically, socially and geographically specific. The right to individual liberty, for instance, is enshrined in the Constitution of the USA, though what constitutes 'individual liberty' is historically contingent. Historically, notions of selfhood are bound up with humanism, Romanticism and utilitarianism, but the modern sense of the self is also the outcome of other far-reaching shifts of thought. Theories such as nineteenth-century social Darwinism underscored the shift from aristocratic to bourgeois power as the 'survival of the fittest' groups of individuals. For our purposes the salient features of this historical impulse towards western individuality is the proposition that each and every self is 'unitary' - different from the next - existing both outside and beside other such selves.

The notion of the artist as self and the viewer as another self is a hallmark of the bourgeois construction of art, based upon the idea of the work of art as an autonomous and discrete object. Indeed, as we will see in Chapter 8, the very design of the modern museum facilitates the private meditation upon, or spiritual contemplation of, the work of art. It is a condition of the special relationship between the viewer and the work of art viewed that the artist should be a meaningful communicator of thoughts and feelings. Borrowing from film theory, the concept of the auteur - the assumption that the author, director, or artist is the pivotal presence in the making of a book, a film or a work of art - helps explain the link between art work, artist and viewer. To regard a work of art as the 'personal vision' of its maker has led art historians to conclude that there must be a significant link between the biographical details of an artist's life and his or her work. We have substituted a focus on what the artist does for who the artist is. Donald Sutherland's portrayal of Gauguin in the film Wolf at the Door (Figure 3.2) is set in the twoyear period between Gauguin's first and his final stay in Tahiti. The film is about only a very brief sojourn in Gauguin's otherwise racy biography. Nonetheless, his feelings of dissatisfaction with France and his longing to be back in the 'primitive' society of the South Seas are what the film conveys.

However, in recent years, the idea of the history of art as a history of great individuals had been steadily undermined. Thought-provoking essays such as Roland Barthes' 'The Death of the Author' (1977) have dealt a blow to some of the critically

Figure 3.2 Wolf at the Door, dir. Henning Carlsen (1986). Courtesy of BFI Stills, Posters and Designs

unreflective adulation accorded to artistic genius. With specific reference to literary theory, Barthes highlights the conceits of authorship:

The Author, when believed in, is always conceived of as the past of his own book: book and author stand automatically on a single line divided into a *before* and an *after*. The Author is thought to *nourish* the book, which is to say that he exists before it, thinks, suffers, lives for it, is in the same relation of antecedence to his work as a father to his child.

(Barthes 1977: 145)

Barthes posits the alternative view that the 'modern scriptor is born simultaneously with the text and is no way equipped with a being preceding or exceeding the writing' (ibid.). Many subsequent postmodern thinkers have built upon Barthes' ideas, referring to 'the fiction of the self - a fantasy, supported by language, that we are unitary selves - something we have invented to reassure ourselves. As Robert Smithson has explained, 'the existence of "self' is what keeps everybody from confronting their fears about the ground they happen to be standing on' (quoted in Lippard 1997: 89). Counter-auteurist theorists would say that the making of art is not the sole responsibility of the individual but the product of a set of external factors which have conspired to make that individual think that he or she really is responsible. While rumours of the death of the author have been greatly exaggerated, there appears to have been a significant shift towards an interpretation of art works that depends upon the position of the viewer as subject. Meaning is not something simply deposited in a work of art by the omniscient artist, but is actively constituted by the viewer based upon his or her subject position as defined by class, race, gender or sexuality. Thus the intention of the artist in creating a work is apparently undermined by poststructuralist theories. For if the work of art is ultimately meaningful only from the position of the viewer as subject, then we can dismiss entirely what follows in this chapter. It is one of the paradoxes of postmodernism that notions of the viewer as subject undermine notions of the artist's subjectivity. It is fair to point out, however, that while artists' intentions are no longer ostensibly the principal concern of art history, it would be premature to relegate artists' intentions to a cameo role, particularly when the 'intention' of so many artists was to 'find themselves' through their art.

Art and spirituality

One of the tasks of the spiritual in art is to prove again and again that vision is possible: that this world, thick and convincing, is neither the only world nor the highest, and that our ordinary awareness is neither the only awareness nor the highest of which we are capable. Traditionally, this task falls under a stringent rule: the vision cannot be random and entirely subjective, but must be capable of touching a common chord in many men and women.

(Lipsey 1997: 92)

We will see in Chapter 5 that there has been a tendency to view progressive modernism as rational and orderly. For instance, the view that Mondrian's neoplasticism was a hard-edged retort to the kind of Expressionism that was dominating the modern movement in the period 1910-20 is characteristic of teleological modernism. 'Neo-plasticism' is a term which Mondrian borrowed from the philosopher M. J. H. Schoenmakers, and although it largely describes Mondrian's formal efforts to rid his paintings of everything bar red, blue and yellow on a black and white grid, it is also a term with metaphysical roots. It describes Mondrian's theosophical endeavour to make 'spiritual' art which was capable of communicating a universal truth. Theosophy was a set of metaphysical beliefs with roots in ancient mysticism which became popular in the late nineteenth and early twentieth centuries. The Theosophical Society's objective of a 'universal brotherhood of humanity' finds its visual counterpart in the claims made for much abstract art. Piet Mondrian's reading of 'universal truth' came via theosophy and stemmed, in part, from the neo-Platonic idea which found favour with many exponents of abstraction, including Roger Fry in his essay 'Art and Socialism' (1961), that there were enduring qualities which lay behind the accidental or surface appearance of things. And it combined with Mondrian's interest in theosophy in which artists find enlightenment from within by invoking the services of transcendental forces.

Although recent writers such as Suzi Gablik have proposed that we need to be sensitive to 'vaster realities' (Gablik 1991b: 57) it has been generally unfashionable (among Greenbergian modernists, at least) to discuss the spiritual in art (although, as Chapter 6 will show, spiritual values do play a large part in the formation of post-war aesthetic theories). The importance of spirituality in the modern period, however, is both remarkable and quite often overlooked. The association of spiritualism (in the guise of a brand of esoteric mysticism) with Nazism in the 1930s and 1940s has discredited it with some of the Jewish intelligentsia and leftist writers who have been responsible for so much of the writing on the history of art. Similarly the rise of Existentialism in the 1950s made an interest in matters spiritual seem like so much unfashionable hokum. Since then many art historians have found it difficult to square

the undeniable fact that artists were influenced by (and put on record their debt to) what might loosely be termed spiritual tendencies with the history of modernism and all that its rhetoric entails. For instance, Wassily Kandinksy's Concerning the Spiritual in Art (first published in 1911) has either been demonised as untheorised mysticism or misread altogether as an apology for a type of woolly formalism. Uninstitutionalised spirituality then, is difficult terrain in the present theoretical climate of 'deconstruction', with its underlying objective to 'demystify' the object of study. The rigorous and pseudo-scientific methods of 'deconstruction' may have dealt a crushing blow to the personal and the subjective, the mystical and the transcendental, but the post-modern climate paradoxically permits the spiritual after all. One of the ironies of postmodernism is that its central lack of faith in 'certainties' – especially the idea that 'modern man', as a rational being, has all the answers to all the world's problems – has permitted a place for the spiritual and the transcendental.

Although spirituality is not readily brought to mind in the Greenbergian formal appreciation that modernism engendered - in fact, Greenberg evacuated it altogether - it was certainly part of the intellectual zeitgeist. Many modern artists were affiliated to spiritual movements in the early twentieth century, such as the Theosophical Society, anthroposophy, Rosicrucianism, and the cult of Mazdaism, all of which had a common interest in the spiritual questions that came to the surface during the 'age of anxiety'. In brief, the tone of these spiritual tracts speculated about the connections between the material and transcendent realms. Notions of the spiritual and the mystical gained credibility with the idealist philosopher Henri Bergson (1859–1941) in works like Creative Evolution (1907) which posited a notion of perception involving memory and the subjective construction of reality. Emanuel Swedenborg (1688-1772), the Swedish scientist and Christian mystic, had outlined notions of 'correspondences' or connections between the visible and invisible worlds. Rosicrucianism, a mystic brotherhood dating from the Middle Ages and committed to advancing occult knowledge, counted many French symbolists among its number. George Ivanovitch Gurdjieff (1872-1949), a self-proclaimed mystic and founder of the Institute for the Harmonious Development of Man, retreated to Fontainebleau to develop his teachings, which were informed by eastern mysticism. Gurdjieffian teachings encouraged a kind of individuality that transcended what Gurdjieff saw as the sleep-like state of the mundane existence and encouraged paths to self-knowledge which gripped the imagination of a significant number of artists and poets in the 1920s and 1930s.

In terms of modern art practice, the most influential of the spiritual movements was the Theosophical Society, which was particularly important to a number of artists including Kandinsky, Mondrian, František Kupka and, post-Second World War, Joseph Beuys. The Society was founded at the end of the nineteenth century and became an organised religion under Madame Helena Petrovna Blavatsky (1831–91). Broadly speaking, theosophists believed in the visibility of spiritual states, in white magic and in a sixth sense, which they referred to as 'superconsciousness'. For the modern artist the idea of a state of consciousness additional to the mundane was seductive. Superconsciousness, in theosophical theories, is a state of intense perceptivity (brought on by clairvoyancy or hypnotism) in which the subject, in a state of trance, has his or her perception heightened and is able to 'see' things not readily visible. The resulting ethereal vision, typically 'seeing' the world from a great

distance or things so close up that they look like worlds within worlds, was to be harnessed by a number of twentieth-century artists.

What is significant about spiritual movements such as theosophy (and the sway that they held over many modern artists) is that they were usually at odds with broader scientific trends in modern thinking. For example, mystics tended to renounce the subject—object division that distinguished between the thinker and the thought. They saw the philosophical fiction of the mind—body dualism as a damaging one which prevents the mind from recognising its essential 'oneness' with the world. Theosophists rejuvenated an age—old belief in the visibility of spiritual states. Theosophy is a doctrine of togetherness rather than of unitary selfhood; the 'higher self' or *atman* is collective rather than personal, and this sits uncomfortably with the ideas of individuality we outlined above (although ironically not with the 'fiction of the self'). Moreover, in these spiritual and occultist beliefs, a retreat into the 'higher self', through the superconsciousness or whatever, was positively encouraged. The 'external world' was often compared unfavourably to the 'inner world' where the authority of feelings, impressions and spiritual knowledge were sovereign.

František Kupka (1871–1957), a Czechoslovakian artist working in Paris before the First World War, has some claim, along with Kandinsky and Picabia, to having 'invented' abstract painting. Kupka was a theosophist and spiritualist (in the sense of being a medium for seances). In line with broad theosophical thinking, he rejected the idea that three-dimensional 'reality' was the only visual experience, and based his abstract paintings on 'inner visions' – sometimes brought on by clairvoyant trances. On the surface his early work such as *Disks of Newton* (1912) (Figure 3.3) blends several concerns (balls in movement, orbits of the planets) with his interest in the laws of Newtonian physics. However, Kupka's interest in spiritualism meant that he believed himself capable of splitting his consciousness during seances and observing the world from 'outside'. Years before the first photographs of the earth from space, Kupka was painting what he believed to be 'visions' of the cosmos. Although Kupka never claimed that his 'inner visions' were any more that fragments which 'float in our heads', he believed that his clairvoyant vision lent him a transcendence which enabled him to survey the cosmos.

Kupka shared Kandinsky's interest in 'thought-forms', or material shapes and colours which can be given to abstract moods and states of being. Both were interested in the philosophical belief in correspondences between painting and music. In the years before the First World War, Kupka painted a series of 'Fugues' and Kandinsky numerous 'Improvisations'. Kandinsky's 1927 *Heavy Circles* (Figure 3.4) depicts disks overlapping like a diagrammatic rendering of planetary motion. For Kandinsky, the circle was the most complex of the three primary shapes (triangle and square being the other two) because it was a mass of contradictions, being both 'quiet' and 'noisy', 'stable' and 'unstable', 'precise yet inexhaustibly variable', and coming as close as it was possible to get to the fourth dimension.

In a number of ways Kandinsky was deeply indebted to European symbolism. He believed, for instance, that the 'inner world' of the artist should be expressed in the artist's work, but more importantly, he inherited the symbolist notion that a work of art has, as well as a material existence, an interiority – even, according to Georges Albert Aurier, a 'soul' (see Chipp 1968: 87). Kandinsky's writings are full of unresolved tensions between physical existence and spiritual transcendence.

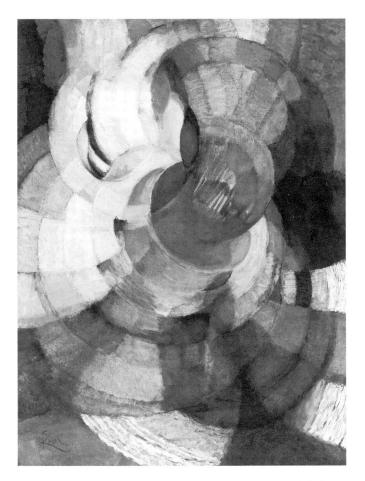

Figure 3.3 František Kupka, Disks of Newton, 1912. Philadelphia Museum of Art: The Louise and Walter Arensberg Collection. Photo: © ARS, NY and DACS, London 1999

He believed that the arts alone could 'give free scope to the non-material strivings of the soul' (Kandinsky 1977: 14). What motivated Kandinsky to search for the spiritual is complex but the idea that the spiritual realm provided a retreat from the worst of 'external' modern life, what he calls its 'dark picture', undoubtedly occurred to him. Kandinsky saw the flight to the inner world of the spirit as a retreat from the uncertainties of the external world – as expressed by science, religion and morality. The 'spiritual revolution' he discerns in literature, music and art constitutes 'a little point of light' in the otherwise 'soulless life of the present' (Kandinsky 1977: 14).

At this point it is useful to return to an idea which has become somewhat discredited under postmodernism – the notion of 'essentialism'. As we have seen, one of the principal tenets of theosophy was its valorisation of the internal over the external, but Kandinsky's search for universal essences was apparently contrary to scientific modernism. For instance, cubism is concerned with presenting the visual world in novel terms (although, of course, it is no less immune to the spiritual than

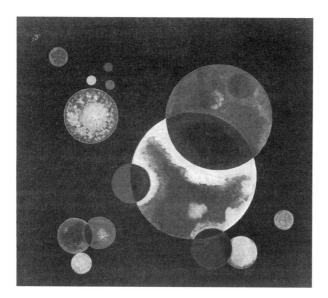

Figure 3.4 Wassily Kandinsky, No.398: Heavy Circles, 1927. Norton Simon Museum, Pasadena, CA, The Blue Four Galka Scheyer Collection, 1953 (P.1953.216B-4). Photo: © ADAGP, Paris and DACS, London 1999

other art movements – for instance the Paris-based art group, Section D'Or). Kandinsky was, however, influenced by European symbolism (or *Jugendstil*, as it was known in German-speaking countries) and was steeped in the symbolists' search for essences. Kandinsky may have produced art materially – oil on canvas or water-colour on paper – but he believed that art was at the same time non-material. He saw art as something striving to be 'pure art' or to overcome its corporeality and become pure essence.² Nor was he alone in seeing the objective of art in this way. Kasimir Malevich's idea of non-objective art as 'milk without the bottle' was formulated along similar lines. Hilla Rebay, the theosophical baroness who exhibited the work of abstract artists in New York in the 1930s, also compared non-objective painting to music (see Frascina 1982: 145). Moreover, Rebay thought that a 'higher intellect' was required both to produce and to consume non-objective art.

Dualism

My work is impure; it is clogged with matter. I'm for a weighty, ponderous art. There is no escape from matter. There is no escape from the physical nor is there any escape from the mind. The two are in a constant collision course. You might say that my work is like . . . a quiet catastrophe of mind and matter.

(Robert Smithson, quoted in Lippard 1997: 89)

In 1969 the earthworks artist, Robert Smithson (1938–73), claimed his work was about 'the interaction between mind and matter. It is a dualistic idea which is very

primitive' (quoted in Lippard 1997: 89). The modern idea of an art practice which linked mind and matter was, by 1969, hardly topical and recalled early modern artists' search for 'pure art'. Smithson acknowledged that his sense of dualism was 'primitive', and what is significant for our purposes is that Smithson should even have been trying to resolve this perennial quest. Smithson's Spiral Jetty at Rozel Point, Great Salt Lake, Utah (1970), approaches the scale on which ancient monuments were constructed, and is often interpreted as an attempt at connecting to a primordial past (see Lippard 1983). Ostensibly it is an example of earthworks art which emerged in the 1960s in the spirit of the 'dematerialisation' of art to be examined in Chapter 7 (Spiral *Jetty* has since 'dematerialised' – disappearing under rising water levels and resurfacing only periodically). However, to see earthworks art as only a form of self-expression that at the same time happened to reject the art market is to miss what was to many the deep spirituality of the earthworks art enterprise. As we saw in Chapter 2, the modernist rejection of traditional sculptural forms precipitated a sculptural practice based on 'essence' and a concentration on the autonomy of art. In a debt to the Minimalism of the 1960s, Smithson rejects the museum as the site for display and seeks out ancient earthworks as a more meaningful, more authentic, art practice. However, it is Smithson's idea of a connection between ancient and modern, mind and matter, that is significant here.

Although poststructuralist theories tend to point to the maxim that all human experience is locally conditioned (by socio-economic and other factors), the idea of universal patterns which permeate all human unconscious expression has been compelling. Jung's concept of a 'collective unconscious' gave expression to it, and Claude Lévi-Strauss in *The Savage Mind* (1972) saw age-old mythic patterns recurring in cultures; while Madame Blavatsky similarly stressed the links between 'civilised' and 'savage' cultures. The continuity of fundamental human experience – across time and space – was, according to some, what lay behind the retreat to the primordial.

The dualism of mental–physical life that emerged in the Romantic period is one which is revisited (often with the trappings of scientific certainty) in the early years of the modern period. Philosophical dualism is as old as philosophy itself. Plato's idea that the intelligible world may be experienced separately from the sensory world is almost identical to the Christian belief that the soul continues to exist after the death of the body. Indeed the demarcation of the spirit and the body is common to many religions. The metaphysical idea of an 'outer' and an 'inner' self is paralleled by the dialectic between external and internal, material and non–material, conscious and subconscious, body and soul that informs many cultures. The Judeo–Christian distinction between spirit and flesh, and Descartes' mind–body dualism – summarised in the famous formula 'I think, therefore I am' – combined as potent philosophical forces.

Modern philosophy, as we will see in Chapter 4, tends towards subject-object dualism – distinguishing between the thinker and the thought, although, it has to be said, 'thinking' was narrowly defined in the modern period, and the invitation to contribute was rarely extended to women. However, the realm of thought was sovereign in philosophical prophecies – Hegel, for example, had thought that man's spirit would eventually overcome matter. In *fin-de-siècle* Europe, 'evolutionary transcendence' was highly fashionable, offering the possibility that evolution itself was

inherently spiritual. Joseph Le Conte, the American Darwinian, published *Evolution:* Its Nature, Its Evidences, and Its Relation to Religious Thought in 1888–91. In a nutshell, his hypothesis was that 'man' was on the verge of evolving from a 'lower' outer life to a 'higher' inner life, throwing off the body and releasing the spirit.³

The Spanish artist Remedios Varo (1913-63) believed in 'spiritual breakthroughs' for women. Her paintings often contrast the mystical activities of women with the rational activities of male scientists. Scientists, she believed, consistently failed to recognise the higher reality of nature, while women intuitively understood its power. Varo saw herself and artists in general as explorers, in search of inner truth and spiritual meaning. Varo collected pre-Columbian art, studied eastern religions and was fascinated by the occult and alchemy, in particular. In the twentieth century alchemy is no longer seen as an outdated search for a formula to turn base metal into gold; it has enjoyed a revival as a highly popular 'science'. Artists including Marcel Duchamp, 4 Salvador Dali and the surrealists certainly wrote about it and Jung published Psychology and Alchemy in 1944. Varo's Creation of the Birds (1958) shows the artist as a seated owl; with the divine help of a beam of light from a star and an alchemical still mixing colours for her palette, she creates a bird, which springs to life from the paper to follow other birds out of the window. The alchemical motif repeats itself in Varo's work - chiefly as a metaphor for female creativity. While the surrealists linked women to the supernatural and believed them to be the (unwitting) possessors of ancient magical knowledge, Varo turned this association to her advantage. She appropriated much occultism, particularly hermeticism (a heady brew of alchemy, Jewish mysticism and Hellenistic white magic). Varo adopted as a feminine prerogative the hermetic doctrine of 'as above, so below' - that is to say, living bodily life in imitation of the spiritual life; women, she believed, instinctively possessed ancient knowledge, while men were insensitive to anything outside the conventional intellect. Varo's sense of her own creativity was mirrored by the 'alchemical' transmutation of pigment in the act of painting. Similarly, her often fey iconography suggests her interest in the supernatural. She personifies the artist (herself) as an owl, itself the personification of wisdom, creating birds which are at once personal symbols and Jungian symbols of transcendence (see Kaplan 1988: 163).

Transcendence

When I stand long before my easel I stand as before an altar
I find new rhythm, new life
I pray with my being
I contemplate with joy
I experience Heaven upon earth
I realize God within myself
by means of my spiritual Hands
walking in my flesh
I transcend myself
(Richard Pousette-Dart quoted
in Polcari 1997: 14)

As we have seen, the belief that a work of art is capable of overcoming its materiality to just be gave impetus to the search for 'essences'. Although sceptics have been dismissive of essentialism, the spiritual idea that art might transcend its materiality is fuelled by essentialist theories. What was attractive about the notion of 'essences' was that they seemed immutable when modern life often highlighted the transient and fugitive. Essences are reassuringly stable since, by definition, the essence of any one thing is timeless and immutable. Richard Pousette-Dart (1916-92) was preoccupied with sacred motifs which represent the fundamental continuity of human spiritual symbols. Symphony Number 1. The Transcendental (1941–42) (Plate V) is a complex web of mythical iconography – planets in orbit, mythical native American birds and magic birth symbols - often underscored by a personal 'sympathy' with Jung's notion of the unconscious. Jung's spiritualised sense of the evolution of a 'collective unconscious', outlined in The Modern Man in Search of a Soul (1933). was based around a repertoire of basic motifs or archetypes - 'primordial images' - which repeat themselves in diverse cultures. Thus the notion that transcendental painting should overcome the local and the temporal, and communicate age-old truths (albeit innocently), draws on theories such as those posited by Jung in which human knowledge is embedded in the pre-historic and pre-personal.

Transcendence is that state of being which is beyond the reach of experience and, as we have seen, the attainment of a 'higher reality' which transcends the commonplace was an aim that united many artists. Brancusi connected his work to a complex web of spiritual ideas and, like many of his contemporaries, mixed and matched eastern and western, ancient and modern mysticism. For instance, the neo-Platonic philosophy of 'endlessness', according to which things are not circumscribed by their physical dimensions, is a recurring motif in soaring works such as Endless Column (see Figure 2.7). Brancusi was interested in things in flight. For instance, the multiple versions of Bird in Space (Figure 3.5) are united by the artist's repeated aim to show a bird struggling to reach heaven. The motif of surmounting (transcending) commonplace concerns to soar freely above the earth is recurrent in psychoanalysis, where the desire to fly is interpreted as a form simultaneously of neurosis and aspiration. In a more literal sense, the 'romance of the skies' was popularised by famous aviators such as Blériot, Lindberg and Earhart, and was celebrated in futurist 'aero-painting' such as Robert and Sonia Delaunay's vast aeroplane murals for the aviation hall at the Paris Exposition of 1937 and Arshile Gorky's 'Aviation' murals at Newark Airport. Assuming aerial perspectives or painting aeroplanes in flight is not, strictly speaking, equatable with the transcendental since both were theoretically within the experience of any modern artist. However, for the first half of the twentieth century space travel was beyond the reach of every-day experience - unless, as Kupka claimed, it was 'experienced' in clairvoyant trances. In 1916 Kasimir Malevich wrote that his paintings did 'not belong to the earth exclusively. The earth has been abandoned like a house eaten up with worms. And in fact in man in his consciousness there lies the aspiration toward space, the inclination to "reject the earthly globe" (Henderson 1983: 285).

There was another sense in which 'space' played an important part in twentieth-century modernism. Max Weber's *Interior of the Fourth Dimension* of 1913 (Figure 3.6) depicts New York as seen from the harbour, with a boat amid the overlapping forms of towering buildings. On the surface, the painting is conventionally

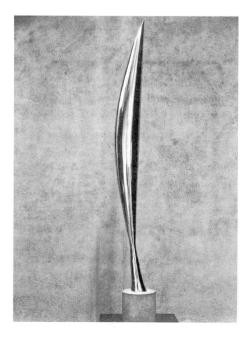

Figure 3.5 Constantin Brancusi, Bird in Space, 1928. The Museum of Modern Art, New York. Photo: © ADAGP, Paris and DACS, London 1999

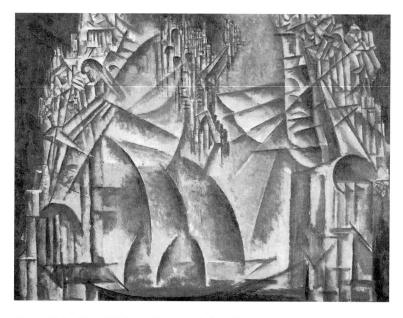

Figure 3.6 Max Weber, Interior of the Fourth Dimension, 1913. National Gallery of Art, Washington, DC. Gift of Natalie Davis Springarn in Memory of Linda R. Miller and in Honour of the 50th Anniversary of the National Gallery of Art. Photo: © 1998 Board of Trustees, National Gallery of Art, Washington, DC

cubist, in the sense that the artist fragments forms and dislocates one-point perspective. However, as the title of the picture reveals, Weber's connection to cubism was via the transcendental. In 1910 Weber published an article entitled 'The Fourth Dimension from a Plastic Point of View', which defined the fourth dimension as 'the consciousness of a great and overwhelming space magnitude in all directions at one time' (1910: 25). Unlike some European cubists, for whom the illusion of 'space' meant depicting three-dimensional space on a flat two-dimensional canvas, Weber's notion of space was an altogether more metaphysical proposition. The geometric forms of *Interior of the Fourth Dimension* recalled the principle of a sacred geometry that served as the basic structure for all matter.

The pursuit of the fourth dimension through art was highly fashionable in the first half of the twentieth century. The fourth dimension came to mean generally one of two things: the search for 'space-time' dimension in which a fourth movement through time could be added to the three dimensions in physical space; or a state of 'higher reality' in line with personal philosophies of spiritual transcendence. More generally still, the fourth dimension came to be equated with something that our eyes are incapable of seeing. Originally the fourth dimension was equated with space, but after Albert Einstein developed his theory of relativity in the first fifteen years of the twentieth century, our understanding of the relationship between time and space altered. Einstein posited a set of theories that for the first time proposed entirely new ways of thinking about time and space, substantially advancing Newtonian physics. Its effects exceeded the boundaries of science and were absorbed into 'unscientific' forms of knowledge. The spiritualist writer P. D. Ouspensky's Tertium Organum (1911) explains the fourth dimension by using the example of the spokes on a bicycle wheel: they are open and objects can pass between them when the wheel is stationary; but when in motion the wheel is apparently solid, and becomes impassable.

The fourth dimension also played a part in uniting a number of abstract painters and sculptors in the inter-war period. Certain influential modern artists signed Charles Sirato's 'Manifeste Dimensioniste' in 1936 – including Joan Miró, Alexander Calder, László Moholy-Nagy, Marcel Duchamp, Wassily Kandinsky, Robert and Sonia Delaunay, Ben Nicholson, Hans Arp, Sophie Taeuber Arp and Francis Picabia. 'Dimensionisme' was a 'new art' that would open up sculpture to 'non-Euclidean space', in the sense of that which cannot be measured, abandon the plane and the rigid in painting in favour of space and 'gaseous materials'. The manifesto was many things to many artists and tended to seek a compromise among the various concepts of the fourth dimension. The fourth dimension was approached through kinetic sculpture, cubist painting, optical effects and synaesthesia (the notion that visual art had an equivalent in musical or literary sensations).

Physical retreats

Artists have lost all of their savagery, having no more instincts, one could even say imagination, went astray on every path, looking for productive elements which they did not have enough strength to create. Consequently, they act only as a disorderly crowd, they feel frightened

like lost ones when they are alone. That is why solitude must not be advised for everyone, since one must have strength to be able to bear it and to act alone.

(Paul Gauguin quoted in Chipp 1968: 86)

Going away to 'find oneself' is a Romantic (and also a gendered and class-ridden) notion used to separate travellers from tourists in the nineteenth century, and which was one of the markers of the difference between elite and mass culture as the package tour became a substantial part of nineteenth-century recreational practice. Thomas Cook began organised tours of Europe and later the Middle East from the 1850s. As more and more people could afford to take package tours, first in Europe and later in the Holy Land and Egypt, travel became tourism - organised parties which visited the same sights. Very often tourists were treading the same ground as that covered in the late eighteenth and early nineteenth centuries by young men undertaking 'the Grand Tour'. The Grand Tour was not only for young men of rank or title but for artists training in the European and North American academies. The common aim was to experience at first hand the cultural beacons of ancient and European civilisation in order to improve themselves culturally and artistically (as well as to affirm their own superiority). Following the development of mass tourism and the general improvement in global transport, artists (and others) began to venture 'off the beaten track' in search of experiences that were not necessarily improving, in the conventional sense of the word, but which might be life-altering. Gauguin went to Tahiti, Matisse to Polynesia, Pissarro to the West Indies, Paula Modersohn-Becker to Worpswede, Remedios Varo and Leonora Carrington to Mexico, and Max Ernst and Dorothea Tanning to Arizona.

Modernism has projected a compelling image of the artist in a state of splendid isolation. Even though modern art is an international movement, the history of modern art is often the history of groups of artists. Although the grouping of artists into 'schools' is in part determined by the retrospective classification of contributors to the diverse disciplines of art, artists have often willingly congregated in the safety of likeminded groups, united by nationality or artistic ambition - French impressionists, German expressionists, the fauves, the cubists, Dadaists and surrealists, and the abstract expressionists. There are even popular images of these artistic groups - the impressionist talking about art over a drink in the Café Guerbois in Paris, the Russian constructivists holidaying together, the surrealists throwing legendary parties, or the abstract expressionists involved in heated exchanges in the Cedar Bar in Greenwich Village, New York. Yet the history of modern art is also the history of the solitary individual, alienated from other individuals: Gauguin's defiant claim 'I do not hunt with the pack' seems to be echoed in Van Gogh's wanderings in the fields around the towns of Arles and Auvers-sur-Oise; or in Cézanne's long walks around Mont Ste-Victoire in Aix-en-Provence. The image of the solitary artist represents the need to retreat from the speed, gigantism and artificiality of the urban terrain in order to commune with nature or oneself.

This struggle with adversity and the resulting self-imposed isolation came to be seen as criteria for artistic genius. The concept of alienation has received a great deal of critical attention since Karl Marx borrowed it from Hegel and used it to describe how workers are literally and spiritually distanced from the product of their

labour. Since then, European existentialism and the corresponding 'loss of God' has, according to its most gloomy interpretation, rendered life ultimately meaningless. The concept of alienation has been extended to include the sense that individuals in society can feel distanced both from other individuals and from society itself. Jack Kerouac and Ken Kesey helped to make alienation cultishly fashionable, and Timothy Leary's famous exhortation to 'turn on, tune in, drop out' became a rallying cry for anyone wishing to reinstate their individuality in the face of structured society by living on its fringes. But even before the beatniks and the hippies, writers and artists such as Gauguin had lived the fiction that distancing oneself from others permits artists to know themselves the better. The irony of Gauguin's retreat (like that of so many other artists) is that it was rarely solitary. Not only was he surrounded by villagers from various Tahitian tribes, but he maintained relationships with several young Tahitian women. His solipsistic claim that he was living a solitary existence was meaningful only because Tahitian men and women did not figure in his sense of what constituted company.

A physical retreat from the city to the country often represented a retreat into the interior landscape, and the dualism between city and country was, for many, representative of the dualism of body and mind. Paula Modersohn-Becker thought of the city and the country as diametrically opposed territories. In a letter of 1905 she described how at Worpswede her life was 'built mostly on inner experiences' and contrasted it with her 'outer life' in Paris (quoted in Perry 1979: 33-4). This sort of distinction was common among 'creative people' who removed themselves to the country or to another country in order to foster an 'inner life'. The retreat from the urban often represented a renouncement of the excesses and complications of city life. For instance, the American transcendental poet and writer David Thoreau rejected the material comforts of the city for an ascetic retreat to Waldens Pond to consort with and find pleasure in the natural world. But, unlike Gauguin, Thoreau's retreat was indeed solitary. Living in self-imposed exile was more than a matter of finding a conducive atmosphere to concentrate on a great work of art, literature or music – a place where the imagination could roam free. The rural retreat was, as we shall see, indicative of yet other complex factors in the relationship of the modern artist to his or her work of art.

Ascent to nature

The ideal or visionary is impossible without form: even angels come down to earth. By walking upon earth and looking up at the heavens, and in no other way, can there be an equilibrium. The greatest dream or vision is that which is regiven plastically through observation of things in nature . . .

(Max Weber 1910: 25)

Des Esseintes, the hero of Huysmans' A Rebours (1884) (sometimes translated as Against Nature, or more properly as 'Against the Grain') argues that 'nature has had her day' and advocates an artificiality in refinements of taste which characterised the Aesthetes. The contrived anti-nature stance of the Aesthetes is, perhaps surprisingly,

often echoed by modernist sophisticates. The well-known anecdote of how Mondrian once went to tea at Kandinsky's studio and took exception to the trees outside, insisting he be seated with his back to the window, is indicative of the kind of modernist myth-making that surrounds the symbolic renunciation of nature (and naturalism). According to the lineage of modernism mapped out by, among others, Alfred Barr, Mondrian's fabled (if feigned) hatred of greenery finds its correspondence in his hard-edged geometric painting. If we examine Mondrian's oeuwre under this rubric, then we see that he begins as a painter of embrowned windmills in a landscape; he moves on to analytical paintings of blossom on a tree under the influence of cubism, and finally arrives at neo-plasticism. We follow the artist from a painter of nature to the abstract painter of geometry, like so many others, and see this 'progression' as a badge of modernity, although we witness many regressions and false starts in this progression. And when artists seem to go backwards, from abstraction to figurative or classical styles (as Pollock, Severini, Malevich and Dali all did), this is seen as retrogressive to modernism's teleological imperatives.

Mainstream modernism has often measured its modernity in terms of how far it dispenses with nature/naturalism. Many modern artists, such as the impressionist painters of Paris, never renounced nature: they painted in sleepy seaside resorts, took weekends on the River Seine and many retired to consort with nature on a permanent basis. It is, however, especially difficult in the history of modernism to reconnect abstract artists with nature. One of the underlying difficulties is the mismatch between the received history of modernism and individual artist's relationship to nature. The received history of western modernism tells us how, in the industrialised period following the end of the Franco-Prussian War in 1870, the French people were drawn towards the city and French artists to its demimonde - seedy night-clubs and brothels. This is contextualised by writers such as Théophile Gautier and Baudelaire who began to see nature – first in the sense of the countryside and later in the sense of 'naturalism' - as ugly. However, Wilhelm Worringer's argument in Abstraction and Empathy (1963), first published in 1908, equates naturalism with a faith in the organic world, and sees abstraction as the result of a lack of faith in the organic world. Naturalism, he argued, provided the viewer with the necessary incentive to empathise with the work; whilst abstraction was a retreat into the 'world of the inert'.5

Nature was ingrained in the Romantic imagination, and it was a condition of Romanticism that writers and poets had a meaningful commerce with nature – for example, Théodore Rousseau's retreat to Fontainebleau and the Romantic poets' relationship to the Lake District and other lakes in Europe. In *Twilight of the Idols*, Nietzsche had rejected the idea of a return to nature in favour of an 'ascent to nature'. A number of colonies sprang up in Germany at the turn of the century; perhaps the best known is the colony at Worpswede where Paula Modersohn-Becker worked. The idea of the artists' colony as a retreat from the sophistication of the city and a place to escape the dictates of academies lured many artists. Paintings such as *Trumpeting Girl in a Birch Wood* of 1903 (Figure 3.7) implicate the indigenous population of Worpswede in a closeness to nature of much the same kind as Gauguin had with the natives of Pont-Aven and Tahiti. What is significant about the artistic perception of a closeness to nature, in the light of the ideas we have examined thus far, are two underlying suggestions. On the one hand, 'closeness to nature' was seen

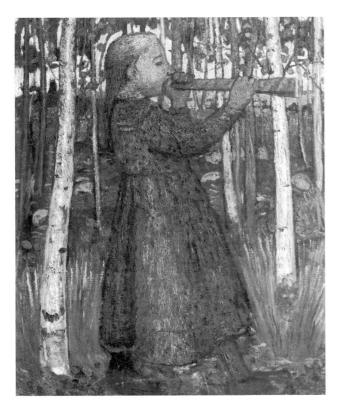

Figure 3.7 Paula Modersohn-Becker, Trumpeting Girl in a Birch Wood, 1903. Courtesy of Paula Modersohn-Becker Haus, Bremen

as an 'ascent' and the quality of 'inner life' among Worpswede or Breton peasants and Tahitian people was more important than their material circumstances. But, on the other hand, the equation of 'peasant' and 'soil', while keying in to Romantic mysticism, was consistent with nineteenth-century doctrines of 'knowing your place'. Modersohn-Becker's interest in local folk culture and 'back to nature' basics made her a formal precursor to German expressionism, but these themes were also later to be identified with the 'blood and soil' ideology of right-wing politics in Nazi Germany.

Like science (as we will see in Chapter 5), the polemical discourse on nature could be harnessed for different purposes. Much of both Hitler and Stalin's spin on socialist realism was imparted against a pastoral backdrop. For instance, Stalin cast tractor-drivers and farmers, just as often as coal miners or canal diggers, as the heroes of the new Russia. Similarly, Hitler's Aryan race was conceived in terms of semi-rural idylls of German workers ploughing German soil, producing indigenous German crops for indigenous German people (regardless of the fact that many workers on the land were the forced labour of 'inferior' races). Karl Alexander Flügel's harvest scene is part of this 'back to nature' enthusiasm. Reworking an almost medieval composition of workers in a field, Flügel's *Harvest* is distinctly unmodern. Its representation of the indigenous German country dweller's closeness to nature is supported insidiously by its appeal to the past and the 'naturalness' of nature.

We will see in Chapter 4 that it was patriarchy which turned the identification of women with nature into a complex negation of a biological fact in favour of an economic necessity. The 'division of labour' that came about in the Industrial Revolution subverted any notion of women's 'biological difference' into a passivity and an objectification predicated on a notion of woman's essence. The proliferation of images of nude women in the landscape in western painting represents, among other things, the quasi-superstitious belief that the reproductive system of a woman's body linked her preternaturally to the reproductive systems of 'mother nature'. But many women artists in the twentieth century have been active in making the identification between woman and nature a positive rather than a negative one. Women surrealist artists, for instance, actively engendered the connections between themselves and nature (and the preternatural). Male surrealist artists had already identified women with organic nature - referencing their sexual organs in flowers and depicting them in meaningful communion with animals. But those women artists, such as Remedios Varo, who came to be associated with the surrealist movement appropriated these identifications and made their own iconography from the animal and plant kingdoms.

The artist and writer Leonora Carrington, like her friend Varo, painted magical birds and shared the same esoteric preoccupations. Carrington's *Self-Portrait* of 1938–9 shows the artist seated in a room with a lactating hyena and a rocking horse. A galloping horse is visible outside the window. In Carrington's personal bestiary the horse was the principal icon. The horse seems to have been a magical Celtic symbol for Carrington – and to have served several different iconographic purposes. Most often, the horse was a magical means of travel: flying through the air in paintings and in her stories.

Retreats into the unconscious

Ever since Leonardo da Vinci exhorted artists to look at stains on dirty walls in order to find fantastic compositions of landscapes and figures, using external resources to alter creative centres has been an feature of underground avant-garde art practice. The possibility of accessing the creative centres of the primal and elemental self where 'pure' artistic intuition resides, stripped of all the external forces that shape and compromise artists, has been a compelling fiction for modernism. Methods used to displace the centre of creativity from the conscious - colloquially known as 'getting off-your-head' - included hallucinogenic drugs, alcohol, starvation, staring at cracks in walls, shamanism, automatic writing, dreams ('oneirology' as described in Freud's The Interpretation of Dreams 1976) and invoking chance. The common denominator in all those searches for ever-more original and authentic sites of creativity was the unconscious. The unconscious was the site of the 'marvellous' for artists disenchanted with the world of conscious encounter. Moreover, it became a place of retreat for artists averse to the civilising processes and conventional gestures of mainstream modernism. A retreat into the unconscious, however, was more than just a riposte to mainstream modernism: it seemed to be a retreat from the rational world. In fact, the retreat into the unconscious was rarely an act of self-indulgent escapism: it was often political. Fuelled by Freudian notions of the unconscious as

the site of 'real' motivations and desires, many surrealists believed the 'irrational' could reveal political and social truths, stripped of any claims to reason.

In order to explain the regard that artists had for the unconscious mind, we must call upon psychoanalytic theory. The role that the unconscious mind plays in art was investigated by Freud at the turn of the century. Freud thought that unresolved childhood experiences can trigger unconscious symbolism in the artist's work. Famously, he attributed Leonardo da Vinci's painting The Virgin and Child with St Anne to the artist's experience of having had two mothers – a natural peasant mother and his father's wife - an experience which he tries to resolve (unconsciously) by uniting the two women in one picture. Jung countered Freud's notion of a personal unconscious with a collective unconscious that governed, a priori, symbolic motifs in art. However, the artistic preoccupation with consciously representing the unconscious, whether personal or collective, rests upon a belief in its accessibility. For example, as we will see in Chapter 6, Jackson Pollock's belief that he was 'painting out of the unconscious' demonstrates not only its topicality but an underlying faith in an accessible unconscious. Pollock also was influenced by the spiritual teachings of Jiddu Krishnamurti (1895–1986), a protégé of the Theosophical Society, whose writings were popular in the United States and Europe from the 1920s. Also of importance to Pollock were the shamanistic sand paintings of indigenous American Indians, for whom working in sand is an act which suspends the conscious mind for an intuitive response to the medium. Confidence in Pollock's belief in an accessible unconscious has been questioned by, among others, Jacques Lacan. Lacan suggests that the very notion of an unconscious has to be understood as a constructed category (constituted in and by language) which is contingent upon social and historical conditions. A case in point is the work produced by Willem de Kooning after he was diagnosed as having Alzheimer's Disease. De Kooning's paintings from this period were bought and sold in the same manner as his earlier work, thereby raising the question of their status as art. On the one hand, we privilege the unconscious in a work of art, but in de Kooning's case some would argue that his lack of consciousness negates the status of his paintings as art.

A much vaunted way of tapping the unconscious was through improvised and spontaneous gestures, which reportedly bypassed the rational controlling mind. 'Chance' was particularly valued since, theoretically at least, chance is the opposite of intention (Breton 1972: 26). André Breton's *Manifesto of Surrealism* (1924) advocated elements of chance (shuffling words cut from a magazine and dropping coloured squares onto paper) in the same way that Freud conceived of psychic automatism (Freudian slips and free association, word games). For Breton, these strategies constituted 'the absence of any control exercised by reason' (ibid.). The jury is still out on just how random and beyond conscious control the laws of chance actually are (and how independent of intention chance can ever be). All the same, chance has played an important part in some artists' perceptions of twentieth-century modernism. It was, after all, the 'accidental' encounter between Kandinsky and one of his paintings, laid on its side in his studio, that reportedly led to his development of abstract painting. Whether or not this often-told tale is true is less important here than the artist's perception of a chance encounter.

The invocation of chance that preoccupied the surrealists took on many guises. Ithell Colquhoun, the English surrealist artist and writer, systematically investigated

Figure 3.8 Jean Dubuffet, Landscape with Drunkards, 1949. Photo: F. W. Seiders. Courtesy of The Menil Collection, Houston. © ADAGP, Paris and DACS, London 1999

automatism in the 1930s and 1940s and published the results in an article entitled 'The Mantic Stain' (1949). Colquhoun was actively involved with various forms of occultism (so much so that she was expelled from the English surrealist group by its Marxist element). The painting Sea Star I (1944) is the product of what the surrealists called decalcomania – where a painted surface is pressed against another and then pulled apart again to reveal a textured surface. Clearly, in terms of its debt to pure 'chance', decalcomania has fairly predictable outcomes. So chance does not entail a total abandonment to chaotic fortune, but it can also describe a state of removal in which conscious control is put on standby.

More extreme retreats to the unconscious are the stuff of art-historical legend. Jean Dubuffet's (1901–1985) interest in the delirious mind and in mental functioning in its most pre-rational stages could be seen in the context of a long line of artists, including Richard Dadd, Vincent van Gogh, Camille Claudel, Egon Schiele and Leonora Carrington, all of whom had at some time or another been declared 'insane'. Dubuffet collected what he called Art brut (literally translating as 'raw art') from 1945. Art brut was work produced by psychiatric patients, criminals and clairvoyants. Like a number of others (most notably André Breton), Dubuffet valued 'instinct, passion, mood, violence, madness'. His 1949 Landscape with Drunkards (Figure 3.8) is characteristically painted in the spirit of Art brut: naive, simplified figures are seemingly hastily drawn out in thick impasto. In a lecture entitled 'Anticultural Position' (1951), Dubuffet described how the west could learn from the 'caprices of savages' (by which he seems to have meant the producers of art brut). He resisted what he called 'acculturation' and was irritated by claims that 'modern man' was more civilised, more sensitive to beauty and more intelligent that either his ancestors or his counterparts outside the west.

Whether or not we believe that there is a place called the unconscious where modern artists can find inspiration for the 'authentic' art work, we are faced with an overwhelming number of artists who have held this view. As we often link modernity to the forces of technocracy, industrialisation and urbanisation, the idea that modernity could be played out in opposition to these forces may seem to negate modernity. However, the retreat from the urban, like the Pre-Raphaelite 'retreat' to the Middle Ages, is just as much a response to the experience of modernity as the embrace of the machine by the futurists or the Bauhaus. They are all linked by the common factors of formal experimentation, idealism, anti-bourgeois politics and a critical engagement with modernity. However, the retreats of artists from the urban, from the conscious to the unconscious, from flesh to spirit, from materiality to non-materiality and from outer to inner, have been both a productive impetus for many modern artists and a compelling 'fiction' for the avant-garde.

Notes

- In Chapter 1 we noted how the Pre-Raphaelites fulfilled many of the conditions of modernity much earlier than had the French impressionists usually credited with 'inventing' modernism.
- This idea that painting could achieve a state of 'pure art' has precedence in philosophy and had been most famously reinstated by the English proto-aesthete Walter Pater (1873: 106) when he prescribed (in another debt to Hegel) that 'all art constantly aspires to the conditions of music'. His (albeit embryonic) idea of a work of art that is capable of overcoming its materiality to become pure art was to gain momentum, especially among artists searching for the spiritual through art.
- This belief that humans would eventually evolve into a much more cerebral life-form, outgrowing the body, recurs in twentieth-century science fiction which features highly evolved life-forms with out-sized brains and little or no body.
- There is an issue over exactly what Duchamp's connection to alchemy was. J. F. Moffitt's essay 'Marcel Duchamp: Alchemist of the Avant-Garde' (1986) traces the influence of occultism and alchemy on Duchamp. And although Duchamp puts on record his interest in alchemy, some see it as nothing more than a flirtation on his part. Duchamp is characteristically ambivalent and himself refutes any practising interest in the subject (see Tomkins 1996: 456–7).
- This connection between the 'regressive' tendency of modern art (namely abstraction) and the 'primitive' obviously pre-dates Hitler's notion of 'degenerate art'.

THE FEMALE NUDE AS THE SITE OF MODERNITY

In 1969, DURING ONE OF THEIR early outings into 'bagism', Yoko Ono and John Lennon were interviewed by journalists. Bagism was the couple's own art movement, playfully parodying '-isms' and an attempt to de-personalise the cult of fame and to confound the kind of judgement that is made on the basis of appearance alone. By (dis)appearing in public in a large bag for two, Ono and Lennon not only preserved their visual anonymity, but challenged the assumptions that viewers make on the basis of gender, ethnicity, age and dress. And yet, ironically, what interested the journalists interviewing Ono and Lennon was not the purpose of the performance but whether they were naked inside the bag. That this mattered at all to anyone outside the bag, on the one hand demonstrates that the press had completely missed the point of bagism, but on the other also shows how the connections between nudity and art had become a cliché in popular consciousness (Figure 4.1).

Images of the nude are commonplace in western art and have been a staple of painting and sculpture since the Renaissance; so much so, in fact, that the nude is now enshrined in art practice and has come to be regarded principally as an art form. However, the male and the female nude carried rather different historical meanings, and in art-historical studies in recent years both have come to be regarded as more than just art forms. For instance, notions of the female nude as the 'privileged object of connoisseurial voyeurism' have been eloquently deconstructed in Marxist and feminist art history. And, in turn, writings about the male nude have been revised in the wake of 'queer politics'.

That it was the female and not the male nude that came to dominate the visual language of early modernism is indicative of an overwhelming shift away from the values embodied in the idealised, heroic, timeless classical male nude. While the classical male nude is clearly dependent upon an accurate, if idealising, representation of the human form, in modernism there appears to be less need of a model. For instance, Matisse and Picasso's nudes often bear little resemblance to the sitter. Ironically, modernism's tendency to distort the female form has simultaneously resulted in an artist—model relationship that ascends to mythical proportions. The modernist myth

Figure 4.1 Marcel Duchamp, Eve Babitz Playing Chess, 1963. Marcel Duchamp Archive, Gift of Jacqueline, Peter and Paul Matisse in Memory of their mother, Alexina Duchamp. Photo: Lynn Rosenthal, 1994, © Succession Marcel Duchamp/ADAGP, Paris and DACS, London 1999

of Bohemia, as Frances Borzello (1982: 86–98) points out, brought out into the open the artist-model relationship. Implicit in the bourgeois construction of the bohemian artist is the idea that 'his' creativity is closely linked to the female model. The female sitter fulfils a triple role as model, mistress and muse but, in addition, she becomes an important sign of the male artist's modernity. In this chapter we examine how the female nude became a crucial element in the formation of art designated *modern*. That is, the female nude – especially the prostitute, the barmaid and the working-class woman – became emblematic of modernity. We saw in Chapter 1 how the move from academy to studio, the appeal to a middle-class patronage, the evolution of a personally expressive iconography and the position of women in modern society under the division of labour brought about by industrial capitalism combined as conditions of modernity. Furthermore, these socio-economic factors combined to make the female nude a complicated carrier of meaning. The nude became, on one level, deeply implicated in the politics of representation and, on another level, a metaphor for the modern artist's own sense of alienation.

It may surprise us today that the fixation with the nude female body in art practice is thus conterminous with modernism – particularly when eighteenth-century academic training had been dominated by the male figure. Before the authority of the academies was challenged by artists working in a less orthodox idiom in the second half of the nineteenth century, their institutional apparatus had upheld classical models of painting and sculpture. Classical art was an exemplary art

practice that taught students to improve upon nature, idealising the subject of the human figure according to a set of prescribed ideas about composition - proportion, harmony and colour. Interestingly, however, it was the male rather than the female figure upon which these principles were visited in the academies. Classical male nudes were heroic exercises in paint or marble: Michelangelo's Adam on the ceiling of the Sistine Chapel or Jacques-Louis David's (1748-1825) Intervention of the Sabine Women (1799) (Plate VI), in which the men fight with only cloaks and shields affording cover for their bodies, are, in this sense, works of the highest order, and the male nude therefore is made to carry important ideological meanings. Some feminist writers, Lynda Nead (1992) for example, have differentiated between the treatment of male and female nudes in which the male figure stands for elevated and timeless values, while the female is left to stand for the 'merely' beautiful (1992: 29). Nead identifies the male nude with notions of the 'sublime' - that is the highest category of aesthetic appreciation in eighteenth-century Romanticism. It is therefore not without significance that it was the female nude - by its very passivity open to any number of patriarchal constructions - rather than the ordained male nude that became an icon of the fragmentary nature of la vie moderne.

The genealogy of the female nude

From the eighteenth to the twentieth century the 'life class' has occupied a central place in the academic training of artists. Entry to the life class would be preceded (and supplemented) by a study of anatomy and by drawing from the antique. All academies and later art schools retained plaster models of well-known antique statues and friezes for students to copy. The root cause of this kind of organisation within the academies was the dominance of history painting as a genre. History painting describes art that has a biblical, literary or classical content, such as David's Intervention of the Sabine Women, which is ostensibly an ancient story about the peace effected by the Sabine women between the Romans and their enemies the Sabines but had a significance for the new French Republican order after years of revolution. History painting was at the apex of the hierarchy of genres - above landscape, still-life or portraiture - into which art was subdivided. History paintings were often weighty and serious in tone, with a moral or exemplary message, like David's painting, which was considered to warrant their place in the hierarchy. It was impossible to have history painting without the human figure and the idealised heroic male nude body was its bedrock. This is not to say that all history paintings depict nudes. They do not. But the preparatory sketches and sometimes detailed studies that preceded them were nearly always nude figure studies of the historical characters. It was only in the final stages of an art work's creation that figures were swathed in drapery or clothed in antique costume.

The nude was therefore a prerequisite of history painting – in the sense that drawing from the nude was a necessary condition of the painting. The precious place of the nude was bolstered by the economics of the art market in the eighteenth and nineteenth centuries. Ultimately, it was the nude that offered the best hope of patronage among art buyers and was the vehicle through which ambitious artists

hoped to gain official recognition. Nineteenth-century notions of artistic excellence were synonymous with how well an artist could convey history and by implication how well they could paint or sculpt the nude. Given that 'academic studies' (decorative drawings of nudes in mock-classical poses) dominated the public art exhibitions of the 1870s in Europe, it is perhaps not surprising that artists should have continued to subscribe to the codes and conventions of academic nude painting. Equally, and as numerous feminist art historians from Germaine Greer to Griselda Pollock have pointed out, the exclusion of women from life classes (and from academies and art schools for most of the nineteenth century) militated against their success, particularly in the genre of history painting. And when women were eventually permitted to draw from the nude (around the turn of the twentieth century in most European countries), male models would be provided with 'posing pouches' or loin cloths (Figure 4.2).

When Thomas Eakins painted the American sculptor William Rush decorously assisting his naked model to step down from the posing dais (1907–8) (Figure 4.3), he (unwittingly) exposed several ambiguities in the conventional portrayal of the female nude. Eakins' painting may be read as a conventional, rather sentimental, image of male chivalry – possibly reflecting what he *knew* of Rush's character. However, it is also an image which disturbs Kenneth Clark's well-known distinction between 'the naked and the nude'. This distinction was made on the basis that the naked was *knowing* and the nude *distinterested* – as one of being 'huddled and defenceless' versus 'balanced and confident' (Clark 1980: 1). The idea of the nude as being somehow 'clothed in art' and therefore de-sexualised is an important one which, in part, derives its authority from the Kantian notion of a 'disinterested aesthetic'. That Eakins'

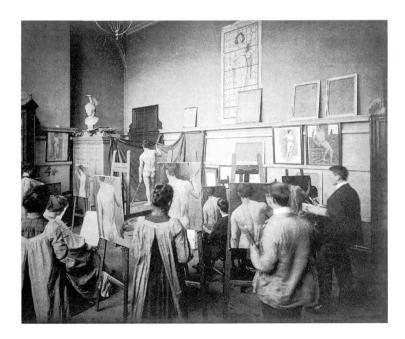

Figure 4.2 Liverpool Art School Life Class, c. 1900

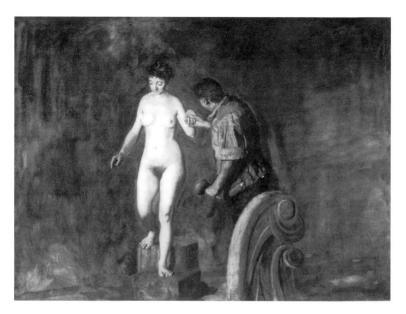

Figure 4.3 Thomas Eakins, William Rush and His Model, 1907–8. Courtesy of Honolulu Academy of Arts, Gift of the Friends of the Academy, 1947 (548.1)

unnamed model is shown with pubic hair marks her, in Clark's terms at least, as 'naked' rather than 'nude' - even though, we presume, the sculptor Rush intends to transform the naked woman into a conventional nude. While Clark clearly ranks the nude above the naked, the Marxist art historian John Berger reverses the ranking since, he claims, 'to be naked is to be oneself' (1972: 54). For art historians such as Lynda Nead, Berger's theoretical counterpoint merely inverts the opposition of 'naked' and 'nude'. Nead challenges the peculiarly western set of binary oppositions that characterise philosophical discussions of art and shows how they do not, in fact, stand up to much close scrutiny. Nead shows how John Berger, in reversing Clark's differentiation of naked and nude, merely elevated the naked (into which Eakins' representation of Rush's studio might fall) as a private act of love, but fails to place it within an understanding of the broader cultural constructions of 'love' and 'the naked'. For Nead this is a perverse answer to Clark and is in an equally false position since it supposes that the naked somehow lies beyond the realm of 'cultural intervention' (1992: 14-16). Naked or nude, semi-clothed or fully clothed, the female body can never be an innocent category, beyond cultural definitions; and, as we will see, it is a perpetual carrier of overwhelmingly male signs.

As Eakins' painting demonstrates, one (academic) artistic convention that distinguished nakedness from nudity was the removal of pubic hair. Classical female nudes were always without pubic hair (except, interestingly enough, in the preparatory sketches). Early modern artists, generally speaking, did little to overturn this convention in painting or sculpture. The issue of pubic hair is neatly concealed by a convenient hand in Manet's otherwise 'naturalistic' *Olympia*. Even photographs of nudes discreetly side-stepped the issue, hiding pubic hair with drapes and clamped thighs. In 1917 police closed a Paris exhibition of Modigliani's paintings, which

Figure 4.4 Amedeo Modigliani, Reclining Nude (Le Grand Nu), c.1919. The Museum of Modern Art, New York. Mrs. Simon Guggenheim Fund. Photo: © 1999 The Museum of Modern Art, New York

included *Reclining Nude* (Figure 4.4), on the grounds that 'they have hair'. Pubic hair, however, does feature in works designated 'pornographic' photography and it does feature in artists' drawings, for example, in Degas' images of brothels (Figure 4.5). In this respect pubic hair is one of the signifiers of sex and its explicit depiction, usually reserved for pornography. Courbet's 1866 *L'Origine du Monde* (Figure 4.6) was a private commission which undoubtedly served an overtly pornographic use for its owner (and for more than 100 years it remained in private collections). It depicts the isolated torso and parted thighs of a 'naked' woman lying down with the covers raised to her armpits. There is little ambiguity here, this is the erotic orifice, surrounded by 'realistic' pubic hair. However, its high art pretensions are hinted at by the epic tone of its title.

From the brothel drawings of Degas to Picasso (who admired and bought Degas' brothel scenes) the implicit and explicit associations of the modern nude are of prostitution. Baudelaire's call for *la vie moderne* was embraced in French literature where books such as Emile Zola's *Nana* and Gustave Flaubert's *Madame Bovary* enlisted the prostitute or 'fallen woman' as a symbol of modernity. This is in stark contrast to the Enlightenment when Denis Diderot, writing in the *Salon Review* on François Boucher in 1765, remarked:

[T]he degradation of his taste, his colours, his composition, his characters, his drawing has followed the depravity of his morals step by step. What do you expect an artist to put on his canvas? Whatever is in his imagination. And what can a man have in his imagination who spends his entire time with the lowest kind of prostitutes?

(Quoted in Elict and Sten 1979: 111)

Figure 4.5 Edgar Degas, The Client, 1879. Musée Picasso, Paris. Photo: © RMN

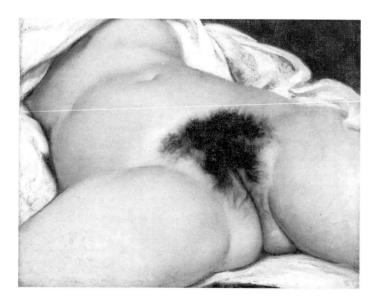

Figure 4.6 Gustave Courbet, The Origin of the World (L'Origine du Monde), 1866. Musée d'Orsay, Paris. Photo: © RMN

However, ever since John Berger pointed out that the bikini-clad woman on a car bonnet (this was the 1970s) signified 'For Sale', semiotic theories of the reclining nude have been under review. Semiotics shows how conveying meanings to members of the same culture relies upon a symbolic order of signification which exposes, in Berger's example of the scantily clad woman on the bonnet of the car, how one cultural code operated in the 1970s.

The complex system of signs we have invented for ourselves often blurs the real significance of things: the naturalising and the normalising of the depilated nude indicates how conventions can arise out of representation. The conventional nude is neither natural nor normal, but the result of centuries of consolidated art practice. It was only when modern artists ruptured these conventions that the conventions themselves were exposed. The critical reception of Courbet's The Bathers (1853) was one of those instances where scandal revealed the hypocrisy inherent in the conventions of a 'disinterested aesthetic'. Executed on the grand scale (90 × 96 inches) normally reserved for heroic images of classical bathers, Courbet's painting is a knowing repudiation of academic codes. Slyly alluding to the iconography of Noli me tangere (representations of Mary Magdalen and the resurrected Christ) in the gestures of the figures, this painting was an affront to French Second Empire bourgeois norms. The conventional 'bather' would have been a milky skinned, aristocratic, teenage beauty tastefully dabbing herself by a stream in an Arcadian landscape. Courbet's bather, however, was a ruddy faced older woman, and she was washing rather than bathing. The conventional bather never actually looked in need of a bath; Courbet's bather, according to his critics, did.

Courbet's conspicuously working-class bather was castigated at the time of the painting's exhibition for being too old, too ugly and too dirty. Paintings of the lower classes certainly existed in the mid-nineteenth century, but they too followed established conventions - generally those of genre painting which rendered the working-class subject either pathetic or foolishly humorous, but never with gravitas. Courbet's The Bathers not only rode roughshod over academic conventions but crossed with several conventions associated with pornography. In the painting Courbet depicts the servant with rolled stockings as she might appear in a pornographic photograph or a print of the period. Moreover, the bather she attends has discarded her very contemporary clothing on the branch of a tree, rather than having been recently disrobed from a classical mantle or shift. This marks the bather as being in a state of undress - naked rather than conventionally nude. False dichotomies or not, these binary oppositions of naked and nude have been cleverly deployed by modern artists, overturning the old order. What is significant for our purposes is that replacing the nude female body with the naked female body should constitute an act of male artistic rebellion.

Representing the female nude

After thirty or so years of scholarship, feminism now has a relatively well-established position within art history. Its impact, in simple terms, has been to bring to light the art produced by women which was hitherto neglected by the canon-forming dominant discourses of art. Crucially, however, many feminist art historians have

worked not solely to rehabilitate forgotten women artists, important though this is, but to look at the operations of the system that supports the privileged status of male artists. Feminist art historians have challenged the very ideological base of a mainstream art history that has hitherto been paraded as 'natural' and 'neutral'. This is part of a broader thrust against 'disinterested' scholarly activity which clearly includes the perception that the nude is principally an art form, a subject for dispassionate scrutiny.

Feminist art history, like lesbian, gay and postcolonial art history, is one in which the ideological position of the critic or historian radically impinges upon her interpretation of art history in general and art works specifically. Of course orthodox art history, when written in the interests of white, male heterosexuality1 and with a Eurocentric agenda that relegated non-western art forms to a lesser category, is similarly conditioned; but orthodox art history had become such a standardized approach to art that it was able to masquerade as 'natural' and 'neutral'. Feminist art historians fundamentally reject the claims to universalism that used to be made on behalf of literature, music, art and culture in general. They expose how art has often been silenced in terms of the politics of race, gender and sexuality. They foreground questions of difference - principally of gender but also of racial, cultural and sexual difference. But we should not think that the insights that feminist art historians have brought to bear, during a very self-analytical period of its development, are applicable only to 'marginalised' art forms: on the contrary, any such tokenism would be detrimental to the possibility of their criticisms serving as a blueprint for the analysis of other power relations and so providing models for change-management. The issues of representation, in particular, that feminism has called into question have a resonance for all aspects of representation, not just representations of women.

For example, Piero Manzoni's Living Sculpture (1961, Milan), in which the artist put his signature on the body of an attractive young naked woman so as to designate her a 'living' sculpture, may be 'revised' in the light of a feminist theory of art history. While the 'old art history' might well have appreciated the 'gesture' the artist is ostensibly punning the notion of creativity by simply signing his model - a feminist art historian would doubtless pose questions. Catherine Elwes describes Living Sculpture as a work which 'represents woman as sexed commodity. She also embodies the traditional model/mistress/muse who supplies material and sexual and spiritual nourishment for the delicate palate of male genius' (quoted in Kent and Moreau 1985: 164). Elwes' interpretation of what is at stake here is indicative of the kind of sea-change in thought that feminism has brought about. Crucially, as Parker and Pollock (1989: 119) put it, 'art is not a mirror. It mediates and represents social relations'. Living Sculpture therefore is typically probed in terms of the power relations between the artist and the model, the representation of the woman and the context in which the work was made. All the 'givens' of the old art history, in particular the notion that the nude is principally an art form - that is, an object of the 'disinterested' connoissseurial gaze - are called into question by feminism. However, undermining the idea that the nude is visually autonomous, that it is nothing but an arrangement of aesthetically pleasing colours and shapes, has been an uphill task.

The relationship between an image and the reality it purports to represent is, according to many contemporary critics, inherently political. This stems in part from poststructualist theorists who have identified a connection between 'texts' (or, for our purposes, 'images') and 'power'. Michel Foucault's reworking of the influential proposition 'knowledge is power' questioned the nature of knowledge itself and, in so doing, emphasised the ideological constructions that underpin the relationship between knowledge and power (Foucault 1994). For example, representations of women, racial minorities or disabled groups are inevitably constructed according to dominant ideologies; and it is not until traditionally marginalised groups represent themselves that their practice exposes the power relationships implicit in mainstream art. Indeed many other art-historical givens have been rendered obsolete by pluralism and cultural diversity. The depiction of the nude in modern art is a given which has been revised by feminists precisely because the representation of a nude women is political. Artists do not present the nude, they represent her.

What we have established is the apparent ease with which the female body came both to represent abstract concepts and to also function symbolically as a metaphor for artistic alienation. A feature of artistic alienation in the modern period has been to look beyond the borders of Europe for inspiration. Clearly the representation of the nude is doubly marked by artists' preoccupation with cultures outside their national boundaries. Edward Said, the Palestinian cultural theorist living and working in the United States, has been highly influential in exposing the specific representations of the east in the west. With specific reference to literature, Said writes:

The things to look at are style, figures of speech, setting, narrative devices, historical and social circumstances, *not* the correctness of the representation nor its fidelity to some great original. The exteriority of the representation is always governed by some version of the truism that if the Orient could represent itself, it would; since it cannot, the representation does the job, for the West and *faute de mieux*, for the poor Orient.

(Said 1995: 21)

Current theories of alterity, particularly those laid down by Said, foreground many of the functions of representation; which is to say, *knowing* the 'other' in terms of providing an accurate and impartial representation is impossible. Edward Said's exemplary investigation of western literature explored relations between the Orient and the Occident (the east and the west), and exposed Orientalism as a peculiarly western discourse based largely upon stereotypes of turban-wearing despots, boasting exotic harems of scantily clad odalisques attended by eunuchs. *Orientalism* (first published in 1978) and *Culture and Imperialism* (1993) deal mainly with representations of the east in literature, but Orientalism was also a fashion in art – typified by Eugène Delacroix's exotic Algerian scenes. What needs to be established here is that in representing the 'other', Delacroix's perception was coloured by his position as a white, male, French colonialist.

Being female is no guarantee of having better *knowledge* of the 'other'. Elizabeth Jerichau-Baumann's undated painting *Odalisque* subscribes to the stereotypes of the

female nude propagated by her male counterparts. However, as Reina Lewis has demonstrated, women's images of Oriental nudes are fundamentally different at the point of reception. She shows how Oriental nudes by women artists were validated by western ethnographic discourses (Lewis 1996: 119) and derived their authority from the rendition of nationality rather than eroticism *per se*. Both male and female artists, unwittingly or not, colluded with and even informed Oriental discourses, simultaneously confirming, rather pejoratively, the Orient as 'non-western'. While near- and far-eastern people were regarded as 'exotic', the 'savage' black Africans had long been part of the slave trade and existed in a debased relationship to white Europeans. The slave trade made it economically advantageous to construct the African as mentally inferior and, as we will see below, called upon the services of medicine, anthropology and Darwinism to support this thesis. The west's economic relationship with the east, however, was not uniform. Depending upon exactly which part of the east the figure represented came from, the odalisque was correspondingly higher in the hierarchy of races than her black African equivalent.

Returning to Said's damning observations about the west's representation of the 'poor' east, we come to two positions: first, a dominant position, which presumes the right of representation; and, second, the basic condition of 'otherness', which is 'to be spoken of rather than 'to speak for oneself'. Neither position is arbitrary - they have arisen out of a set of complex historical circumstances in patriarchal, imperialist and capitalist trade dealings. The act of representing peoples under direct colonial rule or as disadvantaged economic partners of the west is therefore also political. The 'politics of representation' are evident in the value judgements implicit in the hierarchy of races, the appeal to the erotic-scientific curiosity of the west and the confirmation of imperial sovereignty. Even though the conventions of western representation assume a power over the subject depicted, in fact western art profits greatly by its commerce with the east. As Edward Said argues: 'European culture gained in strength and identity by setting itself off against the Orient as a sort of surrogate and even underground self (Said 1995: 3). His point is important, since the influence of other cultures can be clearly seen in the art of the west. It is important to note that the avant-garde artists' claim to originality is, as we will see, predicated upon a much older engagement with a perceived exotic 'other'.

Subject and object

One of the things that any painted object does is to resist signification at some level because of its very objecthood. And the female nude – because of *its* objecthood – may be seen as almost emblematic of that level of resistance.

(Carol M. Armstrong quoted in Suleiman 1986: 223)

The formation of the artist as 'subject' and the nude as 'object' has grown out of a tradition of philosophical inquiry which seeks to distinguish between thinkers and what they think about. It has become customary to assume that the subject is that which acts and the object is that which is acted upon. However, this distinction is seen to be inadequate in many cases of modern art: as we saw in Chapter 3, some artists searching

for the spiritual renounced the subject—object dichotomy altogether; furthermore, the distinction fails to hold when the subject, as we will see in Chapter 7, can also be the object in terms of being a work of art — as in the case of performance art.

To compound the complexities of this subject—object discourse, epistemological shifts over the last twenty or thirty years have questioned the basis for knowledge about notions of subject and object. For instance, poststructuralists regard the subject as that which thinks and acts, but only in so far as the agency of the subject is qualified in some way. Thus in terms of dealing with representations of the nude, we start with the caveat that the subject has first to be recognised as a person or a set of people whose language, ideology, even subconscious desires have been preconstituted in some way. In other words, the artist's representation is, in itself, an enactment of larger cultural forces, not an unmediated act of self-expression. With this in mind it becomes evident that however we qualify the precise nature of subject and object, we come back to a set of conventions — whether visual or linguistic — which in the case of modern art designate the nude object as passive and the artist subject (or viewer) as active in terms of constituting meaning. In particular the conventions of looking and being looked at (surveillance and display) present a set of problems for contemporary art history.

Film theorists first put forward the proposition that the construction of the spectator in mainstream cinema is gendered. What film theorists mean is that, in practice, women are 'objectified': they are displayed for the visual pleasure of male viewers (both within the film itself and in the audience that watches the film). Scopophilia, or 'pursuit of visual pleasure', is a tendency which the film critic Laura Mulvey has argued is overtly masculine.² Blending psychoanalytical criticism with feminist film theory, Mulvey argued that mainstream Hollywood cinema fetishises the female form as embodied in the 'perfect' figures of Hollywood actresses. The audience, although comprised of men and women, shares an identification which is overwhelmingly masculine, both in terms of identifying with the male protagonist and adopting male desire in looking at the female on screen.

Alongside both goes the cultural alignment of male as active and female as passive. For a female viewer to experience the same (active) 'visual pleasure' she has to adopt the position of the male viewer or assume the 'male gaze'. Visual or scopophilic pleasure, then, has come to be seen as an entirely masculine enjoyment.

Theories of female spectatorship often begin by problematising the mechanisms of the male gaze. In *Speculum of the Other Woman* (1985) the French psychoanalyst Luce Irigaray rejects altogether the suggestion that women merely adopt the 'male gaze' rather as if looking in a flat mirror, and offers the exclusively female alternative analogy with the speculum (which has a convex surface that renders any object reflected in its surface as curved) to feminise women's reflections of themselves. The analogy gets to the biological centre of difference, although many women find it problematic that the mirror which enables them to understand themselves should be a speculum – the gynaecological instrument used for internal examinations.

Feminist, lesbian, gay and post-colonial critics have pointed out that claims for any sort of universal gaze are suspect because *man*, in the humanist sense of the word, is invariably constructed as white, western, middle class and male. Nor is *he* really free to determine *his* own existence, but is in fact constrained by conditions of class, race, gender and sexual orientation. Numerous books in recent years have

amply demonstrated that film has always been watched 'subversively' by groups whose identification is unconventionally drawn to minor characters and villains; or else who re-route the overt message of the film to serve an alternative agenda. Mulvey herself has revised her theory in order to accommodate other subject positions of visual pleasure.

For the art historian another aspect of scopophilia, in large part also imported from film theory, is the theory of voyeurism. Film theorists have pointed out that the audience's vicarious enjoyment of watching a film in a darkened room is voyeuristic because pleasure is derived from the viewers' awareness of seeing without being seen. This has a particular resonance in western art when so much that may be categorised as 'the nude' relies upon the premiss that in the scopophilic display of the female nude, she *herself* is unwittingly presented: that is, she has no power over her representation.

A classic case study of the nude (and one which has been amply deconstructed) is Degas' presentation of female nudes 'innocently' performing their ablutions for the spectator (Figure 4.7). Following Baudelaire's imperative that the artist should work from modern life, Degas depicted nudes which were highly specific to Paris in the 1870s and 1880s. As such, they have been viewed principally in terms of their status as modern 'snapshots' (based on Degas' well-documented use of photography) of fragmentary and fleeting moments in every-day life and have been applauded as such by modernists. Degas' unusual perspectival stances, his Peeping-Tom views 'through a keyhole' and his use of flattened perspectival space have equally been upheld as markers of his boundary-breaking modernism.

Until relatively recently, questions about the nature of Degas' 'male gaze' have hinged on the issue of his modernist 'snapshots' and the privileges of his 'keyhole' vantage points, even though some of Degas' contemporaries found the inherent

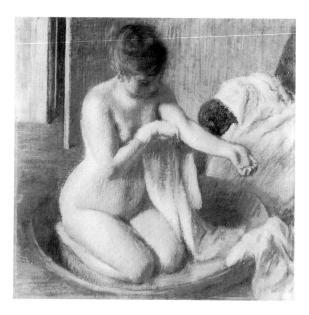

Figure 4.7 Edgar Degas, Woman in a Tub, c.1883. © 1999 Tate Gallery, London

misogyny of his gaze the most remarkable aspect of his nudes. In more recent years, the question of Degas' misogyny has attracted the attention of critical scholarship, much of it influenced by feminism. Charles Bernheimer, deconstructing Degas' nudes, has returned to the critical reception which his work received at the end of the nineteenth century. In 1889 the French novelist Huysmans interpreted Degas' pastel drawing *Woman in a Tub* as proof of the artist's 'attentive cruelty' and 'disdain for flesh' (Bernheimer 1989: 161). He characterised Degas' view of his subject as, 'the penetrating, sure execration of a few women for the devious joys of their sex, an execration that causes them to be overwhelmed with dreadful proofs and to defile themselves, openly confessing the humid horror of a body that no lotion can purify' (Bernheimer 1989: 162). This is quite a shocking response to works of art which subsequent formal appreciations in the twentieth century have come to regard as masterful exercises in the linear modelling of the female form, especially in their innovative use of pastels.

It can be argued that formalism is fundamentally irreconcilable with other readings – especially, in this instance, psychoanalytical readings. Psychoanalytical readings allow the 'return of the repressed', whereby both the subject and the object's underlying motivations are revealed. In Huysmans' terms, Degas' women bathing are read as psychologically revealing and Huysmans claims that the penetratingly voyeuristic gaze of the artist is actually 'punishing' woman for her abject sexuality. Subsequent scholarship on Degas' gaze has tended to focus on his alleged misogyny. On the one hand, some art historians have argued that Degas' gaze puts him in erotic possession of the subject. On the other hand, there are those who have argued that Degas' work actually confounds the mechanisms of objecthood and subjecthood so implicit in the western construction of the male gaze. For this to be, we have to read these images from the point of view of the subject and to believe that the subject is not as frail as we have previously held. The awkwardness of her pose, the vulnerability of her nakedness and her lack of classical credentials are not disempowering but are, in fact, overwhelming proof of her resistance. On the basis of a subjective reading of the woman bather's complete absorption in the act of washing herself (that is, she is not looking back at the artist with complicit covness), she retains her physical integrity. The validity and sustainability of either argument aside, what each tends to do is to weaken any simple binary division between active bestowing object and passive recipient subject.

The formal nude

The art critic of the Mercure de France Albert Aurier wrote in 1891 of Renoir's Nude in Sunshine:

Why show her as intelligent, or even stupid, why show as false or as disagreeable? She is pretty! . . . Why should she have a heart, a brain, a soul? She is pretty! And that suffices for Renoir, and that should suffice for us. Does she even have a sex? Yes, but one suspects it to be sterile and only useful to our most puerile amusements.

(Quoted in Dijkstra 1988: 182)

The fact that women have been repeatedly represented in modernist art by no means implies that their bodies signify 'women'. On the contrary, a nude women is rarely anything but a motif. The art-historical etiquette for describing the nude is to use the pronoun it rather than her. This distancing from the personal (including the fact that the models are often anonymous and interchangeable) is characteristic of centuries of art practice. The nude, then, is not appreciated ostensibly as a picture of a woman but as an abstraction upon the theme of nude woman (Clark 1980: 79ff.). In terms of the modern period, the formal characteristics of the nude have often been represented as a pretext for modernist experimentation with form. This modernist mission to extend the notion of artistic beauty into cubist, expressionist and surrealist stylisations of the nude and in depictions of anti-bourgeois subjects is meaningful mainly because these modes of representation would previously have been regarded as overwhelmingly ugly and profane. The starting-point for any aesthetic evaluation of the art object was based on a consensual notion of beauty. As a criterion for judging art, the aesthetic implies that 'beauty' (in itself a loaded concept) resides in the art object and that 'taste' is the viewer's capacity for appreciating the beautiful. As a facility for appreciating nudes, the aesthetic lays claim to that kind of universalism which, we reiterate, is always suspect. Nonetheless, the championing of beauty in works of art that were consistently regarded as ugly and profane is profoundly important to our siting of the female nude in this endeavour.

That the female body should be the starting-point for so many formal experiments is remarkable given the apparently enduring standards set by the male nude in the eighteenth century. Many seminal works in the modernist canon are based on the female nude: Manet's Olympia, Cézanne's Grand Bathers, Picasso's Demoiselles d'Avignon, Henri Matisse's Pink Nude, Henry Moore's Reclining Nude – take more and more radical liberties with the female form (in Moore's work, the female nude evaporates altogether into rotund forms recalling the fleshy contours of a conventional reclining nude. The crux of the issue here is why formalism and the female nude overlapped at this crucial time in the development of modernism.

Formalism, as we have seen, is the critical practice of focusing on the artistic technique of the art work at the expense of its content or subject matter. As stated elsewhere, formalism evolved in line with developments in modern painting and sculpture. As we have seen, it is not the remit of the modern artist to make facsimiles of nature. In the early phase of modernism, artists were concerned with equivalence – that is, with approximating the sensations evoked by, say, landscape. For this reason, modernism gave artists creative licence to explore abstract patterns and gestures which had more to do with private self-expression than with shared visual perception.

Formalism has aligned itself with the claims that the work of art is an autonomous object and as such one that can be 'understood' from a relatively objective standpoint. For the formalist 'understanding' and 'perception' are one and the same thing. Formalism was conceived at a time when visual perception was a branch of optics which assumed that we all see everything in roughly the same way, irrespective of conditioning factors: that is, we all see objectively. Theories of visual perception have altered significantly in the twentieth century. Rudolf Arnheim's *Art and Visual*

Perception (first published in 1954) established perception itself as a subject for analysis within art-historical discourse, laying down criteria for how and why we perceive the visual field as we do.

Returning to the construction of the gendered gaze and visual pleasure: others have since argued that visual perception is, in fact, always ultimately subjective, since the one doing the perceiving is in the grip of ideological forces. In 1891 when Albert Aurier wrote about Renoir's *Nude in Sunshine* as principally an aesthetically pleasing picture of a pretty woman, he was in thrall to the perceptive structures of his class, race and gender. This is not to claim the moral high ground but simply to acknowledge how the conditions in which judgements are made change: Aurier's comments now jar mainly because formalism, according to more recent scholarship, no longer holds sway.

The anxious nude: death, disease and dangerous women

If 'unconscious' and 'irrational' are the main attributes of primitivism, these very attributes are fundamental in the construction of woman as 'other'. In the context of art these classifications of art operated in two ways in that they constitute particular objects to be represented, 'the native' and 'woman', which as a 'represented' are paradoxically invested with the 'essence' of difference.

(Philippi and Howell 1991: 239)

In 1853 Théophile Gautier referred to the nude woman in Courbet's painting *The Bathers* as 'a Hottentot Venus'. This was a topical term during the nineteenth-century so-called 'scramble for Africa', in which European nations raced to colonise valuable (and sometimes worthless) African territories. Sarah Baartman was the original 'Hottentot Venus'. She was a black South African who was exhibited in Paris and London as a medical curiosity at the start of the nineteenth century (after her death even her preserved genitals were displayed for medical practitioners in Paris). During her lifetime, her buttocks were regularly caricatured in the popular press, and protruding buttocks came to be a stereotypical attribute of black women. More significant for our purposes is how the myth of the Hottentot came to be twisted and entwined with myths of European women – especially the prostitute.

The underlying marker of black women's bodies as representative of primitive sexual insatiability stems from the myth that black men and women were sexually 'uninhibited'. Sander Gilman (1985) has shown how the Hottentot and the prostitute were regularly twinned as examples of the excesses of female sexuality. While images of the Hottentot Venus now seem like gross and offensive racial caricatures, for much of the nineteenth century they carried the aura of 'scientific fact'. Havelock Ellis's Studies in the Psychology of Sex (published in seven volumes between 1897–1928) and Freud's Three Essays on the Theory of Sexuality, (published in 1905), identified, respectively, the black woman's buttocks as a sign of racial inferiority and all women's genitalia as primitive. Gautier's reference to Courbet's The Bathers, then, is actually not just a weak reference to the swarthy complexion of the woman in the water,

but a highly loaded reference to the association of lower-class women (and by association prostitutes) with the 'lascivious' black African.

In the west, as Foucault has demonstrated in *Madness and Civilisation* (1990), so-called empirical knowledge is used to prop up the pseudo-scientific construction of women. In this case anthropology – a 'disinterested' study of other peoples – contributes, with one or two minor adjustments, to the alterity of European women. Importantly, the study of women through sexology, anthropology and medicine, removed the object of study from the exotic and erotic representations of women and into a discourse of biological inferiority. Paradoxically, the presumed 'desexualised gaze' of anthropological voyeurism was current at a time when the depiction of women in mainstream art was becoming more overtly sexualised and blatantly erotic.

Fin-de-siècle anxieties about imminent social collapse, the end of the old order and the ushering in of new and potentially dangerous forces were played out with gusto in the art and literature of the period. Artists literally rehearsed the decline and fall of the old order in images of a world gone mad. Many thought that Europe would follow Babylon, Ancient Greece and Rome into collapse. The role that women played in these nightmare visions of the fin-de-siècle was as a sort of universal inverse of their role in the old order. There was, for instance, a genuine fear among governments and political commentators that emancipating women at home would precipitate the emancipation of colonial subjects abroad. Using women as markers of the inverse of civilisation is a recurring 'displacement activity' for the dominant order. Certain fears tend to be heightened at particular moments; 'displaced anxieties' are evident in 1950s 'sci-fi' films about invaders from outer space or in 1990s films about vampires. On one level these 'texts' may be read literally in terms of their storyline; but their subtext is very pertinent to fears of the time - of communist invasion in the 1950s and more recently of contaminated blood in the wake of the AIDS epidemic. Representations of women - in particular representations of female sexuality in the modern period - shift to carry metaphorically the fears of the time. As Elaine Showalter argues, legislation to regulate the sexual behaviour of women (especially prostitutes) in the fin-de-siècle was, although couched in the language of sexual purity, in actual fact motivated by the resurgent fear of syphilis (see Showalter 1991: 188ff). The nineteenth-century belief that female prostitutes were the carriers of venereal disease, combined with evidence that prostitution was endemic – a result of the move from the countryside to large industrial conurbations - and the Victorian invention of family values, resulted in morally regulative imagery. Images of 'fallen women', brothels and dangerous women from history were offset by images of 'the angel in the house' and scenes of maternal duty.

It is no coincidence that female sexuality (especially 'deviant' female sexuality) was increasingly the subject of scientific analysis in the nineteenth century. Biological folklore had it that women's physical and mental well-being could be guaranteed only through marriage and motherhood. At a time when women were agitating for the vote, pressing for the right to inherit property and enter the professions, women in art (and literature) were sensationalised as *femme fatales*. The negative stereotyping of women in art was often a less than subtle attempt to unsettle the commonplace view of women as harmless — under-educated and ill-equipped for entry into the professions or government. Nudes, like their clothed counterparts, were cast as

dangerous women – the Judiths, Delilahs and Salomes, biblical heroines who used their sex to lull men into a false sense of security before dispatching them altogether.

It is one of the paradoxes of modern art that although the female nude was apparently nothing more than a pretext for painting, a pure form existing in a realm beyond base sexual desire, the conflation of the female form with 'the primitive' suggests a more complex order of engagement. This contradiction has been exposed by the occasional twinning of feminist and black or non-western criticism, and has thrown up some interesting areas of overlap. For example, the types of discriminatory discourse that confirmed the cultural superiority of the western male were, in fact, often predicated on the rhetoric of primitivism and female otherness.

Once a pejorative term for anything that was 'foreign' or had preceded western classicism, 'primitivism' became a way of describing non-European cultural artefacts - such as Oceanic, pre-Columbian, African or Aboriginal carvings and textiles. Used more properly, it describes the west's obsession with otherness rather than the tribal artefacts themselves (Rubin 1984: 5). But because 'primitive' objects were highly collectible in the early years of the twentieth century, the term also came to describe the work of western artists who copied the effects and incorporated the designs of non-European artefacts into their own art. The term is more problematic today since implicit in our understanding of the primitive is the 'cultural supremacy' of the west which has made exchanges between western artists and tribal 'artists' unequal and implicated the latter in a culture of appropriation. What is vital, however, for the production and consumption of images of female nudes within modernism is the slippage between constructions of the primitive and constructions of women, which, as far as we are aware, is without a male equivalent. We should ask why, at the inception of the modernist movement, styling the female nude according to the pictorial habits of an African 'sculptor' was seen as a worthwhile formal exercise for western artists.

Why would modern European artists, representative of the most self-assured and powerful nations on earth, turn for inspiration to the cultures of peoples they thought were vastly inferior? The German expressionist artist Ernst Ludwig Kirchner was a collector of African artefacts who, after 1907, began styling his nudes in deference to the primitive. A founder-member of the German expressionist group of artists Die Brücke, in Dresden, Kirchner exemplified the artist who thought that an engagement with the primitive would liberate the soul. At a time when many ethnic artefacts were entering German museums in Berlin, Munich and Dresden, many avant-garde artists were copying from them, as their predecessors would have copied from the antique. The received history of primitivism then, was that it was a licence for artists to throw off the shackles of European convention and to lose their western inhibitions - not least their moral inhibitions. Collapsing contemporary ideas of the 'primitive' with notions of the 'natural', the primitive came to be seen as a corollary to Bohemia. As Raymond Williams (1989: 58) observes, primitivism was a modernist strategy for breaking with the past (or side-stepping it altogether) on the basis that the primitive was 'innately creative, the unformed and untamed realm of the prerational and the unconscious'. Kirchner's work represents a widespread trend in twentieth-century art to romanticise the so-called 'primitive' - to see it as a place where things were simpler and spiritually more valuable. However, for many since, faith in the integrity and ethics of primitivism has hung in the balance.

Kirchner's rendition of the primitive nude may, stylistically speaking, mark him as an expressionist, rather than a cubist or a surrealist. It is on this question of style that so much twentieth-century art history has been founded – and is currently foundering. However, in terms of content – especially the artist's construction of the nude woman – it is the paintings that are particularly revealing of European values in the period. As Desa Philippi and Anna Howell (1991: 238ff.) have shown, the identification between a non-western 'other' and a 'primitivised' notion of European women is part of the 'fantasy of cultural coherence' which confirms white male rule. But it is also a link which has been positively fostered by 'ethnic' and 'feminist' artists since the 1970s. The ideological connection between women and nature (as we saw in Chapter 3) was common currency among modern European artists. Kirchner showed his female nudes to be natural to the sea, to the forest and to nature in general. The recurrent symbolism of women and nature shows just how issues of gender difference were crucial to early twentieth-century ideas of the primitive and the natural. Our problem is how to retrieve meaning from such notions when the grounds of modernism – in particular the grounds on which we used to value such notions - have shifted.

The primitive was often underscored by social Darwinism. Darwinism showed that extinction was the result of physical weakness or unfitness for purpose. The eighteenth-century fable of intercourse between black Africans and apes was reborn in nineteenth-century colonialism through fear of miscegenation between blacks and Europeans, supported by social Darwinism. What came to be known as the 'science' of eugenics was called upon to 'explain' a number of social ills. By the turn of the century eugenics had become a means of countering the deplorable state of health among the 'canon fodder' of Europe's armies. A survey of volunteers in the Boer War had shown that a large number of British men were physically inferior to required standards and the British government set up a commission in 1902 to investigate the causes of physical deterioration. Baden-Powell's Boy Scouts' Movement, founded in 1908, was an indirect response to this perceived inferiority, aiming to promote a healthy outdoor life to improve the physical condition of potential soldiers. Social Darwinism, however, perversely proved the fitness for purpose of non-Europeans. It is interesting, in this respect, that the Munich 'Degenerate Art' Exhibition of 1937, an exhibition of art confiscated by the National Socialists, 'demonstrated' the inferiority of modernist (especially expressionist) art by showing it alongside a conflation of 'negro art' and the art of the insane. The technical radicalism of European primitivism was effectively dismantled in Nazi Germany on the grounds that it was not Aryan. It was considered a hybridised art practice which had 'interbred' with tribal art and represented the work of 'prehistoric stone-age culture-vultures and art stammerers [who] may just as well retreat to the caves of their ancestors' (Adolf Hitler, in a speech inaugurating the Great Exhibition of German Art in 1937; quoted in Chipp 1968: 482).

It is another paradox of modernism that, as we saw in Chapter 2, the female figure can be made to represent that which she does not possess – liberty, justice, freedom. The female nude has proved a useful repository of anxieties – about political emancipation, about sexual deviancy and about miscegenation – in the modern age. The female nude, then, is more than just a formal site of modernity – a place where modernists experiment with technical radicalism: the female nude is the very site on which male fears, fantasies and projections are played out.

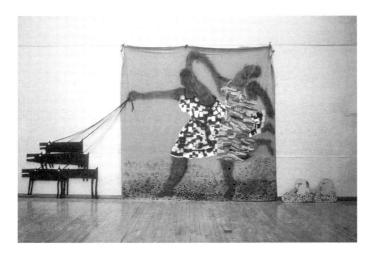

Figure 4.8 Lubaina Himid, Freedom and Change, 1984. Courtesy of the Artist

The nude as the site of postmodernity

Postmodernist claims to redress the excesses and sins of modernism – especially in its racial and gender biases – might lead one to expect that art classifiable as 'postmodern' would have its focus elsewhere than on the female nude or areas of the female anatomy. However, such work can be differentiated from the formal experiments of modernism by the motivation of artists working on the female nude. Postmodern artists continue to focus on the female nude as a crucial part of their art practice, but regularly and knowingly critique the subject of the nude.

The deconstruction of the primitive in the 1980s by black women artists such as Lesley Sanderson, Sonia Boyce and Lubaina Himid has validated one kind of postmodern approach to the thorny issue of representation. Himid's *Freedom and Change* of 1984 (Figure 4.8) is based on Picasso's *Two Women Running on the Beach* and reworks notions of white male power and the eroticisation of the black female in order to deconstruct myths of the primitive. If reappropriation of the primitive is no longer a preoccupation of women artists working in the 1990s, the female nude, as a site of postmodernity, is by no means exhausted.

The Lebanese artist Mona Hatoum's video art work *Measures of Distance* (Figure 4.9) shows the artist's mother in the shower. The screen is overlaid with the Arabic script from letters written by Hatoum's mother to her daughter and there is an accompanying soundtrack of English and Arabic dialogue between mother and daughter. The function of the nude mother in Hatoum's video work is neither erotic nor salacious. As we will see in more detail in Chapter 7, the piece raises interesting questions about the politics of women's writing about themselves, not least in terms of memory and identity. But in terms of the contemporary politics of representing the nude (even if that nude is a family member) postmodernism is clearly radically different from modernism. Hatoum's mother is shown nude not just because she is being filmed in the shower but because her unclothed body acts as a sign of her identity, particularly as constituted in and by her maternity and her ethnicity.

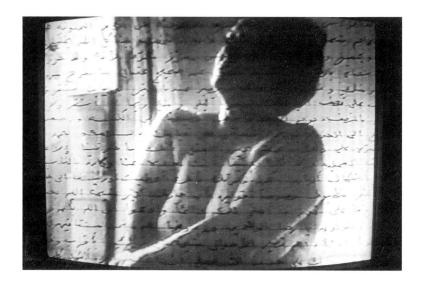

Figure 4.9 Mona Hatoum, Measures of Distance, 1988, video still. Courtesy of the Artist

John Hilliard's *Close Up* (1994) is a postmodern attempt to unsettle a modernist voyeuristic view of a naked woman (Figure 4.10). Hilliard's cibachrome shows a woman with her head turned away from the camera lens. This image is covered by another photograph which is an enlarged view of the (same) woman's pubis and vagina. This image is very close to the conventions of pornography and could even be labelled 'obscene' by the moral right-wing. What validates it as art is its reproduction in particular publications, together with the *gravitas* afforded it by the backing

Figure 4.10 John Hilliard, Close Up, 1994. Courtesy of the Artist

of art's institutions and the sacred spaces of the 'white cubes' in which it is exhibited. (It is worth remembering, however, that such institutional backing is not an invariable guarantee of an item's status as art, as such a well-publicised case as the work of the American photographer Robert Mapplethorpe serves to show.) Hilliard's Close Up could be seen to confound the voyeuristic gaze by magnifying and isolating the female sex organ and depriving the orifice of its 'erotic identity' (Durden 1997: 20). Hilliard's 'close up' is, of course, also a pastiche of Courbet's L'Origine du Monde (see Figure 4.6) and exists alongside myriad other double-coded and cross-referenced works of art that are, as a result, classed 'postmodern'. The difference is that the original Origine was a private piece of erotica produced for the dubious delectation of a Turkish emissary; and it was not intended as, nor was it for at least 100 years, an object for public viewing. Hilliard's work is fundamentally different both at the point of conception and at the point of reception. It is 'saved' from being obscene or pornographic (at least in terms of art-historical consensual notions of art) not solely because of its claim to 'art' status but because it claims to be a critique on the issues, not part of the issue itself. If, however, Hilliard's work were to be sold as 'top-shelf' material, it seems that his 'intention' would in this respect become a matter of little relevance.

The whole issue of art and pornography is complex terrain. Various ideological stances on pornography are polarised between pro- and anti-censorship debates. The liberal position is that there is no evidence that pornography is harmful, while the position of the moral right-wing and many feminists is that it is. According to Lord Longford's well-known definition of the 1960s, pornography is 'something that [gives] incentive to action'; the moral right-wing and some feminists would respond with the extremist statement: 'Porn is the theory, rape the practice'. The vitriolic nature of many of the debates around pornography in the 1970s and 1980s was particularly evident in the attacks on, and the defences of, women artists who wilfully and literally matched their gynaecology with their creativity (see Chapter 7). At the same time, the feminist definition of pornography as sexual exploitation is countered by art that 'explores' rather than 'exploits' female sexuality.

Traditionally, as we have seen, classical and neo-classical images of the nude had obscured the vagina. But vaginas had preoccupied the moderns. Picasso spent the last year or so of his life obsessively drawing vaginas. Duchamp worked secretively for twenty years (1946-66) on Etant donnés, a tableau of partially revealed torso and parted legs of a woman in a landscape (Figure 4.11). So when Judy Chicago reduces her dinner guests in the 1970s to a set of vulvas she was representing a paradigmatic shift in thinking whereby female artists reclaimed the vagina from an exclusively male preoccupation. Of course, The Dinner Party (Figure 4.12) was very much of its time, and in more recent years such gynaecological ripostes have been roundly condemned as 'biological reductivism'. However, it is important to note that these acts of 'making visible', from a female perspective, uncovered a great deal of prejudice. But, as we will see in Chapter 7, using one's genitals to make a political point has had a great deal of artistic currency. Duchamp's tableau Etant donnés was a secret work of art to be peeped at through a crack in a door; so, when Annie Sprinkle publically invites audiences to view her cervix by shining a light along a speculum inserted into her vagina (Figure 4.13), is she critiquing modernism or merely reliving it?

Figure 4.11 Marcel Duchamp, Etant donnés, 1946–66. Philadelphia Museum of Art: Marcel Duchamp Archive, Gift of Jacqueline, Peter and Paul Matisse in Memory of their mother, Alexina Duchamp. Photo: © Succession Marcel Duchamp/ADAGP, Paris and DACS, London 1999

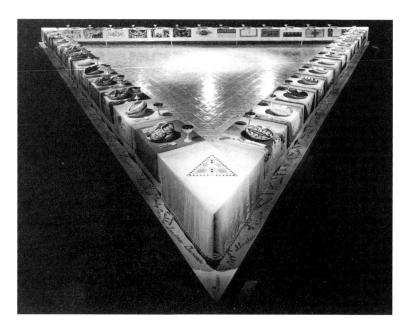

Figure 4.12 Judy Chicago, The Dinner Party, 1979. Courtesy of the Artist and Through the Flower. Photo: © Donald Woodman

Figure 4.13 Annie Sprinkle, Post-Porn Modernist, 1992. Photo: Les Barany. Courtesy of Annie Sprinkle

Barbara Kruger has recently exhibited a sculpture depicting Marilyn Monroe on the shoulders of Bobby and John Kennedy (Figure 4.14). She wears the billowing dress made famous in The Seven-Year Itch, only this time the dress reveals her vagina rather than a pair of white knickers. The work may be called postmodern in many ways: stylistically it refers to Socialist Realism in its kitsch construction of a lifesized super-real monumental figure; but it also makes a knowing reference to the much-publicised alleged sexual relationship between Marilyn and both Kennedy brothers. The use of Marilyn as an icon by Andy Warhol, for instance, is well known. But Marilyn's iconic status has become multi-layered. Appignanesi and Garrett's Postmodernism for Beginners contains a cartoon figure of Marilyn with a speech bubble announcing 'Only by metonymy do I exist as a possibility for men'. Metonymy, the substitution of a name for what is really meant - Marilyn really means sex - is postmodern irony. Of course, for many women, self-awareness of

Figure 4.14 Barbara Kruger, Family, 1997–98 (110" × 82" × 72"). Lacquer/fibreglass. Courtesy of Mary Boone Gallery, New York

108 MODERN ART

their metonymic status can spectacularly backfire – for example, the singer Madonna's book *Sex* (1993) – and the emancipatory politics of gender still sits uncomfortably with the representation of the nude.

Notes

- This is a moot point in relation to nineteenth- and twentieth-century art-historical scholarship: many well-known art historians have been homosexual, but unable to acknowledge openly their subject position (see Chapter 7).
- 2 Laura Mulvey's work (1989) on spectatorship was preceded by that of John Berger (1969; 1972) who raised the question of the gendering of spectatorship.

FROM THE MACHINE AESTHETIC TO TECHNOCULTURE

Since it is correct to say that culture in its widest sense means independence of Nature, then we must not wonder that the machine stands in the forefront of our cultural will-to-style. . . . Consequently, the spiritual and practical needs of our time are realised in constructive sensibility. The new possibilities of the machine have created an aesthetic expressive of our time, that I once called the Mechanical Aesthetic.

(Theo van Doesburg)

In 1913 THE ITALIAN FUTURIST Luigi Russolo toured Europe with his noise machines or *intonarumori*. These consisted of a set of wooden boxes which hid noise-making contraptions designed to make diverse sounds when hand-cranked. For Russolo, noise was art and this belief was central to the claim of his 1913 manifesto *The Art of Noises* (1973). There are several key points that this 'art work' demonstrates in terms of the emergence of a 'machine aesthetic' in twentieth-century modernism. First, that a machine should have been the origin of the art work; second, that there is not a trace of traditional fine art practice here; and third, that as an important postscript to the work, Russolo went on to develop his noise machines into a keyboard – the forerunner of the electronic synthesiser.

In this chapter we will see how ideas about the machine and, later on, about technology have created not only a set of images for twentieth-century art, but a powerful set of metaphors which have reconfigured the way in which we think of artist and viewer, subject and object, and even of mind and matter. Generally speaking, since the Enlightenment 'science' has been a generic term and 'technology' – what Moholy-Nagy in 1922 defined as 'the invention, construction and maintenance of the machine' (see Benton and Benton 1975: 95) – the application of science – the expression of science in society. As a branch of knowledge, 'science' can sometimes seem to be in opposition to 'nature'. Eighteenth-century Romantic notions of the sublime, for example, were overwhelmed by the power of volcanoes and storms; perversely 'science' offered the potential to harness natural forces to

power the sublime machines of the Industrial Revolution. However, the applications of science have a frightening potential tendency to go horribly wrong (witness the metaphoric representation of the consequences of disturbing the natural order in novels such as Mary Shelley's *Frankenstein*). At times when science fails to meet our spiritual and physical needs we often appeal to nature (for instance, new age mysticism or alternative medicine). Our attitudes to science, then, are never fixed but are ever-changing according to technology's many incarnations and, more importantly, what science proposes to add to our futures.

The belief in inexorable technological 'advancement' has spawned both utopian and dystopian premonitions, and the idea that the machine could be alternately a harbinger of disaster and a means of salvation is recurrent in twentieth-century popular culture. In this chapter we start with an examination of the positive and negative metaphors of the 'machine aesthetic'; we consider how its leitmotifs of speed, gigantism, repetition, standardisation, efficiency and noise provided both positive metaphors of harmony and strength and negative metaphors of human alienation in an increasingly mechanised and artificial world. We will also see how the shift from 'machine aesthetic' to 'technoculture' is marked by a continuing radical reordering—disordering of the world, both utopian and dystopian.

Futurism

As we saw in Chapter 1, within the received history of modernism, the key feature of modern art practice was its rejection of everything perceived to be orthodox, even old-fashioned. According to conventional modernist wisdom, modern artists had been enthused by the rhetoric of 'the permanent revolution' which insisted that they do something novel – that they innovate rather than imitate. This may not seem a radical proposition nowadays, but then artists had for centuries been accustomed to copying established models; they were trained, for instance, to imitate antique sculpture and old masters' paintings. So when modern artists such as Manet or Cézanne appeared to lead rather than follow this was seen to be a paradigmatic shift. However, the progressive inclinations of the avant-garde were not necessarily futuristic, and the emergence of an art movement which was self-consciously futuristic in outlook was a shift within a shift. 'Futurism' describes the activities of those artists and designers who collected around Filippo Tommaso Marinetti after 1909; 'futurists' were so called because of their enthusiasm for all things new, the machine especially.

At this point we encounter a fundamental dichotomy in the received history of the modernist mission. When the futurists hijacked modernism they took it to places its original exponents had never expected it to go. Modernism had never been synonymous with scientific and technological advances (except perhaps, to stretch the point, in cases such as Seurat's pseudo-scientific theory of optical mixing). Manet's La Vie Moderne referred to the fleeting and ephemeral experience of modernity, not mechanisation per se. Even Baudelaire's advocacy of the city and rejection of Jean-Jaques Rousseau's nature did not automatically lead to mechanolatry. On the contrary, French modernists, such as Cézanne, remained in thrall to nature, obsessively painting and repainting landscapes. As far as the futurists were concerned, French

modernism, in the early twentieth century at least, was in stasis. Even cubism, the new '-ism', seemed to the futurists to be obsessed with the inert – at first with viaducts in the South of France, and then with still-life on table tops. The cubist concession to modernity was the fragmented representation of mass-produced industrial products rather than apples or mountains.

The futurists, however, were not interested in stationary objects. They were involved in all sorts of activities, including theatrical and live events, sound poems and costume designs (although the 'history of art' has curiously presented futurism as merely a 'history of paintings', with one or two sculptures by Umberto Boccioni). The futurists' mischievous modernism was not only a brash enthusiasm for machinery: it embraced everything which augmented, or came with, the machine. In 1913 Sant'Elia, the Italian futurist architect (on paper only, as he was killed in the First World War), was designing plans for a city (*Città Nuova*). Sant'Elia's city was a utopian metropolis designed on a monumental scale. Committed to a programme of technological innovation, Sant'Elia incorporated in the *Città Nuova* the latest technology (and some technology which then had not been invented) – steel and concrete terraced skyscrapers, multi-storey walkways, detached lift shafts and slender linking bridges.

The call to order

This is our century – technology, machine, socialism. Make your peace with it. Shoulder its task.

(László Moholy-Nagy (1922) Constructivism and the Proletariat, quoted in Benton and Benton 1975: 95)

The 'call to order' (rappel à l'ordre) was an expression, signifying a return to basic principles, given to government policy designed to restore rationality to post-First World War France (and later to Italy) after four years of turmoil. Although it was implemented by means of socio-economic legislation, the 'call to order' was simultaneously interpreted by many artists as a suspension of experimental avant-garde movements, such as cubism, and a resumption of the monumental classicism² that seemed to have held civilisation together for over 2,000 years.

Underpinning this return to classical order was a drive towards 'purification' which aimed to purge art of its excesses. This rationalisation of the visual arts tended in many cases towards advocacy of a sober and impersonal aesthetic based upon geometrical shapes and primary or muted colours as opposed to the flamboyant distortions of expressionism. Purism, a short-lived Paris-based art movement led by the architect Charles Edouard Jeanneret (hereafter, Le Corbusier) and the painter Amdée Ozenfant was one such manifestation of the return to order. Le Corbusier and Ozenfant jointly published their manifesto, 'Purism', in *L'Esprit Nouveau* in 1920, aligning the 'call to order' with their own wish to 'purify' cubism, which appeared to them to be in an overblown, near-Baroque, phase. They meant to impose the same spirit of rationalisation on painting as was already present in architecture. The manifesto explained: 'The highest delectation of the human mind is the perception of order, and the greatest human satisfaction is the feeling

of collaboration or participation in this order' (Benton and Benton 1975: 90). Purism, they argued, can be achieved only by combining enduring primary elements, or what were termed 'plastic constants' – enduringly simple forms which rationalised whatever they 'depicted' – nudes or vases of flowers. In his *Accords* (1922) Ozenfant worked with a standard – prefabricated – set of sizes and compositions, uncomplicated shapes and colours (Figure 5.1). It is not difficult to understand this kind of response to the uncertainties and devastation of war, and the appeal of making sense of the world in terms of 'plastic constants'.

This reaction stands in stark contrast to the 'irrational' responses of surrealism. The proto-surrealists, forming in Paris at the same time, totally disregarded the 'call to order' since, they felt, it was precisely western 'order' and 'rationality' that had led to the mechanised slaughter of so many during the First World War. The surrealists, who formally came together in 1924, believed that 'irrationality' rather than the 'call to order' was worth pursuing.

The visual decorum of the purists, meanwhile, stripped away the apparent excesses of pre-war art, especially of European symbolism, and rationalised the kind of abstraction that had emerged around expressionism. These underlying values of purity, balance, serenity and order are just one set of motifs that the 'First Machine Age' (1996) fostered. The rhetoric of purity had cropped up earlier, in the work

Figure 5.1 Amédée Ozenfant, Accords (1922). Courtesy of Honolulu Academy of Arts, Gift of John W. Gregg Allerton, Commemorating the 40th Anniversary of the Academy, 1967 (3478.1). Photo: © ADAGP, Paris and DACS, London 1999

of the Viennese architect Adolf Loos whose architectural design solutions staked their future on flat-roofed building and geometric cantilevering. Loos' book *Ornament and Crime* was first published in 1908, although it was not published in France until 1920 when it was reprinted in the journal *L'Esprit Nouveau* (the literary organ of the purists), and joined Le Corbusier and others in calling for a rational simplification of architecture. Adolf Loos equated decoration with sinister purpose: his memorable claim, in *Ornament and Crime*, that the two terms were synonymous rested on his observation that 'criminals' nearly always sported 'ornamental' tattoos. Loos' book was clearly part of an escalating rejection of art nouveau or what had been called 'the battle of the styles' in architecture and an attempt to resolve the differences into a single international style. The so-called 'international style' of architecture was wholly devoid of ornamentation, extraneous detail, frivolity and gratuitous detail. Not only did Loos equate architectural ornament with the excesses of European *ant nouveau* but with the kind of ersatz ornament which poorly imitated the lavish craftsmanship of a bygone era.

Reyner Banham ascribes Loos' sense of simplicity to his belief that 'freedom from ornament is the symbol of an uncorrupted mind, a mind which he only attributes to peasants and engineers . . . laying further foundations to the idea of engineers as noble savages' (Banham 1996: 97). As we will see, the idea of the mechanic as ennobled somehow by being a machine operative was a feature of the 'First Machine Age'. The term 'technocracy' which describes a state of 'rule by technicians' had been coined by the Californian engineer William Henry Smyth in 1919 and was developed by Thorstein Veblen, whose book *The Engineers and the Price System* (1921) inspired a brief spell of technocratic idealism in the United States in the 1920s. In contrast to the technocratic idealism of the United States, the European surrealists made a map of the world in 1929 in which space was allocated on the basis of a country's spiritual and magical predilections: so Mexico, Canada and Ireland, with, respectively, indigenous Indian, Inuit and Celtic communities, were relatively huge, while countries that privileged the measurable against the spiritual were reduced to the size of a pinhead or, like the United States, omitted altogether.

The 'machine aesthetic'

The machine is as old as the wheel, the wings of Icarus or the Trojan horse. But it is only in our century that it has transcended its utilitarian functions and acquired a variety of meanings, esthetic and philosophical, which are only distantly related to its practical uses.

(Baur 1963: 33)

The precise signification of machine aesthetic requires a careful introduction since it does not describe a distinct group of individuals or even a 'movement' in art (in the conventional art-historical sense of 'movement'). Rather it is a characteristic that marked certain groups, individuals and movements during the first half of the twentieth century. The machine aesthetic is properly a label for some aspects common to a range of affiliated movements in the First Machine Age of the 1910s and 1920s – very generally purism in France; De Stijl in Holland; suprematism and

Figure 5.2 Elsie Driggs, Pittsburgh, 1927. Whitney Museum of American Art, New York

productivism in Russia; constructivism at the Bauhaus; and precisionism in North America which celebrated the monumental silhouettes of industrial landscape – for example, the work of Elsie Driggs (Figure 5.2).

If there was any commonality among these art movements then it lay principally in their shared aspiration to extend the traditional notion of aesthetic appreciation to include machines and machine effects. Since the eighteenth century the traditional understanding of aesthetics had been related to the visual arts (painting, sculpture and architecture), poetry and music. But in the modern period, prestigious spaces had been found in which to celebrate machines. From the Great Exhibition of 1851 to the World Fairs of the twentieth century, the latest industrial machinery was exhibited all over the world.

The machine's transition from industrial gadget to aesthetic object came at the Museum of Modern Art (MoMA) in New York in 1934 with an exhibition entitled 'Machine Art'. MoMA displayed engines, pistons and propellers, placed on pedestals and mounted on walls, in just the same way as curators exhibit paintings and sculptures (Figure 5.3). In the end these exhibits became the basis of a permanent design collection, but what is important is that, in 1934 at least, they were displayed as works of art. In fact, as we will see in Chapter 8, Alfred H. Barr Jr, Director of MoMA, envisaged the museum itself as a machine, represented diagrammatically as a torpedo (see Figure 8.4). This juxtaposition of 'machine' and 'art' is indicative of an age that was prepared to extend its notion of the aesthetic to include the machine. In fact, many artists put their mechanolatry on record: Marinetti's 'Manifesto of Geometrical and Mechanical Splendour, and the Sensibility of Numbers' (1914; in Flint 1972: 97–103); Gino Severini's 'Machinery' (1922; in Benton and Benton 1975: 96); Nikolai Tarabukin's 'From the Easel to the Machine'

Figure 5.3 'Machine Art' exhibition, 1934, at the Museum of Modern Art, New York.

Photo: Wurts Brother. Courtesy of the Museum of Modern Art, New York

(1923; in Frascina 1982: 135–42); Fernand Léger's 'The "Machine Aesthetic": The Manufactured Object, the Artisan and the Artist' (1924; in Benton and Benton 1975: 96–101); Kurt Ewald's 'The Beauty of Machines' (1925–26; ibid.: 144–6); and Walter Gropius' 'Where Artists and Technicians Meet' (1925–26; ibid.: 147–8) are examples of a crop of celebratory texts exploring the beauty of machines.

The machine aesthetic operated on a number of levels. First, the machine itself was frequently represented in works of art. The American precisionist Charles Sheeler photographed, drew and painted industrial complexes. Sheeler's admiration for machines was evident not only in his subject matter but manifested itself in the clinical 'precision' of his style which imitated the glossy finishes and clean lines of precision instruments. Sheeler's 1931 *Ballet Méchanique* (Figure 5.4) is a crayon copy of a now lost photograph of the Ford Motor Company plant on the Rogue River site near Detroit.³ At the time this was the largest and probably the most technologically advanced factory in the world, employing some 80,000 workers in the 1920s. *Ballet Méchanique* is often read as a celebration of industry even though it was produced at the onset of the Great Depression of the 1930s and only one year before thousands of laid-off workers set out on the first of the Hunger Marches through Detroit. Ultimately, 30 per cent of the American workforce was laid off by the economic slump, that spread worldwide.

The very title *Ballet Méchanique* belies the much broader poetic idea that the moveable parts of industrial machines could be the equivalent of balletic gestures. Striving for an artistic equivalence to the regularity, efficiency and hypnotic rhythms of engines in motion was a feature of many of the cultural enterprises of the First Machine Age. For instance, the poetry of Blaise Cendrars evoked the motion of the Trans-Siberian Express. At the Bauhaus in Germany during the 1920s Oskar

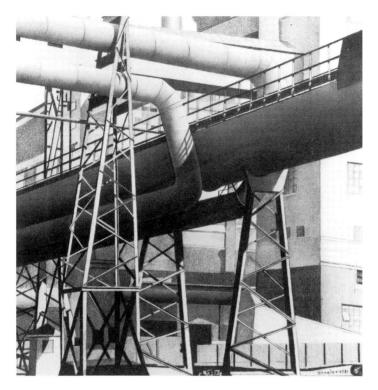

Figure 5.4 Charles Sheeler, Ballet Méchanique, 1931. Memorial Gallery of the University of Rochester

Schlemmer, teacher in the theatre, metalwork and sculpture workshops, was choreographing a number of mechanical ballets in which dancers, stage-sets and costumes were transformed into engine parts and performers mimed the mechanical motions of pistons, cogs and wheels. In France in 1924 Fernand Léger collaborated on a 'film without scenario', *Ballet Mécanique*, a rapid montage of images which repeatedly contrasted machine components, shiny saucepan lids, Christmas decorations and human body-parts in a series of distorted close-ups. What these mechanical ballets share is that they reflected the motifs of the machine aesthetic – speed, gigantism and repetition.

Sheeler and Léger, along with Schlemmer, saw parallels between the machine and the body. Each matched the motions of machine parts with the movements of dancers' limbs. Traditionally ballet, even early avant-garde ballet, was choreographed in terms of seemingly natural, fluid and graceful bodily movements. The tendency of the machine aesthetic towards mechanthropomorphism, or the hybridisation of machines and humans is a direct contrast to the naturalism of ballet. For instance, in *The Mechanic* (1920) Léger's eponymous mechanic is recognisably a man but he assumes the simplified proportions and cylindrical modelling of a robot. Léger painted industrial and mechanical motifs throughout the 1920s, but a characteristic of his work is its recurrent depiction of the heroic worker and its celebration of labour – both manual and mechanised. His vision of an impersonal and efficient body as

a metaphor for harmony and strength recalls Loos' idea of the engineer as noble savage. Far from being depersonalised by the machine, Léger's proletarian figures are ennobled and rejuvenated by it. The fact that Léger's paintings look as if they have been assembled from standard mechanised parts is important. Although formalists such as Greenberg often de-emphasised the socio-political dimensions of the machine aesthetic – especially its commitment to the left (see Greenberg's essay 'Master Léger' in Frascina and Harrison 1982) – artists such as Léger were intrigued by the possibility of an egalitarian art practice, in which (as we will examine in more detail shortly) standardisation was a positive feature.

The flipside of positive images of the mechanthropomorph was the mechanoid monster. For instance, *The Rock Drill* (1913–14) by the naturalised British sculptor Jacob Epstein (1880–1959) shows a visored figure straddling a pneumatic drill supported by a tripod. The title *The Rock Drill* innocuously describes the machine but more disturbing is the mechanthropomorphic figure, complete with a hybrid foetus between its carburettor rib-cage that sits astride the 'phallic' drill. *The Rock Drill* tends now to be read (with the benefit of hindsight) as a prophetic piece – a dreadful portent of the First World War, a mindless monster fulfilling its programming regardless of conscience or consequence. The efficiency with which machines dispatch their orders becomes a nightmarish aspect of modern times, one which the sculptor regarded as 'the terrible Frankenstein's monster we have made ourselves into' (Cork 1976, vol. 2: 479). Epstein himself symbolically emasculated *The Rock Drill* after the First World War when he severed the drill and the driller, exhibiting only the torso of the driller with amputated limbs (Figure 5.5).

A further way in which the 'machine aesthetic' weaved itself into the consciousness of the period was via the self-consciously utilitarian language of the avant-garde. This is particularly evident in the differences between the languages of expressionism and constructivism. As we will see, 'expressionism' and 'constructivism' were generic terms for several types of art practice in Europe and North America in the first half of the twentieth century. In the utilitarian manifesto 'New Way of Life' (1918–19) the constructivist Vladimir Tatlin conceived of the artist as a technician or 'inventor' (as opposed to a creator), a socially useful individual whose work in the studio mimics industrial processes. The vocabulary of the constructivists was demonstrably different from that of earlier modernists. They claimed to 'construct' or 'assemble' rather than paint, cast, carve or model art works. Tatlin's Counter Corner-Reliefs, for instance, typically constructed from sheet metal, expressed a fundamental opposition to the precocity and 'aura' of easel painting and in particular to the semi-mythical view of the solitary artist-genius expressing 'himself' in the medium of paint or stone.4 Constructivism coincided with other confident announcements of the 'death of easel painting' - in the sense of brush and palette activity. For example, Nikolai Tarabukin's From the Easel to the Machine of 1923 reflected the belief that traditional methods of art making had been exhausted by 400 years of convention and repetition. In contrast, artists affiliated to the machine aesthetic flirted with the syntax of the factory and, like Diego Rivera, cast themselves as 'a worker among workers' (Figure 5.6); or, like László Moholy-Nagy, dressed as engineers. The semiotics of Moholy-Nagy's choice of clothing is significant: unlike the Bohemian's greatcoat or the smock of the expressionist, the boiler-suit was more suited to the workshop than to the studio.

Figure 5.5 Jacob Epstein, The Rock Drill, 1913-14. Photo: Courtesy of Beth Lipkin © 1998 Tate Gallery, London

Finally, the machine aesthetic was part of the zeitgeist, the spirit of the age - a palpable sea-change in the mood and temperament of some artists. When Meyer Schapiro, in his influential 1937 essay 'The Nature of Abstract Art', linked Diego Rivera's paintings of factories, Dada's 'burlesque with robots' and the futurists' regard for energy and speed (Schapiro 1978: 206-7) he was summing up a shift in styles and attitudes. This was the 'Jazz Age', and the upbeat tempo and rhythm of jazz music and dance infiltrated the work of many artists, film-makers and designers. Unlike Kandinsky who listened to Schoenberg and compared his expressionist

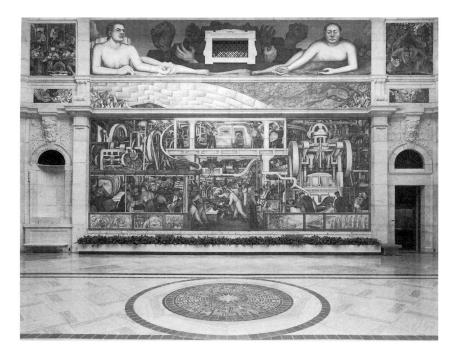

Figure 5.6 Diego Rivera, Detroit Industry, South Wall, 1932–33. Gift of Edsel B. Ford. Photo: © The Detroit Institute of Arts, 1996/DACS

paintings to symphonies, Mondrian painted while listening to popular jazz pianists and was 'inspired' by the staccato drum beats and syncopated rhythms of the 'Boogie-Woogie' (Figure 5.7).

A modernist schism

Beauty is everywhere: more perhaps in the arrangement of your saucepans on the white walls of your kitchen than in your eighteenth century drawing room or in the official museums.

(Léger, quoted in Benton and Benton 1975: 96-97)

In his pamphlet 'Where Artists and Technicians Meet' (1925–26), Walter Gropius differentiated between 'the technological product made by a sober mathematical mind and the "work of art" created by passion' (quoted in Benton and Benton 1975: 147). Gropius' distinction is a sound one. In real terms, he was pointing to a fundamental difference between expressionism and constructivism. Each of these terms tended to act as an umbrella to describe all sorts of European and North American art movements which, as we have seen, adopted dissimilar styles and syntax and engaged in artistic sabre-rattling. This perception that mainstream modernism was subsumed by two overarching trends was confirmed in Alfred Barr's map of modernism (see Figure 1.3) entitled *The Development of Abstract Art*. According

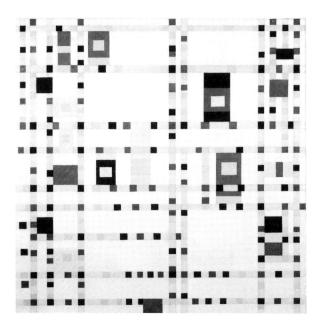

Figure 5.7 Piet Mondrian, Broadway Boogie-Woogie, 1942–43. The Museum of Modern Art, New York. Photo: © 1999 Mondrian/Holtzman Trust c/o Beeldrecht, Amsterdam, Holland and DACS, London

to Barr, by 1936 the course of modern art had split in two. On one side there was 'non-Geometrical abstract art' (growing out of expressionism) and on the other 'geometrical abstract art' (growing out of constructivism). Non-geometrical abstract art traced its line of descent from surrealism and expressionism, while geometrical abstract art stemmed from purism, constructivism and De Stijl, via the Bauhaus. Interestingly Barr's schema puts the machine aesthetic in a box at the centre of this lineage. But, even more telling, by 1936 expressionism and constructivism were, with the exception of an historical link via the Bauhaus, apparently irreconcilable.

The art groups ranged on the side of the machine aesthetic were, again according to modernism's conventional wisdom, part of the backlash against the kind of romantic individuality that expressionism seemed to support. As an antidote to expressionism, geometrical abstract art revealed a broad disenchantment with the cult of the solipsistic and self-indulgent artist. Fernand Léger summed up this attitude in 1924: 'I have more faith in it [the machine] than in the longhaired gentleman with a floppy cravat intoxicated with his own personality and his own imagination' (quoted in Benton and Benton 1975: 98). This is a far cry from the early modernist's heightened sense of self-expression exemplified in Cézanne's maxim 'Let us strive to express ourselves according to our personal temperaments'. Léger's faith rested on a vision of the pragmatic engineer who presided over the technocracy rather than on the hazy idealism of conventional painters. It is possibly not without significance that a number of those artists who subscribed to the machine aesthetic had come from non-fine art traditions: El Lissitzky had a degree in engineering but took up illustration because he could not find work; Theo van Doesburg studied acting

but gave it up because he could not make money at it; and Moholy-Nagy trained as a lawyer but turned to art as a therapy while convalescing from wounds sustained in the First World War. On one level these artists defied the Romantic notion that artists are born, not made, but then the fact of their improbable conversions rather lends credence to the idea that they were fated to be artists from the start. There is an irony in the west's urge towards individuality: that, although artists such as Moholy-Nagy appeared to have been opposed to the cult of Romantic individuality, it is extremely hard for us to do other than merely replace one set of Romantic images of the artist with another.

This dualism within modernism was played out in microcosm at the Bauhaus in Germany. Opened in 1919 as a regional arts and crafts school with an emphasis on bringing together the fine and the applied arts, the Bauhaus was at first indebted to expressionism. However, in 1923, in a lecture 'Art and Technology: A New Unity', Walter Gropius announced that technology was to be the pet project of the Bauhaus. On one level this shift may be interpreted as a survival tactic in the face of budgetary strictures and the climate of accountability towards the arts in Weimar Germany five years after the First World War.⁶ Indeed, the change in policy at the Bauhaus was aided and abetted by the relative stabilisation of the German economy which, at the Bauhaus, permitted an injection of new staff. Yet the zeal with which the Bauhaus reinvented itself appears to be evidence of more than just a nascent business-like attitude: it seems to have been genuinely in keeping with the pragmatic and technocratic spirit of the age. Thus when Walter Gropius enthusiastically reconfigured the Bauhaus, re-named the workshops 'laboratories', employed artists who imitated technicians and pursued the possibility of creating prototypes for mass production, he was not displaying the tendencies of the maverick.

At the Bauhaus of the 1920s Walter Gropius, Oskar Schlemmer and László Moholy-Nagy effectively outlawed the kind of unreconstructed expressionism that had come to be associated with the institution's early years.⁷ Chiding his colleagues - 'you are all sick Romantics' - Moholy-Nagy opposed the rhetoric of expressionism, rooted as it was in Romantic notions of the self, on every level. He modelled himself on the engineer working scientifically and in anonymity and, as we have seen, dressed rather pointedly in a boiler-suit. Moholy-Nagy renounced the Romantic idea that as an artist he had to struggle towards a 'unique signature style'. To this end, his work brazenly undercut the humanist view of artistic practice as an original and wholly autonomous effort which is elevated above all other manual ones. For instance, Light-Space Modulator (1923-30) resides somewhere between machine and work of art (Figure 5.8). It is a revolving kinetic sculpture which reflects and projects light - 'a light fountain' made of metal and mirrors. Made in collaboration with the German engineering firm AEG, Light-Space Modulator is a summary of the activities that Moholy-Nagy encouraged at the Bauhaus: industrial collaboration, constructivism, photography (especially pictograms) and film.

This call for an art practice that was primarily productive was also in evidence in revolutionary Russia. 'Art into Production' was the slogan of Aleksandr Rodchenko and Vavara Stepanova who published 'The Programme of the Productivist Group' in 1920 and called themselves, appropriately enough, 'the Productivists'. Their manifesto contained exclamations such as 'Down with art! . . . Long live the constructivist technician!' (quoted in Benton and Benton 1975: 92), and its tone was not dissimilar

Figure 5.8 László Moholy-Nagy, Light-Space Modulator, 1923-30. Courtesy of the Busch-Reisinger Museum, Harvard University Art Museums, Gift of Sibyl Moholy-Nagy. Photo: © DACS, 1999

to the fighting talk at the Bauhaus after 1923. Productivism, although a short-lived art movement (1920–22), also came at a significant time in the history of Russian avant-garde art. Productivism sought to fulfil practical and utilitarian ends; Rodchenko and Stepanova had also turned their studios into workshops which they used to explore the kinship between technology and art. Rodchenko was disillusioned with easel painting, which he in fact 'gave up' in 1921 to concentrate upon the relatively mechanised processes of photography, photomontage and graphic design. For him 'art has no place in modern life', but photography, particularly experimental photography as opposed to 'connoisseurial photographs', was the ultimate anti-bourgeois, anti-art practice. Rodchenko's acute-angled photographs were intended to emphasise technical, as opposed to 'connoisseurial', aesthetics so that photography could be pressed into the service of the revolution.

To leap ahead of chronology for a moment, we are reportedly now in a *post-photographic* era where digital photography, in theory, makes conventional – analogue – photography redundant. The so-called digital revolution means that a photograph, a frame of a film or a piece of sound can all be digitised – enhanced and manipulated. The notion of postphotography is predicated on the notion that photography is a 'transparent' technology, though photographers early on in the century were aware, as was Rodchenko, that analogue photographs were never simple reflections of the world because they were framed and edited by photographers.

The tendency in western art history to privilege easel painting has marginalised the experimental photography and film that were consistent with the principles of the machine aesthetic. This is puzzling: Alfred H. Barr argued in the 'Russian Diary' (1926; see Barr 1986), in line with Lenin, that it was film and not easel painting that was the most significant art form, because it had the capacity to reach a mass audience. However, the fact that even an arch-modernist like Barr was unconvinced that easel painting could weather the massive upheavals of the revolutionary period ultimately failed to prevent the relegation of early revolutionary art forms to the subordinate status as propaganda in the received genealogy of twentieth-century art history.

As we have seen, the language used by art groups under the sway of the machine aesthetic is significantly different from that of their expressionist counterparts. However, another aspect of the importance of the separatist language of the machine aesthetic is that it came at a time when the very function of artists was called into question. This reappraisal of the role of the artist in society crops up periodically throughout the twentieth century but particularly, as we will see in the next chapter, in the 1930s in North America. However, in the 1920s the notion of a socially useful artist who not only served the interests of the state but connected with the lives of ordinary people seemed a real possibility. It is evident that the machine aesthetic played more than just a stylistic part in the revolution. Rodchenko served the Communist Party in designing advertisements whose uncomplicated design communicated direct messages to a largely illiterate proletariat.8 With copy by the playwright Vladimir Mayakovsky, who called his slogans 'street poetry', Rodchenko's advertisements for Rezinotrest galoshes of 1923 provided straightforward imagery for the new urban masses and bore the hallmarks of the frank and highly legible image-making that represented a utopian implementation of the machine aesthetic.

Another significant aspect of the machine aesthetic, which we alluded to briefly in respect of Léger's standardised figures, was the idea of an egalitarian aesthetic achieved through standardisation. Stemming from the demise of aristocratic privilege, the idea of a universal beauty which may be found in the commonplace gained momentum from Enlightenment thinking and became a standard modernist claim. As early as 1751 Diderot described 'the Stocking Machine' as 'one single and prolonged act of reason'. The Italian futurist Gino Severini explained in 1922 how 'the aesthetic pleasure created in us by a machine can be thought of as Universal, we may conclude that the effect created by a machine on the beholder is analogous to that produced by a work of art' (quoted in Benton and Benton 1975: 96).

By the 1920s universal beauty was, in keeping with the kind of rhetoric that artists on the left tended to adopt, a rallying cry for an art practice that was not

embedded in the cult of personality. It is not insignificant that so many artists 'standardised' their means of production, usually by opting to work with a restricted visual vocabulary of geometric forms (Mondrian, Léger) or crude ready-mades (Tatlin, Moholy-Nagy). It is perhaps the ultimate irony of this project that, although many artists tried to depersonalise their art, removing all traces of the 'unique signature style', works by Léger, Moholy-Nagy, Mondrian or Tatlin are still recognisable as the products of individual artists. Moreover, these works have been displayed by art galleries and museums as the products of individual genius rather than as the outcome of collective enterprise.

In spite of this fundamental paradox, claims to a modern universalism persisted throughout the inter-war period. On one level it is possible to see universalism as yet another form of inoculation against individualism. However, this is only a partial explanation. For the claims to a modern universalism were utopian in spirit and often part of some socialist agenda. However, it is a commonplace observation that capitalism is not well disposed towards standardisation. Although its mode of production operates most efficiently through standardisation and repetition on the commodity conveyer belt, capitalism promotes the myth of specialism. Certainly, the erosion of some of the privileges of western individuality was an important prerequisite of utopia, and artists such as Moholy-Nagy thought that the machine was a great social leveller which had the potential to equalise relations in society.

Artists' utopias had their corollary in popular culture. For instance, the film Things to Come (1936) was a lexicon of the international style, with sets inspired by the very latest in modernist design.9 Although Things to Come is a work of science fiction, the well-known definition of science fiction as 'reality ahead of schedule' points to a utopian future. The film (based on a story by H. G. Wells) traces the 100-year utopian redevelopment of 'Everytown' after it is destroyed by war. As a design for a model society, the notion of utopia had emerged periodically over a considerable period: the term derives from Thomas More's Utopia in the early sixteenth century (though the notion of an ideal state goes back to Plato's Republic) and figured prominently in William Morris's writings on utopian socialism in the nineteenth century. The important point about utopian ideas in the context of twentieth-century technocracy was that they functioned at the grass-roots social level and at the more abstract level of the democratic. Rather than paradise for the few, utopia is a perfect society for the many. The premiss of Things to Come - that the old society has to be dismantled before utopia can be created - goes hand in hand with the notion that war cleared away the debris of the old and that utopias are preceded by dystopias.

Dystopias

As we have seen, many early twentieth-century artists affiliated to the machine aesthetic were engaged in a utopian project to create order and harmony through the machine. But the flipside of utopia, dystopia, has also been a fertile undercurrent of modernity. The 'brave new world' prophesied by some was criticised by others on the ground that technocracy is dehumanising. The positive metaphors of harmony and strength afforded by the utopianism of the machine aesthetic were

countered by negative metaphors of alienation. Antonio Gramsci, the Italian Marxist social theorist, believed that standardisation through mechanisation threatened the uniqueness of the individual, a belief echoed in popular fears that the machine would dislodge men and women from nature, surrounding them with artificiality – gadgets, standardised environments, gigantism, excessive noise and speed.

Moholy-Nagy thought that the machine had the potential to free ordinary men and women from the burden of repetitive labour, but there were many others who contested the relationship between machines and their human operatives. In the film *Modern Times* (1936), Charlie Chaplin parodied the robotisation of human functions in the factories of North America. In one scene, prolonged exposure to assembly-line repetitions drives the protagonist, played by Chaplin, to become temporarily unhinged. Hypnotised by the numbing procession of bolts on the assembly line which he has to tighten simultaneously with two spanners, Chaplin falls into the hidden mechanisms that power the factory and is transformed into an automaton carrying out the machine's instructions with comic consequences (Figure 5.9).

Modern Times is also a critique of what came to be called 'Taylorism' or 'Fordism'. Frederick Winslow Taylor was the pioneer of 'time and motion' studies who advocated that labourers should work like machines in brisk, repetitive and time-saving motions to maximise efficiency in the factories of North America. Taylor and Henry Ford (in whose motor factories Taylor's methods were implemented) sought to improve workers' efficiency by regulating the 'time and motion' of each worker, rationalising every movement along an assembly line. In Modern Times, Chaplin's parody of the excesses of Taylorism points to a very real fear that they blurred the boundaries between the working body and the machine — in particular that this method of production might result in an actual mechanthropomorphism.

The belief that the mechanised world was 'disenchanted' of all the qualities that had previously comforted – especially spiritual meaning – is an undercurrent of dystopia. However, for artists such as Theo van Doesburg, the very fact that machinery had removed 'man' from 'nature' actually facilitated the spiritualisation of human life (see Benton and Benton 1975: 93). Van Doesburg contrasted the materialism of 'handicraft', which he believed 'reduced men to the level of machines', with the 'new spiritual artistic sensibility' afforded by the machine (Banham 1996:

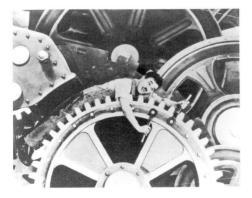

Figure 5.9 Charlie Chaplin, Modern Times, 1936. Courtesy of BFI Stills, Posters and Designs

151). However, the scientific liberation of men and women from religious dogma and superstition went hand in hand with a new sense of human alienation in a mechanised world that offered no redeeming sense of belonging or purpose. This critique was echoed by Gramsci, who exposed morally reprehensible industrial practices that reduced the work of the labourer to soul-destroying, dehumanising, mechanical tasks. Gramsci castigated industrialists, especially Henry Ford, for being exploitative and uninterested in the 'humanity' or 'spirituality' of his workers (Gramsci 1971: 303).

At the same time Marxist theories of 'technological determinism' asserted that, although many of the changes in society are brought about by changes in technological 'tools', it is in fact the 'social relations of production' that are the most salient features of any given period. To follow the Marxist line of reasoning, the combined interests of governments and capitalism shape technology into an insidious form of social control. There was nothing 'neutral' about technology. It was not a self-perpetuating mechanism but one which was controlled by the existing dominant order, and it replicated that order by serving its interests. ¹⁰

The themes of exploitation and the alienation of labour are still persistent elements of dystopia. The critic and interdisciplinary artist Coco Fusco has curated art exhibitions on these very themes. Fusco argues that technology has created a new apartheid: women workers from Mesoamerica (geographically the middle of the Americas) and the former eastern bloc make technological commodities which they cannot afford to buy. In performance pieces based on the disappearance of the maquiladora, Fusco's work shows how the commodification of black and Latino women's bodies (via the international sex tourism circuit) is symbiotically related to their status as 'forced labour' on assembly lines in the electronics industries along the US-Mexico border. Moreover, these women make the technology for surveillance equipment that will be used to control and monitor the activities of other workers. There is a counter-culture potential in technology, however: global action with other electronics workers in Korea and the former eastern bloc and Ireland, for instance, is entirely enabled through the use of electronic communications. It is important to register that Fusco's video work is frequently shown on public television, bypassing the museum altogether, in an attempt to gain access to a wider audience. 11

Video art

[V]ideo posed a challenge to the sites of art production in society, to the forms and 'channels' of delivery, and to the passivity of reception built into them. Not only a systemic but also a utopian critique was implicit in video's early use, for the effort was not to enter the system but to transform every aspect of it and – legacy of the revolutionary avant–garde project – to redefine the system out of existence by merging art with social life and making 'audience' and 'producer' interchangeable.

(Rosler 1996: 258–59)

The emergence in the 1960s of a branch of art practice that calls itself 'video art' is not far removed from the utopian spirit of the machine aesthetic seventy or so

years previously. Mediated through the channels of mass media, video art holds out the possibility of a democratic practice in opposition to the perceived elitism of high modernism. 'Media' is a generic term to describe the systems by which information (and entertainment) are transmitted. The Canadian media guru Marshall McLuhan argued that the existence of mass media – in its most ubiquitous forms of television, radio and newspapers – is more significant than the content or message that they transmit: 'The medium is the message.'

As we saw in Chapter 1 the 1960s were marked by social, political and economic upheavals that, broadly speaking, ushered in a period of competing interests. Although video technology undoubtedly developed in the 1960s, the genesis of video art itself gained a fillip from the emergence of countercultures in the 1960s, since video could be pressed into the service of representing 'others'. The use of mass culture and mass media by oppositional groups seemed to offer the chance for 'others' to control their own representation in art and re-present those images to an audience via familiar modes of transmission. The use of popular culture and familiar graphic modes of communication became the common currency of dissent from the 1960s onwards.

Although the media generally replicates the values of the dominant order, oppositional groups engaged with enthusiasm in the battle for custody of control of and access to mass media. Ironically in the case of video art, its appropriation by marginalised groups required a critique of the medium: a critique of technology which argues for a choice of alternative means-ends systems and therefore, for marginal groups, the subversion of the medium by the message. For instance, in the 1960s the American-based Korean artist Nam June Paik's work keyed in to anxieties about the long-term effects of television viewing on the public, in particular that the medium would induce mindless apathy and passivity, or the 'narcotisation' of the viewer. Paik's video art took the view that television has a democratising potential but only if the medium itself is subjected to critical exploration. In this respect, Paik's association with the subversive strategies of Fluxus is evident in his works which make visible the controlling mechanisms of network television. By making explicit the connection between art and politics, Paik's work exposed the fiction of technological neutrality. In this sense it is no coincidence that Paik uses the neo-Dada techniques of collage and décollage since they were recognised tools with which to deconstruct images and reveal concealed agendas. Paik's video collage Good Morning Mr Orwell (1986) was a global satellite project which pieced together and reconfigured internationally recognisable images in a subversive way.

When the majority of people receive their information through television pictures, painting can seem an outmoded site of cultural production, increasingly redundant in an age of electronic reproduction. However, this idea of the redundancy of painting is problematic. Television's innovative potential has never been realised: television, according to Hall and Fifer (1990: 71),

was not the communications medium it claimed to be but, rather, a oneway channel, broadcasting programs that sanctioned limited innovation and whose very means of production were invisible to the home consumer. Television through its management by corporate monopolies or state run systems had become a seamless hegemonic institution. As Martha Rosler observes, early video art was 'not only a systemic but also a utopian critique' (Rosler 1996: 259) because, for the reasons outlined above, its medium was arguably more democratic, bypassing as it did the corporate structures that controlled public television. The cultural optimism of Marshall McLuhan's 'global village' suggested a contraction of the world and the utopian belief that 'global connectivity' would result in democratic communication. Although in theory video art allows a democratisation of the arts, in stark contrast to high modernism's explicit embrace of a self-sufficient practice, in fact video art can be just as esoteric as any abstract painting.

The technological sublime

Mention was made at the start of this chapter of the Italian futurist architect Sant'Elia and of his designs for a utopian city. The scale on which this city was planned was such that, had it been built, its users would have been forced to assume vertiginous vantage points on top of skyscrapers and multi-storey walkways. Not unlike Russolo's intonarumori, Saint'Elia's plans for Città Nuova tested the limits of sensory tolerance. His gigantic cityscapes would have dwarfed their inhabitants, who would have been whizzed up and down by high-speed elevators, surrounded by multi-storey walkways: and cars would have raced around on specially constructed roads. In 1913 Città Nuova pre-empted the technological advances of the twentieth century that have enabled exhilarating physical experiences of the world not previously possible: flying over cities, standing on tall buildings and travelling at great speed. Città Nuova had the potential to simultaneously thrill and terrify its inhabitants – it was technologically sublime, in the sense of the sublime as a mixture of 'pleasure and displeasure, terror and beauty'.

In the twentieth century experiences of the sublime have been extended to include those which have been made possible by technology. The Enlightenment sublime, a mixture of terror and awe, could therefore attain a sort of modernist equivalence in the machine aesthetic's breathtaking leitmotifs of gigantism, speed and noise. However, at the end of the twentieth century the experiences of speed, vertigo and so on, have become every-day features of western capitalist existence so that it is now perhaps difficult to reconstitute the mixture of pleasure and terror which characterised the machine aesthetic's sublime. At the turn of the millennium just what might approximate the sublime is identifiable only through 'indirect communication' – the sublime through simulation rather than direct experience.

Terry Eagleton defines one aspect of the sublime in Enlightenment-like terms as its 'chastening, humiliating power, which decentres the subject into an awesome awareness of its finitude, its own petty position in the universe' (Eagleton 1990: 90). ¹³ In addition to being described in terms of the physical experiences of speed, noise and giganticism, the sublime has been located in matter that is barely perceptible, and then only with the aid of sophisticated equipment. For example, the physicist Stephen Hawking (1988) sees a kind of sublimity in the microcosmic particle system. Similarly, sublimity can be experienced in notional spaces that are 'unrepresentable'.

Figure 5.10 Greyworld, Greyworld's Layer, Greenwich foot tunnel, June 1997. Courtesy of Greyworld

William Gibson coined the phrase 'cyberspace' in his novel *Neuromancer* (1984) which presents a dystopic vision of the future. Cyberspace is a computer-generated virtual environment that, unlike mere technological artefacts, holds out the promise of a capacity to reconstitute every aspect of human existence. A space and yet a non-space, cyberspace is a notional environment of pure digitalised information.¹⁴ Cyberspace also offers the utopian prospect of the body of flesh transcending its corporeality and 'existing' as pure intelligence in a virtual world.

Although the body is clearly present in virtual interaction, since the body is the device through which we interface with the technology – for instance, by means of touch, sight and sound – it offers the conceit of an out-of-body experience. For example, Greyworld, because this group of artists create sound installations using the sound system Koan to make generative art (Figure 5.10). Generative art involves programming a computer to 'generate' – in the sense of 'setting in motion' – its own drawing or sound. In the case of Greyworld's installations, the invisible application of technology, underneath floors or hidden in handrails, is predicated nevertheless on a physical presence in the sense that each bodily encounter generates a different sound.

Virtual reality

VR technology, far from including the body in a virtual environment, actively excludes the physical body, replacing it with a body image. One does not take one's body into VR. One leaves it at the door while the

mind goes wandering, unhindered by a physical body, inhabiting an ethereal virtual body in pristine virtual space, itself a 'pure' Platonic space, free of farts, dirt, and untidy bodily fluids.

(Penny 1995: 62)

Ways of thinking about technology have undergone changes in line with the shift from modernist to postmodernist thinking. For instance, in the 1950s the first generation of computers was widely regarded with modernist enthusiasm as a rational and 'transparent' technology with the capacity to control and arrange complex data into a manageable system of mathematical algorithms. The invention of the 'postmodern computer' with its 'opaque' technology (graphic interface, mouse and double-click icons) in the 1980s separated the user from the mathematical operating systems. This shift from the 'transparent' modern to the 'opaque' postmodern is, according to Sherry Turkle (1995: 20), in keeping with the postmodern notion of the 'opaque' brain. As Lyotard maintains, new technologies tend to be conceptualised as substitutes for 'mental and/or linguistic operations' rather than as substitutes for mechanical operations. The effect of this is to collapse the Cartesian philosophical distinction between mind and matter. As Lyotard puts it, 'maybe the human mind is simply the most complex combination of matter in the universe' (Lyotard 1989: 19–20).

The corporeal world of physical experience has a parallel world in cyberspace which often mimics the Euclidean space of the three-dimensional world and the western idea of the frame and adds to them the computer graphics, animated sequences and audio soundtrack derived from film. Western culture is, after all, oriented towards books, film and televisual display. Representing the world in digital form began with computer interfaces that were almost entirely text-based, but in recent years there has been a change to a more visual interface which resembles either the layered pages of a book or a television screen with a sense of three-dimensional space.

The advent of virtual reality has added another dimension to our interface with the machine – that of virtual interaction. 'Interactivity', in which the user (rather than the viewer) is also author and editor of a multimedia encounter, is unlike television, video and film, in which it is only possible to 'delegate' one's looking. Successful interaction requires both induction into the technological sphere and sustained involvement in real time. Paul Virilio in *The Art of the Motor* (1995) argues against the humanising of the language of technology. Pointing out that phrases such as 'interactive user-friendliness' are far from being just that, Virilio contends that such language use constitutes a metaphor for the enslavement of humans to intelligent machines (Virilio 1995: 135). This is an extreme view but one that indicates nonetheless the way in which language is used to obscure the often insidious relations between people and new technologies (particularly, as Coco Fusco shows, in the workplace).

Virtual reality began as simulated environments for military training exercises; ¹⁶ subsequently, a lucrative spin-off of this technology 'allowed' civilians to enter virtual worlds of combat, game play and sexual conquest. Of course, we have always possessed the capacity to enter into an imaginative world of game play, literature being a significant example; however, virtual reality holds out the emancipatory offer of participatory interaction and, with the aid of a teledildonic suit, *actual* physical

sensation. The ability to put on suits to replicate the sensations of 'real' war or sex or even remote exploration of places as distant as the other side of the world or outer space marks the transition of this technology from the laboratory to the domestic space.

Traditionally there is something passive about viewing but, as we have seen, in virtual interaction the viewer becomes the 'user' or even the author of his of her experience. The current state of actual reality falls short of the promise of virtual reality. Its currency resides in the speculative philosophical debates that surround the possibilities of the technology – such as altered perception and a paradigmatic shift in the status and use of what we call knowledge. The equation of knowledge and power is undermined by the impact of new technologies on what exactly constitutes knowledge, sweeping away centuries of certainties. This is precipitated in part by a crisis of confidence in institutional structures and, in part, because access to and acquisition of 'knowledge' is a relatively fragmented experience devoid of connectivity with traditional historical narratives. In brief, there has been a shift away from traditional forms of disseminating knowledge to electronically retrievable information, rendering obsolete the power structures inherent in educational infrastructures

The digital world of cyberspace can recreate complex natural structures or fashion totally new illusionistic environments. The group TechnoSphere has developed a website where users can design an artificial 'life-form' or 'creature' and send it to live in an online environment (Plate VII). The 'creature' has to be assembled from a set of prescribed shapes and each user makes a hybrid creature which inhabits TechnoSphere, interacts with other creatures and keeps its 'creator' informed of its actions via email. Unlike the high-maintenance tamogotchi (cyberpets) of the mid-1990s, TechnoSphere 'creatures' have an independent existence in which they are at the mercy of other creatures in cyberspace. TechnoSphere is a space which is navigated in one of two ways: the user can 'see' through the 'eyes' of the creature, or the user can assume the vantage-point of a steady cam, moving around or above the creature, flying over the landscape of TechnoSphere. Virtual reality raises some fundamental questions about the relationship of the human body to virtual space, and particularly about its boundaries. We will explore in more detail the implications of new technologies on our perception of the body in Chapter 7, where we will see how, for instance, the creation of digital alter-egos - avatars - has created the possibility of a disembodied experience of self.

The internet provides extensive and, more importantly, interactive ways of storing, displaying, retrieving and linking information and images. But is interactivity really a substantial alteration to the relationship between artist and viewer? The American artist Dan Graham's video installation and performance work *Present Continuous Past(s)* (1974) consists of two video monitors and two cameras which record the viewer in real time (the temporal relationship of the body to real time and time travel is a common contemporary preoccupation). One surveillance monitor is in simultaneous playback mode, but the other monitor has a time-delay transmission which represents an image of the viewer recorded a few seconds previously. In some installations the sequence is simultaneously broadcast through mirrors. Graham's work is principally a critique of capitalism, especially when he sets up these devices in shop-window displays within the gallery space. However, his preoccupations – time-delay, mirror reflections

and the status of the viewing subject as both the producer and the product of works such as *Present Continuous Past(s)* – are also critiques of perception in the postmodern world, where technology has radically altered our sense of time and space.

As Marshall McLuhan observed, human memory is 'set down through fixed chronology. We remember events by memorizing dates' (McLuhan 1989: 170). Computers have supplanted some of the functions of human memory with what has been called the 'conceit of total recall'. However, computers generally employ non-temporal markers: for example we tend to use spatial references for navigation and orientation ('point and click' graphic interfaces). The question of computer time in relation to real time is philosophically problematical. Hyper-reality happens so quickly that it is estimated that one internet year equals at least two and perhaps as many as seven calendar years. The experience of altered perception in relation to time and space that Dan Graham's work articulates is further problematised by the technological construction of a virtual reality. Even though real time is marked in three-second human pulses, the sense of time passing can be quicker or slower: from the dilation and contraction of time in film to the experience of forms of electronic communication, such as email and video-conferencing. As Virilio puts it, 'telecommunications tools, not content to limit extension . . . are also eradicating all duration, any extension of time in the transmission of messages, images' (Virilio 1997: 9).

Mechanthropomorph to cyborg

[T]he machine is us, our processes, an aspect of our embodiment. We can be responsible for machines; *they* do not dominate or threaten us. We are responsible for boundaries; we are they.

(Haraway 1991: 177)

Your species requires a visual reference point.¹⁷

(Zen, Blake's 7)

Until recently everything hand-made has seemed to be under our own authority. However, the seemingly inexorable progress of the technological revolution suggests that technology may be able to evolve for itself. For instance, science fiction has many dystopic images of machines that become sentient; and nowhere is this more prevalent than in our cultural notion of the evolution of the cyborg. Unlike Léger and the artists of the First Machine Age who depersonalised their subject by depicting people as mechanthropomorphs, many recent artists and film-makers have to an extent humanised the computer by attributing to it personality traits and idiosyncracies. The computer is often given a human name, and our interaction with it is interpersonal. Portrayals of computers in popular culture attribute individuality. HAL in 2001: A Space Odyssey is a melancholic 'character' who is even punished for disobedience; Commander Data in Star Trek: The Next Generation is an android with an almost tragic 'desire' to understand the life forms 'he' encounters. Similarly, in Blade Runner two of the central characters do not know whether they are 'real' or androids who have been implanted with fake human memory. In Robocop parts

of the human body are synthesised with a robot, and a battle for control ensues between the human mind and the mechanical body.

The flipside of this is that some postmodernists tend to think of the human body not as a set of genetic sequences but as electronic circuitry. Merce Cunningham's 'digital choreography' of the 1990s creates dances on the computer screen that reverse the relationships between the performer and the machine enacted in the various mechanical ballets of the 1920s, by using dancers to physically enact a computer programme for choreographing dance. The computer normally notates a choreographed piece in order to record every dancer's part for performance at a later date. Cunningham's inversion of this is to create the ballet digitally first, with the dancers then matching the digital aesthetics of the programme.

It is ironic that a cyborg invested with collective human intelligence should still be represented in a recognisably human form. This continual veneration of the body is perversely, at the same time, a denial of the body. As we will see in more detail in Chapter 7 when we examine notions of self and identity, Donna Haraway's 'Manifesto for Cyborgs' of 1985 (see Haraway 1991) uses the cyborg as a metaphor for a decentred or postmodern sense of self. She argues that the cyborg is a model which has the potential to cast off western notions of individuality and dominant notions of selfhood (in stark contrast to Paul Virilio's negative analysis).

Synthetic life forms have been used as a potent metaphor for lost histories. If cyberspace is the final frontier then, like video art thirty years ago, it has the potential to be a virtual democracy where cultural differences become invisible. However, the homogenising tendencies of electronic production have militated against such difference. Keith Piper's Robot Bodies of 1998 (Plate VIII) explores the metaphorical relationship between the image of the robot in science fiction and the history of black people in popular culture. Pointing out that the robot Sojourner Truth sent to Mars in 1997 was named after a black slave, Piper critiques notions of a culturally diverse future for artifical life forms and simultaneously recovers the history of black peoples. Piper's use of digital technology is significant. As a multi-media artist and a black artist working in Britain, Piper makes explicit connections between notions of cultural displacement and new technologies that are non-linear, intertextual and multi-faceted.¹⁸ Technology does, however, have the potential to be instrumental in forging national identity, as nationals - the Kurds, for example who have been historically dispersed can be 'reassembled' and united through digital technology, for instance via digital television networks.¹⁹

Technoculture

I think lust motivates technology. The first personal robots, let's face it, are not going to be bought to bring people drinks.

(Mike Saenz, in Jones 1995: 48)

Modernism's engagement with the machine has been undeniably gendered. While women surrealists were granted custody of, and implicated in, a close relationship with nature, women did not possess the machine. As we have seen, the language of the machine was industrial and the metaphors for the machine aesthetic were

often masculine. However, in recent years women have acquired more than a walk-on part in both the technological industries and the imagery of technology. As Coco Fusco reveals, women workers are the ideal workforce in the electronic industries since their smaller hands are more adept at manipulating microparts. Correspondingly, images of women figure increasingly in technoculture. For instance, the animated character Lara Croft from the best-selling computer game *Tomb Raider* is an 'Indiana Jane' character who battles her way through increasingly challenging combative levels. On one level, Lara Croft can be seen as an emancipated heroine and on another as a gross stereotype – a cyberspace pin-up with improbable vital statistics.

As the boundaries between biology and technology are arguably dissolving, so the relationships between humans become unstable. The prospect of artificial intelligence and life online has contributed to a radical shift in interpersonal relations. For instance, email communication involves a different set of social interactions which abandon the conventions of formal and informal letter writing. Cybersex electronic intimacy with virtual pin-ups or other consenting (online) individuals - is another area in which technology allows a new dimension to human relationships. As we have seen, the interaction between humans and machines remains problematic, but some critics argue that this is a predominantly male problem and that women may well profit from the shift in power relations brought about by new technologies. The cyberfeminist Donna Haraway, for example, states that she 'would rather be a cyborg than a goddess', and Sadie Plant offers the thought that 'machines and women have at least one thing in common: they are not men' (Plant 1993: 13), maintaining that, in essence, 'woman' is a virtual reality because she plays 'other' to men in a patriarchal society. Both are optimistic, seeing the emancipatory potential of technocultures for women. Conducting our operations through a tactile world of touch-face interscreens amid dispersed networks of information (an early feminist strategy) circumnavigating patriarchal modes of expression altogether.

Notes

- 1 The inability of the Museum of Modern Art in New York to display sound art, theatre or costume design is legendary. The history of art, it has been observed, is often the history of what is on display in museums and art galleries.
- 2 Severini and Picasso for example had 'classical periods' in the 1920s. Picasso's ability to work simultaneously in different styles, including monumental classical figures, helped him to hang on to his radical credentials in a period of conservatism.
- 3 Henry Ford moved his operations to the Rogue River site near Detroit in 1927. Sheeler's photographs were commissioned as part of a much wider publicity campaign to re-launch Ford Motors and to overwhelm the opposition from General Motors.
- 4 He was probably poking fun at artists such as Kasimir Malevich. Tatlin and Malevich were famously at odds in the early years of the Russian avant-garde. Tatlin thought of himself as a technician or 'inventor' and Malevich believed himself to be a mystical 'creator'.
- 5 'A Letter to Emil Bernard' (1906), in Chipp 1968: 21.
- 6 Weimar was the town in Germany which gave its name to the Weimar Period (1917–33), the period of Republican government that ended when Hitler became Chancellor.
- Figure 2 Especially with the mystic Johannes Itten. Itten was replaced by the Hungarian constructivist László Moholy-Nagy as master of the foundation course.

8 The division of the avant-garde into two, introduced in Chapter 1, is in evidence here at the time of the Russian Revolution. There has been a tendency among historians in the west to see this period in the history of the Russian avant-garde in terms of Cold War politics: that is, to see the revolutionary enthusiasm of these artists as politically naive. Their anti-bourgeois imperative to defy the Romantic individuality of early modernism and to work in the mode of mass production conjured up the spectre of artists as political pawns.

Things to Come was directed by William Cameron Menzies, with sets (by Vincent Korda) inspired by Le Corbusier's cities, Oliver Hill's transparent furniture, Norman Bel Geddes and Raymond Loewy's streamform designs. The effects were conceived by Moholy-Nagy (although it seems that these were not used in the finished film

release).

The technological imperative has been questioned by Victor Papanek whose book Design for the Real World criticised accident-prone automobiles, injury-inflicting domestic items and the 'Kleenex culture' of disposability (Papanek 1977: 77ff.).

11 Fusco's publications include English Is Broken Here (1995); her performances include Better Yet When Dead (1998); and her videos include Havana Postmodern — The New Cuban Art and Pochonovela.

Martha Rosler is suspicious of McLuhan's soundbite effects on early video art: 'the idea of simultaneity and a return to an Eden of sensory immediacy gave hippies and critics of the alienated and repressed one-dimensionality of industrial society a rosy, psychedelic, wet dream' (Rosler 1996: 274).

- However, the 'postmodern sublime' is understood in relation to critiques of the aesthetic. Whereas beauty in a given work of art is apprehended via the form that the work of art assumes, the sublime is generally formless or 'unpresentable' (Lyotard 1982). For Lyotard, the sublime is simply 'the unpresentable' so this can include 'ideas' as well as experiences: 'nobody has ever seen a society. Nobody has ever seen a beginning. An end. Nobody has ever seen a world' (Lyotard 1989: 23). Lyotard argues that it is our powerlessness to represent such things that is sublime.
- 14 According to Michael Benedikt, cyberspace 'does not exist' (1991: 3).
- 15 At time of writing one company is anticipating the production of cybersmells.
- The ultimate is 'virtual warfare', as Paul Virilio has remarked. The Gulf War (1991–92) was in two respects the first electronic war: at both the level of arms' production and the transmission of the war via live satellite link-ups.
- 17 Blake's 7, Episode 3: 'Cygnus Alpha Time Squad', by Terry Nation.
- 18 Keith Piper was a member of Digital Diaspora, an organisation which saw a connection between new technology and culturally diverse notions of identity.
- 19 John Byrne (1999) 'Cybersublime: Representing the Unrepresentable in Digital Art and Politics', *Third Text*, 47, summer 1999.

AMERICAN ART AT MID-CENTURY

The history of avant-garde painting is that of a progressive surrender to the resistance of its medium; which resistance consists chiefly in the flat picture plane's denial of efforts to 'hole through' it for realistic perspective space.

(Clement Greenberg)

It is ironic but not contradictory that in a society politically stuck in a position to the right of centre, in which political repression weighed as heavily as it did in the United States, abstract expressionism was for many the expression of freedom: the freedom to create controversial works of art, the freedom symbolized by action painting, by the unbridled expressionism of artists completely without fetters.

(Serge Guilbaut)

In 1953 THE AMERICAN ARTIST Robert Rauschenberg, best known for his mixed media 'combines' (art works that combined diverse media and techniques), asked Willem de Kooning for a drawing that he could obliterate. Rauschenberg's Erased de Kooning Drawing (Figure 6.1), perhaps a homage by a young and relatively unknown artist to a major figure in American art, was an ambiguous gesture. The act of creation-through-destruction can be seen as both a tribute and a dismissal, at once metaphorical and literal. The erasure of an abstract expressionist work, existing now only in memory and the fine indentations on the blank paper, was perhaps a forerunner of the conceptual work (simplistically put, an art of ideas, not necessarily of outcomes) that came to dominate the American scene by the 1960s. The act of erasure was also a gesture that radically critiqued the modernist trope of self-expression — an ironic commentary on the residual Romanticism that dominated abstraction. The erasure of abstract expressionism and the questioning of authorship, creativity and originality that found their apotheosis in 'pure' abstraction have been major preoccupations of contemporary artists since

Plate I Natalia Goncharova, Linen, 1913. © Tate Gallery, London. © ADAGP, Paris and DACS, London 1999

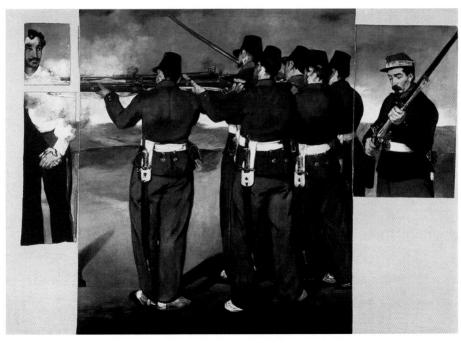

Plate II Edouard Manet, The Execution of Maximilian III, 1868–69. Courtesy of the National Gallery, London

Plate III Horst Hoheisel, 'Negative Form' Monument to the Aschrott-Brunnen, Kassel, 1987. Photo: Authors. © Pam Meecham 1999

Plate IV Claes Oldenburg, Lipstick Ascending on Caterpillar Tracks, 1969, Yale University Art Gallery. Gift of Colossal Keepsake Corporation

Richard Pousette-Dart, Symphony No. 1, The Transcendental, 1941–42. The Metropolitan Museum of Art, New York, Purchase, Lila Acheson Wallace Gift, 1996. Photo: © 1996 The Metropolitan Museum of Art

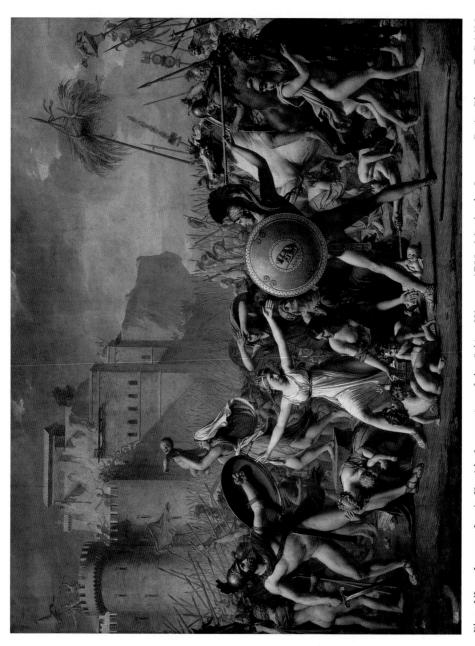

Jacques-Louis David, *Intervention of the Sabine Women*, 1799, Musée du Louvre, Paris. Photo: © RMN – Jean Arnaudet Plate VI

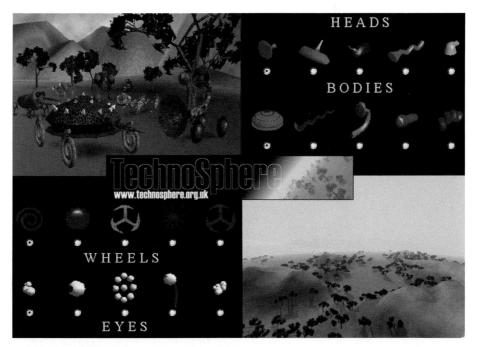

Plate VII Courtesy of TechnoSphere

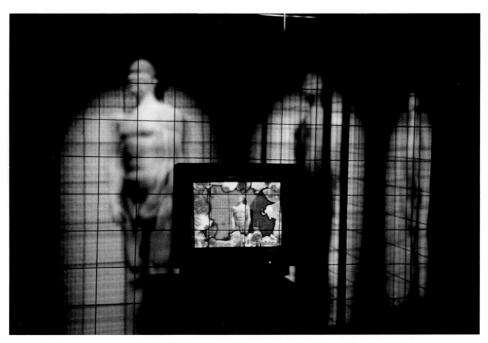

Plate VIII Keith Piper, Robot Bodies, 1998. Installation at Bluecoat Gallery, Liverpool. © Foundation for Art and Creative Technology. Courtesy of FACT

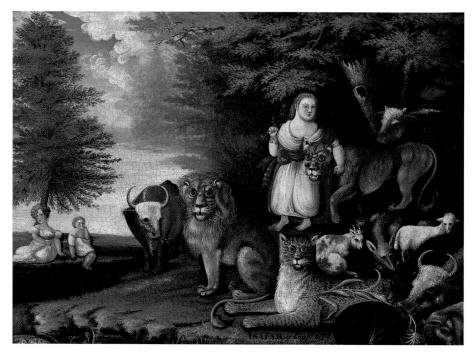

Plate IX Edward Hicks, The Peaceable Kingdom, c.1840. The Metropolitan Museum of Art, New York. Gift of Edgar William and Bernice Chrysler Garbisch, 1970

Plate X Ben Shahn, A Score of White Pigeons, 1960. Photo: © Moderna Museum, Stockholm/ DACS. © Estate of Ben Shahn/VAGA, New York/ DACS, London 1999

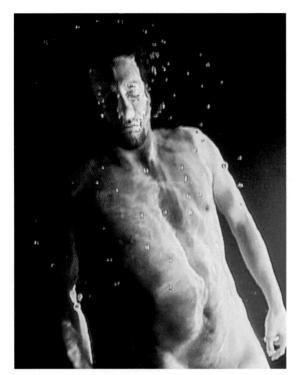

Plate XI Bill Viola, The Messenger, 1996. Courtesy of the Artist.

Plate XII Yinka Shonibare, How Does a Girl Like You Get to Be a Girl Like You?, 1995. Courtesy of the Stephen Friedman Gallery, London, and the Artist

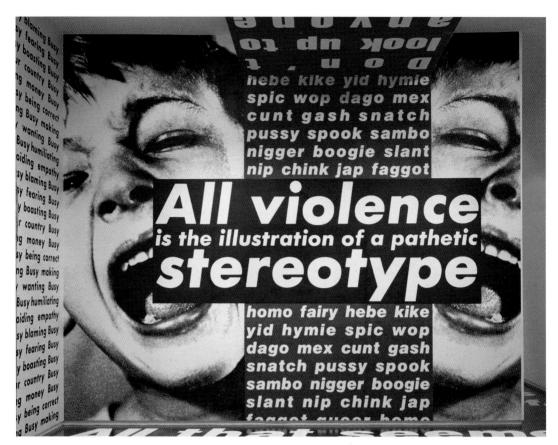

Plate XIII Barbara Kruger, 'Untitled' (All Violence is the Illustration of a Pathetic Stereotype), 1991. Courtesy of Mary Boone Gallery, New York

Plate XIV Johan Grimonprez, Dial H–I–S–T–O–R–Y, 1995–97. Courtesy of Incident vzw. Photo: Rony Visser

Figure 6.1 Robert Rauschenberg, Erased de Kooning Drawing, 1953. Courtesy of Leo Castelli Gallery, New York. Photo: © Robert Rauschenberg/VAGA, New York/DACS, London 1999

the 1950s. The assaults on the nature of subjectivity and the myth of the artist are, however, often replaced by another layer of myth. It is not, perhaps, until the 'unmediated' 1980s and 1990s' interventions of Sherrie Levine – who re-presents photographs by 'modern masters' such as Edward Weston either without changing them or by merely presenting a negative to emphasise the technological processes involved in creation – that authorship, particularly in its most masculine manifestation, and the myths of creativity are laid bare. However, Rauschenberg's act is important in establishing the necessity of acknowledging the importance of usurping the claims of abstract expressionism.

Rauschenberg's work would, in turn, become the subject both of homage and enigmatic appropriation by the pop artist, Andy Warhol. Pop art of the 1960s traded-in the unique signature style of abstract expressionism for an unabashed impersonal and reproducible collaborative and commercial art. By using commercial techniques like silk-screen printing and drawing on imagery from advertising and by paying scant attention to 'finish', the artistic 'purity' of abstract expressionism's serious endeavour was mocked. However, Warhol's anti-signature style, the evasion of individuality in artistic practices, becomes in turn its own 'unique' style label.

Referencing, indexing and artistic 'incest', are, of course, nothing new in art production. As we saw in Chapter 1 Manet had referenced 'old masters' in his paintings, but Manet had not been critiquing the nature of the artistic process. He, as the author of the work, is still very much in evidence. But Rauschenberg and more latterly Levine were making an entirely different point, and their works can be seen as examples of palimpsest. Palimpsest, the removal of the original to make way for another, is historically a reference to parchment on which text is written over previous text. Palimpsest is a metaphor commonly used by deconstructionists, particularly Jacques Derrida. Deconstruction is not just a reversal of strategies or a neutralisation of binary opposites: it is a process of displacement. Deconstruction is a strategy for reading texts and images which 'attempts to make the not-seen accessible to sight' (Derrida 1976: 163).

The erasure of the de Kooning, emblematic of American abstract expressionism, came at a complex moment in American art history. The reworking of another artist's work – by appropriation or erasure – has been identified as a postmodern preoccupation. It was not just a way of finding a new style, although in the search for novelty that underpins the art market this undoubtedly played a part: it was symptomatic of a 'crisis of confidence' both in the centrality of the artist and in the unique act of creativity.

Abstract expressionism is commonly identified as the pinnacle of modernism. It stands at the pinnacle of notions of individual self-expression and artistic freedom. However, a closer scrutiny of the movement within its historical context, reveals a raft of major issues, not the least of which was the transition of the avant-garde from adversarial culture to a petrified modernism. The erasure of a work by de Kooning, when seen within the broader political and social world of post-war USA, is symptomatic of a crisis of confidence in the institutional success of an oppositional culture. Far from hanging on to its radical credentials, abstract expressionism was seen by many to have sedimented into mainstream orthodoxy. Just how the avant-garde came to renege on its radical promise is part of a broader story of exclusions and preoccupations in the USA in the 1950s.

Depression America

In order to unpack the received wisdom of American art which identifies abstract expressionism as the only significant art in America in the late 1940s and 1950s, it is necessary to recover the marginalised history of the 1930s. According to this tradition, American art achieves 'global' importance at mid-century, after the abandonment of America's pre-war isolationism and a denial of the relevance of the social art of the 1930s. Typically, 1930s' art works were not placed exclusively in the art gallery or museum but were commissioned for public places – post offices, schools, hospitals and airports, although the 'Easel Section' based in New York employed many artists to work in the more traditional art practices.

The public art projects, exemplified by images such as *Negro Art Class*, usually *celebrated* America in all its racial and cultural diversity under the slogan 'difference without antagonism'. The crisis in monopoly capitalism following the Wall Street Crash of 1929 had been ameliorated by Roosevelt's New Deal administration. Funding

for public works, including community-based arts projects, went some way towards alleviating mass unemployment. The public works' projects placed the artist back in the community, making works that often related to the experiences of 'ordinary' Americans. From 'proletarian fiction' to the ballets of Martha Graham – for example, 'We Are Three Million Women', a dance within *American Document* (1938) – to the documentary photography of the Farm Security Administration, and films such as Pare Lorenz's *The Plow that Broke the Plains*, art celebrated the 'common man'. However, the 1940s saw the premature closure of publicly funded arts projects, principally the Federal Arts Project (FAP) (1935–43) and Works' Progress Administration (WPA). The resurgent economics of war did alleviate the need for uplifting *American* art works, but the rejection of the projects was ideological in character.

Maurice Dickstein has remarked on the myths and legends that encompassed the 1930s – a period which still occupies an almost polarised position in the American consciousness. Although it is a 'byword for economic crisis . . . and represents to the resurgent right the beginning of the hated welfare state' it was a period of 'remarkable political excitement and cultural buoyancy intimately connected with the social stress of the times' (1996: 65). The article documents the nature of cultural practices that stressed the gritty realism of the period, thrown into relief by the comedy and lightness of the all-singing-all-dancing musicals, Hollywood films and pulp fiction, where the Depression was rarely directly tackled. Dickstein, reminiscing on his 1950s' experiences as an aspiring writer at college, wrote;

it appeared to us in the hazy distance as a golden age when writers, artists and intellectuals developed strong political commitments and enlisted literature on the side of the poor and destitute . . . we hated the blandness and repressive limits of the political culture of the fifties, and looked back wistfully at the excited ideological climate of the thirties, about which we knew next to nothing (ibid.: 69).

Many artists in the 1930s followed an overtly political agenda. The captioned photographs used to document the American Depression, for example the work of Margaret Bourke-White, were intended to evade formal readings, subverting a purely aesthetic response in order to encourage a political-social reading.² The caption for Bourke-White's photograph You Have Seen Their Faces? reads: 'A man learns not to expect much after he has farmed cotton most of his life'. Martha Graham's work in the 1930s is similarly apposite because it is customary to read Graham's dance in formal terms and to acknowledge her preference for mythic subject matter over political relevance. She is remembered largely for her pioneering 'dancing modernism', a corollary to abstract expressionism. However, Graham's work in the 1930s had an overt political-social basis. American Document (1938) and Frontier: An American Perspective on the Plains (1935) were considered testaments to American democracy threatened by the collapse of the US economy. Unlike any of her later works, in the ballet American Document Graham used the spoken word to control meaning: the 'silence' of traditional ballet was broken in order to underscore a political reading.

The rejection of the kind of art works produced by the New Deal programmes was linked also to the rejection both of the period's social basis for art practices and

of its reconfiguring of the artist as citizen. The archetypal New Deal art work can be seen in Lucienne Bloch's 1936 Cycle of a Woman's Life, a mural painted for the recreation room of a women's house of detention in New York City. In an interview entitled 'Murals for Use' Bloch commented: 'As for the matrons, outside of the fact that their concept of an artist was shattered when they saw me work without a smock and without inspired fits, they were delighted to witness a creation of a 'genuine hand-painted picture' (quoted in O'Connor 1975: 77). The reasons for the shift away from this view of the artist–citizen can be traced to post–war values, both monetary and political, and to the increasing dominance of a formalist aesthetic, although any easy correlation between the economic and political and contemporary cultural production would be dangerously reductive.

It is important to recognise that although modern art practice moved into a new phase or style deemed more appropriate for a post-war world, the rigid divisions between the 1930s and the 1950s have been critically endorsed by modernist historians. For them this change required a rejection of previously held social and political commitments. There were many continuities that have been repressed in favour of the emphasis of 1950s' triumphalism. In her influential book *American Art since* 1900, Barbara Rose declared:

[T]he WPA is a unique but crucial chapter in American art. This is so despite the fact that, outside of a few sketches or reconstructions, such as Gorky's Newark airport mural or de Kooning's sketch for the Williamsberg housing project, the WPA programs produced almost no art of any consequence that has survived.

(Rose 1975: 126)

No art of any consequence is a denial of the diversity of practice supported by the left in the 1930s. Jonathan Harris's work on the American Artists' Congress, an independent collective of artists and writers during the 1930s, supports the view that there was no single aesthetic, no cohesion of styles: the common agenda was broadly political, not asethetic.³ By the early 1940s the Federal Arts Project increasingly came under attack. The project was defended, however, by MoMA, particularly by its curator A. Conger Goodyear and the director Alfred H. Barr Jr, who said he was 'greatly encouraged by the quality of the WPA and believed that it would be a serious blow to American culture if it were to be discontinued'. There was still in the 1940s a positive idea of eclecticism rather than a monolithic programme of correctness.

However, the artists Rose does cite approvingly from this period are those who were to become major figures in abstract expressionism in spite of their 1930s' output. Pre-war American painting, characteristically categorised as regionalist and right-wing, or as involved in social protest and essentially left-wing, is usually relegated to a footnote in history; a *cul-de-sac* on the way to the real business of art – the 'pure' painting of the 1950s. Art from the 1930s, such as the English artist Edward Burra's *Harlem* (Figure 6.2), receives little academic or critical acclaim, beyond this 'roots' approach to abstract expressionism. The *esprit de corps* generated by Roosevelt's New Deal programmes for unemployed artists during the Depression years are usually credited in terms only of their contribution to the homogeneity of so disparate a group as the abstract expressionists.

Figure 6.2 Edward Burra, Harlem, 1934. Photo: © 1999 Tate Gallery, London and Lefevre Gallery

In attempting to disclaim their artistic roots in the political radicalism of the 1930s, many artists and critics have diminished the artistic experimentation – particularly that learned from the revolutionary Mexicans José Clemente Orozco (1883–1949), David A. Siqueiros (1896–1974) and Diego Rivera (1886–1957) – in favour of a representation of 1930s' art works as 'murals of men in dungarees'. The debt of the 1950s to 1930s is reduced to one of the abstract expressionists copying the monumental scale of Mexican mural painting (see Figure 5.6). This is perceived as the *legitimate* legacy of the modernism of the Mexicans to abstract expressionism. As for their ideological bequest – their Marxist politics or their insistence on a socially relevant art – debates at the American Artists' Congress demonstrate just how indebted the latter were to the theoretical and political position of the Mexicans.⁴

Modern American art *appears*, therefore, to have started in the mid-1940s, although there is plenty of evidence of a vibrant modern movement in existence well before the 1930s. Early American modernists like Arthur Dove were producing abstract works like *Clouds and Water* (Figure 6.3), some work as early as 1910 when Dove produced a series of paintings called *Abstractions*. The precisionists, particularly Charles Sheeler and Charles Demuth (Figure 6.4), as we saw in Chapter 5, were producing works that bore the hallmarks of modernism. Moreover, the Armory Show, held in New York in 1913, consisted of 1,500 European and American

Figure 6.3 Arthur Dove, Clouds and Water, 1930. Metropolitan Museum of Art, New York, Alfred Stieglitz Collection, 1949

modern art works. Interestingly the exhibits were largely from Parisian art movements, and excluded examples of German expressionism and Italian futurism – a prefiguring, perhaps, of the francophile tendency of American modernism. The Stieglitz School, clustered around the Photo-Session Gallery and later 291 Gallery in New York, and the associated publication *Camera Work*, promoted European modernism and American modernist artists like Georgia O'Keefe.

Mexico

It is part of the legacy of the 1950s and 1960s that the myth of modernism centred on Paris and then migrated to New York. This myth has persistently mitigated against a recognition of other centres of cultural activity. Many American and European artists had strong links with Mexican revolutionary cultures both at the level of the political and the aesthetic represented here by Tina Modotti's 1928 Woman Carrying a Flag, Mexico (Figure 6.5) and Stuart Davis's New Mexican Landscape⁵ (Figure 6.6). Mexico and the expansion westwards to places 'unmarked' by European culture played a more important role in artistic production than art history's emphasis on east-coast avante-gardism would suggest.

The Mexican Revolution of 1910 like the Russian Revolution of 1917 saw artists mobilised in the service of a revolutionary culture, resulting in an overtly politicised art. In an address to the American Artists' Congress in the 1930s, David Siqueiros, drawing on the experience of the League of Revolutionary Artists and

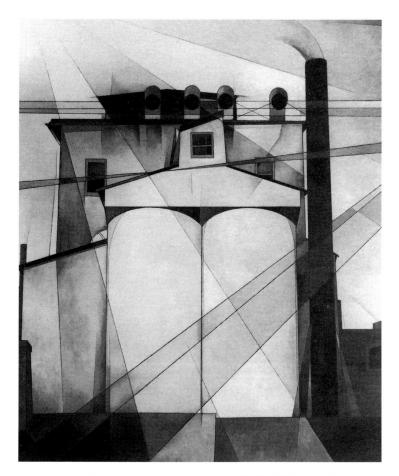

Figure 6.4 Charles Demuth, My Egypt, 1927. Whitney Museum of American Art, New York

Writers in Mexico, argued that revolutionary art should be accessible to the greatest number of people. Similarly, writing in *Modern Art Quarterly* (1932), Diego Rivera argued in an article entitled 'The Revolutionary Spirit in Modern Art', that all art was propaganda and that even apolitical art, that is 'art for art's sake' or 'pure' art, had 'enormous political content'. He continued:

[A]ll painters have been propagandists or else they have not been painters. Giotto was a propagandist of the spirit of Christian charity, the weapon of the Franciscan monks of his time against feudal oppression. Bruegel was a propagandist of the struggle of the Dutch artisan petty bourgeois against feudal oppression. Every artist who has been worth anything in art has been such a propagandist.

(Quoted in Frascina 1992: 407)

The revolutionary ferment profited from the arrival of the Russian revolutionary Leon Trotsky, expelled from the USSR in 1929 by Joseph Stalin for criticising the

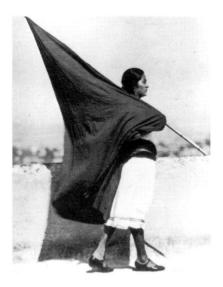

Figure 6.5 Tina Modotti, Woman Carrying a Flag, Mexico, 1928. Courtesy of Galerie Bilderwelt

doctrine of 'socialism in one country' and the Comintern's policies, particularly on fascism. In Mexico, Trotsky continued to attack what he saw as a false claim by Marxism to provide a 'universal system'. Trotsky held to a belief in the non-rational side of politics. It was not surprising, therefore, that in 1938 he should publish in the American Marxist publication *Partisan Review* with the surrealist André Breton, 'who shared Trotsky's commitment to the irrational. Their resulting collaboration, 'Manifesto: Towards a Free Revolutionary Art', written in anticipation of the Second World War, in essence repeats the call for a combination of politics and art while acknowledging art's own internal laws. They wrote:

[I]n defending freedom of thought we have no intention of justifying political indifference, and . . . it is far from our wish to revive a so-called 'pure' art which generally serves the extremely impure ends of reaction. No, our conception of the role of art is too high to refuse it an influence on the fate of society. We believe that the supreme task of art in our epoch is to take part actively and consciously in the preparation of the revolution.

The manifesto maintains that the artist was not to imitate the model of socialist realism (see the discussion of monuments in Chapter 2). For the revolutionaries Trotsky, Rivera and Breton, 'the artist cannot serve the struggle for freedom unless he *subjectively* assimilates its social content, unless he feels in his very nerves its meaning and drama and freely seeks to give his own inner world incarnation in his art' (Trotsky quoted in Harrison and Wood 1992: 528; emphasis added). There is the by-now familiar ring of 'art for art's sake' being part of a bourgeois conspiracy. Rivera would have found little solace in Roger Fry's creed 'Art, then, is an expression and a stimulus of this imaginative life, which is separated from actual life by the absence of responsive action' (Fry 1961: 26). Rivera would have found more

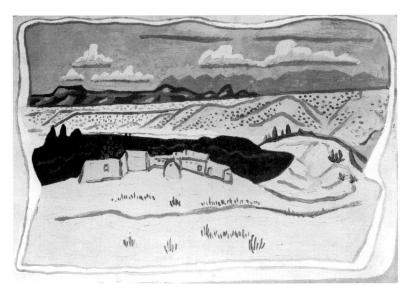

Figure 6.6 Stuart Davis, New Mexican Landscape, 1923. Whitney Museum of American Art, New York. Photo: © Estate of Stuart Davies/VAGA, New York/DACS, London 1999

consolation, perhaps, in Greenberg's Marxist-inspired writing of the 1930s. However, an engagement with the social for the Mexicans did not necessarily result in the kitsch, in the sense of bad taste, that Greenberg was anxious to avoid. In 'Avant-Garde and Kitsch' the issue for Greenberg was how easily art with 'content' could become a tool of propaganda. He advocated a complete withdrawal from the world to save art from the kitsch culture of capitalist economics, which he characterised as one of 'vicarious experience and faked sensation' (1985: 25). It is perhaps worth noting how far the parameters of the language of purism have changed: 'vicarious experience and faked sensation', as we will see, seems to be exactly the point in late twentieth-century culture.

To recap: these debates were part of the intellectual climate of many artists who subsequently changed their art practice from one of social engagement to one of apparent social disengagement within, during and after the Second World War. The revolutionary potential seen in the unconscious and irrational realism of surrealism and the Mexican muralists was marginalised, leaving Jackson Pollock's work dependent upon the surrealist practice of automatism and mural-painting scale. His early realist works like *Cody Wyoming* (1934–38) are not considered anything other than a rehearsal for his mature signature-style work.

The revolutionary alliance of surrealism and Marxist politics is not without its basic contradictions, and was no guarantee of an artistic high ground. There was a basic discrepancy between the revolutionary tenets of Marxism and surrealism. Breton was aware that the surrealist view of the unconscious as a means of tapping the artist's individual centre of creativity collided with the Marxist, particularly the Trotskyite, use of art as a political weapon. Reconciliation between the polarised positions of Marxism and modernism seems unlikely.

Revisionism

Writing about American abstract expressionism altered radically in the 1970s and 1980s, with widely disseminated essays such as Max Kozloff's 'American Painting during the Cold War', William Hauptman's 'The Suppression of Art in the McCarthy Decade' and Eva Cockcroft's 'Abstract Expressionism: Weapon of the Cold War' all appearing in Art Forum between May 1973 and October 1974, together with Serge Guilbaut's 'The New Adventures of the Avant-Garde in America' and David and Cecile Shapiro's 'Abstract Expressionism: The Politics of Apolitical Painting' from the 1980s (all reproduced in Frascina (ed.) (1985), except for Hauptman). The titles of these essays indicate that the terms in which historians were writing about abstract expressionism had refocused art history. These were not essays dealing with the Formalist concerns of an earlier generation: they were accounts of how abstract expressionism rose to prominence beyond the particular merits of the work itself. Serge Guilbaut's book How New York Stole the Idea of Modern Art: Abstract Expressionism, Freedom and the Cold War published in 1983 consolidated these positions by accounting for abstract expressionism's institutional promotion as predicated on a reading of the works as apolitical.

Although there are areas of significant difference between them, the essentially revisionist line dictates that abstract expressionism was not a hermetic practice that gained critical acceptance because of the formal innovations of its radical techniques. Critical historians argued that the hegemonic status of abstract expressionism was achieved because the liberal intelligensia — usually spearheaded by MoMA, and covertly funded by the Central Intelligence Agency (CIA) — promoted it during the Cold War as representative of an art devoid of political content and an expression of American individuality and freedom. The collapse of an adversarial modernism into a liberal culture was predicated on a binary division between the hostile camps of the avant–garde and mass culture. Some revisionists laid the blame for the collapse of art's perceived autonomy at the door of abstract expressionist artists, who they saw as willing conscripts into Cold War politics and collaborators with capitalist and imperialist agencies like MoMA. The 'critical distance' that was necessary for revolutionary action could not take place inside the whitewashed walls of MoMA, which, along with chic apartments, seemed to be abstract expressionism's natural habitat.

The revisionists of the 1970s and 1980s regarded the conditions of production as crucial to the explanation and interpretation of art works. Revisionists attempted to explain the shift from the left-wing 1930s practice dominated by social realism to a position in the 1950s that seemed to capitulate to market forces. The revisionists, in attempting to account for the de-Marxification of the American intelligensia and a move to a liberal-democratic position, confronted not only the art but also the political complexity of post-war America.

The USA in the 1950s

The USA in the mid-1950s was a potent cocktail of power and paranoia, fuelled by fears of Communist infiltration of the body politic. Nuclear testing, the Korean War (1950–53) and the McCarthy 'witch hunts' against alleged Communist sympa-

thisers were compromising the rhetoric of freedom expounded in the Truman Doctrine.⁷ The American Depression of the 1930s, and a utopian view of social changes in the USSR after the Bolshevik Revolution in 1917, had resulted in a commitment by many Americans to left-wing politics. This was not sustained, however, and by the late 1930s the left began a retreat from which it has never fully recovered. The loss of confidence in left-wing politics was aggravated by the Nazi-Soviet Non-Aggression Pact of 1939, the Soviet invasion of Finland and the failure of the Popular Front Against Fascism.⁸

The diminution of the left accelerated during the political hysteria of the early 1950s when Senator Joseph McCarthy began a campaign that resulted in the removal from public office and prominent places of persons implicated in Communism. Intimidated by newspaper headlines like 'Einstein Red Faker Should Be Deported, Rep. Rankin Screams', blacklisting and senate investigations, suspected Communists such as Hollywood stars Charlie Chaplin and Paul Robeson fell from grace. The de-Marxification of the intelligentsia gained momentum in the period of de-Stalinisation in the Soviet Union in the mid-1950s under Nikita Khrushchev, following Stalin's death in 1953 and the Russian invasion of Hungary in 1956. The subsequent crisis in the Soviet system, compounded by the Moscow show trials, exposed the dystopic methods of utopian Communism.

We have seen in previous chapters how the abandoning of earlier art forms was an essential part of the process of avant-gardism, usually involving a rejection of bourgeois norms or traditional art practices. American modernism appears to be based on a very different premiss. Although ostensibly a continuation of the rejection of mimetic illusionistic devices that began in the late 1800s, American modernism is also related to a rejection of European modernism in favour of an 'authentic' expression of American values.

Accounting for abstraction

We knew something about Art but we didn't know what we liked. (John Ferren, in Chipp 1968: 573)

We have already seen that art which gains prominence in any given culture does so through a selection process that is culturally determined rather than on the basis on any innate value of the work itself (even though it has been a productive fiction to present art works as representative of eternal verities). The dominance of abstract expressionism has been buttressed by an impressive degree of partisanship and an illusion of consensus. The principal advocates of the works, however, often present irreconcilable differences in both interpretation and methods of advocacy.

The term 'abstract expressionist' came into common usage in 1946 with additional terms like 'action painting' or 'American type painting' or just the 'New York School'. Conventionally, American abstract expressionism has its roots in European modernism through its use of the language of the sublime, the transcendental and the revelatory. However, American art had its artistic abstract precedence in the work of the nineteenth-century American symbolist Albert Pinkham Ryder (1847–1917). Frederic Fairchild Sherman says of Ryder's seascapes:

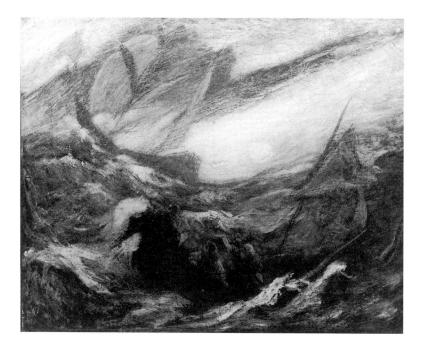

Figure 6.7 Albert P. Ryder, Flying Dutchman, 1887. Courtesy of the National Museum of American Art, Smithsonian Institution. Gift of John Gellatly

obviously unreal in themselves, they embody the very reality of the tragedy of the sea, and by appealing to the *imagination* rather than the *intellect* release subconscious presentiments of indescribable verisimilitude that are no more truthful mental images of remembered scenes than the paintings themselves are faithful transcripts of nature.

(Sherman 1963: 82; emphasis added)

Ryder is an important reference point. He was considered important enough to be included in the 'Armory Show' of 1913. Moreover, paintings such as Ryder's Flying Dutchman (Figure 6.7), certainly influenced Pollock, who claimed in 1944 that Ryder was the only American 'master' who interested him. According to Naifeh and Whitesmith, Pollock's early tutor and mentor Thomas Hart Benton, the American scene and region painter, introduced an 'incompetent' Pollock to the work of Ryder, maintaining that Ryder was an example of someone who 'couldn't draw the boat as finely as contemporaries like Winslow Homer, but could capture in his turbulent brush strokes its pitch and roll on a roiling sea' (Naifeh and Whitesmith 1989: 184). Ryder said of his own work: 'the artist should fear to become the slave to detail. He should strive to express his thoughts and not the surface of it. What avails a storm-cloud accurate in form and detail if the storm is not therein?' (quoted in Baur 1976: 100). It is important to note that Ryder's ideas were highly conditioned by eighteenth- and nineteenth-century Romanticism; and, crucially, it was this aspect of Ryder's work that the young Pollock assimilated. Of course, Pollock's historicism can be misleading, particularly when it implies that art can be ahead of its time.

However, the influence of Ryder's thinking and work finds a resonance in Pollock's and other artists' work, suggesting an older and distinctly American pedigree for abstract expressionism.

The national myth of origin

The urge to define that which is American, according to Lloyd Goodrich, director of the Whitney Museum of American Art, writing in 1958, was the result of a 'search for a self-image . . . a result of our relative youth as a civilization, our years of partial dependence on Europe' (Goodrich 1967: 7). It is this complex relationship to the past that singles out the art of America from the confidence of the French modernist model. Ostensibly Paris-based, French modernism was marked by a form of internationalism: it was essentially the art of the émigré or the cosmopolitan. Although it can be argued that New York is the ultimate city of émigrés and therefore the rightful heir to European modernism, America's notion of itself is problematic. The official self-image of a 'purer' form of democracy and individualism free from the corruptions of Europe needs to be tempered by an understanding of how national representations are constructed. Edward Said maintains,

every society and official tradition defends itself against interferences with its sanctioned narratives; over time these acquire an almost theological status, with founding heroes, cherished ideas and values, national allegories having an inestimable effect in cultural and political life.

(Said 1975: 149)

America's pioneering past has been subject to revisionist histories that have pointed out the contradictions of a democracy built on the ruins of indigenous peoples. Although called to account, the myth of the unique origins of the American project remains the founding cornerstone of American identity.

The utopianism of the new world was not extended either to the indigenous population or to the 'imported' Africans. Even so, it is the search for the mythic self (national or individual, or a conflation of the two) that dominates accounts of abstract expressionism.

Traditional histories often relegate earlier forms of American art to the margins of European modernism: dependent (and therefore derivative and impoverished), and tainted twice – once by its very Americanness and again by the need to go to Paris, Rosenberg's 'cultural Klondike', for 'inspiration' and training. This construction, however, is a complex amalgam of dismissals and priorities that are ideological in character. Ideologies generally operate through a process of binary oppositions, which are themselves locked in with notions of their opposite for validation, and so each member of the pair is dependent on the other. So, for example, 'truth' and 'falsity' are codependent terms, as are 'left' and 'right'. Although such polarities do not always hold in American art, abstraction has had as its binary opposite – realism. Early modern art, particularly abstraction and expressionism, had been successfully utilised by both left– and right-wing regimes to represent alternately idealistic or degenerate art. To put it crudely, American freedom came to be represented in the

1940s and 1950s by abstract expressionism and realism came to be seen as equated with Russian totalitarianism and socialist realist art. Abstraction, willingly or not, in the 1950s became allied with the right and realism with the left.

At this point it is useful to establish some of the fictions surrounding Cold War rhetoric. François Mauriac, writing in mid-century, argued:

It is not what separates the US from the Soviet Union that should frighten us, but what they have in common . . . those two technocracies that think themselves antagonists, are dragging humanity in the same direction of de-humanisation . . . man is treated as a means to an end – this is the indispensable condition of the two cultures that face each other.

(Harrison and Wood 1992: 668)

The Cold War itself was useful in establishing the sabre-rattling position of two major powers who rarely looked likely to invade the other's agreed upon position. As Eric Hobsbawm puts it,

until the 70s [the] tacit agreement to treat the Cold War as a Cold Peace held good. The USSR knew (or rather learned) as early as 1953 that the US calls to 'roll back' communism were mere radio histrionics; there was no intervention when Soviet tanks were quietly allowed to reestablish communist control against a serious working class revolt in East Germany.

(Hobsbawm 1994: 228)

In terms of establishing the urgency and necessity of additional taxation in the US, under the Truman administration in the 1940s the Cold War apocalyptic rhetoric of 'struggle for supremacy or annihilation' proved a powerful ally. The unholy alliance of the Truman Doctrine, the Marshall Plan and Arthur Schlesinger Jr's book *The Vital Center*, became in the 1950s more than a ghostly shadow in America's art institutions. The covert activities of secret service and conspiracy theories entered the apparently benign, neutral world of the art museum. America's political freedoms, its democratic idealism, was compromised in the 1950s by McCarthy's virulent anti-Communist stance. 'Blacklisting' artists with an unacceptable political past made a mockery of the American rhetoric of freedom.

At least part of the 'retreat' into abstraction can be seen as a response to this climate of repression. Ben Shahn, writing from a politically beleagured position in the 1950s (he had formerly worked for the communist John Reed Club), believed abstract work was 'neutral enough to stay out of trouble' (Shahn 1953). However, any straightforward belief in institutional acceptance of government interference in the selection procedures for art works being sent abroad is simplistic. There is evidence to suggest that institutions often represented works as apolitical in order to manoeuvre their way around government censorship. What has been seen as an institutional rejection of the political side of art in the 1950s can instead be viewed as an attempt to get works by artists with a political past — and there were few artists who came out of the 1930s without one — shown anywhere at all. Freedom and individuality could be found not in abstraction alone but in artistic diversity.

An apolitical art

As we have seen, advocates of abstract expressionism have tried to remove it, often for politically expedient ends, from the realm of the social. The apolitical nature of abstract art increasingly came to dominate debates in the late 1930s, partly because institutional publications about modern art were seeking to *explain* the modern movements to a lay public. In 1937 the historian Meyer Schapiro, writing first in *Marxist Quarterly*, analysed the opposition of realist and abstract art. Schapiro refuted Alfred H. Barr's claim in his books *What Is Modern Painting?* (1943) and *Cubism and Abstract Art* (1936) that representation 'is a passive mirroring of things and therefore essentially non-artistic, and that abstract art, on the other hand, is a purely aesthetic activity, unconstructed by objects and based on its own internal laws' (Schapiro 1978: 195).

Schapiro contends that an art that has 'its own internal logic' is essentially 'unhistorical'. The accusation against Barr, whose approach in writing in defence of abstract art was to present a history of '-isms' with dates, is that he speaks 'of this [abstract] art as independent of historical conditions, as realizing the underlying order of nature and as an art of pure form without content'. The central paradox occurs, therefore, that although we attempt to understand abstract art as developing chronologically, through a succession of '-isms', the claim from some quarters is that the works exist outside of the – 'irrelevant' – history of art. Barr saw the removal of historical conditions and content from art practice as problematical, and he acknowledged that modern art was impoverished by the exclusion of the historical and political – but at least it was 'pure' (Barr 1986: 86). He 'preferred impoverishment to adulteration'.

Schapiro's argument, much like those of Breton, Rivera and Trotsky that we encountered earlier, was that there is a way for the artist to work, even in abstraction, that is not devoid of social engagement (1978: 187). Schapiro insists on a social basis for all art production, representational or not, maintaining that 'as little as a work is guaranteed aesthetically by its resemblance to nature, so little is it guaranteed by its abstractness or "purity". Nature and abstract forms are both materials for art, and the choice of one or the other flows from historically changing interests' (1978: 196). In pointing to abstraction's social dependence, its lack of separateness, Schapiro's victory was a Pyrrhic one. Abstract art could no longer insist on its isolation from the world, but just what role it could be alloted was unclear. Barnett Newman was in no doubt about the revolutionary potential of abstraction, which he felt could resist the spiritual impoverishment brought about by American capitalism. In a much-quoted conversation with Harold Rosenberg, he stated that if his paintings could be read properly that 'would mean the end of all state capitalism and totalitarianism', although quite how is not explained (Harrison 1997: 63).

Abstract expressionism's principal early advocates in New York were Harold Rosenberg and Clement Greenberg. While the latter's influence has been challenged and his position as official high priest of modernism seems less secure, his writings have been influential in promoting abstraction as the dominant 1950s art form. Harold Rosenberg, attempting in 1952 to isolate the moment of 'pure' painting, stated that:

many of the painters were 'Marxists' (WPA unions, artists' congress); they had been trying to paint Society. Others had been trying to paint Art (cubism, Post-Impressionism) – it amounts to the same thing. The big

moment came when it was decided to paint ... just TO PAINT. The gesture on the canvas was a gesture of liberation, from Value – political, aesthetic, moral.

(Chipp 1968: 569–70)

It was this desire 'just to paint' that distinguished the abstract artists from the social realists. Any group which attempted to engage with social content was marginal to the avant-garde who appeared to be concerned only with the experience of painting. Rosenberg, like many others in the 1930s, had been a Marxist and although the above quoted statement suggests a significant shift in his priorities, the commitment 'just to paint' has to be seen as a social act.

A brief note on existentialism

The 1950s were characterised by despair in a post-Auschwitz world, the rise of a 'crass mass culture' and anxiety over nuclear-bomb testing. For Rosenberg, faced with the realities of the world, the canvas would become the site of an existential encounter. Rosenberg argued in 1952 that 'the painter no longer approached his easel with an image; he went up to it with material in his hand to do something to that other piece of material in front of him. The image would be the result of this encounter' (quoted in Chipp 1968: 569). Whatever the merits of Rosenberg's conception of the artist heroically confronting his canvas, any kind of painterly correspondence to existential philosophy is ill fated.

Existentialism is an important element in post-war thought. Although its philosophical roots can be traced back to mid-nineteenth-century Europe, and Kierkegaard and later Heidegger, its influence on American painting is most usually sited in post-war France and the writings of Jean-Paul Sartre and Simone de Beauvoir. Existentialism emphasised the need to take responsibility for one's own existence but acknowledged the unpredictable and anxiety-producing state that a rejection of any sense of determinism might have produced. In the context of post-war uncertainty it is relatively easy to relate existentialism to abstract expressionism. As with the contradiction between Marxism and surrealism, where those committed to the irrational and the unconscious found it difficult to align with the political and the revolutionary, so the exponents of existentialism and abstract expressionism found it problematic to apply a philosophical idea to the painted surface.

Clement Greenberg's preoccupations, while focused entirely on the supremacy of abstract expressionism and a 'remove' from the world, are different from Rosenberg's. By 1965 (the year in which he published 'Modernist Painting') Greenberg saw this 'removal' from the world hardened into a search for the primary conditions of painting. He saw painting's self-criticism as a critical imperative, stating, 'the essence of modernism lies, as I see it, in the use of the characteristic methods of a discipline to criticize the discipline itself – not in order to subvert, but to entrench it more firmly in its area of competence'. Taking his cue from Kantian notions of autonomy, he continued, 'it was the stressing, however, of the ineluctable flatness of the support that remained most fundamental in the processes by which pictorial art criticised and defined itself under Modernism. Flatness alone was unique

and exclusive to that art' (quoted in Frascina and Harris 1992: 309). According to this theory, the challenges necessary to guarantee avant-garde status came from the artist's concentration on the medium itself and an increasing move to 'flatness'. The language of purity and the necessity of finding a defining voice for Abstraction, ideally someone who could identify quality now that technical competence could no longer be an adequate signifier, substantially marginalised those who were still working in what was identified as an increasingly reactionary art of retardataire form. The breakup of the American Artists' Congress in the 1940s and the retreat of the left effectively silenced some artists and writers committed to a plurality of aesthetics.

Politics of identity in the Cold War

It is a certain burden, this American-ness. . . . I feel somehow an American artist must feel, like a baseball player or something — a member of a team writing American history.

(Willem de Kooning, quoted in Johnson 1982: 21)

Culture has long been an acknowledged tool of government - seen as both a cultural reflection of power and as playing a transformative role in the formation of national identities. National identities are not constant and unchanging givens. As we have seen, culture came to be a powerful instrument of regeneration under the ideological imperatives of Roosevelt's New Deal. These decentralised programmes of community renewal had community art projects, particularly outside traditional art strongholds like New York, as their central plank. The drive towards a common culture involved continual compromise between many, often conflicting, ideas in a country as culturally diverse as America. It can be encapsulated in Walt Whitman's version of democracy: 'I dream in my dreams all the dreams of other dreamers'. Yet although a single dream could embrace the entire republic, 'the divers shall be no less diverse' ('The Sleepers' [1855] 1986: 441). Carter Ratcliff acknowledges that the links between Whitman and Pollock show 'no obvious resemblances' (Ratcliff 1994: 66). But he argues: 'Because an ideal of absolute equality invites extreme diversity, works by two proponents of that ideal would of course not display much similarity' (ibid.).

By the 1940s the issue of American identity had taken on a greater urgency. A place in the new world order and increased economic success seemed to require an American art that reflected what it was to be *both* 'American' and 'universal' – a new and ambitious art independent of European models. The Cold War period required a specific form of national identity to export as part of America's cultural arsenal: art as incendiary device. American scene painting and social realist art (not to be confused with socialist realism) were deemed by many too parochial for the modern world stage. Early American modernist art, however, was somehow too unAmerican, too dependent on the European model, to be charged with the task of envisioning the American Dream for export to a war-ravaged Europe. Ironically, however, the new art form also had roots in European traditions. European artists and intellectuals dislocated from war-torn Europe had exerted a powerful influence on a generation of

artists cut off from Europe by the Depression. The surrealists, especially André Breton and Salvador Dali, held a particular fascination for artists of Pollock's generation. One important influence was Picasso whose exiled work *Guernica*, a response to the bombing of the Spanish Basque town by Hitler's Condor Legions in collaboration with General Franco's fascists in 1937, was shown at MoMA in 1939. Pollock visited the exhibition daily and assimilated its iconography and stylistic innovation.

Received and revisionist histories of the period, both working largely within a Marxist world view, have looked at abstract expressionism's relation to Cold War politics. Abstract expressionism, like the cartoon hero Captain America, gained the dubious status of conscript. However, although received wisdom saw abstract expressionism as the ideal Cold War weapon, it was a poor emissary to Europe, not least because abstract expressionism is no more free of ideology than, say, figurative American scene painting. In addition the New York art critic Emily Geneaur (herself a casualty of McCarthyism), writing in the 1950s, could not see the point in using artists, who in her words were 'inarticulate adolescents', to represent any aspect of American freedom. In spite of the common presentation of the abstract expressionists as the primary Cold War cultural warriors, there is evidence in the exhibitions sent abroad to suggest that an extraordinarily eclectic body of work was made to represent American democracy. Art works sent abroad represented American art, craft and design in all its variety, from Grandma Moses and early frontier works like the bronze cowboy sculptures of Frederic Remington (1861–1909) to the social realist works of Ben Shahn. Even The Sacco and Vanzetti Series, shown at the Venice Biennale in 1954 and highly critical of a racist, anti-immigration, American judicial system, could be subverted and neutralised by a liberal American democracy that 'allowed' dissent, unlike its totalitarian counterpart. Abstract expressionism alone would not have been enough to represent America's notion of itself; it was crucial that that should be played out against works from the 1930s and 1940s - works which had previously been seen as 'Red'. So, although much has been made of abstract expressionism's suitability for the task of establishing a uniquely American identity, there were alternative views.

In the politically conservative climate of the late 1940s and 1950s American culture was sent abroad to counter the routine charge of American philistinism. By 1953 the United States Information Agency (USIA) was set up to oversee the replacement of 'dollar diplomacy with cultural diplomacy'. Many art exhibitions and cultural events were sent abroad. Sending art works abroad to represent America to the rest of the world required careful monitoring, not least because so many modern artists had a 'politically compromised' past. The need to guard against the sending abroad of any subversively 'Red exhibitions', however, led politicians to take a closer interest in art.

Works by known Communist sympathisers (Stuart Davis, William Gropper, Yasuo Kuniyoshi, Philip Evergood, Jack Levine and Ben Shahn), represented in exhibitions such as the State Department's 'Advancing American Art' in 1946–47, were recalled by Secretary of State George Marshall before their tour of Europe and Haiti were finished. The works were declared 'un-American and subversive' and were sold cheaply as government surplus property. The chief aesthetic charge against the art works was that their characteristically modernist expressionist distortions failed to conform to a naturalistic realism. President Truman too criticised the exhibition,

declaring, on seeing Kuniyoshi's Circus Girl Resting, 'If that's art, then I'm a Hottentot' (The Washington Post, 18. 2. 1947). The list of exhibitors in 'Advancing American Art' constituted a roll-call of the artists who had worked on Federal Art Project initiatives in the 1930s, including early modernists such as Georgia O'Keeffe and John Marin, with little space given to the abstract expressionists.

A poll in *Look* magazine of November 1949 questioned influential museum directors and art critics to select the ten best painters in America, and established a Best Painter Category under: 'Are these Men the Best Painters in America Today?'. The list surprisingly included artists rejected by government as unworthy to travel as cultural ambassadors in 'Advancing American Art'. The completed list comprised of John Marin, Max Weber, Yasuo Kuniyoshi, Stuart Davis, Ben Shahn, Edward Hopper, Charles Burchfield, George Grosz, Franklin Watkins, Lyonel Feininger and Jack Levine. John Marin (1870–1953), an early American modernist was placed at the top and was a favourite of USIA, frequently chosen to represent American art in exhibitions abroad. A further poll by artists confirmed the directors' exclusively male selections, and added to the list Max Beckmann, Philip Evergood, John Sloan and Rufino Tamayo.

This audit in *Look* is important in countering the myth created by *Life* magazine's casting of Jackson Pollock as possibly 'The Greatest Living Painter in the United States' only three months earlier, in August 1949. If *Life* magazine was posing the painter and the question, the unequivocal answer from the art establishment and artists was 'No'. The museum directors and critics did not name any abstract expressionist, let alone Pollock. What is pertinent in the competing polls is the extent to which early American modernists still dominated American painting and had institutional support, despite their compromised political past and the apparent suddenness of their fall from grace.

Theories of abstraction

In order to gain a fuller picture of the complexities of abstraction around this period, we must return to the ineluctable progress towards flatness. Formalist analyses of abstract works proved compelling at first, although they became difficult to sustain. Greenberg's 1939 diktat was:

Retiring from public altogether, the avant-garde poet or artist sought to maintain the highest level of his art by both narrowing it and raising it to the level of expression of an absolute in which all relativities and contradictions would be either resolved or beside the point. 'Art for art's sake' and 'pure poetry' appear, and subject matter or content becomes something to be avoided like the plague. . . . Content is to be dissolved so completely into form that the work of art or literature cannot be reduced in whole or in part to anything not itself.

(Quoted in Frascina 1985: 23)

Greenberg's emphasis on form and purity minimised the influence of the European surrealists, 10 although automatism and chance clearly played an important part in the

work of Jackson Pollock, particularly in Pollock's drip paintings. In these works Pollock dispensed with the paint-brush and traditional artists' paints in favour of a stick and pots of industrial paint which allowed the paint to flow directly on to the canvas. This system, which was 'invented' around 1946 and used extensively into the early 1950s, stems from earlier Mexican influences.

In the 1930s Pollock had worked with David Alfaro Siqueiros in Siqueiros' experimental workshop in New York. Siqueiros experimented with new industrial paints called nitrocellulose with which he created free-form images, earning him the nickname 'El Duco' after the paint brand name. Pollock was also influenced by his experiences of scenery backdrop painting techniques in theatre and by Native American sand painting. Greenberg diminished the spiritual aspects of abstract works which were relegated to Romanticism. For Greenberg and later Michael Fried, what was important in Pollock's strategy was the proximity of surface to canvas. That is to say, the splatters and skeins of paint that lay across the canvas brought painting closer to its surface, emphasising the flatness of the canvas. In formalist terms, Pollock abandoned illusionistic—perspectival space, which was rendered redundant as efforts to 'hole-through' the canvas ceased.

In contrast, Harold Rosenberg tended to emphasise the individual's soul and spirituality, and he later offered an existentialist interpretation of the abstract works. Rosenberg linked 'action painting' to surrealist practices which he believed could reveal what has been termed the artist's 'interiority'. The difference between the two critics is important in terms of the role they played in the support or dismissal of abstract expressionism. For Rosenberg, formalism collapsed too easily into a question of taste. 'Taste' was to Rosenberg unequivocally an anti-critical value, one of a whole set of inert standards belonging to an established elite for whom art meant prestige objects and investments. He thought taste and the other formalist criteria of his time had become firmly institutionalised as 'bureaucratic assents' constituting 'the outstanding menace to critical consciousness'. 11 For Rosenberg, Greenberg became a representative of an institutional modernism that removed the potential for critical distance and constituted art's objects as decoration. As we have seen in Barnett Newman's statement, abstraction had to stay in opposition to bourgeois standards of taste in order to maintain its revolutionary potential. Rosenberg represents a position that is complex - one that put him at odds with many artists and critics.

This issue of abstract expressionism's flirtation with taste still retains its cachet even in the language-preoccupied 1990s. T. J. Clark, building on Greenberg and Barr's work, enlists 'vulgarity' as a term of value in expounding abstract expressionism's continuing relevance. Value-laden terms like 'taste' and 'vulgarity' are not without overtones of class. However, Clark maintains that 'if the formula were not so mechanical I would be prepared to say that abstract expressionist painting is *best* when it is most vulgar because it is then that it grasps most fully the conditions of representation – the technical and social conditions of its historical moment' (Clark 1994: 46).

It is part of the central contradiction of claims for art's autonomy that, in trying to explain autonomy, it is necessary to reflect on art as a social activity. Relating only to canvas and paint, however, was unsatisfactory and Rosenberg contended that, 'satisfied with wonders that remained safely inside the canvas, the artist accepts the permanence of the commonplace and decorates it with his own daily annihilation.

The result is an apocalyptic wallpaper' (Shapiro and Shapiro 1990: 82). For Rosenberg the peril of this approach was that it would result in megalomania, not revolution. Although it would be reductive to see Rosenberg as influential only through action painting, this was a crucial concept in the period following the Second World War. For Rosenberg, action painting is not to be reduced to the language of 'purity', familiar in Greenbergian formalism. In 'The American Action Painters' (ibid.: 72) he stated unequivocally that:

the new American painting is not 'pure art', since the extrusion of the object was not for the sake of the aesthetic. The apples weren't brushed off the table in order to make room for perfect relations of space and colour. They had to go so that nothing would get in the way of the act of painting. In this *gesturing* with materials the aesthetic, too, has been subordinated. Form, colour, composition, drawing, are auxiliaries, any one of which — or practically all, as has been attempted logically, with unpainted canvases — can be dispensed with.

(see Chipp 1968: 570; emphasis added)

The 'gesture' – the action of drip painting – was crucial to Rosenberg's notion of artistic truth and authenticity. For Rosenberg, then, as we will see in Chapter 7, 'the revelation is contained in the act', while for Greenberg the aesthetic success of a painting was determined by 'experience'.

For the Marxist Meyer Schapiro, abstraction could be understood by other means. In 'The Nature of Abstract Art', written in 1937, he said that:

just as the discovery of non-Euclidean geometry gave a powerful impetus to the view that mathematics was independent of experience, so abstract painting cut the roots of the classic idea of artistic imitation. The analogy of mathematics was in fact present to the minds of the apologists of abstract art: they have referred to non-Euclidean geometry in defence of their position, and have even suggested an historical connection between them.

(Schapiro 1978: 186)

In brief, Schapiro's argument suggests that abstraction exists, like non-Euclidean geometry, outside of or even contrary to expected (mathematical) norms:¹²

All the new geometries, like the old one, were submitted to the rules of logic; in each geometry the new theorems had to be consistent with each other and with the axioms and postulates. In painting as in mathematics, the role of structure or coherence became more evident and the range of its applications was extended to new elements.

(Schapiro 1978: 213)

In effect, Schapiro argues in favour of an abstract art that possesses 'the qualities not so much of things as of impulses, of excited movements emerging and changing before our eyes' (Schapiro 1978: 219) – the antithesis of the old Euclidean order.

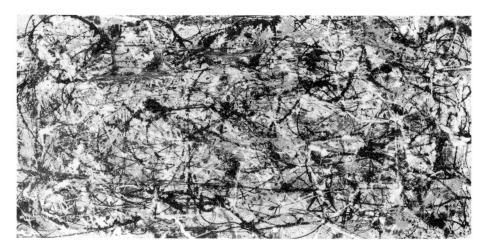

Figure 6.8 Jackson Pollock, Cathedral, 1947. Dallas Museum of Modern Art. Photo: © ARS, NY and DACS, London 1999

All-over painting

A return to the issue of 'all-over' painting raises another spectre in the plethora of possibilities that abstract expressionism seemed to offer. All-over painting techniques, such as in Jackson Pollock's 1947 *Cathedral* (Figure 6.8) which appears to have no centre, no traditional composition, and therefore no hierarchy, were interpreted as democratic by some analysts. Carter Ratcliff states: 'order without hierarchy may be a practical impossibility, and yet it has an imaginary existence in America's egalitarian ideals'. He cites Walt Whitman's elegy to equality, the poem *Leaves of Grass* (1855), continuing:

as in Pollock's paintings, so in the sprawl of Whitman's verse: there is energy, an implication of boundlessness, and an intricate weave of incident that never coalesces into a stable hierarchy. In the work of both painter and poet the lack of hierarchical structures is the prerequisite for what is positive about their work: its power to image forth a political premise still basic to America's idea of itself.

(Ratcliff 1994: 65)

Rosenberg, too, was to solicit posthumous support from Whitman, likening the abstract expressionists to Whitman's 'cosmic gangs', but stating less enthusiastically: 'The cosmic "I" that turns up to paint . . . shudders and departs the moment there is a knock on the studio door . . .' (quoted in Shapiro and Shapiro 1990: 82).

By the 1940s abstraction was nothing new in art. We saw in Chapter 1 how all that was accomplishable in avant-garde art had arguably already been achieved by 1917. The attempt to be both specifically American and to accomplish artistic innovations in form, therefore, relies on the touchstone of Whitman. His poetry was self-designated as an authentic American voice. In *To Foreign Lands* Whitman

states his aim to 'define America, her athletic Democracy, therefore I send you my poems that you may behold in them what you wanted' (p. 39). Whitman defined himself as 'a Kosmos' (p. 86) and although his poem Song of My Self (p. 63) seems at first solipsistic, self is quickly developed into others, a nation and finally a universal humanity. Whitman extends Ralph Waldo Emerson's idea of the transcendental 'self'. Similarly Henry David Thoreau's solitary stay, from 1845 to 1847 in a hut on the north shore of Walden Pond near Boston, is the basis for another sustaining myth of creativity that influenced subsequent generations of artists and writers. Walden, published in 1854, combined the experience of living day-to-day at Walden Pond with an experience of transcendence. The belief that man's relationship to nature transcends the utilitarian is co-opted into the rhetoric that surrounds abstract expressionism. For example, Pollock's working close to the earth, literally laying the canvas on the ground to work was seen as part of a mythical and mystical authenticity. Pollock said 'on the floor I am more at ease. I feel nearer, more a part of the painting, work from the four sides and literally be in the painting' (quoted in Shapiro and Shapiro 1990: 356).

Whitman was important for American painters in terms of his formal devices. Whitman used form, poetic form, to free American verse of its dependence on European, particularly English, conventions, seen as over-sophisticated and repressive. Whitman's free verse, while abandoning poetic ornament and usually also traditional metre and stanzas, nonetheless contains strong rhythmic patterns. Parallels have been drawn between Whitman's verse and Pollock's rhythmic flick of the wrist, seen most famously in the Hans Namuth film made in 1950. The movement of the hand or wrist, it has been argued, creates a 'psychogram' – broadly speaking, a visual representation of an emotional state.

American national identity is constructed, at least in part, on the failure of the English Civil Wars, and in an uneasy alliance of puritanism with the Enlightenment rhetoric of egalitarianism and constitutional idealism. The puritan belief in vocation also reappears from time to time with a proselytising zeal in the rhetoric that surrounds American art. Thomas Paine's 1776 tract 'Common Sense', the foundation-stone of American democracy, suggests that America, being closer to nature, is purer than a corrupt Europe, making separation from Europe a moral imperative as well as a practical one. The Quaker Edward Hicks' *The Peaceable Kingdom (c.* 1840) (Plate IX) is paradigmatic of the utopian nature of the emergent nation and its move westwards.

The mythology of the west and the 'horizontality of the land' also emerge in some readings of the monumental abstractions by Clyfford Still, Pollock and Newman. Frontier theories, particularly the Turner 'thesis', 13 were important to artists like the regionalist Thomas Hart Benton, precisely because they defined American democracy in relation to the frontier rather than European 'decadence'. Although such theories lost academic credibility, by the 1950s the myth of frontier remained strong in popular culture and imagination. The frontier offered a place unfettered by European bondage. Still's work conveys to some 'a boundlessness and openness that calls to mind panoramic American prairies and plateaux – awesome crags and fissures' (Sandler 1993: 81). It is perhaps significant that in the 1950s, at the height of abstract expressionism's critical if not popular acclaim, 'the Western' dominated television programming. Some television networks showed nothing else from 7.00pm to midnight. 14

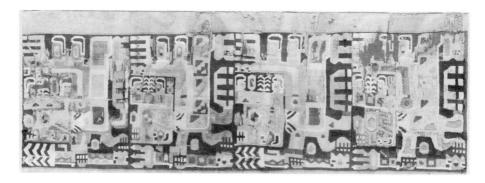

Figure 6.9 Textile–Woven–Peruvian, ca. 800 Pre–Inca Period. Highlands Region: Tiahuanaco II Culture. The Metropolitan Museum of Modern Art, Gift of George D. Pratt, 1930

'The First Man Was An Artist'15

As we have seen in Pollock's work, early abstract expressionism often turned to Native American traditions, earlier archaic art forms and the primeval past, much as the early modernists turned to Africa and the South Seas, in the search for a purer ancestry, for a more authentic 'primitivism'. However, American sources for abstract works suggest a more complex relationship to the past than the emphasis on formalist readings of abstraction often allow. As early as 1933, the MoMA exhibition 'American Sources of Modern Art' brought together a collection of ancient American art, in fact all pre-Columbian, displayed alongside modern art works. The collection ranged from Mayan sculptures to artefacts from the Aztec, Toltec and Peruvian cultures. Displayed were objects in ceramic and gold, funerary urns, as well as amulets and fragments of tapestry (Figure 6.9). The 'contemporaries' included Diego Rivera, David Siqueiros, Max Weber and William Zorach. The catalogue stated: 'It is intended, simply, to show the high quality of ancient American art, and to indicate that its influence is present in modern art in the work of painters and sculptors, some of whom have been unconscious of its influence, while others have accepted or sought it quite consciously' (quoted in Cahill 1969: 5). In 1941 MoMA also showed 'Indian Art of the United States'. It is worth noting that as MoMA is a modern art museum, both exhibitions were presented as 'sources' for modern artists rather than attempting to satisfy the anthropological interest of visitors to a museum's ethnographic section. Pollock, in the Hans Namuth film, referred to American Indian sand paintings as an influence on his work. In an interview with Howard Putzel, published in Art and Architecture in 1944, Pollock said:

I have always been impressed with the plastic qualities of American Indian Art. The Indians have the true painter's approach in their capacity to get hold of appropriate images, and in their understanding of what constitutes painterly subject matter. Their color is essentially Western, their vision has the basic universality of all real art. Some people find references to American Indian art and calligraphy in parts of my picture.

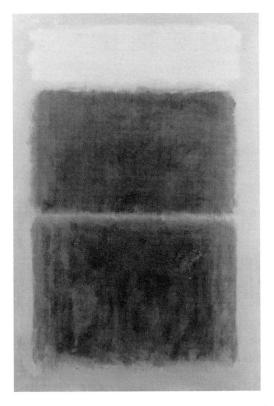

Figure 6.10 Mark Rothko, Light Red Over Black, 1957. Tate Gallery, London. Photo: © ARS, NY and DACS, London 1999

That wasn't intentional: probably was the result of early memories and enthusiasms.

(Quoted in Johnson 1982: 2)

It is the modernist claim to universal truth, rather than the works themselves, that is problematic. The works of the abstract expressionists, most notably those of Mark Rothko and Pollock, are deeply embedded in the rhetoric of the emotions, the imperative that art should aspire to the emotional power of music being part of that rhetoric. Rothko stated: 'I became a painter because I wanted to raise painting to the level of music and poetry.' To be confronted with Rothko's monumental canvases was to invoke the modernist trope of *feelings*. Famously, Rothko claimed 'I'm interested only in expressing human emotions – tragedy, ecstasy, doom, and so on' (Rodman 1961: 93–4). Paintings such as his 1957 *Light Red Over Black* (Figure 6.10), it was claimed, stimulated an appropriate emotional response in the viewer. Cultural studies, taking its cue from anthropology and linguistics, has explored the contradictions inherent in the notion of a universal response to art works. Poststructuralist theories (particularly those of Michel Foucault) acknowledge that critiques of emotions have been belated in anthropological debates. Emotions, it is assumed, are the least constructed and therefore the least learned of our responses.

This is in part due to an assumption that emotions are located 'in' the body. The sense that emotions are somehow universally shared and therefore 'natural' has made them resistant to sociocultural analysis. Taking Foucault's discursive approach to inquiry as a starting-point, poststructuralist anthropology rejects traditional 'certainties' concerning the psychology of the emotions.

Traditional theories and supporting practices have maintained that the emotions are the preserve of the individual. However, what have been termed 'emotionologies' (Stearns and Stearns 1988) suggest that the study of the ways in which specific local cultures identify, recognise and classify emotions might be a more fruitful line of enquiry than the assumption of a universal response which is rooted in biological reactions. Essentialising emotions within the realm of feelings removes the study of the emotions from the realm of social interaction and its relation to language. It also tends to reinforce the naturalness of emotional universalism. Through the study of historical data, including diaries, and the close linguistic analysis of other cultures' codes, it seems possible to establish that emotional displays are more than physiological reactions and are related to specific conventions locally constructed.

Postmodern critiques of abstraction have 'recovered' what seems to be a natural psychological given. As we saw in Chapter 3, Pollock's claim that he was painting out of the unconscious is problematic. Is the unconscious, like the uniform emotional response, a 'productive fiction'? Confidence in easy access to the unconscious has been questioned by, among others, the psychoanalyst Jacques Lacan (1901-81). If access to the unconscious can be secured, can the unconscious be represented by any characteristic imagery, such as Jung's notion of archetypes? Postmodern theories insist that even the unconscious needs to be understood as a constructed category; that its form therefore is always contingent upon social and historical conditions. The unconscious is not a transhistorical fixture. Perhaps therefore rather than painting out of the unconscious, Pollock's enterprise is better explained as representing the unconscious.

Michael Leja, in Reframing Abstract Expressionism, has noted that the abstract expressionist idealistic 'vision' of a more 'authentic' pre-civilised state stood for what life in a despiritualised twentieth century was not. However, as Leja states, 'to hold that these images and ideas of the primitive captivated the abstract expressionists by virtue of some power residing within the images and ideas themselves ... some inherent truth or rightness recognised by the artists . . . is ahistorical idealism' (Leja 1993: 54). Nonetheless, Mark Rothko repeatedly refers to the modern in relation to the past. He combined a version of surrealism with Greco-Roman imagery. In Tiresians 1944 we can see a direct correlation between archaic forms and surrealist biomorphism. Although iconology - reading works of art in terms of their symbolic meanings - has been marginalised as an art-historical tool, its procedures can prove valuable in uncovering meanings in modern art. 16

Jackson Pollock died at the wheel of a car in 1956. The myth of self-destructive genius gained a fillip with Pollock's violent death, and this impacted on the market value of abstract expressionist art. Financial success for abstract expressionist works did not come until after Pollock's death, undermining any easy correlation by revisionist historians who equated early market success with the promotion of abstract expressionism during the Cold War. In fact, Alfred H. Barr at MoMA had declined to buy Pollock's Autumn Rhythm (1950) in 1955 because the figure of \$8,000 was too high.

With the death of the artist, less than a year later, the work was sold by the Sidney Janis Gallery for \$30,000 to the Metropolitan Museum of Art in New York. ¹⁷ Allen Kaprow, writing in 1958 on the legacy of Pollock, two years after the artist's death, acknowledged the tragedy of a man who did not die at his peak but in a period of decline, both personal and of the art that had come to dominate the American scene. Kaprow wrote: 'Was it not perfectly clear that modern art was slipping? Either it had become dull and repetitious qua the 'advanced' style, or large numbers of formerly committed contemporary painters were defecting to earlier forms.'

Kaprow, using the language of modernism and avant-garde culture, suggests that Pollock's heroic stand had been futile. What is important here is that the historic moment of abstract expressionism was brief, shifting swiftly from an adversarial culture to a sedimented modernism. Even before Pollock's death, Rauschenberg had erased de Kooning's drawing and Pollock's most significant contributions, as identified by Greenberg, had already been made. Greenbergian formalism evolved to promote the younger abstractionists, Morris Louis, Kenneth Noland and Jules Olitski. Ironically, by the early 1960s the work of the earlier generation of abstract painters gained institutional acceptance, becoming an orthodox climax to the story of modern art.

Post-modernism and abstract expressionism

Adolph Gottlieb predicted that abstract expressionism would reign for a thousand years (Rodman 1961: 87) and, given that the language of abstract expressionism was imbued with transcendentalism and universalism, there seemed little reason to doubt this. Subsequent parodies and pastiches of abstract expressionist works have not necessarily undermined the strength of the modernist project. In 1997 Vik Muniz produced Action Photo (After Hans Namuth), one in a series of cibachrome photographs of soft toffee dripped to represent the image of Pollock throwing paint in the Hans Namuth film from the 1950s. Muniz parodies the painter's technique by simulating his gestures, dripping chocolate syrup on to paper and then photographing the result. For Muniz this is a subversively political act which calls into question the traditional readings of Pollock and, by extension, of other abstract works. Muniz's Action Photo simultaneously critiques all of modernism's sacred cows: like Rauschenberg's erasure of the de Kooning drawing, it is both homage and reproach; but, like Sherrie Levine's appropriation of Edward Weston, it uses a photographic process. The photograph, mechanically reproducible, is a challenge to the authentic act of painting. The substitution of toffee for paint is an ironic reference to both the preciosity of paint and the act of painting itself.

The nature of creativity and the status of abstraction in modern art and modernism, particularly its American manifestation, have become contested arenas. Elitism is the usual charge against works seen as white, male and middle-class. This chapter's emphasis on men, at the expense of women, is in part a reflection of abstract expressionism's machismo. There were influential women artists and theoreticians like Elaine de Kooning and Lee Krasner, but their status as artists' wives has militated against their inclusion in the pantheon of great artists. For instance, Krasner's work was widely regarded as 'domesticated Pollock' – a less authentic and tamer mode of self-expression. Feminist critiques of abstract expressionism, like Muniz's irreverent gesture in toffee,

have tended to critique by mocking the gestures of action painting and the primacy given to paint. Therefore, like Shikego Kubota (as we will see in the next chapter), many women artists turned to performance art or to new technologies as a way out of the gender bias of abstract expressionism.

The avant-garde's failure to resist institutionalisation and its easy co-option into politics, ironically through a process of de-politicisation, have undermined the original radicalism of the artistic enterprise. Postmodernism has, however, opened up the terrain, thus allowing a reappraisal. Richard Pousette-Dart (1916–92), once a casualty of the narrow ranks of abstract expressionist artists deemed worthwhile, has been one beneficiary of the recuperative effects of postmodern re-evaluations. In part, his earlier 'dismissal' was due to the rejection of notions of the spiritual in a secular world.

Pousette-Dart's 'search for the sacred' seemed anachronistic at best. Many abstract expressionists were influenced by notions of magic and ritual, and by modern-man discourse through the anthropological works of writers like Margaret Mead and Ruth Benedict. More recently, an increasing emphasis on the effects of the Second World War has informed writing on the period. As we saw in Chapter 3, a move towards a kind of modern spirituality has been a preoccupation of many artists, from the Romantics to the expressionists, and even those involved in the machine aesthetic saw the endeavour as more than the glorification of speed and technology. Pousette-Dart and others working in post-war art believed that spirituality could offer more than a means of merely personal redemption:

For Pousette-Dart the implicit need for healing and regeneration is ... historical as well as personal; the quest for the sacred is also characteristic of war culture in modern times, and that culture undoubtedly had a catalytic effect on the search for respiritualization manifested in the work of Pousette-Dart and others.

(Polcari 1997: 62)

For Pousette-Dart (see Plate V) this meant a 'return' to the primitive, which was accessed through Jungian notions of archetypes and the unconscious. For him, transcendental in nature, Pousette-Dart's work uses symbolic forms invoking ritual as a way in to a spiritual world. Drawing heavily on a knowledge of native American symbolism, totemic and shamanistic, of medieval stained glass and imagined gothic emblems; Pousette-Dart 'imagined' a world of transformation and regeneration through the creative act. Pousette-Dart reworked the modernist idea of nature, which was 'a mystical identification with the soil as cosmic force' (Polcari 1997: 67).

Shahn and the Lucky Dragon

It is impossible to Contemplate the Bomb. At the Down Town Galleries one can.

(O'Doherty, New York Times 10 December 1961: 40)

Another artist to be recovered from the narrow canon of modernist art history is Ben Shahn (1898–1969), who had featured in *Look* magazine's poll, been represented

in 'Advancing American Art' and was, according to Michael Kimmelman, 'the most popular artist in America in the 1950s'. In reviewing the 1998 exhibition 'Common Man: Mythic Vision. The Paintings of Ben Shahn' at the Jewish Museum in New York, Kimmelman wrote: 'I emphasise his popularity because we easily forget how popular Shahn was. With the Pollock and Rothko retrospectives now at the Modern and Whitney, the Shahn exhibition is a useful reminder that it was he more than they who dominated the country's public consciousness at mid-century' (*New York Times*, 13 November 1998). Orthodox modernists have dismissed Shahn as a 1930s' social realist with unreconstructed illustrative and narrative tendencies. It is often assumed that artists who had been successful in the 1930s either turned towards abstraction or ceased to have a career after the war.

Ben Shahn, although usually 'relegated' to the role of quintessential protest artist, continued working in the 1950s and 1960s on themes of social injustice, characteristic of his earlier work. Where Shahn is acknowledged as a 'truly modern' post-war artist, it is usually because art historians perceive a shift away from the social to a more 'personal' vision. In fact Shahn's greatest institutional successes came not in the 1930s but in the 1940s and 1950s, with major 'one-man' shows at MoMA in 1947 and critical acclaim at the Venice Biennale in 1954. His retrospective at MoMA included his political posters designed for labour organisations and peace programmes. ¹⁸ Retrogressive realism was still his preferred working method and, heretically for modernist critics, his works had often first appeared as illustrations in popular magazines and were derived from photographs (he had been a photographer with the FSA (Farm Security Administration) in the 1930s).

During the late 1950s and early 1960s Shahn produced the Lucky Dragon series, consisting of 26 paintings including A Score of White Pigeons (1960) (Plate X). The Lucky Dragon series was based on an incident involving the exposure of a Japanese fishing crew to radiation. On 1 March 1954 the US detonated its first thermonuclear bomb at Bikini Atoll in the South Pacific. The crew of the Lucky Dragon (No. 5 Fukuryu Maru) were unwittingly exposed to the testing; Kuboyama, its radio operator, died as a result, and the Japanese fishing industry was brought to a halt. The political fallout was so great that Secretary of State John Foster Dulles, who negotiated the final Peace Treaty with Japan in 1951, worried that it might 'rip apart the essential elements of American national security policy'. He hypothesised that America and her allies would 'conclude that alliances and atomic weapons were not complementary instruments for the preservation of national security and world peace' (Dingman 1990: 187). The negative international response to the testing and the sudden realisation of the destructive potential of the H-Bomb (the New York Times ran front-page articles showing diagrammatically what would happen should Manhattan be the epicentre of a blast) contributed to the general despair. The work of Dr Ralph Lapp, an atomic physicist sent to Japan to monitor the condition of the fishermen, was at least in part responsible for the peace movements of the 1960s and 'laid the foundations for the Nuclear Test Ban Treaty of 1963' (Dingman 1990: 207).

Shahn's response to this crisis utilises the formal language of modernism – loose brushwork – and combines it with social commentary in an accessible illustrative style. A Score of White Pigeons refers to the Japanese funerary custom of releasing white pigeons after cremation. Shahn was not alone in questioning abstract expressionism's ability to respond to the modern world in all its complexity – asking must

'all our pity and anger to be reduced to a few tastefully arranged straight lines?' (Shahn, *New York Times*, January 1953).

Shahn's work originally appeared in Harpers Magazine in 1957 and 1958, as illustration to Lapp's Lucky Dragon articles and then in Richard Hudson's book Kuboyama and the Saga of the Lucky Dragon. Shahn's support of the plight of Japanese fishermen, who saw themselves as victims, for the second time, of American nuclear bombing, came at an anxious time in both art and world politics. With American political involvement in Indo-China leading to the Vietnam War, the Russians launched their first Sputnik satellite in 1957 with consequent outbreaks of patriotic fervour. Reaction to Shahn's work is therefore instructive. Late in 1961 the Down Town Gallery in New York showed the Lucky Dragon series. The exhibition attracted record attendances - more than 7,000 visitors in the first two weeks, setting an attendance record at the gallery. Reviews were outstandingly positive, although Jack Kroll, writing in the influential Art News in 1961, argued that Shahn had illustrated the victims to no real effect, noting the cartoon-like presence of the dragon, used 'to symbolise the malignity of the holocaust'. Kroll sensed that the 'real tragedy of these paintings is that something has gone, not out of Shahn, but out of us and our time. These people are innocent in a way for which we have as yet found no plastic symbology.'

There are echoes here of earlier comments by Rothko, who had said: 'it was with the utmost reluctance that I found the [human] figure could not serve my purposes . . . but a time came when none of us could use the figure without mutilating it' (quoted by Dore Ashton, New York Times, 31 October 1958). Shahn, in his lecture series The Shape of Content given at Harvard University in 1957, did not separate content from form – for him they were inseparable. Of Clive Bell's mantra 'The representative element in a work of art may or may not be harmful, but it is always irrelevant', Shahn retorted that it was 'a credo, that might well have been erased by time, but which instead has grown to almost tidal proportions and which constitutes the Procrustean bed into which all art must either be stretched or shrunk' (Shahn 1957: 26). For Shahn, and many like him, abstraction inadequately met the needs of the age but was still a standard by which 'other' art was measured. Contrary to the kind of formalist readings that Greenberg provided, it was possible to read in to abstract art the unstable 'spirit of the age'. For instance, the art historian Henry McBride read Pollock's drip paintings in terms of their relationship to war, stating that 'the effect it makes is that of a flat, war shattered city, possibly Hiroshima, as seen from a great height in moonlight'. It is to be doubted that this metaphorical reading of Pollock's work was more than speculative, but it does demonstrate just how broad the response to post-war anxieties was and, moreover, how open to interpretation abstract art could be.

Notes

- 1 The modernist argument maintains that only the immediate past is important. The 'historic', artistic past, they argued, was re-worked by Manet to such an extent that it need not be revisited.
- The captions were removed from many FSA documentary photographs in the 1940s and 1950s, which were then re-presented to evoke purely aesthetic responses.

- Stuart Davis, in 'Abstract Painting Today' (reproduced in O'Connor 1975), lamented 3 the loss of experimental work and acknowledged that the WPA programmes sometimes had conservative agendas. However, there is plenty of evidence to suggest that a wide range of work was produced during this period.
- See particularly Siqueiros, David A. (1975) Art and Revolution, Lawrence & Wishart,
- See particularly Celeste-Adams, Marie (ed.) (1986). 5
- This was originally published, for 'tactical' reasons, under the name of Diego Rivera, not Trotsky (Chipp 1968: 457).
- 7 The Truman Doctrine was the name given to a policy which established a commitment to policing the planet that maintained democracy and where necessary rolled back Communism in the name of freedom.
- See Jonathan Harris's forthcoming book 'Seeing Red': The American Artists' Congress and New York - Left Activism in the Late 1930s for a fuller account of the left's retreat during the late 1930s and the 1940s.
- Schlesinger's The Vital Center (1949) was a highly influential tract that established a set of liberal business values for its generation.
- Clement Greenberg's 1948 essay 'The Decline of Cubism' promoted the idea of a weakened School of Paris and the opportunity for culture to be revived in the USA. 10
- 11 Elaine O'Brien, unpublished PhD (1997) 'Harold Rosenberg: Aesthetic Assault' p. 332.
- Clyfford Still wrote of the restriction placed upon him by the picture frame, which 12 he likened to a 'Euclidian prison' needing to be annihilated (interview with Ti-Grace Sharpless, published in the 1963 catalogue Clyfford Still, Philadelphia Institute of Contemporary Art, University of Pennsylvania, Pennsylvania).
- Frederick Turner's 'thesis' (The Significance of the Frontier in American History) of 1893, delivered at the Chicago World's Fair, held that American democracy developed in 13 line with the movement westwards, bypassing conventional wisdom which held that American democracy was dependent upon German and English models.
- 14 William Boddy (1998: 119) estimated that 'in the 1957-8 season, four of television's five most popular programmes were Westerns and the following season, despite widespread predictions of saturation, Westerns represented nine of TV's top eleven shows - the 570 hours of TV. Westerns in the 1958-9 season were estimated to be the equivalent of 400 Hollywood features a year.'
- 15 This is the title of a 1947 article by Barnett Newman; see Chipp 1968: 551.
- 16 Stephen Polcari (1991) Abstract Expressionism and the Modern Experience principally uses iconography as a tool for analysing abstract expressionism.
- Florence Rubenfeld (1998: 210) reflected: 'Pollock's funeral was barely over when 17 Janis sold for \$10,000 a de Kooning he had been unable to move a month earlier for half that amount.'
- Shahn's CIO-PAC (Congress of Industrial Organisation Political Action Committee) 18 posters were the subject of controversy at MoMA and at the Venice Biennale, but were shown nonetheless.

SELF AND IDENTITY POLITICS IN PHOTOGRAPHY AND PERFORMANCE ART

Genius is the extravagant manifestation of the body.

(Arthur Craven)

You value him [Jackson Pollock] because he had made such a radical gesture with the invention of drip painting; the result didn't matter as much as the gesture. Then you valued him because the gesture meant so much, in terms of the relationship between the painter's body and the canvas, the decentring of the self, the final abandonment of the Albertian window, and why not?

(Thierry de Duve)

The body is the new art medium of this century.

(Martha Wilson)

Our FASCINATION WITH THE ARTIST'S physical appearance, especially when linked to their creativity, has been encouraged by artists – many of whom have permitted themselves to be filmed or photographed at work. In the hypnotic footage of Picasso, Kandinsky and Matisse in the act of painting, or the 1950 film by Hans Namuth of Jackson Pollock at work (Figure 7.1), the creative process is as engaging as the actual art work itself. This fascination with process raised an interesting set of questions for the American art critic Harold Rosenberg writing in the 1950s, the most pressing of which concerned the very 'essence' of a work of art. Rosenberg's theory of what he called 'action painting' (in relation to the drip paintings of Jackson Pollock) hinged on the belief that the instinctive and spontaneous action of painting is the truest expression of an artist's individuality. Rosenberg was transfixed by the idea that the process of making the work of art is more important than the extant work of art: 'In this act

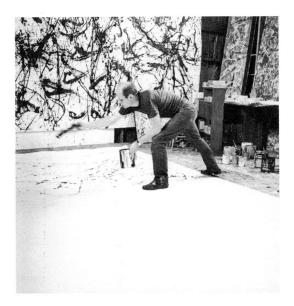

Figure 7.1 Hans Namuth, 'Jackson Pollock'. © Hans Namuth

timing is decisive; the object itself is a mere souvenir of the occasion' (Rosenberg 1982: 23).

Since an action painter eliminates all reference to anything other than 'his' (and it usually meant *his*) own unique and unreflective gestures, Rosenberg concluded that the work of art actually resided in the 'act' of painting itself. He regarded the painter as an actor and the picture an event. So in Jackson Pollock's dramatic confrontation with the canvas – 'an arena in which to act' – the creative moment is more important than the actual work of art.

This chapter looks at some of the other ways in which artists have used their bodies in the production of art. From performance art to artists using digital photography, we consider the use of the autobiographical body not simply as 'art' but as a site of political and social discourse.

Autobiography and authenticity

Action painting certainly privileges the unique signature style of the artist – even though, as in the case of Pollock, its effects may seem accidental and uncontrolled. By privileging the unique signature style of the modern artist, modernism also privileges the notion of the artist as a conveyor of personal 'truths'. The confessional mode, in which the artist or writer assumes a quasi-autobiographical intimacy with the audience, is a feature of post-war art and film – especially in America. The self-referential and angst-ridden expressionistic mode of painters such as Pollock and Rothko, and of writers such as Norman Mailer and Erica Jong, could be seen as part of what was called the 'culture of narcissism' (a culture parodied in many of Woody Allen's films).²

Autobiography has a privileged status in the hierarchy of discourses produced in the modern western world, and if we extend the definition of the genre to include other forms of self-writing such as memoirs, diaries and journals, then autobiography can be seen as a key component of the west's literary heritage. The notion of the author as sole authority, solely responsible for his or her writing, is important to our consumption of autobiography because modernism has made it possible to be highly personal and yet, at the same time, to convey a 'truth' that is communal. Autobiography allows the interior expression of personal self-writing to become the exterior collective story of a communal group with a vested interest in sharing desires, aspirations and histories. So Wordsworth's *Prelude*, Jean-Jacques Rousseau's *Confessions*, Gertrude Stein's *The Autobiography of Alice B. Toklas* communicate under various autobiographical guises to a like-minded community.³

Finally, the art of autobiography is contingent on a particular set of notions of *self*. First there has to be a consensus of agreement about what constitutes a self, before one self can represent itself to another. In telling one's unique story one has to have common ground, a common sense of self, with others before the story can be consumed. We have to believe that the 'I' doing the speaking is not dissimilar to 'us' doing the reading. This is one reason why the west finds it so hard to deal with art from other cultures and tends to understand that art in terms of its own knowledge – for instance, regarding Aboriginal art as though it were akin to abstract expressionism.

The autobiography, whether communicated in art or literature, is a form of myth-making which casts the self-writer as the hero or heroine. This may extend to writing which is about another subject, as the case of Rosenberg who cast Pollock in the starring role in 'the mythic act' of action painting. However, autobiographies do not always have to be genuine or to have been actually lived. Unlike an earlier generation of artists, who believed that authenticity of lived experience conveyed all sorts of universal truths, in much of the art we will consider in this chapter, the artist's ability to establish a point of view or a narrative which is believable is far more important than conveying absolute truth. This belief sits well with contemporary critical theory, where the suggestion that truth is relative rather than absolute has been amply explored, for instance in 'Myth Today' (1957) where Roland Barthes questions the relationship between 'ideology' and 'truth'.

The question of 'truth' in contemporary art practice is a difficult one. On the one hand, the authenticity of lived experience is highly important in validating modern art. For instance, from the pseudo-confessional paintings of David Hockney in the 1960s to the 'Queer Politics' of the 1980s and 1990s, the importance of openly acknowledging one's sexuality ('coming out') is one example of the way in which authenticity is a hallmark of 'truth' in modern art. Hockney's *Third Love Painting* (1960) includes text, poetry and graffiti in combination with an abstract expressionist and pop style of painting. *Third Love Painting* is about homosexuality, and yet was painted at a time when homosexuality was illegal in Britain. Hockney said that the painting was an act of propaganda for homosexuality which he felt 'should be done' because it was 'part of me'. However, the painting is highly coded and not immediately accessible to those not 'in the know'. In recent years, artists have dealt with homosexuality in much more uncompromising terms, for instance Bruce Naumann's neon-lit explicit depictions of homosexual group sex show by how much the overt has superseded the covert.

In Seedbed (1971, Sonnabend Gallery, New York) spectators were invited to walk across a ramp beneath which the performance artist Vito Acconci was reportedly masturbating while his grunts were amplified around the space;⁴ in the 1970s the Vienna Aktionist Rudolf Schwarzkogler exhibited pictures of a bloody bandaged stump, claiming to have cut off his penis (he had not);⁵ in the 1960s Yves Klein collaged a photograph to show himself jumping off a high wall (which he had not). These 'suggestions' are interesting precisely because the artist's body is temporarily designated as the site of 'truth'. Not necessarily true in the sense of 'actual' but true in the sense of being 'capable' of truth within the confines of a consensus of agreement about what, historically at least, constitutes art.

Other examples of artistic 'untruth' include the Australian performance photography collaborators, Farrell and Parkin, who deliberately play upon linked ideas of sex, pain and death, in what look like reconstructions of torture chambers (Figure 7.2). In their exhibition 'Black Room' of 1992–93 they use their own bodies and eighteenth-century bandaging techniques and prosthetics to play upon visual ambiguities and to tell 'untruths'. The works excavate, in the archaeological sense, lost forms of knowledge – such as alchemy and forms of healing. Crucially, the viewer interprets the past in the light of the present, often misreading the works as sadomasochistic, and not as a history of early medicine. For instance *Untitled Image #1* shows a 'tranquillising chair' designed by Benjamin Rush in 1810. The chair was designed to restrain and blindfold distraught patients in order to restabilise them by removing sensory experiences. However, to the contemporary viewer *Untitled Image #1* evokes images of the electric chair. Because we do not possess the visual references to read Farrell and Parkin's work correctly, the images force us to re-evaluate the status of what we currently call knowledge.

Performance art

The advent of what became known as performance art in the 1960s and 1970s gave a further dimension to Rosenberg's suggestion that an art work should strive to be a

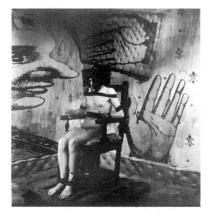

Figure 7.2 Farrell and Parkin: Untitled Image #1, from 'Black Room' (1992–3). Courtesy of Open Eye Gallery, Liverpool

'unique signature'. Normally, performance art involves a body or bodies localised in time and place for the purpose of a live event, which may or may not be documented. In performance art the art work is inseparable from the process of enactment. For example, Breaking Test (Zerreissprobe) (see Figure 7.3) is a 'work of art' by the Vienna Aktionist, or performance artist, Günter Brus in which the artist urinated, defecated, masturbated and slashed himself with a razor blade. We are offered an 'art work' that resides wholly in the artist's body located in time and space – in this case, Vienna in 1970. There is no other art work, no resulting paintings, no artefacts, only 'documentary' photographs of the live event. The 'actions' of the performance, like those of the action painter for Rosenberg, are essential to the work of art but, in this case, they do not give rise to any 'incidental' work which may be bought or sold after the event. 6 Unlike conventional painting or sculpture, performance art identifies the work of art as the performed event. The event – and therefore the work of art – may last a few moments or a few days; it may involve one artist or several; it may include music, poetry and dance, or it may be silent. It may or may not invite audience participation. Performance art is often said to be the only art form which guarantees the actual presence of the artist. There are, however, numerous exceptions to that rule: for example, the German artist Rebecca Horn often choreographs models to enact her ideas rather than 'performing' herself.

An art work which dispenses with all the paraphernalia traditionally associated with art making - paint, brushes, frames, chisels, marble, art galleries - should really be seen in the context of the so-called 'dematerialisation of the art object' in the 1960s (see Lippard 1997). Sometimes called conceptual art, this movement within post-war western art was often a deliberate strategy on the part of artists to expose the covert symbiotic relations between art institutions and the art market, and also to evade the institutionalism that seemed to have neutralised earlier avant-garde art movements. In theory, the 'dematerialised' art object – in performance art, conceptual art and land or earth art - undermined the authority of the gallery, the auction house and the dealer, precisely because such art had no real currency in the twentieth-century operations of the art market. For example, it was supposed to be difficult to make a commodity of either the performance artist's body or the 'suggestion' made by an item of conceptual art. However, the art market exists to preserve the sanctity of the commodified art work and it has been remarkably resilient in finding ways to incorporate conceptual art. The performance artist therefore parodies the 'art object' (the thing in itself), rendering its commodification futile since the work can only exist once the performance is over in the guise of documentary 'evidence' - photographs, memorabilia, and perhaps film or video. Yet the will to art objecthood is strong and the art market will always find a way to barter; so incidental memorabilia - especially in the form of headline-grabbing publicity - is eminently marketable. As Lucy Lippard pointed out in 1967, the performance artist is no more exempt from economic and ideological 'exploitation' by the art market than the next painter or sculptor (Lippard 1997). Conversely, performance artists themselves can exploit the publicity value of what they do.

This somewhat romanticised view of performance art as a unilaterally defiant declaration by the artist about what constitutes a work of art points to the continuing presence of the modernist construction of the 'artist as hero'. It rests on the premiss that the artist – in the sense of the unitary self which we encountered in Chapter 3

- is a figure who is expected to subvert classifications and transgress boundaries, just as those unitary selves who have made the canon of modern art were engaged in redrawing the boundaries. As we saw in Chapter 1, it is in the function of a selfannointed avant-garde to do this. The attitude of this type of avant-garde activity stems from a set of strategies designed to conflate the artist and the artwork that emerged at the end of the First World War. The underlying spirit of performance art and the challenge it presented to the institutional infrastructures of art has roots firmly in the international events staged under the aegis of Dada cabaret and futurist evenings of the 1910s. It is tempting to see performance art as an extension of fine art practice, or as merely a reductive offshoot of avant-garde theatre, or as the two combined under the rubric of 'Happenings' and 'Fluxus'. We have seen how, through Dada and Duchamp, the art work could be whatever the artist said it was. Indeed, when asked 'What is art?', the German collagist and sound poet Kurt Schwitters replied 'Everything the artist spits out is art'. To follow his logic, forty years on, through to the age of the dematerialised art work, it became only a small imaginative leap to accept that the artist's body, a thing in itself, can be the art object in the orbit of the art work.

The subjective body

[T]he old metaphysical opposition of inside versus outside, soul versus body, is the very basis of expressionism . . . however decentered in relation to society (Marx), the unconscious (Freud), language (Saussure), science and technology, the self remains sovereign in art.

(Hal Foster 1985a: 75)

The history of the study of the body is a relatively new area of inquiry, arising from a convergence of histories such as medicine, food and hygiene, gender and sexuality. Contemporary social anthropologists such as Ted Polhemus, Mary Douglas and Bryan S. Turner foreground the body in their work; making the body (as opposed to previous discourses of class) the axis around which all sociological analyses turn. Of course, the body has seldom been absent from the visual arts. In western art the body is prominent, though it is absent from several non-western cultural forms. However, the use of the term the *body*, as opposed to the *nude*, is a relatively recent phenomenon in the history of art.⁷ The changing discourses around the body require a different set of critical tools and a vocabulary imported from social anthropology and philosophy rather than formalist aesthetics. To talk in terms of beauty and aesthetic value in relation to performance art is to completely misread the work: performance art demands a broader lexicon.

For performance art, the centre-staging of the autobiographical body – the self – in art from the 1960s in particular, has had a profound effect on notions of artistic expression. We saw in Chapter 3 how artists' search for new and authentic experiences led some to turn in on themselves to make perceived 'inner experience' the basis of their art works. Here we revisit the process of subjectification in which social networks, political systems and cultural codes conspire to shape the subject, in order to examine how discourses of identity, histories of the subject and cultural inscriptions of the body all converge.

The artist's body, for example in Günter Brus's interpretation of action painting, may be both the subject and the object of the work of art. The body becomes, literally and simultaneously, the medium and the tool. Brus's gestures with bodily fluids are analogous to Pollock's fluid skeins of paint,8 only, in Brus's case, the connection between the body and the gesture is explicit – a cypher for the 'return of the repressed'. The overarching themes of self-mutilation and self-destruction were not only corporeal expressions of Teutonic angst but part of the rhetoric of being free, in a Freudian sense. The psychoanalytic idea that sadism, aggression, greed, obscenity (all acted out in Breaking Test (Zerreissprobe)) and other primal human drives are 'buried' or repressed in every one of us implies that to express them is to be liberated and free. The idea of freedom is further rooted in the Romantic belief that the 'essence' of a work of art can overcome its material form. So whereas Pollock, according to Rosenberg, is a subject producing the object, in the case of Brus, the performing subject is also the object of the art work. As long as the artist's body remains the work of art there will be only a limited number of ways in which that work of art can be reconfigured.

Returning to our claim that the artist's appearance in the creative act has long been of great interest to modern art, for artists to actually reconfigure their appearance, or to surrender their bodies to another's control, is to foreground notions of subjectivity. Take, for example, the French artist Orlan, who has enjoyed a good deal of media attention as a result of shocking cosmetic surgery by which her face and body have been spectacularly remodelled. Recalling what was said about artists' publicity-seeking tactics as commodification in recent years, Orlan's work does graphically illustrate the kind of question that accompanies this literal understanding of the body as work of art. Orlan is gradually creating a total work of art out of her body which, she says, she intends to leave to a museum rather than to medical research when she dies. The operations she instigates are the equivalent of Rosenberg's concept of process - they are watched by an audience, via satellite, and filmed for subsequent showing - but the record of process is a bizarre spin on the Hans Namuth film of Jackson Pollock. Unlike Rosenberg's belief in the gesture being paramount, it is in part in the act of watching the performed event but also in part in Orlan's reconfigured physical body that the work of art exists.

In Chapters 3 and 4 we saw how the exact nature of the subject-object division has long been a philosophical problem, but that the usual formula is to describe the subject as that which acts and the object as that which is acted upon. For instance, in the relationship between artist and model, we saw how the objectification of the female nude is contained within the discourse of subjectivity which identifies the subject as masculine and the object as feminine, and presents this relationship as 'natural'. An extension of the terms 'subject' and 'object' gives the terms 'subjective' and 'objective'. To be 'objective' usually means to be impartial, rational and in command of the relevant information; while to be 'subjective' is to be involved, engaged and to stake one's claims on the basis of personal conviction. A degree of objectivity is often the hallmark of empirical history, but that any individual subject (a writer, an artist, an art historian) can ever be truly objective is a questionable proposition.

Poststructuralist thinkers such as Julia Kristeva and Michel Foucault have dealt with the notion of subjectivity as though it were a link between individuals and

the ideological power structures around them. In poststructuralist writing, ideas such as 'learning to live with the contradictions' acknowledge the difficulties of any easy distinctions. The subject - that is the acting person writing history or making art - is always constituted in and by 'language' and, therefore, the French Marxist philosopher Louis Althusser argues, is in the grip of an ideology which precludes objectivity altogether. As Edward Said put it: 'Of what philosophical use is it to be an individual if one's mind and language, the structure of one's primary classifications of reality, are functions of a transpersonal mind so organised as to make individual subjectivity just one function among others?' (Said 1975: 293). The concept of individuality within western monopoly capitalism's commodity culture is sacrosanct - the myth of the individual subject as the basis of all buying power. Said's critique of the individual is, therefore, deeply subversive when capitalism is contingent upon a consensual notion of individuality shaped in terms of ownership. Paintings and works of art function in the marketplace only because their 'unique signature style' guarantees their authenticity and exclusivity. When push comes to shove, we can all paint like Pollock but it is in the interests of monopoly capitalism that there is only one Pollock. By the same token, the market takes such an equally dim view of fakes and forgeries; after all, if it looks like a van Gogh why does it matter if it is not a van Gogh?

The modernist ideal in which the artist's idiosyncratic gestures are unquestioningly received by the viewer is the basis of a notion of genius in western culture. So it *does* matter that a number of van Gogh paintings are now believed to have been painted by an aquaintance, Claude Emile Shuffenecker. The 'authenticity' of the work includes, though is not exhausted by, the fact that it guarantees the presence of the artist. But, like Marxist social theory, poststructuralist theories of the artist tend to be dismissive of the concept of genius in terms of its potential to overcome the social constraints that shape identity. They argue that this model of the active artist and the passive viewer is unsustainable. Of course, in the 1970s when poststructuralists began to advance such arguments, art practice had already begun to shift and to question established ideas of genius and creativity.

The body politic

I do not need to visualize the word in order to know and pronounce it. It is enough that I possess its articulatory and acoustic style as one of the modulations, one of the possible uses of my body. I reach back for the word as my hand reaches towards the part of my body that is being pricked; the word has a certain location in my linguistic world, and is part of my equipment. I have only one means of representing it, which is uttering it.

(Merleau-Ponty 1989: 180)

The period since the 1960s – whether or not we give it the title *postmodem* (and as we have seen the distinction between modern and postmodern is a slippery one) – has offered a radical critique of established structures of sexuality, race and gender and has revealed the political bias of what was paraded as natural and neutral under modernism. Postmodernism calls into question codes, structures and societal relationships

– and with it the very structures by which we come to understand the world and our position within it.¹⁰ What is important here is the notion of the individual subject and how that subject represents his or her position within society. Given that unmediated self-expression and subjective experience is reportedly defunct under postmodernism, it is ironic that the phrase 'express yourself' is more that ever a rallying cry for the disenfranchised. In an uncertain world, following our individualistic instincts seems to be one of the few ways left to validate our place in the overall scheme of things.

Postmodernism may have deprived us of some of our staple ideas (for instance, the idea of a unitary or core self) and unmasked the experience of being that we call 'identity' as an illusion but it does not preclude the possibility that many individuals do indeed feel that they have 'identities'. Although dismissed as a productive fiction, the trappings of individualism, especially the expressive significance of bodily activity, seem to be intact. Laying aside the proof that everything we think of as unique about ourselves is ultimately always socially instituted, there remains the sense that individuals do have a unique way of doing and saying particular things. Forgetting all the things that mark our activities as common, we are left with the realisation, however contentious, that the body is not a passive object seized by social practices but an active living entity, a being who learns from the social but then expresses what is learned in what are perceived to be unique gestures. Just as it is unsatisfying to view the body as the instrument of a non-material free will, so too it is wrong to conceive of it as the passive tool of social forces. The traditional dichotomy of free will versus determinism will not suffice as a model for the expressive body.

The expressive body becomes political when it meets other bodies, since at the point where one body ends and another one starts there are borders, and borders inevitably generate dispute. According to Judith Butler (1990: 139):

If the body is not a 'being' but a variable boundary, a surface whose permeability is politically regulated, a signifying practice within a cultural field of gender hierarchy and compulsory heterosexuality, then what language is left for understanding this corporeal enactment, gender, that constitutes its 'interior' signification on its surface?

The claim that the female body (and indeed other bodies) is politically and socially inscribed is symptomatic of the ways in which the physical body has been reconfigured in cultural and philosophical discourse since the 1960s. In particular, the notion that the body is a metaphor for social and political models of behaviour is crucial to understanding the claims of much performance art. Mary Douglas (1984: 115) wrote that 'the body is a model that can stand for any bounded system. Its boundaries can represent any boundaries which are threatened or precarious.'

The artist Marina Abramovic explores the most precarious manifestation of the boundaries that can obtain between bodies – when bodies come under threat from other bodies. In her earliest work, for example *Rhythm O* (1974, Naples), Abramovic allowed herself to be physically and verbally abused by an audience for a period of six hours. Instruments of torture were laid out on a table as in a surgical operating theatre, and Abramovic permitted herself to be stripped and slashed. She explained the work, equating physical suffering with the emancipatory politics of self-

expression: 'you have to nearly break your body before you can free the mind'. In Art Is Beautiful. Artists Must Be Beautiful the artist brushes her hair in ever more vigorous strokes until she scratches her face with the hairbrush. Of course there is ample precedent in many cultures for the idea that physical pain is a means of self-realisation (for instance, in most religions where male denial of the body is a means to higher spiritual states) and that the mind is a prisoner of the body unless the body is physically undermined.

It is not really surprising that women have been generally excluded from access to this spirituality since women have historically been seen as in thrall to their bodies to the detriment of their mental development. Centuries of patriarchy have shaped and maintained a myth of woman as closer to nature, a martyr to her hormones, prone to hysteria¹¹ and irrationality. As Diana Fuss puts it, 'on the one hand, woman is asserted to have an essence which defines her as woman and yet, on the other hand, woman is relegated to the status of matter and can have no essence' (Fuss 1989: 72).

We will return to this culturally complex designation of woman shortly, after first considering another interesting question for the body politic raised by Abramovic's performance. Although such works as *Rhythm O* or Brus's *Breaking Test (Zerreissprobe)* (Figure 7.3) are 'art' by declaration (since someone not sanctioned by the label 'artist' performing similar acts would be in danger of being declared obscene or insane), there is a consensus to 'suspend disbelief' around Abramovic's actions – to designate the processes of sadomasochism and self-immolation not simply as 'art' but as a gesture by the individual which is of collective interest and capable of collective representation. By definition this is what the body politic is.

It can be inferred from the examples given thus far that many works of performance art are provocative - the result of a particular notion of spectacle and display in which expressive bodies enact their message. In the past, performance art has been criticised as being 'mere' theatre because it dramatises the relationship between object (in this case, the artist's body) and beholder. Perhaps it is because the performance artist is generally in direct contact with the viewer (that is, unmediated by a canvas¹²) that the message of the event can be uncompromisingly direct. 'Protest art' - as some forms of performance art were termed in the dissenting climate of the late 1960s - which sometimes mimed but more often re-enacted sadomasochistic acts, drew upon Bertolt Brecht's notion that the audience-performer relationship should be an uncomfortable one since this would reduce the gulf between the two. In 1972 the English performance artist Stuart Briseley lay in a stagnant bath in a darkened room for two weeks and invited an audience to watch the squalid spectacle which he intended as a metaphor for the alienation of the individual. Entitled And For Today . . . Nothing, this was an act of symbolic self-punishment which signified Briseley's feelings about human alienation and the depoliticising of the individual. Briseley's work demonstrates the move from body to body politic, the invocation of the body for the purposes of broader social comment or political demonstration.

Many performed events – and particularly those by women performance artists – were designed to unsettle the audience, just as surrealist film had aimed to do thirty years earlier. Why is it necessary for performance artists to perform in the nude? Why did so many resort to sensationalist tactics? Some see it as a Brechtian intervention to disabuse the audience of their cosy middle-class sensibilities; others,

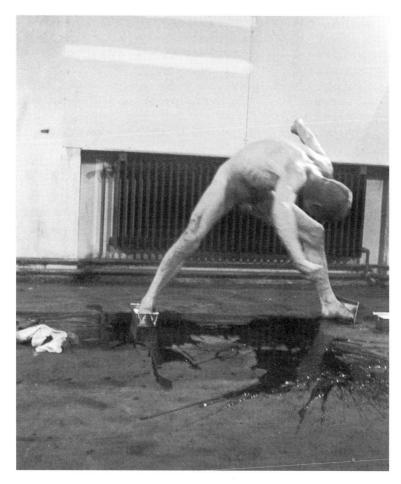

Figure 7.3 Günter Brus, Breaking Test (Zerreissprobe), Aktionsraum 1, Munich 1970. Courtesy of Günter Brus. Photo: K. Eschen

however, have argued that the performance artist's banalisation of sex and bodily waste is a strategy not so much for shocking or offending middle-class sensibilities but for 'getting back to the body' (Brookes 1991: 144) precisely because, in contemporary western culture, we do not generally expose our bodily functions to public scrutiny. As a metaphor for dissent or alienation, the annexed body, standing naked on a stage or in a gallery, rests partially on a notion of the 'abject'. Julia Kristeva's definition of the abject is that which 'does not respect borders, positions, rules' (1982: 4), and includes excrement, bodily emissions and death itself.

Whether just as a strategy for 'getting back to the body' or as exorcisms of the abject, the breaking of bodily taboos is a large part of the repertoire of performance artists. Bill Viola's The Messenger (1996) projected onto the Great West Door in Durham Cathedral is a secular image of a male body floating under the water, coming to the surface and gasping for a deep breath (Plate XI).¹³ The Messenger reflects Viola's recurring motif of mortality: his belief that life begins and ends with the body. Viola also videotaped the birth of his child and the death of his mother in *The Nantes Triptych* (1992). Bob Flanagan recorded his illness and death from cystic fibrosis on 4 January 1996 in a film entitled *Sick: The Life and Death of Bob Flanagan, Supermasochist* (USA, 1997). Of course, there are many examples of the abject, especially the corruption of flesh in the history of Christian art where they served to highlight the mortality of the flesh and the transcendence of the soul. These secular images of death, although we might invest them with a 'spiritual significance', tend to reinforce the limitations of existence in and through the body.

The phenomenal body

Signifying must not be understood on the order of an immaterial mind that controls the body as a captain steers a ship. A person *is* his or her body. Once it is signified to someone that such and such an action is to be carried out, he therewith performs the bodily action that constitutes the signified one. For it is the same person signified to who, *in being his body*, carries out bodily activity. There is no need for him to seize, occupy, or activate his body in order for bodily activity to occur . . . an instrumental body does not imply that the body is an instrument. (Schatzki 1996: 45)

The emergence in the second half of the twentieth century of the notion of the 'body politic' testifies to a changing set of ideas about what the body may signify. Our way of thinking about the body changed in the post-war period largely as the result of two types of discourse – social anthropology and French philosophy. What these discourses have in common is their contention that the physical body is an object we 'perceive' rather than one which we 'possess'. For example, in the nineteenth century anthropology measured black people using quasi-scientific methods to order and classify 'species' as a justification for colonial rule. However, the social anthropology of the 1970s argued that 'the human body is always treated as an image of society' (Polhemus 1978) and that the physiological properties of the body are subordinated to their ideological position within any given society.

James Luna's 1990 Artifact Piece (Figure 7.4) combines performance and mixed medium to question the representation of Native American Indians and artefacts in North American museums, and shows how not all bodies are equal. Polarised as they are, these two positions bear witness to a sea-change, in which the ways we 'perceive' the body are ultimately conditioned by society.

Maurice Merleau-Ponty (1908–61), Professor of Child Psychology and Pedagogy at the Sorbonne in Paris, made the body the centrepiece of his philosophical inquiry. He posited his theory of 'the primacy of perception' in *The Phenomenology of Perception* (1989). In brief, this maintains that all our higher, intellectual functions are contingent upon our preflective bodily existence – that is, perception. His writings emphasised the bodily nature of the human subject – or what he termed 'the philosophy of the lived body' (*le corps propre*). Merleau-Ponty said that the lived body is not an 'object' in the world, separate and distinct from the knowing subject, but that the body is the subject's own 'point of view on the world' – that is, the

Figure 7.4 James Luna, Artifact Piece, 1990. Courtesy of the Artist

knowing subject. This privileging of the live body is understood not just as a physiological entity but as a 'phenomenal' body – the body as individuals experience it. However, individual experience is not a purely cognitive process – as Enlightenment thought maintained. The distinction between being and having a body is an important one.

Representing one's specific experience of being a body or of lived experiences of class, race, gender, sexual orientation or health is a preoccupation of much postmodern art — as opposed to modernism's preoccupation with universal 'truths' accessed through the subjectivity of the artist. The British photographer Jo Spence's autobiographical images reinforce many of the ideas which we have discussed — namely that the artist's body can be both the subject and object of the work of art — both photographer and photographed. In *Putting Myself in the Picture* (1988) phototherapy is primarily a means of self-knowledge which operates also at the level of wider cultural critique. Reclaiming her body from overarching cultural identifications that narrow the range of acceptable imagery of and for women, Spence makes personal exhibitionism into a defiant political act. Her photographs, essays and commentary combine personal history (memory) with omnipresent comments on the power of photographic images.

Putting Myself in the Picture chronicles Spence's own 'rise' behind the camera, from photographer's assistant to phototherapist; and in front of the camera, from the (com)posed to the self-posed. Spence's use of photography is revealing, challenging the notion of photography as an recorder of 'objective' truth, Spence uses it to explore 'subjective' experience. Disempowered by hospital procedures, being the other side of the lens enabled Spence to represent her lived experience as the object of medical intervention. Spence turns surveillance techniques to her advantage. She comes to realise that she should 'use photos to ask questions rather than

to try to show facts' (Spence 1988: 98). She seeks to undo the social construction of the female subject in order to expose the power relations that have shaped it. Spence fixes on her body - not least because her own experience of breast cancer led to a partial mastectomy. One frontal photograph shows the artist before surgery with the words 'PROPERTY OF JO SPENCE?' written across her left breast (Figures 7.5a and 7.5b). Spence's show of control over the representations of her body in an overtly hostile body politic (social as well as medical) exposes the myths and prejudices that censor certain bodies. In the west, in spite of cultural diversity, mainstream images of women exclude the vast majority of women - on grounds of race, class, age and size. However, Spence's autobiography is unresolved: 'there is no peeling away of layers to reveal a 'real' self, just a constant reworking process'. (ibid.: 97). This is far from the modernist idea that inner-self may be expressed unmediated by social forces and recalls Judith Butler's idea of an illusionistic 'gender core'. Photographs of Spence's body before and after medical intervention are poignant examples of the phenomenal body. Spence, the physiological entity, has since died but the photographs record that for a number of years the experience of that body constituted her own 'point of view on the world'.

Unitary selfhood and the 'decentred subject'

As Terry Eagleton has pointed out, 'certain meanings are elevated by social ideologies to a privileged position, or made the centres around which other meanings are forced to turn' (Eagleton 1983: 131). The notion of selfhood in the west continues to possess one such meaning. As we have seen, the construction of the artist as self and the viewer as self is a formalist one, where art is autonomous and comprised of discrete objects. Under this model of artist and art work, the individual is consciously and directly expressing his or her self to another self in the medium of paint, dance, poetry, music or performance. Expression in this sense is, according to Hegelian philosophy, where 'idea' achieves 'form'. It relies upon the continuing understanding that the intellectual and contingent worlds are separate and that expression is a temporary meeting of the two.

In terms of the phenomenal body, nothing is meaningful until it has either been experienced by the body or experienced by the body in and through the mind. Set against orthodox western notions of unitary selfhood, the complex negotiations between mind and body in the understanding of selfhood are highly problematical. Writers often identify the separation of mind and body as beginning with Descartes, who differentiated between 'matter' (res extensa, which is divisible – malleable) and 'mind' or 'soul' (res cogitans, which is indivisible – immutable). Freud, many believe, destabilised the notion of a rational self by identifying influences which were beyond conscious control – namely the unconscious. For Jacques Lacan (psychoanalysis) and Derrida (deconstruction) the self is a fiction – an illusion of storytelling. Ferdinand de Saussure's theory of linguistics problematised language, arguing that the old certainties that the subject employs language to pursue his or her own purposes should in fact be reversed in favour of a model in which the subject is actually spoken by language – the autobiographer is not the speaker of a neutral language but the unwitting carrier of a loaded language. Social anthropology

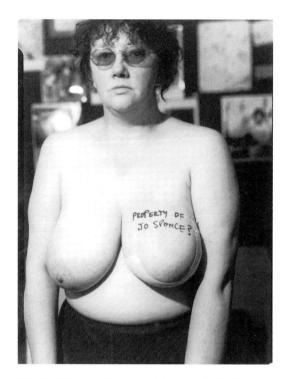

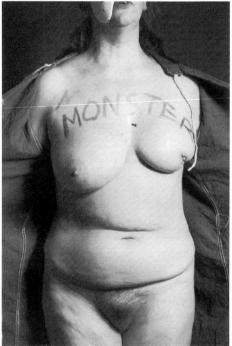

Figure 7.5 (a) and (b) Jo Spence/Terry Dennett, Property of Jo Spence? and Monster, from the Cancer Project, 1982. Courtesy of the Jo Spence Memorial Archive

and the systematic investigation of non-western cultures have demonstrated that a sense of self is by no means universal and is always contained within language.

Yasumasa Morimura, through a process of reconfiguring the self into a kind of 'technotransvestite', uses digital technology to produce multiple selves. 14 For Morimura, currently interested in growth hormones and cosmetic surgery, the reconfiguring of the unitary self is not a negative act but opens up the possibility of freedom. He says: 'if it were possible to liberate ourselves from the bodies and characters we were given and to choose a favourite combination ourselves, expressions like "true face" would eventually become superfluous. And of course we would have no need for words like "self" (quoted in Weiemair 1996: 236). Morimura's Angels Descending Stair (1991) reworks Edward Burne-Jones's Golden Staircase. In the original, Burne-Jones's classically timeless bodies, at their most unphenomenal, are apparently unaware of the spectator's gaze. Morimura completes Burne-Jones's asymmetrical design so that the image is mirrored into a whole, with each figure reflected in reverse. In addition Morimura superimposes his androgynous face and body, clothed in a timeless shift, thirty-six times on the circular staircase. His serial replication of digitised selves attacks the west's notion of the unitary self by confronting it with sexually and racially ambiguous 'otherness'. His cultural intervention into western universals plays on stereotypes that are dependent on the notion of unitary selfhood.

Postmodern writers tend towards the view that that there is no such thing as the unitary self. The postmodern self is split between self—other and conscious—unconscious and the search for unitary selfhood is itself a shifting enterprise. This is not to say that there is no longer a dominant liberal humanist notion of unitary self or that all notions of unitary selfhood have suddenly been replaced by a postmodern heterogeneous model.¹⁵

'Decentred subject' is a phrase often used in relation to modern notions of the self. To understand the implications for current performance art practices of the 'decentred subject', the latter has to be seen as part of the project to undermine the notion of a fixed centre of any description – fixed centre of identity, of consciousness, of history. Freud's 'discovery' of the unconscious removed the certainty that there is rational and conscious mind at the centre of being and Jacques Lacan's formulation of the 'mirror stage' has undermined it further. Reductively put, the 'mirror stage' is that stage in a child's development when, between 6 and 18 months, the child develops the capacity to recognise his or her image and follow his or her movements in a mirror. The real conceptual leap for the child, however, is the awareness that accompanies this discovery, that there is a gap between self and self-image. Lacan also argued that women are born to a condition of 'lack'. The infant, according to Lacan, is not a human subject, but becomes one gradually through a subjectively illusory sense of autonomy. The infant gradually takes on a sexed identity, but at that moment female infants come to realise their lack of a phallus - not in the Freudian sense of lack which leads to 'penis envy', but lack of a symbolic phallus, that stands for patriarchy. Infant girls are therefore unable to assume a place in the symbolic order of sovereign power. Although Lacan's ideas have been hotly debated, many feminist critics have seized upon his account of the moment of 'decentring' of self in the mirror phase and of the realisation of 'lack' as the mechanisms by which the individual subject is separated or alienated from larger cultural structures.

Ecriture feminine: from essentialism to poststructuralism

Linnaeus¹⁶ what would you say,
how define such wanton play?
vaginal towers
with male skirt,
gender bending water sport?
(Helen Chadwick, *Piss Posy*, in Curtis 1993: 47)

Nearly half of all the works performed in the 1970s were given by women. It is hardly surprising that those defined as 'other' should have been particularly concerned with questions of identity and selfhood. The female performance artist brought with her a complex, if occasionally repetitive, repertoire of experiences around which she negotiated the autobiographical intimacies of self. This coincided with the emergence of the women's movement and the wholesale reappraisal of art's objects and subjects. In 1971 the American art historian Linda Nochlin published an essay whose title asked the question 'Why Have there Been No Great Women Artists?' (see Nochlin 1989), and a year earlier Germaine Greer published The Female Eunuch. While Nochlin's essay listed all the external constraints that had prevented women from becoming 'great' artists (most of them relating to lack of access to the institutions of art), Greer emphasised the internal constraints by which women have been 'bred' to undervalue themselves, referring to what she called 'damaged egos'. With hindsight, we can now see that both explanations were symptomatic of an unfolding history of ideas about women - from the psychoanalytical positioning of women as 'other' to the linguistic formations of a male-centred lexicon, to Marxist-feminist revelations about gender - all of which impacted, in particular, upon women's performance art.

One feminist concern upon which opinion is divided is the question of whether an art practice which is inherently female actually exists. The same question was first asked of literary practice, and to much the same effect, with women writers such as Virginia Woolf describing how they felt handicapped by the legacy of a language that is overpoweringly male and wondering what it would be like to write a female sentence. In much the same way women artists either work within the framework of existing art practice or seek a separate one. Feminist writers such as Hélène Cixous have put forward the idea of an *écriture feminine* which is exclusively associated with the female transgression of established forms of language, grammatical structures and meanings. Cixous (1981: 256) believes that:

women must write through their bodies, they must invent the impregnable language that will wreck partitions, classes, and rhetorics, regulations and codes, they must submerge, cut through, get beyond the ultimate reserve-discourse, including the one that laughs at the very idea of pronouncing the word 'silence'.

This coercive language – women 'must' obey the call to a feminised separatism – is not always seen as being in the best interests of feminism. On the contrary, the idea of the 'pure essence' of the female (as expressed in an inherently female art practice)

overcoming the institutional and/or gender conditioning described by Nochlin and Greer has raised eyebrows among anti-essentialists. Much feminism has been about deconstructing the idea of 'man' as a natural and normal category against which all human experience can be judged. The problem is that the proposed category of 'woman' seems also to overlook the experiences of black women, working-class women, lesbian women and non-European women. Ideas about identity as the sum of socio-economic circumstances are so prevalent in contemporary critical theory that the notion of a more supranatural identity (essentialism) is untenable to many. Can women transcend conditions of time and place and just *be* women? These are questions that concern, obliquely or directly, the female performance artist.

In the context of androcentric art practice, the popularity of performance art among women in the 1970s was part of the search for a feminised art practice. Painting and sculpture were seen as male media; even the paint-brush has been described as ultimately phallic. When Shigeko Kubota performed her Vagina Painting in 1965, attaching to her knickers a paint-brush that had been dipped in red paint and squatting over a piece of paper, she parodied the associations of the paint-brushas-phallus as used by action painters in the 1950s and Piero Manzoni's signature on the model in Living Sculpture (1961) (Duncan 1988). On the one hand, Kubota appears to literally pre-empt Cixous' call for women to 'write through their bodies'; but, on the other hand, this kind of feminist aesthetic has subsequently been revised in the 1980s on the grounds of 'biological reductivism'. But the project of 'making visible' that which traditionally was concealed - especially by drawing attention to female genitalia - was a necessary part of the genesis of the feminist project. Radical feminism of the 1960s and 1970s was very much associated with 'gynocentric' strategies. This first generation of feminism - sometimes called 'essentialist' feminism - was superseded in the 1980s and 1990s by second-generation 'poststructuralist' feminists.

Language and text-based performance is important to much contemporary feminist art. The radical questioning of gender roles has by no means been abandoned and the body is still an important site of emancipatory politics. Helen Chadwick, an artist who was known for working with the body, exhibited Piss Flowers, a set of twelve shiny white-enamelled bronzes arranged on the gallery floor. Each bronze is in the shape of a five-petal flower with a stamen in the middle, but was actually cast from plaster moulds made from 'piss holes' in the snow created by the artist and her male partner David Notarius. The fact that 'piss' is the origin of the form that the work takes is obviously important or else the artist would not acknowledge the fact in her title. Some critics have aestheticised the piece, commenting on the sensuous qualities of the bronzes; others read the work as a feminist subversion of the male habit of urinating to create territorial markings. However, the artist is interested in metaphysical questions of mind and body, and how a work of art may unite the two. This might seem like a grand claim for pissing in the snow, but it has been argued that Piss Flowers are 'concrete realisations of the artist's body melting into the world outside' (Curtis 1993: 11).

Critiquing Jacques Lacan's theory that women are born to a condition of 'lack', Helen Chadwick's *Piss Flowers* can be seen as an inversion – the erect central stamen of the flower (Linnaeus's male sex organ) was made from Chadwick's urine, the flowery petals around it (Linnaeus's female sex organ) were created by the male

collaborator's sprinkling of urine. Chadwick's inversion of both Linnaeus's classification of plant species and Lacan's theory of lack parodies the virility of the creative male act by referencing one of the most basic of human activities. However, in critiquing the impartiality of science (in this case botanical classification), Chadwick also suggests the permeability of boundaries – that urine is part of the body until it is expelled – to be bounded by the body and then unbounded by the body.

Identity and 'identity politics'

The question 'What constitutes identity?' has, like notions of the self and the body, shifted in recent years. It used to be assumed that identity is a bedrock that binds us together – art works speak to 'us' and there is a universality in 'our' appreciation of them. However, the status of identity as a piece of absolute self-knowledge residing firmly in the conscious or rational mind has been questioned by Freud, Jung and Lacan. Although there are differences in approach, the abiding lesson seems to be that since the subject is constituted in and by language, so too is identity.

We saw in Chapter 4 how notions of the 'other' put forward by Edward Said and Simone de Beauvoir have been used to differentiate the unequal relations between dominant and marginalised groups, although, increasingly in a postmodern world, it has been argued that we are all 'others'. For our purposes in this chapter the 'other' is considered to be non-self – that is, 'not me'. To differentiate another's body in terms of its colour, sex, physical properties or sexuality is to confirm one's own identity. In terms of dominant discourses, the treatment of the 'other' is not always openly hostile: marginalisation can take a number of forms. What Gramsci defined as hegemonic control has been successful because it insinuates itself as natural and beneficial to the needs of both dominant and subservient groups. Thus hegemony may be endorsed from below by a confidence in its mutual benefits; for example, after the Second World War women vacated their 'unnatural' workplaces – shipyards, munitions factories and farms – and returned to their 'natural' workplace in the home. Hegemony operates only through complicit coercion so that women, in the case of post-war reconstruction, continued to justify male economic privileges.¹⁷

Exposing these forms of control and empowering 'the other' through an exploration of identity has been very much a project of artists working from a position which they establish as 'other'. Keith Piper's Surveillances: Tagging the Other (1992) is a video showing the head and shoulders of a young black man in profile surrounded by a computer generated box and the words 'subject' and 'reject'. The piece refers to the way in which young black men are visualised in terms of criminal stereotypes (or as potential criminals) in police photo-fits. Piper mediates representation in order to define 'identity politics' – in the sense that identity can be offered by communities formed on the basis of race, class, gender or sexual preference. That our belief in our own free agency should coincide with others' perceptions of their own free agency is the very basis of identity politics. For instance, although originally intended as shaming insults, the terms 'queer' and 'dyke' have been positively reclaimed by the gay and lesbian communities to neutralise their derogatory connotations.

While Piper exposes media stereotypes, Mary Duffy comments on the body fascism which has rendered disability and invisibility as one and the same thing. Cutting

the Ties that Bind (1987) consists of eight panels which, when read from left to right, reveal the artist's body unravelling from a winding sheet. What starts as a 'timeless', disembodied, shrouded figure is eventually revealed to be an ambiguous image, at once rooted in the classical Greek ideal of a fragmented torso, and in the less than idealistic construction of images of disability in current cultural practices. In Stories of a Body the artist, as both subject and object, questions attempts to normalise her body through medical technology. Our visual culture is one which does not extend the same cultural privileges to disabled bodies: the history of western art immortalises ideals – famous people, beautiful women, magnificent horses, heroic bodies. It largely ignores old age, physical disability and disease except to use them to impart salutary lessons. The 'emancipated' image of Mary Duffy striding away from 'the ties that bind' is one which uses the conventions of autobiography (self-writing) to re-present and make visible the specificity of individual experience of the body.

The obsolete body

Thus far we have seen the body (usually the artist's body) playing a crucial role in the communication of the art work. From pure self-expression to the body politic, the centre-staging of the body is a constant. However, some artists have questioned these overdeveloped notions of the self and the identity as residing wholly in one's own body. For instance, the work of the Australian artist Stelarc, while firmly rooted in body art, predicts the eventual obsolescence of the body. Stelarc's body art has taken on several aspects since the 1970s: suspending himself from meat hooks through his back over selected sites; inserting an endoscope in his stomach in an act of biotourism; covering his body with electrodes to shock his muscles into movement. Stelarc refers to his art in the third person: he refers not to 'my body' but to 'the body' - for instance, 'I suspended the body over a street in New York'; 'I inserted an endoscope inside the body', and so on. Stelarc's studied denial of first-person experience sits uncomfortably with his performances which surely cause great physical discomfort to the artist. His performances assiduously predict the obsolescence of the body: he stands for the nihilistic belief that our assumption that we will continue to experience the world primarily through our bodies will diminish in the face of our increasingly technologised environment. Stelarc's most recent performances use a 'stimulation system' to deliver up to 60 volts to electrodes strategically fixed on primary muscle sites. This causes Stelarc's muscles to contract and 'the body' to move. A touch-screen interface (sometimes controlled by internet users who send instructions down the line) choreographs the artist's movements during the performance. He usually stands next to a 'robot', a giant yellow crane with a rotating 'eye' or video camera which scans the stage around Stelarc.

Sterlarc's combining of his body with state-of-the-art technology has led some to compare him to a cyborg (although this is difficult to square with the more mechanised and sleek images of cyborgs in popular culture). As we saw in Chapter 5, the cyborg (a hybrid of human and machine) is a powerful metaphor in the twentieth century. In particular the cyborg in postmodern culture has assumed a metaphorical state equivalent to that described under the rubric of 'decentred subject'. According to Donna Haraway's 'Manifesto for Cyborgs' (1991), a cyborg is not

only a metaphor for postmodern notions of identity as 'decentred' and 'hybridised' but it 'denaturalises' received ideas about whole or unitary selfhood. Haraway asks a basic but profound question: 'Why should our bodies end at our skin?'. She argues that since new technologies have made it possible for us to think of ourselves as entities — a bundle of neurons that may be taken apart, combined with other entities or reconfigured altogether — then we should be positive about its possibilities. Haraway is basically optimistic that new technologies will offer a truly decentred experience of selfhood and that this is of great value. She points to the fact that when the self was conceived to be unitary, it was much easier to identify deviations from the norm and to judge them accordingly. With a 'split and contradictory self there is a greater tolerance for diversity and deviation from the norm. Moreover, this idea of the self offers the possibility that, in theory at least, split halves can combine.

New technologies have provided opportunities for individuals to exist beyond their skins. Since Sherry Turkle wrote of the computer as a 'second self', the prospect of 'reconstructing our identities on the other side of the looking glass' (Turkle 1995: 177) has seemed increasingly possible, especially through avatars. Avatars are artificial selves – electronically generated entities that 'exist' usually in online chat environments. The internet user creates a (fictitious) digital alter-ego to inhabit a simulated environment in cyberspace. Avatars, or digital alter-egos, can assume any identity the user wishes, and as such they are currently generating a great deal of interest in debates about decentred selfhood. The struggle to retain identity in a postmodern world, a world that is supposed to be somehow less 'real' for its inhabitants than was the modern world, makes the avatar a compelling metaphor for millennial culture. Opinion is divided on the potential of avatars. For instance, it is estimated that there are eleven different genders of avatar on the internet at the present time. However, the suggestion that life online will offer a different experience of self from that available via corporeal existence is somewhat premature.

In this chapter we have seen how subjective experience, in the period we call postmodern, has been deprived of many of its privileges. As Craig Owens writes: 'For modern man, everything that exists does so only in and through representation. To claim this is also to claim that the world exists only in and through a *subject* who believes that he is producing the world through producing its representation' (Owens 1990: 67). Avatars, cyborgs and the decentring of the self have questioned the notion of free agency: the idea that 'we' – a set of unitary selves – exercise determination if not outright control over our desires and destinies and that we create our own meanings. As the examples discussed here of performance art and photography of the body reflect, a Romantic self-absorption and preoccupation with subjective experience is by no means defunct in contemporary art practice, but the whole process of representing the self in and through the body has been made sociologically, politically and philosophically accountable.

Notes

Leon Battista Alberti, the Renaissance architect, artist and author of *On Painting* (1436) was the first writer to describe single-point perspective as the rational system by which artists should describe the world in painting.

- 2 In *The Culture of Narcissism* (1979) Christopher Lasch, historian and social critic of modern culture, identifies an unhealthy preoccupation with the self.
- 3 However, our trust in autobiography has been undermined in recent years by notions such as the 'unreliable narrator' and the possibility that such accounts will be self-justifying and include gaps and omissions.
- 4 Whether or not he was actually masturbating is not known.
- 5 Many books have erroneously insisted that he did cut off his penis.
- 6 More recently video footage of performances is commercially reproduced after the event.
- Works such as Kenneth Clark's *The Nude* (written in 1956) have been replaced by books such as Marcia Pointon (1990) *Naked Authority: The Body in Western Painting.*
- 8 Steven Naifeh and Gregory Whitesmith connect Pollock's drip paintings with his well-known habit of urinating in inappropriate places. They see Pollock's art as some kind of transference of indiscreet urination: 'for all his problems with impotence and bedwetting, Jackson could "control the flow" in the studio. Creative potency, like sexual potency, came down to a peeing contest' (Naifeh and Whitesmith 1989: 541).
- 9 Shuffenecker is now believed to be the author of one version of *Sunflowers*, sold for a record £22.5 million to a Japanese insurance firm.
- However, as Terry Eagleton (1996: 56–7) has cogently argued, the casualty within postmodernism's political radicalism has been class: 'social class tends to crop up in postmodern theory as one item in the triptych of class, race and gender . . .'. The history of visual representations of class is currently conspicuous by its absence.
- 'Hysteria' was the term given to a malady, to which women were believed to be subject, that was characterised by irrational behaviour. The term comes from the Greek for 'womb' and the word 'hysterectomy' describes the surgical removal of the womb, which was also a 'cure' for hysteria.
- We have seen, however, that Rosenberg talked about the relationship between the artist and canvas as if it were an existential encounter.
- 13 The Messenger (1996), Chaplaincy to the Arts and Recreation, Durham, England.
- This digital technology is commercially available, and as such an obvious example of the fusion of art and commodity: for instance, T-shirts with the wearer's head digitally reproduced over famous paintings.
- On the contrary, the postmodern account of selfhood has been challenged by Terry Eagleton, for instance, as an 'ignorant and dogmatic travesty' which overlooks or oversimplifies the variable positioning of philosophical thinking (Eagleton 1996: 79).
- 16 Carolus Linnaeus's *Systema naturae* (1735) stated that all living things in the world were created by God. The original of each species of plant was classified by its sex organs, that is seed, stamen, pistil.
- In fact, so established had women become as part of the workforce during the Second World War that post-war reconstruction was impossible without women fulfilling two roles a series of 'Twilight Acts' encouraged women to rejoin the workforce 'after hours' to supplement the labour force, but still remain 'feminine' wives and mothers during the day.
- Although Michael Gibbs berates online avatars for their lack of imagination and regards them as 'hardly anything to get excited about'. *Art Monthly* (1998), No. 218: July–August, 53–4.

THE MUSEUM OF MODERN ART

I want art that does something more than sit on its ass in a museum. (Claus Oldenberg)

N 1938, AT THE FOURTH INTERNATIONAL surrealist Exhibition, held at the Galerie Beaux-Arts in Paris 1,200 dusty coal bags stuffed with newspapers were suspended from the ceiling. The gallery was dark, and what light there was came from poorly fuelled braziers (Figure 8.1). Torchlight was required to search out and view the assorted surrealist art works and the twenty-five 'hidden' female mannequins (all dressed by different surrealist artists), clothed in ways designed to reveal suppressed fetishes. André Masson's mannequin had her head dressed as a birdcage and her mouth covered with a black velvet band; Man Ray showed his mannequin with large tears running down her face and soap bubbles foaming out of the hair. Here, dismembered dolls, puppets and mannequins served as objects of transference, objects of subliminal motivations and desires. The installation revelled in obscurantism, in 'not seeing' - cherchez la femme, closed eyes and blindness are familiar leitmotifs of surrealism. The treatment of the female muse, however, is less important for our purposes in this chapter than is the surrealists' pleasure in displays that destabilise conventions of creativity, production and display. In many senses, the surrealist display stands as a metaphor for the paradoxes and contradictions that surround the practices of display in the twentieth century.

The project of questioning the 'art' object's relationship to the gallery centred around several assumptions: first, that there is something worth displaying; second, that there is a specific context for display; and, third, that the 'installation' disorientates expectations of the display, particularly by its acknowledgement that display can also be an act of concealment. The surrealists' strategy of deracinating bags of coal and shop fittings highlighted the myth that masks art's autonomy, exposing art as merely a designated cultural category, in this case chosen by the artists. Art, it seemed, was not a neutral category of identifiable quality – the preserve of disinterested scholarship and curatorial practices. The surrealist intervention, while iconoclastic on one

Figure 8.1 Surrealist Exhibition, 1938, at the Galerie Beaux-Arts, Paris

level, was ultimately validated by the weight of institutional apparatus – the Galerie Beaux-Arts was a prestigious venue. However, the surrealist exhibition was an ambiguous gesture which at once laid bare, and yet was complicit in, the fiction of the art gallery and its romance with the artist.

These questions of display and the status of 'art' are still preoccupations in the 1990s. Yinka Shonibare's 1995 How Does a Girl Like You Get to Be a Girl Like You? (Plate XII) questions the function of display at the level of the personal and political. The 'colonial' dresses of batik cloth are representations of prints designed within a western conception of non-western cultures. The designs are in fact appropriations made in Europe which are then re-presented as pseudo-primitivism within a 'sophisticated' European dress form. The power relations between the cultures are concealed behind the facade of conspicuous show. The preoccupations of the surrealists and of Shonibare are not dissimilar – all attempt to uncover 'pretend identities', whether overt or covert psychological manifestations of power relations. The personal and public functions of collecting, displaying and consuming rather than simply manifesting truths are often acts of concealment, fictions masquerading as a kind of truth. The social contradictions of galleries and the imperative to either conceal or to reveal these paradoxes have been major preoccupations of artists, curators and historians in the modern period.

The function of the museum

A glance around the cramped basements of museums and galleries reveals reputations lost and names forgotten, a storehouse of remaindered works once given prominence and now representing no more than an enthusiasm of the specialist or just an

historical curiosity. Only 12 per cent of the Tate Gallery's holdings are ever on display at any one time. Thus the history that is on offer at the gallery is highly selective, an edited version of what is already a collection circumscribed by history. The dearth of works in certain areas can be accounted for by the political expediency of the day rather than by aesthetic considerations. This is apparent, for instance, in the patriotic lack of interwar German paintings in British galleries and the enthusiasm for socialist realist art in Soviet galleries post-1925. Mere whimsy or serendipity will not account for the formation of the collections. Museums and the collections they hold are social organisations endorsing particular values. Curators' reputations are often consolidated in weighty tomes of impenetrable text written by experts to go alongside the display of art work, part of the huge publishing industry that supports and sustains scholarship as crucial to the validation of key works, movements, artists and media.

Currently enmeshed in the leisure industry, providing 'blockbuster' exhibitions, smart cafés, corporate sponsorship, the mug and the T-shirt, art galleries and museums occupy an ambiguous position that belies their origins. The museum now is polarised between commodity and communion: that is, as a place in which to purchase constructivist scarves and surrealist umbrellas and/or a place in which to contemplate the works that inspire the commodities. In spite of the gallery's monolithic presence, its status is less secure than the permanence of the buildings suggests. Built on a foundation of the sacred and the secular, art has long occupied an enigmatic site.

Collection, classification, surveillance and ordering of the other

The seventeenth-century cabinet of curiosities (Wunderkammern) – an aristocratic collection of disparate objects, from art to fossils – and its antecedents, the shrine and saintly reliquaries (Bann 1995: 529), testify to a desire to collect, display and pay homage to objects. While undoubtedly a form of self- or state-aggrandisement, a signifier of power and taste, the desire to collect cannot be reduced to just the play of power and a need to display prestigious objects. Collections are often secretive, sometimes fetishistic, and can consist of the mundane and disposable, fragments of nature or urban waste – club-flyers, packaging and the like. The collecting of art works and their ordering and display at the level of the national or the municipal are not, however, so remarkably different from the rituals of private collectors of 'worthless' objects.

To take a more specific example, shells found in collections in the Victorian museum were often brought back as curiosities by ships travelling in search of fruitful economic enterprise. The shells, once ordered and classified, were placed on display as a signifier of Enlightenment reason and order and of the economic, political and moral power that sustained the merit of collecting. Damien Hirst's 1991 Forms Without Life (Figure 8.2), part of a series of works grouped under the title Internal Affairs, consists of display cabinets containing the familiar repertoire of museum objects – shells, fish, phials of medicine – a modern-day memento mori. The works, however, are unclassified, without labels and in more or less random order. The title Forms Without Life is indicative of the failure of the collection to give us the sustaining knowledge needed to make sense of our own mortality.

Figure 8.2 Damien Hirst, Forms Without Life, 1991. Photo: © Tate Gallery, London

The psychoanalyst Sigmund Freud, who was an avid collector of antiquities, largely ancient Greek, Egyptian and Roman sculptures, argued that collecting, and the ordering and obsession that accompany it, can tell us much about the unconscious mind. He likened psychoanalysis, the process of uncovering the mind, to an archaeological process: an attempt to recover buried memories. Freud (and others) have related the collection and its ordering, its secretive and compulsive aspects, to sublimated sexual desires in response to actual physical, social or sexual impotence.² Jean Baudrillard's 1968 essay 'The System of Collecting' traces the process whereby objects are divested of their function and come to stand for the *collector* through the abstract process of possession (Baudrillard 1994).

Objects inducted into the museum or gallery collection become part of a ritual that developed from medieval reliquaries, acts of observance and atonement that belong to the process of coming to terms with loss akin to mourning. Hirst's work may demonstrate that the compulsion to order and classify is not a neutral activity but constructed within power relations. His work also signifies at the level of the loss and melancholy in which collecting invests because the objects once contained life and only enter the museum once they are 'dead'. Susan Hiller's 1992 creation At the Freud Museum is beguiling in its tasteful nostalgic arrangement of cultural fragments and images in this bogus museum, recalling the eighteenth–century cabinet of curiosities and Freud's own enthusiasm for collecting. However, Hiller also points up the paradox contained within these fragments, because, even if put together, the fragments cannot make a whole or answer all our questions.

The taxonomy of anthropology

The classification and what has been termed the 'ordering of others' gained a pseudo-scientific credibility with the conscription of photography. Its development took place within the mindset of the 'Age of Empires': the mid-nineteeth century. In part, photography was used to replicate the order needed to sustain the power relations obtaining between empires and their dominions; but it was used also to shape those relations. Photography unlike other forms of recording – for example, painting and its popular counterpart the print – was presented as a realistic recording of things as they then were found in the world. The exotic, erotic and primitive could be surveyed and ordered according to imperial imperative. The comparatively simple reproductive capability of photography quickly gained commercial ground, cheaply producing postcards and prints. Commercial photography fed images of colonised peoples to a Europe hungry for exotica (tourism was a new venture) and self-improving knowledge.

The alliance of anthropology and photography and its use as a form of surveillance and ordering has been re-presented in the work of Dave Lewis. His 1995 work Haddon Photographic Collection, at Cambridge University's Museum of Anthropology and Ethnography takes the classic object of anthropological study, the 'tribesman', and superimposes the image on the classification indexes of anthropology. Lewis's work brings into play new meanings precisely because of photography's conscription into colonial expansion and Darwinian racial determinism. Lewis's images, in part using the fish-eye lens, questions the 'dispassionate' observational eye of the camera and of classification systems that merely 'record' what is taken for 'fact'. The basis of much nineteenth-century anthropological work which endeavoured to classify tribal differences was validated through photography. Susan Sontag has shown how the photograph created an ethics of seeing that identified what could and could not be looked at. She observes that 'in teaching a new visual code photographs alter and enlarge our notions of what is worth looking at and what we have the right to observe. They are the grammar and more importantly the ethics of seeing' (Sontag 1987: 3). By recording allegedly 'scientific facts', the union of photographic 'realism' and anthropometric study helped to sustain colonial power relations.

Generally speaking, nineteenth-century anthropology was a manifestation of positivism, a theory of knowledge that restricts itself to empirical enquiry, to observable facts. Mythology and the subjectivity of the observer, it was believed, had no place in the collection of data. It is at the level of the mythical and the subjective that so seemingly neutral a practice as ordering and indexing has been questioned. In seeking to explain the image on display, particularly by removing it to the realms of scientific inquiry or taxonomy, the stuff of archives, an act of concealment rather than disclosure, is in operation.

Contemporary anthropology and art share the imperative to explore 'difference' (the term is derived from Derrida's différance), a notion of hybridity being used to critique power relations rather than conceal them. This has often meant a removal of the art work from the gallery space to other arenas of cultural practice, including, as we have seen, museums of anthropology, but also to fertilisation clinics and libraries. David Bunn's 1997 Here, There and Everywhere installed in Liverpool Central Library, was part of a broader Library Relocations project. This move out of the

museum into the library is not merely a part of an egalitarian scheme to take art to a wider audience. Library Relocations and numerous other institutional interventions are part of the postmodern critique of power and knowledge: it uses the stuff of knowledge and the structures that support it to create new meanings.

The American Bunn's work is in part a nostalgic remembrance of 'the Beatles [as] metaphors for the post-war moment of optimistic modernity' (Hunt 1997: 64). It is also, as the title suggests, a metaphor for the British colonial expansion that issued out of the docks to the territories of the British Empire. The works within Bunn's project which entwine Los Angeles, via The Doors, and Liverpool look at the changing properties of information and learning. Using defunct manual library catalogues, now replaced by computer microfiche, Bunn creates books of poems from phrases and sequences of titles randomly selected from the card indexes and titles. From 'The Sea is a Magic Carpet' (Hunt 1997: 64) we get:

Must Britain travel the Moscow road? \ must Britain fail? \ must I go down to the sea again? \ must night fall? must philosophers disagree? \ must the League fail? \ must the West Decline? \ must we burn De Sade? \ must we lose Africa? \ must we mean what we say?

The strategy bears some comparison to the situationist strategy of derivé and the surrealist engagement with chance. Bunn's previous work, A Place For Every Thing and Everything in its Place (1993), displays an abandoned card-index system as a permanent installation in the elevators of Los Angeles' Central Library. The preoccupation with lost and sometimes counterfeit forms of knowledge is not without its casualties. What has been termed the 'end of history' has in some quarters been accompanied by conditions characterised as schizophrenic and melancholic. Part of the 'post-modern condition' is to acknowledge the impossibility of certainty; and though some art works 'fiddle while Rome burns', many others are characterised by a profound sense of loss. This fits the mindset of the museum as a repository for that which is past.

Carol Duncan has remarked on the ritualistic aspects of the art museum. Although a secular activity, visiting an art gallery retains an aura of the religious 'ritual' (see Duncan 1995: 7-20). This is conditioned by the cathedral- or templelike structures of the nineteenth-century museum and art gallery; and it is suggested, in part, by the attachment to fetishised art objects, and, in part, by the conditions under which visitors are regulated in the space. The etymology of 'exhibition' includes the unveiling of a sacrificial offering, and visiting a museum can be related to an act of mourning, confirming Theodor Adorno's observations that museums are akin to mausoleums, sepulchres to house the dead. The act of mourning is reinforced by a conflation of the ritual with its object that in some cases blurs the boundaries between art and the monumental stonemason's craft. The model for a tomb by the British sculptor Alfred Gilbert (1854-1934) is displayed alongside paintings and sculpture in the Walker Art Gallery, Liverpool. The work, Mors Janua Vitae (Death, the Door to Life, 1905-7), shows a husband and wife holding the casket that will eventually contain their ashes. The museum-art gallery is not just an important site for the play of power at the level of the civic, the personal, the public and now the corporate: once something enters the permanent collection

of the gallery or museum, it is as if it has finally crossed the Styx - a kind of entombment.

Housed in buildings

Cultivation of the arts was part of the reforming spirit of Victorian altruism. Cultural philanthropy rather than financial patronage was the basis for zealous attempts to 'elevate' degraded working-class taste. Reformers promoted, through education programmes, what they regarded as morally and spiritually elevating works to improve the social conditions of the casualties of industrialisation and urbanisation, a process identified by Frances Borzello (1987) as 'Civilising Caliban'. The imperative for self-improvement, witnessed, for example, in the huge increase in the number of mutual improvement societies, mechanics' institutes and exhibitions in late Victorian Britain, was robust. Access for all was no simple matter, however, as entrance fees and particular forms of policing mitigated against universal access.

The move from the private collections of the late eighteenth century to the public spaces of museums and galleries in the nineteenth century was not a seamless transition. It can be seen as part of a hegemonic process of regulation in which the 'improving' societies were voluntarily attended by the complicit labouring classes. Universal entry to museums, initially conceived as a possible threat to public order through the pernicious over-indulgence of the masses, was quickly, through the manifest visible order and restraint of display, co-opted into the orthodoxies of state apparatus. Entry to the sanctified spaces of the secularised temples was a dubious privilege - the whole experience of works of art was framed within high-Victorian discourses of class and gender. The workers' societies tutored appropriate forms of behaviour for entry to the galleries, to both see and become, through self-regulation, part of the spectacle. An unholy alliance of education, discipline and art was formulated at the formation of The National Gallery in 1824 (a model disseminated throughout the western world) which was in part a regulatory practice by which the productive working-class visitor was socialised into Victorian notions of citizenship. Within this context, what was important was not what was exhibited so much as what the gallery represented and the mechanisms by which social control and regulation were imposed. The linking of education programmes to the art gallery is still very much part of the remit of many galleries but its function now is, arguably, largely subordinate to the aesthetics of display. The language of regulation is less overt than it was in the nineteenth century; but the acquisition of taste and cultural refinement (rather than knowledge of its institutional infrastructures) is still the underlying reason for museum visiting.

The etymological roots of 'museum' are derived from the Hellenistic term for a 'place of the Muses', nine sister goddesses personifying such cultural forms as music, astronomy, dance and so on. Museums were, from their inception, as much about memory³ and its power to inspire as they were about learning. However, museums were often found to have an alienating effect on 'the masses'. In part, because the physical geography of the Victorian gallery celebrated nineteenth-century private capitalism. Victorian collections were usually housed in purpose-built temples such as the Walker Art Gallery in Liverpool (Figure 8.3), the Art Institute of Chicago

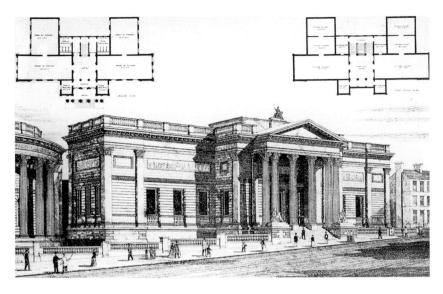

Figure 8.3 Walker Art Gallery, Liverpool in 1874, reproduction in Building News, 7 September 1877

and the National Gallery of New South Wales in Sydney, all classical, temple-fronted buildings with classical porticos and rotundas, and all monumental in scale. Most civic buildings (except the notably gothic Houses of Parliament and many town halls) incorporate facsimiles of the Parthenon frieze, decorative caryatids and classical columns as signifiers of power, order and restraint. The awed Victorian visitor needed to be initiated into the spaces of the gallery.

Colin Trodd identifies the present National Gallery building at its inception (1853) as the articulated space of two possible discourses, one of connoisseurship and the often of hygiene. The gallery, he argues, acts as the site of a retreat from the urban, a sanctuary and a place of contemplation. But more insidiously, the hallowed space of the National Gallery is one in which the working-class body, 'filthy' and with a 'most disagreeable smell', could be regulated into another social order. Within nineteenth-century discourses there was a binary opposition between the social world rudely represented by the working-class body and the cultural world entered via the aesthetic experience. For many writers on art, the 'aesthetic' signified the highest form of consciouness and transcended mere corporeal experience. Paraphrasing the rhetoric of the mid-ninteenth century Trodd states: 'From the ethereal enchantment of empyrean air to the epic excreta of "foreign" bodies, we witness the way in which the city enters the language of cultural discourse and the space of the cultural institution via the collective form of the crowd' (Trodd 1994: 43). This is an important point. Although the public gallery was nearly always an urban phenomenon, it was regarded as an elevated space which existed in a realm beyond that of industrialisation. So, paradoxically, galleries and museums came to conceal what they represented - namely, the power structures embedded in nineteenth-century patriarchal and colonial values and discourses of class.

Foucault's highly influential work *The Archaeology of Knowledge* (1994) informs much postmodern museum discourse. His explorations of the incarceration of *categories*

of people designated 'insane' and 'criminal' have been utilised to uncover how meaning is formed and sustained within institutional practices. The Tate Gallery at Millbank, for instance, was built in 1893, on the site of a prison, Millbank Penitentiary. Contemporary accounts in diaries, newspapers and the like were quick to point out the 'improving' link between the two institutions.⁵

The replacement of one house of correction by another form of correction, the morally improving art gallery, is a Foucaultian gift. Enlightenment following punishment and the elimination of crime through beauty and cultural refinement were well-established tropes of nineteenth-century thought. The ordering of narratives and the periodisation of history offered a kind of systematic rationale which the enlightened Victorian felt would contribute the same principles to the disorderly lower classes. Foucault's method, however, if unimaginatively applied, does sound rather like conspiracy theory or, paradoxically, given Foucault's view of history, attempts to correct the injustices of the past.

Nevertheless, Foucault's archaeology of epistemes, that is to say, the excavation of layers of meaning which constitute knowledge (espisteme), and the adoption of the idea of discourses (practices), have opened up the museological field. His methodological inquiry into the structure of knowledge and its relation to power, particularly the institutions of state power, has proved a fruitful area for the museologist. It is to be doubted that all of his criticisms of the Enlightenment, of which the museum is a symbol, can be sustained. However, by focusing on society's exclusions, most notably the mad, the criminal and the sick, he maintained that it is possible to find out what counted as truth and what did not. Foucault's contribution to museology therefore, is to argue that there is no history, though there are legitimised and excluded histories. It is important to remember that even legitimised histories share much common ground with excluded histories.

As we have seen, postmodern discourse around the social regulation of the body, in relation to the physical geography of the museum, can reveal other histories. The recent accelerated growth in number of culturally diverse galleries and museums demonstrates the interest in previously marginalised or suppressed histories – such as Aboriginal, Japanese–American, African–American, and Plains' Indian. As we will see, the retrieval of these histories by contemporary museums and art galleries has been an important, but not always successful, act of redress.

The modern museum

The oxymoronic title 'Museum of Modern Art' has tended largely to leave behind the classical exterior and silk-wallpapered interiors of the nineteenth-century gallery, abandoning decoration in favour of the tasteful 'White Cube' developed initially principally in America in the 1920s. 'New' galleries such as the Musée d'Orsay and the Tate Galleries in Liverpool and at Millbank in London are part of urban regeneration packages, sited in disused industrial buildings, obsolete railway stations, warehouses and power stations. The idiosyncratic nature of the buildings, however, is sanctioned internally by remarkable similarities of display across the institutions. The presentation of modern art in puritanically regulated white-walled rooms, with strategically placed spotlights and humidity monitors, is a familiar part of any visit to the modern art gallery

- across the globe. But how did this style of design of the spaces become a universal given, by-passing local and specific cultures to take its place on the international stage? In what ways does the design of the modern gallery space 'colour' our experience of its contents? What are the postmodern 'politics of display'?

Museums and art galleries are the spaces in which histories and the fixtures and fittings of meaning are installed. Once upon a time the permanent collection was the dominant sign of power, often representing a vanquished culture or the 'trophies of empire'. The museum validated the fiction of a linear historical narrative by ordering the art of a previous epoch into convenient periods and national styles. A post-colonial age, impatient with the past, has renamed former 'colonial institutes' to 'museum' forms more appropriate to a new age, as in the Tropenmuseum (formerly known as the Colonial Institute) in Amsterdam and the Museum of Mankind in London, or has created galleries with titles that announce the problematics of inclusive histories, like the Yiribana Gallery at the Art Gallery of New South Wales in Australia. The modern art gallery, without the same obligations to present identity-forming national collections or to serve the redemptive function of many nineteenth-century philanthropic collections, seemed, at least until the early years of the twentieth century, to provide an ideology-free space. These galleries were not, or at least not overtly, implicated in the same discourses of anthropology, colonialism and social engineering as had been their predecessors. But, from their inception, in part because of their rejection of the official academies, modern museums have not been an ideology-free space, a sanctuary from the world.

The Museum of Modern Art, New York

As we saw in Chapter 1, artists' attempts to evade the regularising and depoliticising tendencies of museum practices have provided us with some interesting artistic alternatives. In 1960 Jean Tingueley's *Homage to New York*, a 'self-consuming artefact', was assembled in the gardens of MoMA in New York. Tingueley's sculpture involved the construction and destruction of a machine, its components including eighty bicycle wheels, motor parts, a piano, a go-cart, battery and tubes. In the event, the machine failed to destroy itself as intended; instead it ignited and had to be extinguished by the New York Fire Department. In a radio debate in 1982, Tingueley said:

I wanted something ephemeral, that would pass; like a falling star and, most importantly, be impossible for museums to re-absorb. I didn't want it to be 'museumized'. The work had to pass by, make people dream and talk, and that would be all, next day nothing would be left, everything would go back to the garbage cans. It has a certain complex seduction that made it destroy itself — it is a machine that committed suicide. A very beautiful idea, I must say.

(Hulten 1987: 14)

The setting for the machine's self-immolation – the gardens of MoMA, the model for all modern museums of art – ironically is what validates the work. Had

it been realised outside of the museum's gardens, the work's incendiary potential might have gained notoriety in terms of arson rather than art. For many years MoMA was the museum to which the avant-garde had aspired; and although Tingueley's reluctance to be 'museumized' led him to create an ephemeral art work, paradoxically his anti-institutional stance needed to be validated by MoMA.

The Museum of Modern Art in New York, the first museum to devote itself exclusively to modern art, was founded in 1929, the year in which the stock market crashed and America entered the Great Depression. It has been the most influential modern art museum, not just in terms of design and display but in the definition of the art that would be considered modern. It is unsurprising then that it, and its first director, Alfred H. Barr Jr, have been the focus of so much anti-modernist venom. Dubbed by Emily Genauer 'the fur-lined museum',6 it was conceived by 'The Ladies', three wealthy art collectors: Mrs John D. Rockefeller Jr, Miss Lillie P. Bliss and Mrs Cornelius J. Sullivan. In part this silver-spoon birth has contributed to MoMA's association with power, money and politics. Its close proximity to fashionable Fifth Avenue has contributed to its status as a 'tasteful' preoccupation for 'ladies who lunch'. The Guggenheim Gallery, on Fifth Avenue in New York, famously designed by Frank Lloyd Wright as a conspicuously 'modern', whitewashed spiral in which to view art on a continuous platform, has a similar pedigree. Under the direction of Hilla Rebay, it functioned as a repository for 'non-objective' art, although any charges of 'hobbyism' need to be tempered by an acknowledgement of Rebay's critical writings on abstract art.

Alfred H. Barr Jr was aged only 27 when appointed as the director of MoMA. His and MoMA's avowed mission was to distinguish 'quality from mediocrity' in art. His early enthusiasm for the machine aesthetic, De Stijl, the Bauhaus and Russian Constructivism is evidenced in his fervour for and somewhat puritanical conception of the museum as a 'machine to show pictures in' (Pointon 1994: 198). Barr's 1930s' and 1940s' schemas showing the ideal museum as a torpedo (Figure 8.4) are emblematic of the MoMA's thrusting zeal. They show the museum as a machine of the future, penetratively streamlined. The schematic design delineated modern art's evolution from its European beginnings to its apotheosis in the 1920s in the United States and Mexico. The ideal collection was to consist of 'modern' works. When they became 'tired' or just not modern enough (this fate was envisaged as a numerical certainty), art works could go to a retirement home at the nineteenth-century 'temple of art', the Metropolitan Museum on Fifth Avenue. This policy, however, proved difficult to implement. Pensionable status or the designation 'classic' did not suit works like Picasso's 1907 Demoiselles d'Avignon (see Figure 1.8). The pivotal role of Demoiselles d'Avignon in establishing the genesis of modern art's 'trajectory' militated against its retirement. By the late 1940s the policy of transfer was abandoned and MoMA holdings began to resemble those of other art collecting institutions.

Barr's early visits to the Bauhaus influenced the design of the new premises on 53rd Street (Figure 8.5). MoMA differed from its European counterparts in openly embracing the machinery of capitalism and in recognising the importance of efficiency and marketing, making these attributes visible in the design and display of the gallery spaces. The facade of the building and its entrance hall resemble those of a department store. Unlike the Victorian temple, with its vast spaces designed to awe the visitor, MoMA's spaces, beyond the entrance hall, are relatively small and

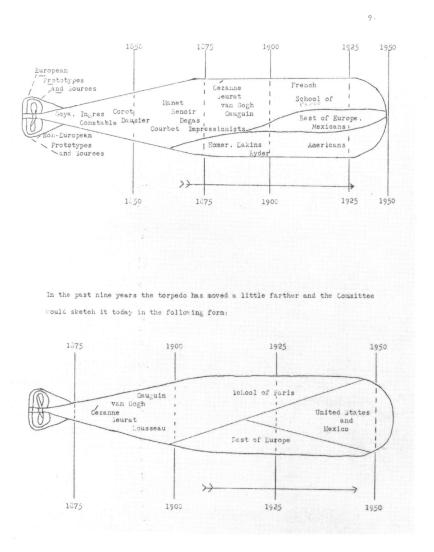

Figure 8.4 Alfred H. Barr Jr, 'Torpedo' diagrams of the ideal permanent collection of the Museum of Modern Art. The Museum of Modern Art Archives, New York: Alfred H. Barr Jr Papers (9a.15). Photo: © 1999 the Museum of Modern Art, New York

intimate. This is an important point: contemplation seems to benefit from a degree of privacy, low ceilings and small units – rather apartment-like and quite different from the civic ambition expressed in the morally elevating Victorian edifice.

In the seventeenth century David Teniers the Younger, in works like *The Archduke Leopold Wilhelm in His Gallery in Brussels*, painted galleries (Figure 8.6) in which the displayed works seem to have operated as floor-to-ceiling decoration. Allegorical subjects hang cheek-by-jowl with genre scenes, religious and mythological subjects and portraits of the great and good. Diversity and chronology aside,

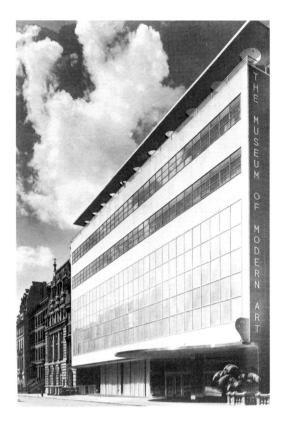

Figure 8.5 Philip L. Goodwin and Edward D. Stone, the Museum of Modern Art, 1939. Photo: © 1999 the Museum of Modern Art, New York

it is the relationship of the spectator to the works that distinguishes the modern museum from its antecedents. When Théodore Géricault's *Raft of the Medusa* (1819) was hoisted up in the gallery, Géricault was reputedly dismayed at the height, as his heroic life-sized figures were reduced to mere mannequins. The modern museum carefully regulates the visitor. Works are usually placed at eye-level, positioned to facilitate their individual contemplation. Communion with the work, it seems, requires, at once, a sense of other-worldliness combined with the department-store's display for consumption so clearly lacking in museums of earlier epochs. The art on show in the modern museum is usually displayed with a minimum of attention to matters of context: works are usually isolated from anything that might interfere with or detract from their status as autonomous 'art' objects.

There is one aspect of MoMA's genealogy that we have to revisit: that of gender. It has been argued that the white cube of the modernist gallery space is resolutely masculine. 'The Ladies' of New York, although powerful, represented the regrettable face of art collecting – hobbyism. The austere Barr, who, in forming the collection, was 'guided primarily by his superb taste and connoisseurship, and his art-historical knowledge' (Sandler and Newman 1986: 9), created in the white cube a space devoid of 'troubling femininity' and of an overt sensuality.

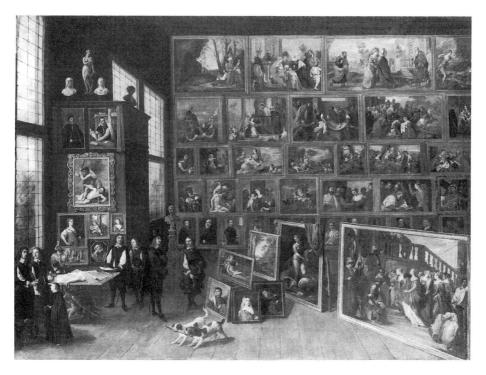

Figure 8.6 David Teniers the Younger, The Archduke Leopold Wilhelm in His Gallery in Brussels, before 1690. Courtesy of the Kunsthistorisches Museum, Vienna

'Aura' and the sacred space of the 'white cube'

A painting has always had an excellent chance to be viewed by one person or a few. The simultaneous contemplation of paintings by a large public, such as developed in the 19th century, is an early symptom of the crisis which was by no means occasioned exclusively by photography but rather in a relatively independent manner by the appeal of art works to the masses.

(Walter Benjamin 1970: 236)

Walter Benjamin's influential essay 'The Work of Art in the Age of Mechanical Reproduction' (first published in 1939 and reprinted in Benjamin 1970) identified the notion of 'aura' as a major factor in our appreciation of a painting. 'Aura' was the term he used to describe the uniqueness of the single art object, occasioned by its unreproducibility. Mechanical reproduction (by which Benjamin, writing in the 1930s, meant principally photography, film and lithography), however, had the potential to undermine the uniqueness of the art object. He wrote:

The uniqueness of a work of art is inseparable from its being imbedded in the fabric of tradition. . . . We know that the earlier art works originated in the service of a ritual – first the magical, then the religious

kind. It is significant that the existence of the work of art with reference to its aura is never entirely separated from its ritual function. In other words, the unique value of the 'authentic' work of art has its basis in ritual, the location of its original in-use value. This ritualistic basis, however remote, is still recognisable as secularised ritual even in the most profane forms of the cult of beauty.

(Benjamin 1970: 236)

Benjamin's argument is that the museum or art gallery legitimises the uniqueness of a relic or work of art. The work of art obtains its ritualistic significance at the level of a secular spirituality. To a Marxist such as Benjamin, this form of mystification could be endorsed only by the uniqueness of the art object. Benjamin believed that new technologies, especially film and photography, could help to create an authentic mass culture in opposition to the elitism of 'auratic' art.

The uniqueness of the art object, however, was never entirely eradicated by mechanical reproduction, and individual art works still change hands for enormous sums of money in spite of the accessibility for purchase of calendar reproductions or a Monet on an ashtray. But Benjamin's essay did establish the sacral status of the art work in a secular age. The white cube under this rubric becomes a secular shrine, an ersatz temple for the ritual of viewing.

The western notion of individuality is a prerequisite of the 'aura', predicated on the basis of unitary selfhood in which one individual expresses him or herself to another. The artist qua artist, as distinct from the artisan supported by personal patronage or the guilds, was now drawn into a web of novelty and innovation. The new art gallery, through its 'disinterested' display, embraced, albeit covertly, the art work as commodity. Subsequently the ambitious artist found it difficult to avoid the expediency of individuality and the rhetoric of originality. Moreover, the modern museum sustained the humanist myth of individual genius, with 'one-man' shows, monographs about and interviews with the artist. In its presentation of a coherent, authoritative, although usually depoliticised, account of modern art, the modern museum utilised the idea and language of the 'aura' of the art work.

Artists as curators and ahistorical exhibitions

Fiction enables us to grasp reality and at the same time that which is veiled by reality.

(Crimp 1995: 200)

Most modern galleries group works according to type and style, a curatorial method driven by chronology and periodisation. MoMA in particular has been criticised on the grounds that its displays lead the witness historically towards the triumph of American abstract expressionism, extending the logic of Barr's 1936 schema (see Figure 1.3). There have been interventions into what are considered by some to be 'false narratives'. That is to say, the galleries construct histories consistent with the ideologies that they represent. The kind of historical narrative that was adopted by individual modern museums was supported by periodisation, that is the 'truths'

of the history-as-chronology approach, consisting of dates, movements, styles and geographic origins. These have been regarded by postmodernist thinkers as 'false narratives' because they offer at best only a partial account of the human past.

Postmodernism's revelations, deconstructions and fictions have been cogently explored by the Belgian artist Marcel Broodthaers (1924-76). In Les Animaux de la Ferme (1975) he reworked the popular learning aid, the grid-like poster, with its images of cattle, but disrupted its educative potential by substituting the names of cars for those of the animals. Broodthaers' conversion from poet to artist at the age of 40 is as well documented as Duchamp's change of focus in later life, from art to chess. The decisions are not unrelated. For Broodthaers, the change was a positive acceptance of art's fictions. Aware of the complicity of art in relations of exchange, discussed in Chapter 1, Broodthaers embraced the counterfeit aspects of art's relationship to capital and to the fiction of display. Broodthaers entered the art world declaring that 'the idea of inventing something insincere crossed my mind and I immediately set to work'. It was not, however, a merely cynical act. Behind his work is a probing analysis of the museum system. Broodthaers created, over a number of years, his own bogus museum. A montage of eagles, from art, advertising and taxidermy in his taxonomic 1972 display Broodthaers Section Publicité (Advertising Section) confronted the viewer with that which displays and often obscures - the ideological imperatives behind the facade.

The disruption of false narratives accelerated in the 1980s and 1990s. Foucault's work on theories of knowledge and Derrida's work on deconstruction, the process of revealing the underlying meaning (assumed or suppressed) of texts, can be seen in many strategies to undermine notions of the 'aura' of art works and to seek out fictions, visible or covert, in their power relations. The conceptual artist Joseph Kosuth has curated several shows that not only deprive narrative of some of its privileges but attempt to reposition the viewer in relation to his or her interpretation of works. Kosuth argues that:

The primary difference between a show curated by an art historian and an installation curated by an artist, is that the artist, due to the nature of the activity, takes subjective responsibility for the 'surplus' meaning that the show itself adds to the work presented in it. Traditionally the art historian's practice involves objectifying what is basically a subjective activity, by masking it with a pseudo-scientific veneer. While scholarship has a role to play in the assessment of older works, the closer one gets to contemporary art, the more the need arises for an informed understanding rather than that 'objectivity'.

(Kosuth quoted in Papadakis 1991: 23)

Kosuth's installation *The Brooklyn Museum Collection: The Play of the Unmentionable* (1990) combined classical and modern, painting and sculpture, with books and text in an attempt to disrupt 'our habituating, institutionalised approach to the exhibition format' (ibid.). An ahistorical approach to curating attempts, by foregoing chronology and classification systems, to allow viewers to make their own connections in response to the juxtaposition of disparate objects, from Greek sculptural fragments to nineteenth-century painting, from portraiture to allegory. Kosuth maintained that

he did not make any claims for the validity or importance of particular art works but that his installations made *difference* visible and, as such, the viewer could participate in the 'meaning-making process' (ibid.).

Ahistoric exhibitions intervene in the construction of hierarchies. This is difficult terrain and an indication of the loss of confidence in style as a category and in the history of art as an evolutionary process. However, while the ahistorical exhibition, as Deborah J. Meijers points out,⁷ confronts the viewer with the constructs which art historians employ: its curators resort to creating a new unity through 'correspondences', that is by projecting 'essences' from one art work to another. Meijers argues that in some cases a form of essentialism is still in operation: 'the works of art', she says, 'are arranged on the basis of new truths which are presented as universals, despite their strong personal colourings. Regrettably, this essentialism closes the door which these exhibitions had seemed to open' (Meijers 1996: 19). To sum up, hierarchical structures of display can accommodate dissenting practices.

Alternatives to the museum

We could take this point further by returning to the exiled artists, poets and musicians performing collaboratively in Zurich, while around them Europe engaged in the 'war to end all wars' (1914–18). The Cabaret Voltaire, an extension of Umberto Boccioni's legendary Italian futurist evenings, was founded and directed by Hugo Ball and Emmy Henning. It was an anarchic extension of the concept of Gesamtkunstwerk, the total art work, often a reference to Wagnerian opera or theatre. The Cabaret became the focus of Zurich Dada's anti-war, anti-nationalist writers and artists, like Tristan Tzara, Hans Arp, and Marcel Janco and Richard Huelsenbeck. At the Cabaret Voltaire, the categories of culture, painting, print, music, poetry, dance, etc. were not separated into departments. The Cabaret opened with hastily collected art works made by performers and artists, but eventually the Gallerie Dada would show Janco, Kandinsky, Klee, posters by Italian futurists, 'negro' art and Picasso.

These international non-hierarchical collaborators worked across what would later become institutionalised as disciplines. They were involved in film, through Hans Richter, dance, philosophy and puppetry as well, as painting and printmaking, and their performances are illustrated in Janco's painting Cabaret Voltaire in 1916. Richard Huelsenbeck, writing in 1920, summed up the times: 'In that period, as we danced, sang and recited night after night in the Cabaret Voltaire, abstract art was for us tantamount to absolute honor. Naturalism was a psychological penetration of the motives of the bourgeois, in whom we saw our mortal enemy . . .' (Chipp 1968: 378). Huelsenbeck delineated the revolutionary precepts of Dada as anti-nature, evoking Archipenko, for whom 'any imitation of nature, however concealed, was a lie' (ibid.). For the Dadaists truth was found in abstraction, but it was not separate from the world or displayed uncritically in a vacuum.

We should bear in mind what André Malraux has defined as the 'museum without walls', the recurring issue of reproduction. Malraux's 'super-museum' was created by the 'homogenising' effects of the photographic image which rendered disparate objects, such as the classical sculpture and the painting, the same.

Any work of art that can be photographed can take its place in Malraux's super-museum. But photography not only secures the admittance of objects, fragments of objects, details, etc., to the museum: it is also the organising device: it reduces the now even vaster heterogeneity to a single perfect similitude.

(Crimp 1995: 50)

Early examples of the museum without walls are Duchamp's portable museums which were suitcases containing selected objects such as photographs and bottles arranged in compartments. Some of Duchamp's portable museums are miniature versions of earlier works, such as *Fountain* and *The Large Glass*. Often collaborating with the American surrealist, Joseph Cornell, Duchamp reproduced multiple versions of his portable museums with the intention of undermining notions both of exclusivity and of authenticity. Ironically, these portable museums are much sought-after acquisitions by orthodox museums, in which they are displayed, contrary to Cornell and Duchamp's 'outsider' agendas.

Fluxus

There have been many interventions into the triad of museum, artist and original ('auratic') work. Inspired by Dada, the 1960s 'movement' Fluxus, although having the literal meaning of 'to purge', programmatically resisted attempts to define itself. Like many other modern art movements it had no ambitions to be an '-ism', although 'concretism' is the other term applied to Fluxus. With an anti-high art agenda informed by the commodity culture of post-war American affluence, its protagonists led the assault on institutionalised modernism. 'Quality' was designated under the categories of 'amusement' and 'fun' rather than the austere aesthetic of curators such as Barr. Fluxus was anti-individualist, anti-museum and anti-European high culture, attitudes summed up by Yoko Ono's *Painting to Be Walked On*, that required the literal act of trampling irreverently over the canvas.

Action Against Cultural Imperialism (Henry Flint) Picket Stockhausen Concert! (1964), a manifesto broadside designed by the founder-member of Fluxus George Maciunas, was part of the culture of resistance. Through the collective creation of games, leaflets, films and performances (and, paradoxically, now the subject of intense interest and collecting), Fluxus both unsettled the auratic art object and bypassed the museum. Works produced by Fluxus would often be started by one artist but completed by others, thus subverting the traditional role of the artist under modernism (although not in Renaissance workshops) as the sole creative agent. Works like George Brecht's Games and Puzzles/Name Kit (1965-77) included multiple ready-made boxes that resembled earlier surrealist games. The reproduced boxes and games were attempts to remove the uniqueness of the art work and, by distributing them through mail order, to provide an alternative to the museum context. Yoko Ono's performance A Grapefruit in the World of Park (1961) was delivered on the street. Her particular contribution was to disrupt the notion of licence through the dissolution of the individual author/artist's signature. Ono's combination of Zen Buddhism and haiku works were 'instruction art works' which came into being when someone acted on

the instruction of the artist: for instance, drill a small, almost invisible hole in the centre of a canvas and see the room through it (Ono 1995: 29).

Art for the museum space

Attempts to undermine the art gallery, although interesting, have been largely unsuccessful. The white cube of the modern museum has acquired the status of the 'natural habitat' for the display of art works. The context afforded by the white cube, as we have seen, differs from those of the traditional museum and gallery. Older institutions often held works that previously had belonged somewhere else, most notoriously the Elgin Marbles, principally sections of the Parthenon frieze that were taken to the British Museum for 'safe keeping' in 1801–2. Religious works originally placed or built into the structure of sacred places have also been removed, deracinated, and displayed out of context, thus altering the function and meaning of the work.

The Kantian notion of a 'disinterested aesthetic' has been used to legitimise this removal by its employment in support of the argument that the work of art is autonomous and can be appreciated without recourse to its original function. This approach has its merits, as we have seen: it allows for widely diverse works to be displayed without necessitating recourse to political or religious justifications. However, a reading which takes into account only the formal elements of a work of art is problematic. For example, it was the selective removal of the politics of European modernism that has made MoMA and its curatorial agenda problematic. Too often art works were decontextualised and depoliticised in favour of a version of European and American modernism that seemed divorced from every-day contingencies. Christoph Grunenberg has commented:

The austere gallery spaces with their pristine white walls epitomised MoMA's ambition for purity and neutrality, historical accuracy and objectivity: modernism became history. MoMA's politics of presentation replaced political engagement with formalist aesthetics, anarchy with rationalisation, internationalism with individualism, diversity with absolute purity, and fragmentation with aesthetic autonomy . . .

(Grunenberg in Pointon (ed.) 1994: 193)

The modern art museum adds another set of conundrums to the problem of deracination. Not all art in galleries has arrived through relocation. Many artists create specifically for the modern gallery because therein are to be found the scale and resources capable of sustaining such works. Barbara Kruger's 1991 installation 'Untitled' (All Violence is the Illustration of a Pathetic Stereotype) (Plate XIII) at the Mary Boone Gallery in New York uses the space to physically engulf the viewer. The art work actually is the walls, rather than being displayed on the walls. MoMA may have established the pattern of display and consumption, but many of the newer galleries have departed from the provision of intimate spaces to become sites of a different viewing experience which sets up a critical space between the object and the viewer's own corporeality.

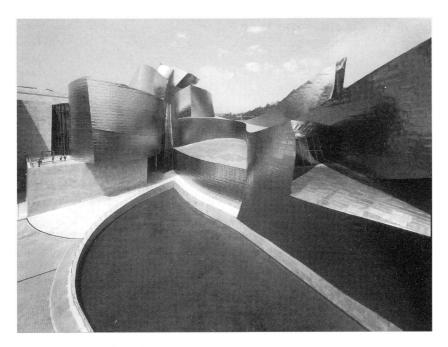

Figure 8.7 The Guggenheim Museum, Bilbao. Photo: Erika Barahona Ede. © FMGB Guggenheim Bilbao

The new Guggenheim Gallery in Bilbao, designed by Frank Gehry (Figure 8.7), eschews the white cube for flamboyance, spectacle and colossal scale. Richard Serra's 1997 13-foot *Snake* made of hot-rolled sheets of steel meanders across over 100 feet of floor, towering over visitors. At the DIA Foundation, New York, Serra's 1996–97 *Torqued Ellipses* (Figure 8.8), made from rolled steel, monopolise the vast industrial space. Iwona Blazwick identifies a new sense of the gallery experience stating:

[T]he industrial spaces converted by Saatchi in London, the Crex Collection in Switzerland, the DIA Foundation in New York, or the hospital building converted into the Reina Sofia in Madrid, are galleries where the visitor experiences objects in a physical way. Their immense scale, the hard edged utilitarian aesthetic of their architecture, and the way objects are arranged . . . make the experience of viewing an exhibition a sensory one.

(Blazwick, quoted in Papadakis 1991: 35)

In the monumental spaces of these converted industrial buildings, the critical space between the viewer and the object is not just an aesthetic of the eye: it is closer to Edmund Burke's notion of the sublime. As the Victorian working-class museum visitor was awed by the beauty of the buildings and the works of art, so the contemporary visitor to the modern museum is often awed by the sublime scale of its exhibits.

Figure 8.8 Richard Serra, Torqued Ellipses, 1996–97. Cor-Ten Steel. Installation View. Permanent Collection DIA Center for the Arts, New York. Photo: Ivory Serra, © ARS, NY and DACS, London 1999

Technology and the museum

As we saw in Chapter 5, new technologies offer the experience of art works that are electronically generated; but they offer also the opportunity to 'virtually' experience art works, without ever setting foot inside the museum space. Although often displayed in galleries, art that utilises newer technologies such as CD-ROM and web sites does offer alternatives to the museum, but whether this amounts to a democratising of art is another matter. Putting a camera in everyone's hand was never a guarantee of visual democracy: as Marxists demonstrated some time ago, it is the means of production, rather than production itself, that controls the implementation of technology in our culture. The link between capitalism and new technologies can be seen in the contemporary theme park which has adapted the seemingly commerce-free space of the museum. History can be represented through the theme park in a painless and sanitised way, almost indistinguishable from fiction. Ethnographic tourism dictates a form of re-presentation that incorporates 'living museums', in which redundant coal-miners are employed to re-enact their own industrial history. Again, the 'living museum' can present live performances of dance and music as part of the 'experience' of authentic Polynesian life, for instance. Increasingly, in a global village the portrayal of other cultures is conditioned by tourist expectations and the commodification of culture.

The Holocaust Memorial Museum in Washington is paradigmatic of the problems raised by the distancing capacities of new technologies, seen most notoriously in the Gulf War of 1991 during which American bombings were allegedly timed to coincide with prime-time television broadcasts. Viewed at a safe distance, the Holocaust too can be just part of a 'virtual' experience. At the Washington Museum visitors are issued with an ID card which 'matches' the visitor to a 'victim' or a survivor of the Holocaust. The bar-coded card gives access to technologised images of mass murder and the 'total' concentration camp experience. Alan Schechner's 1994 Bar Code to Concentration Camp Morph (one of a series of stills taken from the computer animation Taste of a Generation) takes issue with the experience of hyper-

reality by making explicit the links between capitalism and the museum experience, via the bar-code and the photographic images of the Holocaust.

The relationship between knowledge and technology has been amply critiqued by the French deconstructionists and is a familiar theme of contemporary practice. Johan Grimonprez's 1995–97 Dial H–I–S–T–O–R–Y (Plate XIV) is a video film of almost an hour's duration which questions history and the media presentation of 'events' by initially confronting the position of the writer. The soundtrack is a fictional narrative drawn from Don DeLillo's novels, White Noise and Mao II. The mixture of fiction, documentary evidence in the shape of newsreel footage, the testimony of 'experts', cartoons, movie footage, digital imaging and reconstruction with the manipulative effect of background muzak, coalesce to bring into question the neutrality of histories and media representations (in this case a definitive 'chronological' history of plane hijackings). Media fictions merge with facts, and what counts as evidence becomes contradictory and even meaningless. The film collapses the polar opposition of fiction and documentary and questions our confidence in the visual image and reportage as the site of anything we ordinarily call 'truth'.

Grimonprez's earlier work, a collaboration with Herman Asselberghs, placed the viewer (spectator) effectively in the role of curator. In *Beware! In Playing the Phantom You Become One*, a video work on the history of television, the viewer could intervene in the art work, which again was a collection of facts and fictions, documentary and cartoons, experimental cinema and video extracts. The opportunity to incorporate one's own video gems into the work extended the possibilities for the spectator to undertake curatorial work. Asselbergh stated: 'Just as in life, the spectator—visitor of this site creates a personal hypertext' (in Joly (ed.) 1997: 80).

The work of art in the electronic age

Baudrillard has made us aware, through what he terms 'image proliferation', that we live in a world saturated with images, but that our capacity for communication is not necessarily commensurate with what is required to enable worthwhile exchanges: we have fewer important things to communicate. Although Baudrillard's view of the relationship obtaining between the passive consumer of mass culture and the omnipresent television screen is problematic, what he makes clear in 'The Work of Art in the Electronic Age' (1998) is that Walter Benjamin's utopian vision, which dispensed with art's traditional aura of 'sacredness forever', has been replaced with a nihilisitic vision. We are saturated with images, but electronic media seems nevertheless to hold out an emancipatory prospect (see Chapter 5). Many have argued that the art world's ideologies of individuality, originality and creativity have remained in place in spite of the electronic works of artists such as Bill Viola, Trin T. Minh Hah and Gary Hill. Jonathan Harris (1997: 41) has argued that powerful institutions and dealers 'seemingly may take hold of any raw materials [they find], and accounts of the decline or even death of auratic art begin to sound like wishful thinking'. The fact remains that in a period of obsession with virtual reality and online communication, visiting art galleries to see an 'actual' art work has never been more popular. Surveys of galleries and museums point to a massive increase in attendance figures, showing the 'art fix' to be integral to many a tourist's itinerary.

New technologies offer the possibility of viewing the museum, by means of the CD ROM and web sites, as a virtual gallery. The traditional curatorial system can be bypassed and viewers can create their own museums, collect their own works and install them in their own homes — an electronic museum without walls. However, as we have seen in the work of Grimonprez and Alan Schechner, the use of new technologies guarantees nothing except its own mutability. This raises the spectre of the virtual museum's short life-span. If the permanent collection recalls a mausoleum, then the virtual museum is a case of short-term memory. Its built-it obsolescence is guaranteed by the technologically 'progressive' impulses of monopoly capitalism. Paradoxically, however, new technologies offer the conceit of 'total recall', whereby everything ever stored on computers (even an item binned from the hard disk) is recoverable.

In an age of mass reproduction, with the manipulation of images available at the touch of a remote control, cyberspace, online museums and virtual reality raise issues about our understanding of and relationship to the past. Technology itself, as we saw in Chapter 5, has no ideological infrastructure: its role is 'determined' by the dominant social factors. As Raymond Williams observed in relation to television, technology reproduces the existing social order. In terms of the modern museum, and more particularly the technologised museum, it is uncertain how technology will impact upon the mission statements of the future. Linked to the leisure industry, the fortunes of the modern museum - its modes of display and its objects of desire - are riven by competing agendas. Museums and art galleries have perhaps never been more popular than they are at present; yet never have they been more vulnerable. Utopian perhaps, but new technologies still hold out the prospect of a reordering of hierarchies, a questioning of the relationship between popular culture and high art and a challenge to institutional authority. Increasingly art works enter the public sphere without formally being housed in a gallery. The 'museum without walls' to be found in cyberspace effectively signals the end of the institutional structures, restraints and power relations of the old museums of modern art. They can, however, succeed only in a climate of continual questioning.

As many art historians have observed, the development of the museum is coextensive with modernism. However, the links between modernity and the museum extend beyond the evolution of the modern museum: museums are implicated in both the evolution and sustenance of modernism. Although modernism may have become simultaneously a term with overtones both of nostalgia and of approbation, it is still true to say that modernism is tremendously successful, especially when it is endorsed by major museums. For instance, the unparalleled success of the Monet Exhibition on both sides of the Atlantic, between 1998–99, which at the height of its popularity was open round the clock to the public, demonstrates modernism's popular acclaim and its marketability. However, when viewed within the postmodern environment, modern art and its museums are in the equivocal position of having all the vestiges of institutional authority without the homogenising remit of continuity with their past.

Nevertheless, viewed optimistically, the calling to account of museums under the aegis of state of the arts' debates allows for diverse strategies and eclectic practices: artists are no longer in thrall to the proscriptions of modernism, and museums have had to adapt to this, permitting the possibility of re-presenting themselves. As we are seeing, art institutions are infinitely adaptable, not only in adjusting to the demands of a post-colonial age, but re-configuring their spaces to absorb that which was previously excluded. In spite of postmodernism's apparently open and equalising remit, much contemporary art within western culture appears to be 'more of the same' modernism. The difference is that proponents of postmodernism recognise that, unlike their modernist predecessors, their relationship with the past can never again be one of heroic rupture and revolution. Contemporary art seems therefore to be condemned to revisit the past – but, ironically, only in so far as that past is mediated by the experience of museums.

Notes

1 Seen/Unseen Exhibition Catalogue (1994) Bluecoat Gallery, Liverpool, p. 10.

It is outside the scope of an introductory text such as this to pursue the Freudian interpretation; however, Susan Pearce (1998) is interesting in this respect.

3 The National Curriculum for Art (England) still maintains that a sense of spiritual and moral growth is related to the acquisition of taste.

The Muses were the daughters of Zeus and Mnemosyne (memory).

For a fuller but by no means entirely Foucauldian account of the formation of the Tate Gallery at Millbank, see Brandon Taylor (1994).

This was also a reference to Meret Oppenheim's surrealist sculpture Fur Breakfast (1936)

which was on show at the time.

She writes in relation particularly to Harald Szeeman's A-Historische Klanken (Ahistorical Sounds), Museum Boymans-van Beuningen, Rotterdam, 1988, and Peter Greenway's The Physical Self, Boymans-van Beuningen, Rotterdam, 1991–92.

Glossary

The following are broad definitions of terms or phrases contained within this book. However, some of the terms have a narrower application; these are defined in the specific sense of their usage in particular chapters.

- **Abstract** Generally polarised against *figurative* art or *naturalism*, though one should guard against hard and fast distinctions since all art works are abstracted in some way. Abstract art generally refers to art that either does not represent things from the visible three-dimensional world or that only partially suggests things.
- **Abstract expressionism** Although in use from the 1920s onwards, *abstract expressionism* came to describe the work of painters based mainly in New York in the 1940s and 1950s. Broadly speaking, their work is characterised by formal experimentations with media (generally paint) and the evolution of unique signature styles.
- **Academies of art** First formed in Europe in the sixteenth century to professionalise training for students in the fine arts. By the eighteenth century, academies' institutional apparatus had enforced *classical* models of painting and sculpture, and this regime remained in place until the end of the nineteenth century. The authority of the academies was challenged by an artistic *avant-garde*.
- **Aesthetic** Imported from philosophy, *aesthetics* is concerned with the principles of taste according to which judgements about what constitutes 'beauty' are made, though art-historical discourse tends to refer rather to *the aesthetic*. The debate around the construction of the aesthetic has, on one side, Immanuel Kant (1724–1804) and his twentieth-century acolytes Clive Bell and Roger Fry supporting the notion of a universal 'disinterested' aesthetic, immune to the contingencies of the day; on the other are the more recent theorists who have argued that the aesthetic is relative to and ultimately informed by local conditions. More recent scholarship insists that the context in which the art object was produced and that in which it is subsequently viewed (*including* the class, race

and gender of the viewer) invariably impinges upon our appreciation of the art object's merit.

Autonomy 'Art's autonomy' frequently features as parlance shorthand to assert art's freedom from cultural, political and social structures and strictures. Early in the twentieth century, notions of autonomy (especially in the sense of 'artfor-art's-sake') fuelled debate around the direction that art should take. By the mid-1950s, through the dominance of *formalist* critics like Clement Greenberg, a victory for autonomy seemed assured. Since the 1960s, however, the Greenbergian notion of autonomy has been attacked for its assumption that art is radically free from social contingencies and cultural shifts.

Aura Gained currency within art-historical debates because of its use by Walter Benjamin. His influential essay 'Art in the Age of Mechanical Reproduction' (1937), argued that the *aura* is an attribute that we give to original works of art to distinguish them from reproductions. It is a special property of the original work of art, in respect of which we invest the work with an almost sacral presence that supposedly transcends its material fact.

Avant-gardism Seen by some theorists as a prerequisite condition of modernity, avant-gardism is closely linked to ideas of bohemianism, alienation and counterculture. The term described the jettisoning by nineteenth-century artists of conventional practices (especially academic conformity) in art, music and literature. Although still a moot point, *avant-gardism* is often seen (for example by theorists such as Peter Bürger) as having two irreconcilable strands: the political and the apolitical. The alleged death of the avant-garde as early as the 1970s can be seen in the light of increasing pluralism and a lack of consensus about that to which the avant-garde stands in opposition.

Bauhaus An influential German school of art and design located in Weimar, Dessau and Berlin between 1919 and 1933. The *Bauhaus* sought to unite the *fine* and *applied arts* in a utopian coalition of technology and art. Endorsing a loosely *constructivist* approach to art and design, the enforced closure of the Bauhaus by the National Socialists in 1933 failed to prevent its highly influential teachings on art and design becoming widespread after the Second World War.

Bohemianism A taste for the unconventional; *bohemian* describes those who conform to unorthodox (according to the standards of the day) manners. Artists and writers have been associated with the term since the nineteenth century when their lifestyles were viewed as outside bourgeois social and moral codes of behaviour.

Bourgeois culture Although synonymous with the *middle classes*, in the first half of the nineteenth century *bourgeoisie* designated (according to Karl Marx) a revolutionary force responsible for social upheavals in France. In the second half of the nineteenth century the bourgeoisie themselves became the establishment, and their attendant ideologies predominated. This antecedent has defined bourgeois culture as one which is essentially conventional, unadventurous and supportive of the status quo, though its often disparaging usage suggests an acquisitive materialism.

Canon A collective noun used by art historians to identify works and artists considered to be of major significance to the development of particular forms. For an artist to be given *canonical* status was once seen as an issue of quality, but is

now seen as the result of a combination of factors – the art market, institutional validation rather than any intrinsic worth. The *canon* is not fixed and may be revised in the light of critical ratification.

- **Classical** Once a formal designation of Greek and Roman artefacts, classical art came to be associated with the *academies*, which taught students to improve upon nature, idealising the subjects of the human figure and the landscape according to certain preconceptions about composition proportion, harmony and colour. *Neo-classicism* was the prevailing standard of excellence in the nineteenth century in opposition to which the *avant-garde* defined itself.
- **Cold War** Coined in 1947 to describe hostilities, real and imagined, between the United States and the USSR. This was war conducted largely through political and economic wrangling and the spread of propaganda on both sides, including government support of 'culture' as a weapon. The collapse of *Communism*, symbolised by the dismantling of the Berlin Wall, effectively saw an end to much *Cold War* rhetoric.
- **Collage/Decollage** Collage is the act of attaching materials to a surface, and decollage is the act of unsticking or peeling away. While always a feature of popular and domestic craft, collage gained high-art status through the work of the cubists after 1912 and the artists connected with the Dada movement, in particular by Hannah Hoch and Kurt Schwitters.
- **Commodity** The slogan 'Born to Shop' may very well prove to be a defining one in the new millennium. It is a marker of the *purchasable* status awarded to all products, including works of art. However, since the mid-nineteenth century works of art have been subject to the forces of market values and have acquired investment status.
- **Connoisseur** Authority deriving from an ability to judge the merits of a work of art on the basis of *taste* justifies the epithet *connoisseur*. Since the 1960s authority through taste alone has been superseded, in art-historical terms, by *Marxist*, *feminist*, and *postcolonialist* scholars, who base their judgements on more tangible criteria.
- **Constructivism** Has come to describe the work of painters, designers and architects in revolutionary Russia during the first two decades of the twentieth century. *Constructivists* usually worked in an *abstract* idiom to an impersonal and common revolutionary agenda. Its utopian associations, fuelled by an enthusiasm for socialism, technology and the machine, were developed by the *Bauhaus* after 1923.
- **Culture** A term which so proliferates as both affix and prefix (youth culture, mass-culture, television culture, culture-shock, culture-vulture) that in *postmodern* societies *culture* is inclusive of much more than what even today passes as art. Art history has both benefited and lost from the academic romancing of *cultural studies*: on the one hand, the inclusion of popular culture, comics and film has opened up the discipline, and, on the other, it has caused a crisis of confidence about the identification, for purposes of study, of art's appropriate subjects.
- Dada The name selected for a loose confederation of artists (including Hugo Ball, Emmy Hennings, Marcel Duchamp, Francis Picabia, Hans Arp, Man Ray, John Heartfield and Kurt Schwitters), musicians, poets and performers working in Zurich, New York, Berlin, Cologne, Paris and Hanover between 1916 and 1921. Appalled by the destruction left after the First World War, *Dada* responded

by challenging notions of rationality and bourgeois values through performance, soundworks, ready-mades and collage.

Discourse According to Michel Foucault, discourses generate *knowledge* about particular groups, objects or ideas (as well as being specific to those groups – hence medical discourse, legal discourse, etc.). A *dominant discourse* is the product of dominant social and institutional formations, which may be why *discourse* is sometimes confused with *ideology*.

Enlightenment An eighteenth-century philosophical (in the broadest sense) movement, also called the 'Age of Reason', characterised by the tendency to *order* the world through *systematic categories* of knowledge. The *Enlightenment* was epitomised by the production of the world's first encyclopedia. The Enlightenment *project* is associated with humanistic scepticism, political reform and a thoroughgoing belief in the efficacy of science and the centrality of man (as opposed to God). The reforming zeal of Enlightenment thinkers deeply influenced the French and American Revolutions, and underscored the shift from aristocratic to bourgeois culture.

Ethnography Strictly speaking, designates the study of cultures *from the inside*. However, within western art history the term has a more specific application, since so much modernism was driven by a desire to simulate the *primitive*. Paradoxically, African masks and Aboriginal 'paintings' have traditionally been displayed in cabinets in museums rather than on the walls and pedestals of art galleries alongside modernist approximations.

Expressionism Has come to signify paintings, sculpture, dance, theatre and film which emphasise *mood* and exaggerate *feeling*. Although the roots of *expression* theory are wrapped up in psychoanalytical theory and philosophy, *expressionism* is often located in the work of early German modernists – such as Käthe Kollwitz and Ernst Ludwig Kirchner – whose unconventional techniques (exaggerated outlines and unnaturalistic colours) were highly influenced by notions of *primitivism*. Hal Foster's influential essay 'The Expressive Fallacy' has uncovered some of the myths of expression theory.

Feminism and postfeminism Well-documented 'interventions' in mainstream art and art history have exposed a system of *patriarchy* which has long controlled the institutions of art. *Feminism* introduced more rigorous methodologies as a way of uncovering *gender bias* in relation to images and writing about images. The term *postfeminism* acknowledges that the debate has moved on; postfeminists have revised earlier positions and introduced greater plurality of references.

Formalism The critical practice of *privileging* an art work's *formal qualities* (colour, composition, technique, etc.) over its *content* (subject matter and socio-historical context). Its key twentieth-century exponents include the *Bloomsbury* writers Clive Bell and Roger Fry, and the American modernist critic Clement Greenberg. In recent years *formalism* has been challenged on the grounds that criticism should be more responsive to a wider range of contexts.

Futurism Filippo Marinetti launched the movement in Italy with the first *futurist manifesto* in 1909. The futurist programme rejected earlier Italian movements, particularly the *Renaissance*, in favour of a celebration of the *machine age*, *speed*, the *automobile* and *cities*. The movement covered all the arts from painting and sculpture to performance, music and dance, and fashion design.

Fluxus Incorporating much conceptual and performance art, *Fluxus* was an international art movement of the 1960s which attacked many of the institutions and orthodoxies of the art world, specifically notions of *originality* and *authenticity*. Fluxus contributed to the *dematerialisation* of the art object through strategies such as mass-producing works of art in the style of games and boxes, performance and 'instruction art works' which defied formal modernist notions of *authorship*.

Hegemony In its original application, hegemony meant 'lordship', but came to be used to signify the dominance of one group or culture over another. In Marxist criticism, it has a more precise application: hegemony designates the complex socio-economic and political control exerted by the dominant social class over less powerful groups. The pattern of hegemonic control is often invisible because it is 'naturalised' into existing practices and is a subtle form of coercion which appears to serve mutual interests.

High art The antithesis of all modes of expression to which the words *mass* or *popular* normally apply, high art is perceived by proponents of the former as elitist; or, one might say, if popular art forms connect the tastes, opinions activities and habits of the majority, high art assumes the interest of a minority. So, painting and sculpture, to the extent that they issue in unique art objects, are definitively elitist activities. The accommodation within much modern art practice of *populist* modes and styles has contributed to a gathering scepticism about – even, in some circles, disdain for – high art's endeavours.

Humanism Renaissance *humanism* was the conviction that the individual was of paramount importance in the shaping of his or her own world. Believing that the *human realm* was explicable without having recourse to notions of the *divine*, humanist thinkers, such as Descartes, placed man at the centre of things. *Postmodem* critics have pointed out that humanist values posit a false unity that belies the specific determinants of class, race, gender and sexual orientation.

Ideology Broadly speaking an *ideology* is the set of values, practices or beliefs which underpin a particular society or group. Ideologies marginalise alternative or conflicting systems of belief that run counter to its ideas. These countercultures (peoples, systems or sets of values dispossessed by a dominant ideology) are often referred to as 'others'.

Illusion The links between *art* and *illusion* have become complex in the twentieth century, since modernist art frequently employs anti-illusionistic devices which confound the viewer's visual expectation of a facsimile of nature. Modernism has given artists creative licence to explore *abstract* alternatives which have more to do with individuated *self-expression* than shared visual perception.

Imperialism The conquest and subsequent rule of land and peoples by a more powerful nation state. The heyday of *imperialism* extended from the late nineteenth century up until the First World War when, for example, powerful European countries ruled over the various territories that had been colonised. Imperialism is interpreted by *Marxists* as an outlet for economic trade and political gain, although often justified in terms of 'civilising' a 'lesser developed' group. Latterly imperialism has been inclusive of global strategies, such as the McDonaldisation and Disneyfication that employ more subtle economic practices.

Impressionism In the 1990s, the subject of blockbuster exhibitions, it is difficult from a contemporary vantage-point to see impressionism as revolutionary art and the *first avant-garde*. But from the 1860s onwards, the impressionists challenged the authority of the *academic system* and paved the way for twentieth-century *modernism*. As a style, impressionists used looser brushwork and a lighter palette to depict modern life.

Individualism/individuality A central tenet of bourgeois ideology is that each person 'owns' his or her destiny. Postmodernist writers have argued that individuals' lives are determined by their social relations and that true *individualism* is a fiction. *Poststructuralists* argue that we are *determined* and maintained in and by language (you are what you communicate).

Installation A term to describe art works which are usually commissioned, generally site-specific and often temporary. An *installation* occupies a site (sometimes in a gallery, but theoretically in any agreed spot) and can take its physical dimensions, materials, and occasionally its thematic cue, from its surroundings.

Kitsch Clement Greenberg's essay 'Avant-Garde and Kitsch' established the necessity of defending high art against mass bad taste, or *kitsch*. It is a measure of a major contemporary *cultural shift* that the reverse strategy of employing 'low' art forms in contemporary practice has such currency. The appropriation of mass culture into high art is evidence of a collapse of consensual values.

Marxism/post-Marxism Since 1989 and the collapse of the Soviet Union, Marxism as a political discourse, so characteristic of art-historical studies in the 1960s and 1970s, has been less influential. Its totalising tendencies have rendered it ill-equipped to deal with the fragmented, *pluralistic* and heterogeneous 1990s. Nonetheless, some of the central tenets of Marxist art history, for instance, that art does not possess any intrinsic, immutable values and that art is, to a greater or lesser degree, contingent upon social, economic and political conditions have become enshrined in most art-historical discourses.

Minimalism A deliberate reaction, dating from the 1960s, against the idiosyncratic gestural qualities of *abstract expressionist* painting. Characteristically, in art, *minimalism* employed sheet metal, perspex and house bricks to make regular geometric constructions, sometimes on a grand scale, for art galleries and earthworks. In music, minimalist works are characterised by a relentless repetition of sounds or even total silence.

Modern period Within the remit of this book, the *modern period* is taken to be synonymous with the *urban industrial* and the *post-industrial* age. The term *modern* has had a currency for art historians ever since Baudelaire's 'Painters of Modern Life' (1863) described the work of those who were actively engaged with the subjects of modern city life. However, 'the modern painters' defined by John Ruskin in the 1840s and 1850s constituted merely the category for contemporary artists.

Modernism Has a long and varied usage as a designation of a *period*, a *style* and a *theoretical stance*. Broadly speaking, the inception of *modernism* can be dated to the 1840s where it described the efforts of artists, musicians, architects, designers and poets to break with the predominant codes and conventions of cultural production. Typically modernist art was concerned with the 'new' – using unconventional materials, novel means of construction and experimentation with new ways of depicting the subject.

- Modernity/modernisation In his book All that Is Solid Melts into Air: The Experience of Modernity (1983) Marshall Berman distinguishes between modernism. modernity and modernisation. According to Berman, modernisation describes processes of economic, social and technological advance based on innovations associated with capitalism, whereas modernity is the transformed condition or state brought about by capitalism in the nineteenth and twentieth centuries in Europe and North America.
- **Naturalism** Often used in opposition to both the idealising tendencies of *classicism* and the 'unnaturalistic' distortions of modernism; the term is synonymous with realism, the term *naturalism* defies precise definition. Naturalism itself is a shifting category which has changed over the centuries and across cultures. In western art history the term has come to mean an imitation of perceived reality.
- New art history The theoretically rigorous and 'politically correct' approach to the discipline, especially where certain issues of class, race and gender are concerned. As its name implies, the new art history was a reaction to the 'old art history'. Targeting connoisseurial and formalist as well as certain Marxist art histories, 1980s' practitioners of the new art history introduced what they believed to be a more accountable approach to the discipline.
- New Deal The American stock market crash in 1929 was followed by a decade of economic and social depression. The New Deal was a domestic policy delivered by President Franklin D. Roosevelt to rescue the American economy. The New Deal programmes established a degree of state intervention unprecedented in America. In particular, government-sponsored Federal Art Programmes employed artists on community-based projects, reconfiguring the role of the artist as socially responsible rather than individual outsiders.
- Orientalism Edward Said's influential books Orientalism and Culture and Imperialism exposed the dynamics of the power relations at play in the western perception of the orient. Crucially, Said explored the ways in which the power relations between cultures are reinforced through their visual and literary productions. The implications have been far-reaching, forcing art historians to question misconceptions based on long-held stereotypes of orientals.
- Pluralism One of the most problematic aspects of postmodernism is pluralism: as an attitude which maintains (nominally, at least) that all points of view, all styles of art, all cultural forms, are open and equal, it would seem to offer but another utopian prospect. However, pluralism is ultimately relative and, at its most pessimistic, can be seen as a dissolution of the modernist confidence that quality is an identifiable datum.
- Politics of representation As a gauge of the changing relationship between language and art, the politics of representation acknowledges the values inherent in seeing and representing. The politics of representation attacks notions of 'disinterested' representation, exposing the power relations implicit in the act of looking and how art has legitimised certain forms of surveillance.
- Popular culture The collapse of the division between high art and popular culture has been a hallmark of postmodernism. Previously beyond the preserve of art history, popular culture (comics, television, pulp fiction, popular music) have now joined the list of respectable objects of academic study.
- Postcolonialism A considerable shift has taken place in global power relations

between the former *colonial powers* – British rule in India or French rule in North Africa – and their 'subjects'. *Postcolonial* theories have impacted on culture in two ways: first, to give voice to the recipients of the legacy of colonialism and, second, to re-read art works in the light of previous power relations.

Post-impressionism The term retrospectively applied to artists whose time and styles of working followed those of the *impressionists*. While sharing few things in common, works by *post-impressionists* are identifiable by their formal rejection of the *naturalism* of impressionism.

Postmodernism An overused catch-all for anything playful, humorous, ironic, knowing, appropriative, pluralistic and code-breaking in our culture. The downside of *postmodernism's* lack of fixed principles and standards is a melancholic schizophrenia, in which the lack of boundaries becomes itself restrictive and even repressive. The current general apprehension about the future, endemic in millennial western cultures, is offset by the emancipatory prospects a postmodern vision offers to *countercultures* (simultaneously depriving them of that status).

Poststructuralism Although often erroneously used as a synonym for *postmodemism*, the term *poststructuralism* has more precise applications. The works of Jacques Derrida, Julia Kristeva, Jacques Lacan, Jean-François Lyotard and Michel Foucault collectively debunk older notions of absolutes, essences and legitimised power structures, replacing them with contingencies and the decentred subject, and exposing all forms of cultural behaviour as *linguistic constructions*.

Primitivism Once the preserve of anthropology, *primitivism* entered the lexicon of art history as a problematic term in the 1960s. Although the term had a long usage as a label for anything that was non-European, folkish or childlike, primitivism came to have political ramifications within *postcolonial* cultures. While *modernists* benefited from the stylistic innovations gleaned from *primitive* models, their ahistoric appropriation of, for instance, 'other' cultural artefacts never extended to a radical review of the power relations between *imperialist* cultures and their subject peoples.

Psychoanalytic theory of art The theory that the psychological state of the artist – often repressed – can be uncovered in the work of art has a long precedence: for example, Sigmund Freud's interpretation of Leonardo da Vinci's *Virgin and Child with Saint Anne* reads unresolved tensions in the artist's relation to his two 'mothers'. While a much used method of inquiry (for example, in T. J. Clark's *Farewell to an Idea*), *psychoanalytic theories*, applied to the visual arts, is necessarily speculative.

Ready-mades The staple diet of twentieth-century art and almost a prerequisite of *postmodernism*. From Marcel Duchamp's urinals and bottle-racks to Damien Hirst's farmyard life-forms, the use of *ready-mades* is a constant and accelerating feature of twentieth-century art practice. The significance of ready-mades in the bifurcated history of *modernism* is that they dispensed altogether with the notion of a *fine-art practice* that was skill-based and attacked notions of self-expression, hierarchy and *taste* by using objects from the 'real' world as 'art'.

Realism Almost all twentieth-century art lays claim to a notion of *realism*, whether social, psychological, political or optical. Hyperrealism, superrealism and virtual reality all testify to the continuing currency and elusiveness of the term. At its simplest it is inextricable from the notion of *resemblance to actual life* in which

artists' depictions are 'true to life' or use technical means to closely approximate the way things 'really' appear. Realism is bedevilled by any simple understanding of lived experience, whether actual or virtual.

- **Renaissance** The belief that a revival of *classical* models in art and literature had started in the fourteenth and fifteenth centuries conditioned every aspect of dominant western academic art practice. Within modernism, therefore, the Renaissance was the moment of inception of the dogmatic, classicising and rule-bound conventions of western art. The rejection of orthodoxies within modernism required a dismantling of this tradition. Modernism has at once, however, both romanced and rejected the Renaissance, although not always in equal measure.
- **Romanticism** Often erroneously opposed to bloodless *classicism* as its passionate counterpart. The works of Beethoven, the paintings of Géricault and Delacroix and the poetry of Lord Byron are axiomatically Romantic. Storm-tossed landscapes, violent human encounters between isolated subjects and exotic locations are the stock-in-trade of the Romantic imagination.
- **Self-expression** This *modern* notion underlines the individuality of the artist as self endowed with a unique ability to represent feelings or ideas through art. Modernism is predicated on essentialist notions of expression as a capacity unrestricted by cultural constructions and accessible only to the gifted few.
- Situationists/Situationism An anarchic but politically unaffiliated confederation of artists and intellectuals, who first outlined their views in the magazine Internationale Situationniste in 1958. Situationism evades any single definition since it refers to a programme of 'constructing situations', and its adherents advocated a 'revolution of everyday life' which extended to all forms of intellectual activity. It was, therefore, process rather than product which was significant. Famously the situationists were responsible for much of the graffiti and many of the slogans that featured in the student-led demonstrations of 1968.
- **Socialist realism** Unlike its close namesake social realism, socialist realism is marked by optimism and utopianism. The official doctrine in the 1930s in revolutionary Russia advocated for all the art works that were at once accessible to a mass audience and a celebration of the audience itself. Replete with images of labour in the collective's fields and co-operative factories of the new Russia, socialist realism favoured naturalism over the earlier revolutionary constructivism.
- **Subjectivity** Together with its modernist polarity objectivity, subjectivity haunts the pages of modern literature. While objectivity lays claim to some kind of disinterested neutrality, subjectivity demands interested partiality. Modernism's espousal of the essential individual permits a Romantic involvement with the work of art on the basis of feeling and imagination.
- (The) Sublime The Romantics used the notion of sublimity when faced with overpowering natural forces, an experience which, in the eighteenth century, was associated with oceans, steep cliffs, volcanoes and raging torrents. The Enlightenment philosopher and statesman Edmund Burke's designation of the sublime, for example, was the simultaneous apprehension of terror and beauty in the face of natural forces, or even of the collective anger expressed in the French Revolution. Within postmodernism the sublime has become associated with experiences mediated by new technologies.

Surrealism Led by the writer, André Breton, *surrealism* was an anti-establishment, anti-bourgeois, international art movement that grew out of the political disenchantment of Dada and culminated in the first 'Surrealist Manifesto' of 1924. By defamiliarising and 'making strange' the object, the surrealists typically confounded the viewer by juxtaposing objects, images, words and sounds in an *irrational* manner. In thrall to the *psychoanalytic theories* of Freud and Jung, the surrealists attempted to account for the irrationality of modernity by uncovering civilisation's *unconscious* motivations and desires.

Universal The totalising tendencies of western culture rest on the possibility of universal laws and *grand narratives*. The assumption that western values are universal was predicated on our inability to 'know the other' and a capacity for marginalising alternative or counterculture experiences. Under this rubric *beauty* and *truth* were assumed to be unchanging givens – *a priori* categories beyond the realms of contingencies such as cultural constructions, gender, class and race.

Utopian The unrealised project of *modernism*, in all its manifestations, was undoubtedly utopian, in the sense that it held sacred a vision of a better world for all. Modernism's democratic allegiance to *progressive socialism* motivated a number of *experimental* approaches to art which both embraced and rejected technology.

Bibliography

- Ades, Dawn (1995) Art and Power: Europe under the Dictators, 1930–45, Thames & Hudson, London.
- Adler, Kathleen and Marcia Pointon (eds) (1993) The Body Imaged: The Human Form and Visual Culture since the Renaissance, Cambridge University Press, Cambridge.
- Althusser, Louis (1971) Lenin and Philosophy and Other Essays, NLB, London.
- Appignanesi, R. and C. Garrett (1995) Postmodernism for Beginners, Icon Books, London.
- Arnheim, Rudolf (1974) Art and Visual Perception: A Psychology of the Creative Eye [revised edition], University of California Press, Berkeley [1954].
- Banham, Reyner (1996) Theory and Design in the First Machine Age, Athenaeum Press, Tyne and Wear [1960].
- Bann, Stephen (ed.) (1974) The Tradition of Constructivism, Da Capo Press, New York.
- —— (1995) 'Shrines, Curiosities and the Rhetoric of Display', in Cooke and Wollen (eds) Barr, Alfred H. Jr (1975) *Cubism and Abstract Art*, Secker & Warburg, New York [1936].
- (1986) 'Russian Diary' and 'Cubism and Abstract Art' [1926], in Irving Sandler and Amy Newman (eds) *Defining Modern Art: Selected Writings of Alfred H. Barr, Jr.*, Harry A. Abrams Publishers, New York.
- (1988) What is Modern Painting? (9th edition), Museum of Modern Art, New York [1943].
- Batchelor, David (1997a) Minimalism: Movements in Modern Art, Tate Gallery Publications, London.
- (1997b) Chromophobia, Henry Moore Institute, Centre for the Study of Sculpture, Leeds. Baudelaire, Charles (1965) Art in Paris: 1845–1862, Landmarks in Art History, Phaidon, Oxford.
- Baudrillard, Jean (1988) America, Verso, New York and London.
- —— (1993) Simulations, Semiotext(e) Publications, New York.
- —— (1994) 'The System of Collecting', in Elsner and Cardinal (eds), trans. Cardinal.
- --- (1998) 'The Work of Art in the Electronic Age', Block 14.
- Baur, John I. H. (1963) 'Beauty or the Beast? The Machine in American Art' [1960], in Jean Lipman (ed.) What Is American in American Art?, McGraw-Hill, New York.

—— (1976) Revolution and Tradition in Modern American Art, Frederick A. Praeger, New York. Beauvoir, Simone de (1949) The Second Sex, Jonathan Cape, London.

Becker, S. Howard (1982) Art Worlds, University of California Press, Berkeley.

Bell, Clive (1982) 'The Aesthetic Hypothesis', in Frascina and Harrison (eds).

Belting, Hans (1984) The End of the History of Art? [trans. C. S. Wood], University of Chicago Press, Chicago.

Benedikt, Michael (ed.) (1991) In Cyber Space: First Steps, MIT Press, Cambridge, MA.

Benjamin, Walter (1970) Illuminations, Jonathan Cape, London.

—— (1979) One-Way Street and Other Writings, NLB, London.

Benthall, Jonathan (1972) 'The Body as a Medium of Expression: A Manifesto', *Studio International* 184 (July/August): 6–8.

Benton, Tim and Charlotte Benton, with Dennis Sharp (1975) Form and Function: A Source Book for the History of Architecture and Design 1890–1939, Open University Press, London.

Berger, John (1969) Art and Revolution, Writers and Readers' Publishing Co-operative, London.

—— (1972) Ways of Seeing, BBC Books, London.

Berman, Marshall (1983) All that is Solid Melts into Air, Verso, London.

Bernheimer, Charles (1989) 'Degas's Brothels: Voyeurism and Ideology', in R. Howard Bloch and Frances Ferguson (eds), *Misogyny, Misandry and Misanthropy*, University of California Press, Berkeley.

Betterton, Rosemary (ed.) (1987) Looking On: Images of Femininity in the Visual Arts, Pandora, London.

Blavatsky, H.P. (1972) *Isis Unveiled*, Theosophical Publishing House, Wheaton, IL, and London, 2 vols [1877].

Bloch, Lucienne (1975) 'Murals for Use', in Francis V. O'Connor (ed.) WPA. Art for the Millions. Essays from the 1930s by Artists and Administrators of the WPA Federal Art Project, New York Graphics Society Ltd, Boston: 76–7.

Boddy, William (1998) 'Sixty Million Viewers can't Be Wrong: The Rise and Fall of the Television Western', in E. Buscombe and Roberta E. Pearson (eds.) *Back in the Saddle Again: New Essays on the Western*, British Film Institute, London.

Borzello, Frances (1982) The Artist's Model, Junction Books, London.

— (1987) Civilising Caliban: The Misuse of Art 1875–1980, Routledge, London.

Bourdieu, Pierre (1984) Distinction: A Social Critique of the Judgement of Taste, Routledge & Kegan Paul, London.

Bowie, Andrew (1995) Aesthetics and Subjectivity: From Kant to Nietzsche, Manchester University Press, London.

Bown, Matthew Cullerne and Brandon Taylor (1993) Art of the Soviets: Painting, Sculpture and Architecture in a One-Party State, 1917–1992, Manchester University Press, Manchester.

Breton, André (1972) Manifesto of Surrealism, Ann Arbor, MI.

Brookes, Liz (1991) 'Vile Bodies', Artscribe 88: 144.

Bryson, Norman (1983) Vision and Painting: The Logic of the Gaze, Yale University Press, New Haven, CT, and London.

Bunn, David (1997) Here, There and Everywhere, Liverpool Central Library and Book Works, London.

Bürger, Peter (1984) Theory of the Avant-Garde, trans. M. Shaw, University of Minnesota Press, Minneapolis.

Burgin, Victor (1986) The End of Art Theory: Criticism and Postmodernity, Macmillan Press, London.

Butler, Judith (1990) Gender Trouble: Feminism and the Subversion of Identity, Routledge, London.

— (1993) Bodies that Matter: On the Discursive Limits of 'Sex', Routledge, London.

- Cahill, Holger (1969) American Sources of Modern Art, Museum of Modern Art, New York [1933].
- Carter, Michael (1990) Framing Art: Introducing Theory and the Visual Image, Transvisual Studies, Hale & Iremonger, Sydney.
- Caton, Joseph Harris (1984) The Utopian Vision of Moholy-Nagy, UMI Research Press, Ann Arbor, MI.
- Caws, Mary Ann, Rudolf Kuenzli and Gwen Raaberg (eds) (1991) Surrealism and Women, MIT Press, Cambridge, MA.
- Celeste-Adams, Marie (ed.) (1986) America: Art and the West, American-Australian Foundation for the Arts and the International Cultural Corporation, Australia, Ltd., Abrams, New York.
- Chadwick, Whitney (1991) Women Artists and the Surrealist Movement, Thames & Hudson, London.
- Cheetham, Mark (1991) The Rhetoric of Purity: Essentialist Theory and the Advent of Abstract Painting, Cambridge University Press, Cambridge.
- Chevlowe, Susan (ed.) (1998) Common Man, Mythic Vision: The Paintings of Ben Shahn, The Jewish Museum, Princeton University Press, New York.
- Chipp, Herschel B. (1968) Theories of Modern Art: A Sourcebook by Artists and Critics, University of California Press, London.
- Choucha, Nadia (1991) Surrealism and the Occult, Mandrake, Oxford.
- Cixous, Hélène (1981) 'Laugh of the Medusa', in Elaine Marks and Isabelle de Courtivron (eds) *New French Feminisms*, Harvester Press, Brighton.
- Clark, Kenneth (1980) The Nude, Penguin, Harmondsworth.
- Clark, T. J. (1973a) Image of the People: Gustave Courbet and the 1848 Revolution, Thames & Hudson, London.
- —— (1973b) The Absolute Bourgeois: Artists and Politics in France 1848–1851, Thames & Hudson, London.
- —— (1994) 'In Defense of Abstract Expressionism', October 69: 23-48.
- —— (1999) Farewell to an Idea: Episodes from a History of Modernism, Yale University Press, New Haven, CT, and London.
- Cockcroft, Eva (1985) 'Abstract Expressionism: Weapon of the Cold War', in Frascina (ed.). Colquhoun, Ithell (1949) 'The Mantic Stain', in *Enquiry* (October).
- Contreras, Belisario (1983) Tradition and Innovation in New Deal Art, Associated University Presses, Inc., London.
- Cooke, Lynne and Peter Wollen (eds) (1995) Visual Display: Culture Beyond Appearances, Bay Press, Seattle.
- Cork, R. G. (1976) Vorticism and Abstract Art in the First Machine Age, Gordon Fraser, London, 2 vols.
- Crane, Diana (1987) The Transformation of the Avant-Garde: The New York Art World, 1940–1985, University of Chicago Press, Chicago.
- Crimp, Douglas (1995) On the Museum's Ruins, MIT Press, Cambridge, MA.
- Crow, Thomas (1996) *Modern Art in the Common Culture*, Yale University Press, New Haven, CT, and London.
- Curtis, Penelope (ed.) (1993) Elective Affinities, Tate Gallery, Liverpool.
- Davidson, Abraham A. (1994) Early American Modernist Painting 1910-1935, Da Capo Press, New York.
- Dawtrey, Liz et al. (eds) (1996) Investigating Modern Art, Yale University Press, New Haven, CT, and London.
- Demarco, Richard (1982) 'Conversations with Artists', Studio International 195 (996).
- Denis, Maurice (1909) 'Subjective and Objective Deformation' in Herschel B. Chipp (1968) Theories of Modern Art: A Sourcebook by Artists and Critics, University of California Press, London.

- Derrida, Jacques (1976) Of Grammatology, Johns Hopkins University Press, Baltimore, MD. Dickstein, Maurice (1996) 'Depression Culture: The Dream of Mobility', Partisan Review (Winter): 65-80.
- Dijkstra, Bram (1986) Idols of Perversity: Fantasies of Feminine Evil in Fin-de-Siècle Culture, Oxford University Press, Oxford.
- Dingman, Roger (1990) 'Alliance in Crisis: The Lucky Dragon Incident and Japanese-American Relations', in Warren I. Cohen and Akira Iriye (eds) The Great Powers in East Asia 1953-1960, Columbia University Press, New York: 187-214.
- Doss, Erica (1991) Benton, Pollock and the Politics of Modernism: From Regionalism to Abstract Expressionism, University of Chicago Press, Chicago.
- Douglas, Mary (1984) Purity and Danger: An Analysis of the Concepts of Pollution and Taboo, Routledge, London.
- Duncan, Carol (1988) 'The Aesthetics of Power in Modern Erotic Art', Feminist Art Criticism, Icon Editions, New York.
- (1995) Civilizing Rituals: Inside Public Museums, Routledge, London.
- Durden, Mark (1997) 'The Beyond and the Ridiculous', Art Monthly 207 (June): 207-8.
- Duve, Thierry de (1993) 'Ex Situ', Art & Design: Installation Art, Academy Group, London, pp. 25-30.
- (1996) Kant after Duchamp, MIT Press, Cambridge, MA.
- Eagleton, Terry (1983) Literary Theory: An Introduction, Blackwell, Oxford.
- —— (1990) The Ideology of the Aesthetic, Blackwell, Oxford.
- (1996) The Illusions of Postmodernism, Blackwell, Oxford.
- Elderfield, John (1995) The Museum of Modern Art at Mid-Century: Continuity and Change, Studies in Modern Art 5, The Museum of Modern Art, New York.
- Elict, Simon and Beverly Sten (eds) (1979) The Age of Enlightenment, trans. Rosemary Smith, Ward Lock and OUP, London.
- Elsen, Albert (1974) Origins of Modern Sculpture: Pioneers and Premises, Phaidon, Oxford.
- Elsner, John and Roger Cardinal (eds) (1994) The Cultures of Collecting, Reaktion Books, Ltd., London.
- Featherstone, Mike et al. (1991) The Body: Social Process and Cultural Theory, Sage, London. Feenberg, Andrew (1999) Questioning Technology, Routledge, London.
- Ferguson, Russell and Martha Gever (eds) (1990) Out There: Marginalization and Contemporary Cultures, The New Museum of Contemporary Art, New York, and MIT Press, Chicago. Flint, R. W. (ed.) (1972) Marinetti: Selected Writings, Secker & Warburg, London.
- Foster, Hal (1985a) 'The Expressive Fallacy', Recodings: Art, Spectacle, Cultural Politics, Bay Press, Seattle.
- —— (1985b) 'The Primitive Unconscious in Modern Art', October 34 (Fall): 45–70.
- (ed.) (1990) Postmodern Culture, Pluto Press, London.
- —— (1996) The Return of the Real: The Avant-Garde at the End of the Century, MIT Press, Cambridge, MA.
- Foucault, Michel (1970) The Order of Things: An Archaeology of the Human Sciences, Tavistock Publications, London.
- —— (1977) Discipline and Punish: The Birth of the Prison, Penguin, London.
- —— (1990) Madness and Civilisation: A History of Insanity in the Age of Reason, Routledge, London.
- ---- (1994) The Archaeology of Knowledge, trans. A. M. Sheridan Smith, Routledge, London, first
- Frascina, Francis (1982) Manet and Modernism, Block 1 (A315), Open University Press, Milton
- (ed.) (1985) Pollock and After: The Critical Debate, Paul Chapman Publishing Ltd., London.
- —— and Charles Harrison (eds) (1982) Modern Art and Modernism: A Critical Anthology, Paul Chapman Publishing, Ltd., London.

- and Jonathan Harris (eds) (1992) Art in Modern Culture: An Anthology of Critical Texts, Phaidon, Oxford.
- Freud, Sigmund (1976) *The Interpretation of Dreams* (eds J. Strachey and A. Richards), Pelican Freud Library, Penguin, London.
- Fried, Michael (1992) 'Art and Objecthood', in Charles Harrison and Paul Wood (eds) Art in Theory, Blackwell, Oxford.
- Fry, Roger (1928) A Record of the Collections in the Lady Lever Art Gallery, Port Sunlight, Cheshire, Port Sunlight, Wirral.
- —— (1961) 'Art and Socialism' [1912] and 'An Essay in Aesthetics' [1920], Vision and Design, Oxford University Press, Oxford.
- Fukuyama, Francis (1992) The End of History and the Last Man, Hamish Hamilton, Penguin, London.
- Fusco, Coco (1995) English Is Broken Here: Notes on Cultural Fusion in the Americas, The New Press, New York.
- Fuss, Diana (1989) Essentially Speaking: Feminism, Nature and Difference, Routledge, London. Gablik, Suzi (1991a) Has Modernism Failed?, Thames & Hudson, London [1984].
- --- (1991b) The Re-Enchantment of Art, Thames & Hudson, London.
- —— (1991c) 'The Aesthetics of Duplicity', in Papadakis (ed.).
- Gallagher, Catherine and Thomas Laquer (eds) (1987) The Making of the Modern Body: Sexuality and Society in the Nineteenth Century, University of California Press, London.
- Gibson, William (1984) Neuromancer, Grafton, London.
- Giedeon, Siegfried (1948) Mechanisation Takes Command, Oxford University Press, London.
- Gilman, Sander L. (1985) 'Black Bodies, White Bodies: Toward an Iconography of Female Sexuality in Late Nineteenth Century Art, Medicine and Literature', in Henry Louis Gates Jr (ed.) 'Race', Writing and Difference, University of Chicago Press, London.
- Glimcher, Marc (ed.) (1987) Jean Dubuffet, Pace Publications, New York.
- Goldberg, Rose Lee (1990) Performance Art, Thames & Hudson, London.
- Goldwater, A. (1938) *Primitivism in Modern Art*, Harvard University Press, Cambridge, MA. Gombrich, E. H. (1984) *The Story of Art*, Phaidon, Oxford [1950].
- Goodrich, Lloyd (1967) The Artist in America, Compiled by the Editors of Art in America, W. W. Norton & Co., New York.
- Gramsci, Antonio (1971) 'Americanism and Fordism', in Selections from the Prison Notebooks of Antonio Gramsci, Lawrence & Wishart, London.
- Greenberg, Clement (1939) Partisan Review VI (5).
- —— (1948) 'The Decline of Cubism', Partisan Review 15 (3).
- (1982) 'Master Léger', in Francis Frascina and Charles Harrison (eds) Modern Art and Modernism: A Critical Anthology, Paul Chapman, London.
- (1982) 'Modernist Painting', in Francis Frascina and Charles Harrison (eds) *Modern Art and Modernism: A Critical Anthology*, Paul Chapman, London: 5–10.
- (1985) 'Avant-Garde and Kitsch' [1939], in Francis Frascina (ed.) *Pollock and After: The Critical Debate*, Paul Chapman, London.
- (1986) 'The Beginnings of Modernism', in John O'Brian (ed.) Clement Greenberg: The Collected Essays and Criticism, University of Chicago Press, Chicago.
- (1986) 'Newness in Sculpture', in John O'Brian (ed.) Clement Greenberg: The Collected Essays and Criticism, University of Chicago Press, Chicago.
- —— (1992) 'Towards a Newer Laocoon' [1940], in Charles Harrison and Paul Wood (eds) *Art in Theory, 1900–1990*, Blackwell, Oxford.
- Greenberg, Reesa, Bruce W. Ferguson and Sandy Nairne (eds) (1996) Thinking About Exhibitions, Routledge, London.
- Greer, Germaine (1971) The Female Eunuch, Flamingo, London.
- (1979) The Obstacle Race: Fortunes of Women Painters and their Work, Secker, London.

- Gropius, Walter (1923) 'Art and Technology: A New Unity', unpublished lecture.
- Guilbaut, Serge (1983) How New York Stole the Idea of Modern Art: Abstract Expressionism, Freedom, and the Cold War, University of Chicago Press, Chicago.
- —— (1985) 'The New Adventures of the Avant-Garde in America', in Frascina (ed.).
- Habermas, Jürgen (1990) 'Modernity An Incomplete Project', in Hal Foster (ed.) (1990) Postmodern Culture, Pluto Press, London.
- Hagen, Margaret (1986) Varieties of Realism: Geometries of Representational Art, Cambridge University Press, Cambridge.
- Hall, Doug and Sally Jo Fifer (1990) Illuminating Video, Aperture/BAVC, New York.
- Hamilton, George Heard (1984) Painting and Sculpture in Europe 1880–1940, Penguin, Harmondsworth.
- Haraway, Donna (1991) Simians, Cyborgs and Women: The Reinvention of Nature, Routledge, London.
- Harris, Jonathan (1993) 'Art Histories and Visual Cultural Studies', in Kate McGowan (ed.) The Year's Work in Critical and Cultural Theory, vol. 3, Blackwell, Oxford.
- (1995) Federal Art and National Culture: The Politics of Identity in New Deal America, Cambridge University Press, Cambridge.
- —— (1997) 'Art Education and Cyber Ideology: Beyond Individualism and Technological Determinism', *Art Journal* (Fall): 39–45.
- (forthcoming) 'Seeing Red' The American Artists' Congress and New York Art: Left Activism in the Late 1930s.
- Harrison, Charles (1997) Modernism: Movements in Modern Art, Tate Gallery, London.
- and Paul Wood (1997) Art in Theory, Blackwell, Oxford.
- Hartley, Keith et al. (eds) (1994) The Romantic Spirit in German Art, 1790–1990, Scottish
 National Gallery of Modern Art, Hayward Gallery, London and the Nationalgalerie, Berlin.
 Harvey, David (1989) The Condition of Postmodernity, Blackwell, Oxford.
- Hawking, Stephen (1988) A Brief History of Time: From the Big Bang to Black Holes, Bantam, London.
 Henderson, Linda Dalrymple (1983) The Fourth Dimension and Non-Euclidean Geometry in Modern Art, Princeton University Press, Princeton, NJ.
- Highsmith, Carol M. and Ted Landphair (1995) Forgotten No More: The Korean War Veterans' Memorial Story, Chelsea Publications, Washington, DC.
- Hiller, Susan (ed.) (1991) The Myth of Primitivism: Perspectives on Art, Routledge, London. Hobsbawm (1994) Age of Extremes: The Short Twentieth Century, 1914–1991, Michael Joseph, London.
- Hollander, Anne (1993) Seeing Through Clothes, University of California Press, London.
- Hooper-Greenhill, Eileen (1992) Museums and the Shaping of Knowledge, Routledge, London. Hughes, Robert (1980) 'Ten Years that Buried the Avant-Garde', Sunday Times Magazine,
- January; reprinted in Andreas C. Papadakis (ed.) (1987) 'Post-Avant-Garde Painting in the '80s', *Art and Design*, Academy Group, London.
- Hulten, Pontas (1987) Jean Tingueley: A Magic Stronger than Death, Thames & Hudson, London. Hunt, Ian (1997) 'The Sea Is a Magic Carpet', Library Relocations, Book Works, London. Irigaray, Luce (1985) Speculum of the Other Woman, trans. G.C. Gill, Cornell University Press, Ithaca, New York.
- Jameson, Frederic (1991) *Postmodernism, or the Cultural Logic of Late Capitalism*, Verso, London. Johnson, Ellen H. (ed.) (1982) *American Artists on Art from 1940–1980*, Icon Editions, New York. Joly, Françoise (ed.) (1997) *Short Guide to Documenta X*, Cantz, Kassel.
- Jones, Steven G. (1995) Cybersociety: Computer-Mediated Communication and Community, Sage, New York.
- Jung, C.J. (1933) The Modern Man in Search of a Soul, Routledge & Kegan Paul, London. Kandinsky, Wassily (1977) Concerning the Spiritual in Art, Dover Publications, New York. Kaplan, Janet A. (1988) Unexpected Journeys: The Art and Life of Remedios Varo, Virago, London.

Kaprow, Allen (1958) 'The Legacy of Jackson Pollock', Art News (October).

Kent, Sarah and Jacqueline Moreau (1985) Women's Images of Men, Pandora, London.

Kozloff, Max (1967) 'The "Poetics of Softness", in Maurice Tuchman (ed.) American Sculpture of the '60s, New York Graphic Society, New York.

—— (1985) 'American Painting during the Cold War', in Frascina (ed.).

Krauss, Rosalind (1977) Passages in Modern Sculpture, Thames & Hudson, London.

— (1990) 'Sculpture in the Expanded Field' [1983], in Hal Foster (ed.) *Postmodern Culture*, Pluto, London.

Kristeva, Julia (1982) Powers of Horror: An Essay on Abjection, Columbia University Press, New York.

Krutch, Joseph W. (ed.) (1981) Walden and Other Writings by Henry David Thoreau, Bantam Classic, New York.

Kuhn, Thomas (1970) The Structure of Scientific Revolutions (2nd edition), University of Chicago Press, London.

Lacan, Jacques (1977) Ecrits: A Selection [trans. Alan Sheridan], Norton, New York.

Lapp, Ralph E. (1957) The Voyage of the Lucky Dragon, Frederick Muller, Ltd., London.

Lasch, Christopher (1979) The Culture of Narcissism: American Life in an Age of Diminishing Expectations, W.W. Norton & Co., New York.

Leja, Michael (1993) Reframing Abstract Expressionism: Subjectivity and Painting, Yale University Press, New Haven and London.

Levin, Harry (1960) 'What Was Modernism?', *The Massachusetts Review* (August); reprinted (1966) in *Refractions: Essays in Comparative Literature*, Oxford University Press, New York and Oxford.

Lévi-Strauss, Claude (1972) The Savage Mind, Weidenfeld, London.

Lewis, Reina (1996) Gendering Orientalism: Race, Femininity and Representation, Routledge, London.

Lindey, Christine (1990) Art in the Cold War: From Vladivostock to Kalamazoo, 1945-62, Herbert Press, London.

Lipman, Jean (ed.) (1963) What Is American in American Art?, McGraw-Hill, New York.

— (1976) Bright Stars: American Painting and Sculpture since 1776, E.P. Dutton & Co., New York.

Lippard, Lucy R. (1983) Overlay, New Press, New York.

— (1990) A Different War. Vietnam in Art, Watcom Museum of History and Art and Real Comet Press, Seattle.

— (1997) Six Years: The Dematerialisation of the Art Object from 1966 to 1972, University of California Press, Berkeley, Los Angeles and London.

Lipsey, Roger (1997) An Art of Our Own: The Spiritual in Twentieth-Century Art, Shambhala, Boston and London.

Littleton, Taylor D. and Maltby Sykes (1989) Advancing American Art, Painting, Politics and Cultural Confrontation at Mid-Century, University of Alabama Press, Tuscaloosa, Alabama.

Lodder, Christina (1993) 'Lenin's Plan for Monumental Propaganda', in Brown and Taylor, Art of the Soviets: Painting, Sculpture and Architecture in a One-Party State, 1917–1992, Manchester University Press, Manchester.

Lumley, R. (1988) The Museum Time-Machine, Routledge, London.

Lutz, Catherine A. (1990) 'Engendered Emotion: Gender, Power, and the Rhetoric of Emotional Control in American Discourse', in Catherine A. Lutz and Abu-Lugodh (eds) Language and the Politics of Emotion, Cambridge University Press, Cambridge.

Lynes, Russell (1973) Good Old Modern: An Intimate Portrait of the MOMA, Athenaeum, New York.

Lyotard, Jean-François (1982) 'Presenting the Unpresentable: The Sublime', Art Forum XX(8): 69–74.

- —— (1989) 'Complexity and the Sublime', in Lisa Appignanesi (ed.) *Postmodernism: ICA Documents*, Free Association Books, London.
- (Madonna) Meisel, Stephen (1992) Sex, Warner Books, New York.
- Mansbach, Steven A. (1979) Visions of Totality: Lazlo Moholy-Nagy, Theo Van Doesburg, and El Lissitzky, UMI Research Press, Ann Arbor, MI.
- Marcuse, Herbert (1968) Negations: Essays in Critical Theory, Lane, London.
- (1978) The Aesthetic Dimension: Towards a Critique of Marxist Aesthetics, Beacon Press, Boston, MA.
- McLuhan, Marshall (1989) The Global Village, Oxford University Press, London.
- Meijers, Deborah J. (1996) 'The Museum and the "Ahistorical" Exhibition: the latest gimmick by the arbiters of taste, or an important cultural phenomenon?', in Reesa Greenberg et al. (eds). Thinking About Exhibitions, Routledge, London: 7–20.
- Merleau-Ponty, Maurice (1989) The Phenomenology of Perception, trans. Colin Smith, Routledge, London.
- Miller, Catriona (1996) 'Modernism and Modernity', in Shearer West (ed.) *Guide to Art*, Bloomsbury, London.
- Mitchell, W. J. T. (ed.) (1992) Art and the Public Sphere, University of Chicago Press, London.
- Moffitt, J. F. (1986) 'Marcel Duchamp: Alchemist of the Avant-Garde', in E. Weisberger (ed.) *The Spiritual in Art: Abstract Painting, 1890–1985*, Abbeville Press, New York.
- Mulvey, Laura (1989) 'Visual Pleasure and Narrative Cinema', Visual and Other Pleasures, Indiana University Press, Bloomington.
- Museum of Modern Art (1994) Machine Art, 60th Anniversary Edition, Museum of Modern Art, New York [1934].
- Naifeh, Steven and G. W. Whitesmith (1989) Jackson Pollock: An American Saga, Clarkson N. Porter, Inc., New York.
- Nead, Lynda (1992) The Female Nude: Art, Obscenity and Sexuality, Routledge, London.
- Nelson, Robert S. and Richard Schiff (1997) Critical Terms for Art History, University of Chicago Press, London.
- Nochlin, Linda (1989) 'Why Have there Been No Great Women Artists?', reprinted in Linda Nochlin *Women, Art and Power and Other Essays*, Thames & Hudson, London (first published in 1971).
- (1991) The Politics of Vision: Essays on Nineteenth-Century Art and Society, Thames & Hudson, London.
- O'Brian, John (ed.) (1986) Clement Greenberg: The Collected Essays and Criticism, University of Chicago Press, Chicago, 4 vols.
- O'Connor, Francis V. (ed.) (1975) WPA. Art for the Millions. Essays from the 1930s by Artists and Administrators of the WPA Federal Art Project, New York Graphics Society, New York.
- O'Neil, John (1993) 'McTopia: Eating Time', in K. Kumar and S. Bann (eds) (1993) *Utopias and the Millennium*, Reaktion Books, London.
- Ono, Yoko (1995) Instruction Paintings, Weatherhill, New York and Tokyo.
- Open University (1982) Modern Art and Modernism: Manet to Pollock (Third Level Arts' Course), A316, Open University Press, Milton Keynes.
- Orten, Fred and Griselda Pollock (1981) 'Avant-Gardes and Partisans Reviewed', Art History (September).
- Ouspensky, P. D. (1922) *Tertium Organum* (trans. Claude Bragson and Nicholas Bessaraboff), Alfred A. Knopf, New York [1911].
- Owens, Craig (1990) 'The Discourse of Others: Feminists and Postmodernism', in Hal Foster *Postmodern Culture*, Pluto Press, London.
- Panofsky, Erwin (1987) Meaning and the Visual Arts, Penguin, Harmondsworth (first published in 1955).

Papadakis, Andreas C. (ed.) (1991) New Museology, Art & Design Profile, Academy Group, Ltd., London.

Papanek, Victor (1977) Design for the Real World (2nd edition), Paladin, London.

Parker, Rosika and Griselda Pollock (1989) Old Mistresses: Women, Art and Ideology, Pandora, London.

Pater, Walter (1873) The Renaissance: Studies in Art and Poetry, Macmillan, London.

Paz, Octavio (1987) Essays on Mexican Art, trans. Helen Lane, Harcourt Brace & Company, New York.

Pearce, Susan (1998) Collecting in Contemporary Practice, Sage, London.

Penny, Simon (ed.) (1995) Critical Issues in Electronic Media, SUNY Press, New York.

Perry, Gillian (1979) Paula Modersohn-Becker, The Women's Press, London.

Philippi, Desa and Anna Howell (1991) 'Dark Continents Explored by Women', in Susan Hiller (ed.) *The Myth of Primitivism: Perspectives on Art*, Routledge, London.

Picon, Gaeton (1978) The Birth of Modern Painting, Macmillan, London.

Plant, Sadie (1993) 'Beyond the Screens: Film, Cyberpunk and Cyberfeminism', *Variant*, 14: 12–17.

Pogglioli, Renato (1968) *The Theory of the Avant-Garde*, Harvard University Press, Cambridge, MA.

Pohl, Frances K. (1989) Ben Shahn: New Deal Artist in a Cold War Climate, 1947–1954, University of Texas Press, Austin.

— (1993) Ben Shahn, with Ben Shahn's Writings, Pomegranate Artbooks, San Francisco, California.

Pointon, Marcia (ed.) (1989) Pre-Raphaelites Re-Viewed, Manchester University Press, Manchester.

— (1990) Naked Authority: The Body in Western Painting, Cambridge University Press, Cambridge.

—— (ed.) (1994) Art Apart: Art Institutions and Ideology across England and North America, Manchester University Press, Manchester.

Polcari, Stephen (1990) 'Martha Graham and Abstract Expressionism', Smithsonian Studies in American Art (Winter).

— (1991) Abstract Expressionism and the Modern Experience, Cambridge University Press, Cambridge.

— (1997) Richard Pousette-Dart (1916–1992), Metropolitan Museum of Art, New York. Polhemus, Ted (1978) The Social Aspects of the Human Body, Penguin, London.

Pollock, Griselda (1990) Vision and Difference: Femininity: Feminism and the Histories of Art, Routledge, London.

Ratcliff, Carter (1994) 'Jackson Pollock and American Painting's Whitmanesque Episode', Art in America (February).

Rees, A. L. and Frances Borzello (eds) (1986) *The New Art History*, Camden Press, London. Rewald, John (1973) *History of Impressionism* (4th edition), Secker & Warburg, London (first published in 1946).

Rian, J. (1993) 'What's All this Body Art?', Flash Art XXVI(168): 51-5.

Richter, Hans (1965) Dada: Art and Anti-Art, Thames & Hudson, London.

Rilke, Rainer Maria (1930) The Notebook of Malte Laurids Brigge, Hogarth Press, London.
—— (1991) Letters on Cezanne, Vintage, London.

Rodman, Selden (1961) Conversations with Artists, Capricorn, New York.

Rose, Barbara (1975) American Art since 1900: A Critical History, Frederick A. Praeger, Inc., New York.

Rosenberg, Harold (1982) Art Works and Packages, University of Chicago Press, Chicago [1969] Rosler, Martha (1996) 'Video: Shedding the Utopian Moment', in The Block Reader in Visual Culture, Routledge, London.

Rubenfeld, Florence (1998) Clement Greenberg: A Life, Scribner, New York.

Rubin, William (ed.) (1984) Primitivism in Twentieth-Century Art, Museum of Modern Art, New York.

Russolo, Luigi (1973) 'The Art of Noises (extracts)', Umbro Apollonio (ed.) Futurist Manifestos, Thames & Hudson, London: 74–8.

Said, Edward (1975) Beginnings: Intention and Method, Basic Books, New York.

—— (1993) Culture and Imperialism, Chatto & Windus, London.

— (1995) Orientalism: Western Conceptions of the Orient (reprinted with a new Afterword), Penguin Books, London [1978].

Sandford, Mariellen (ed.) (1995) Happenings and Other Acts, Routledge, London.

Sandler, Irving (1970) The Triumph of American Painting, Praeger Inc., New York.

— (1993) 'The Noise of the Traffic on the Way to Walden Pond', American Art in the Twentieth Century: Painting and Sculpture (1913–1993), Prestel and the Royal Academy, London.

— and Amy Newman (1986) Defining Modern Art: Selected Writings of Alfred H. Barr, Jr., Harry A. Abrams, Inc., New York.

Saussure, Ferdinand de (1983) Course in General Linguistics, Duckworth, London.

Schapiro, Meyer (1978) Modern Art: 19th and 20th Centuries. Selected Papers, George Brazillier, London.

Schatzki, Theodore (1996) Social Practices: A Wittgensteinian Approach to Human Activity and the Social, Cambridge University Press, Melbourne.

Schimmel, Paul et al. (1998) Out of Actions: Between Performance and the Object, Thames & Hudson, London.

Schlesinger, Arthur, Jr (1949) 'The Vital Center: Our Purpose and Perils on the Tightrope of American Liberalism', reprinted in 1962 as *The Vital Center: The Politics of Freedom*, Riverside Press, Boston, MA.

Schneider, Rebecca (1997) The Explicit Body in Performance, Routledge, London.

Senie, Harriet F. and Sally Webster (eds) (1992) Critical Issues in Public Art: Content, Context, and Controversy, HarperCollins, New York.

Shahn, Ben (1955) New York Times, January 10.

—— (1957) The Shape of Content, Harvard University Press, Cambridge, MA.

Shapiro, David and Cecile Shapiro (1985) 'Abstract Expressionism: The Politics of Apolitical Painting', in Frascina (ed.).

—— (1990) Abstract Expressionism: A Critical Record, Cambridge University Press, Cambridge. Sharp, Willoughby (1970–72) 'Bodyworks', Avalanche 1–10.

Sherman, Frederic Fairchild (1963) 'The Marines of Albert P. Ryder', in Jean Lipman (ed.). Shilling, Chris (1993) *Body and Social Theory*, Sage, London.

Showalter, Elaine (1991) Sexual Anarchy: Gender and Culture at the Fin de Siècle, Bloomsbury, London.

Simmel, George (1978) Philosophy of Money, Routledge, London [1900].

Smith, Alison (1996) The Victorian Nude: Sexuality, Morality and Art, Manchester University Press, Manchester.

Smith, Bernard (1998) Modernism's History: A Study in Twentieth-Century Art and Ideas, Yale University Press, New Haven, CT, and London.

Sontag, Susan (1987) On Photography, Allen Lane, London.

Spence, Jo (1988) Putting Myself in the Pieture: A Political, Personal, and Photographic Autobiography, The Real Comet Press, Seattle.

Stanley, Nick (1998) Being Ourselves for You: The Global Display of Cultures, Middlesex University Press, London.

Stearns, Carol Z. and Peter N. Stearns (eds) (1988) Emotion and Social Change: Toward a New Psychohistory, Holmes & Meier, New York.

Storey, John (1997) Introduction to Cultural Theory and Popular Culture (2nd edition), Harvester, London.

Stott, William (1973) Documentary Expression and Thirties' America, Oxford University Press, Oxford.

Suleiman, Susan Rubin (ed.) (1986) The Female Body in Western Culture: Contemporary Perspectives, Harvard University Press, Cambridge, MA.

Sypher, Wylie (1979) *The Loss of Self in Modern Literature and Art*, Greenwood Press, Westport, CT.

Sztulman, Paul (1997) 'Johan Grimonprez', in Françoise Joly (ed.) (1997) Short Guide to Documenta X, Cantz, Kassel.

Tagg, John (1992) Grounds of Dispute: Art History, Cultural Politics and the Discursive Field, Macmillan, London.

Tatlin, Vladimir (1918-19) 'New Way of Life', unpublished lecture.

Taylor, Brandon (1994) 'From Penitentiary to "Temples of Art": Early Metaphors of Improvement at the Millbank Tate', in Pointon (ed.) (1994) *Art Apart*, Manchester University Press, Manchester.

Thistlewood, David (ed.) (1993) American Abstract Expressionism, Critical Forum Series, vol. 1, Liverpool University Press and the Tate Gallery, Liverpool.

Timms, Edward and Peter Collier (eds) (1988) Visions and Blueprints: Avant-Garde Culture and Radical Politics in Early Twentieth-Century Europe, Manchester University Press, Manchester.

Tomkins, Calvin (1996) Duchamp, Chatto & Windus, London.

Trodd, Colin (1994) 'Culture, Class, City: The National Gallery, London, and the Spaces of Education, 1822–57', in Pointon (ed.) (1994) *Art Apart*, Manchester University Press, Manchester.

Trotsky, Leon (1968) 'Manifesto Towards a Free Revolutionary Art', reprinted in Herschel B. Chipp (ed.) *Theories of Modern Art: A Sourcebook by Artists and Critics*, University of California Press, London.

— (1992) 'Revolutionary Spirit in Modern Art', reprinted in Charles Harrison and Paul Wood (eds) *Art in Theory*, 1900–1990, Blackwell, Oxford.

Tucker, William (1974) The Language of Sculpture, Thames & Hudson, London.

Turkle, Sherry (1995) Life on the Screen: Identity in the Age of the Internet, Weidenfeld & Nicolson, London.

Turner, Bryan S. (1996) The Body and Society (2nd edition), Sage, London.

Turner, Frederick J. (1893) The Significance of the Frontier in American History, Irvington Publishers, Inc., New York.

Veblen, Thorstein (1921) The Engineers and the Price System, B. W. Huebsch, New York.

Vergo, Peter (ed.) (1989) The New Museology, Reaktion Books, London.

Virilio, Paul (1995) The Art of the Motor, Minnesota University Press, Minneapolis.

—— (1997) Open Sky, Verso, London and New York.

Warner, Marina (1985) Monuments and Maidens: The Allegory of the Female Form, Picador, London.

Waterfield, Giles (ed.) (1991) Palaces of Art: Art Galleries in Britain 1790–1990, Dulwich Picture Gallery, London.

Watson, Peter (1992) From Manet to Manhattan: The Rise of the Modern Art Market, Hutchinson, London.

Weber, Max (1910) 'The Fourth Dimension from a Plastic Point of View', Camera Work 31 (July).

Weiemair, Peter (1996) Prospect Photography and Contemporary Art, Edition Stemmle, Frankfurt, Kilchberg and Zurich.

Wells, Liz (ed.) (1997) Photography: A Critical Introduction, Routledge, London.

Wheale, Nigel (ed.) (1995) The Postmodern Arts, Routledge, London.

236 BIBLIOGRAPHY

Whitman, Walt (1986) The Complete Poems, Penguin Classics, Harmondsworth.

Willet, John (1987) The New Sobriety: Art and Politics in the Weimar Period, 1917–33, Thames & Hudson, London.

Williams, Raymond (1979) Television: Technology and Cultural Form, Fontana, Glasgow.

- (1981) Culture, Fontana, London.
- (1988) Keywords, Penguin, Harmondsworth.
- (1989) 'What Was Modernism?', The Politics of Modernism: Against the New Conformists, Verso, London.

Williamson, Judith (1996) 'Baudrillard Interview', *The Block Reader in Visual Culture*, Routledge, London.

Wilson, Martha (1997) 'Performance Art', Art Journal 56(4).

Worringer, Wilhelm (1963) Abstraction and Empathy, Routledge & Kegan Paul, London.

Young, James (1993) *The Texture of Memory: Holocaust Memorials and Meaning*, Yale University Press, Cambridge, MA.

Index

Abramovic, Marina 176–77 abstract 4, 39–40, 43, 49, 66, 68, 75, 78, 81, 83, 215 non-geometrical/geometrical 7, 120	and construction of identity 159 and the Depression 138–42 and myth of national origin 149–50 American Arts Congress 142
paradox of 40	American type painting 147
theories of 155–57	Anderson, Laurie xv, xviii, 58
abstract expressionism 6, 27, 51, 76,	anthropology 99, 194–96
136–38, 215	anthroposophy 67
advocates of 151–52	Appignanesi, R. and Garrett, C. 107
all-over painting 158–59	architecture 30, 113
and American Depression 138–42	Armstrong, Carol M. 94
apolitical nature of 151–52	Arnheim, Rudolf 98
and the Cold War 153–55	Arp, Hans 25, 75, 206
emergence of 147–49	Arp, Sophie Tauber 75
gender bias 163	art
and McCarthy 146–47	as apolitical 151–52
and myth of self-destructive genius 162	for art's sake 11
native American influence on 159–62	as authentic 83
and post-modernism 163–64	and the 'call to order' 111–13
revisionist views 146	in electronic age 211–13
and revolution 142–45	for museum space 208–10
and taste 156	as radical 26
academies of art 215	relationship to gallery 190–91
action painting 147, 157, 168-71	and spirituality 66–70
advertising 35–36	uniqueness of object 203–04
aesthetic 23, 215, 215–16	art history xvii-xviii
aesthetic autonomy 21–22	and connoisseurship xx
alienation 10, 77, 177, 178	and critical distance 10
all-over painting 158–59	feminist 91–92
Althusser, Louis 175	gendered xx
America 136–38	and heroism 14
in the 1950s 146–47	hierarchical approach 4-5
and abstract expressionism 6, 147–49	and individuals 64–65
and the Cold War 153–55	and language xviii–xx

1:	D. D. D. H. W.
art history (continued)	Benedict, Ruth 164
narrative structure 6	Benedikt, Michael 135
siting of xxii	Benjamin, Walter 37, 58, 203-04
and theory xx–xxiii	Benton, Tim and Benton, Charlotte 109,
art nouveau 45, 113	111, 112, 115, 119, 120, 123, 126
Art Workers' Coalition (AWC) 51	Berger, John 39, 87–88, 91, 108
artist	Bernheimer, Charles 97
appearance of 168-69, 174, 187	Beuys, Joseph 46, 47, 67
as citizen 140	Blanc, Charles 52
as curator 204–06	Blavatsky, Helena Petrovna 67, 71
as genius 10	Blazwick, Iwona 209
as imaginative 62–66	Bliss, Lillie P. 200
as realist 62	Bloch, Lucienne 140
role of 123	Boddy, William 167
as socially useful 123	bohemianism 216
see also performance art	Boltanski, Christian 48
artistic authority 61–62	Bonnard, Pierre 20, 21
Artists' Protest Committee 51	Borzello, Frances 85, 196
Ashton, Dore 166	Bourdieu, Pierre 23
Asselberghs, Herman 211	bourgeois culture 22-23, 216
aura 216	Bourke-White, Margaret 139
Aurier, Albert 68, 97, 99	Boyce, Sonia 103
auteurs 64–65	Brancusi, Constantin 43-44, 44, 58, 73, 74
autobiography, and authenticity 169-71	Brecht, Bertolt 3, 177
automatism 43, 145, 155	Brecht, George 207
autonomy 21–22, 152, 156, 216	Breton, André 25, 81, 82, 144, 154
avant-garde 3, 4, 10, 15-16, 15-21, 22-26,	Briseley, Stuart 177
28–31, 38, 117, 153, 158, 163, 216	Britt, David 31
complexity/vulnerability of 23-26	Broodthaers, Marcel 3, 205
culture of 20–21	Brookes, Liz 178
death of 28-31	Brus, Günter 172, 174, 177, 178
first use of term 18	Bryson, Norman xxi-xxii
history of 16-21	Bunn, David 194-95
and relationship to bourgeois culture	Burchfield, Charles 155
22–23	Burckhardt, Jacob 31
avatars 188	Burne-Jones, Edward 183
	Burra, Edward 140, 141
Baden-Powell, Robert 102	Butler, Judith 176
bagism 84	, 3
Ball, Hugo 25, 206	Cabaret Voltaire 206
Banham, Reyner 113	cabinet of curiosities 192
Bann, Stephen 192	Cage, John 2
Barr, Alfred H. Jr 8, 78, 114, 119-20,	Cahill, Holger 160
123, 140, 200–03, 203	Calder, Alexander 75
schematic approach of 7-8, 64, 120	canon 216–17
Barthes, Roland xxiii, 64-65, 170	Carrington, Leonora 76, 80, 82
Batchelor, David 43, 52	Celeste-Adams, Marie 166
Baudelaire, Charles 9, 62, 110	Cendrars, Blaise 115
Baudrillard, Jean 57, 58-59, 60, 193, 211	Central Intelligence Agency (CIA) 146
Bauhaus 45, 83, 114, 115, 120, 121, 122,	Cézanne, Paul 42, 63, 110, 120
200, 216	Chadwick, Helen 184, 185–86
Baur, John I. H. 113, 148	Chaplin, Charlie 125
Beauvoir, Simone de 46, 152, 186	Chicago, Judy 51, 105, 106
Beckman, Max 155	Chipp, Herschel B. 68, 76, 102, 147, 152,
Bell, Clive 9, 11, 12, 23, 24	157, 167, 206
Belting, Hans xxiii	Christos 41

city changing realities of 33 experience of 57–58 relationship with countryside 32 state values in 37–38 Cixous, Hélène 184 Clark, Kenneth 87, 88, 98, 189 Clark, T. J. 14, 15, 22, 156 classical 18, 85, 111, 217 Claudel, Camille 82 Cold War 217 collage/decollage 217 colonialism 100 Colquhoun, Ithell 81–82 commodity 26–28, 35, 36, 92, 217 communism 37–38, 154 computers 132–33, 188 conceptual art 46, 83, 172 connoisseur 217 constructivism 24, 26, 76, 114, 117, 119–20, 200, 217	Dickens, Charles 17–18 Dickinson, Emily 42 Dickstein, Maurice 139 Diderot, Denis 9, 89, 123 Die Brücke 101 Digital Diaspora 135 Dijkstra, Bram 97 Dingman, Roger 165 discourse 218 Disneyland 59 dodecaphony 31 Doesburg, Theo van 109, 120, 125–26 Douglas, Mary 173, 176 Dove, Arthur 141, 142 Driggs, Elsie 114, 114 drip painting 156, 157 dualism 70–72, 130, 174, 181 Dubois, Abbé 9 Dubuffet, Jean 82, 82 Duchamp, Marcel xv, 1, 3–4, 5, 12, 28, 56, 72, 75, 83, 85, 105, 106, 173, 207
Cornell, Joseph 207	72, 75, 83, 85, 105, 106, 173, 207 Duffy, Mary 186
Courbet, Gustave 18, 19, 89, 90, 91, 99	Duncan, Carol 185, 195
Craven, Arthur 168	Durden, Mark 104
Crimp, Douglas 204, 207	Duve, Thierry de 9–10, 16, 20–21, 40, 168
cubism 3, 7, 31, 69–70, 75, 76, 78, 98,	dystopias 124–26
101, 111–12 culture 35, 217	Eagleton, Terry 22, 45, 128, 181, 189
Cunningham, Merce 133	Eakins, Thomas 87, 88
Curtis, Penelope 184, 185	earthworks art 70–71, 172
cybersex 134	Edwards, Mel 51
cyberspace 129, 131	Eisenman, Peter 48
cyborg 133, 134, 188	Eisenstein, Sergei 38
D 1 2 24 25 27 77 440 427 472	Elict, Simon and Sten, Beverly 89
Dada 3, 24–25, 27, 76, 118, 127, 173,	Ellis, Havelock 99
206, 207, 217–18 Dadd, Richard 82	Elsen, Albert 43 Elwes, Catherine 92
Dald, Richard 82 Dali, Salvador 72, 154	Emerson, Ralph Waldo 159
dance 2	emotionologies 161–62
Danto, Arthur C. xxiii	Enlightenment 9, 12, 89, 218
David, Jacques Louis 86	Epstein, Jacob 117, 118
Davis, Stuart 145, 154, 155, 166	erasure 136–38, 163
De Stijl 113, 120, 200	Ernst, Max 76
Debussy, Claude 2	essentialism 44, 45, 69, 73, 174, 184–86
Degas, Edgar 88, 90, 96, 96, 97	ethnography 218
degenerate art 149 Delacroix, Eugène 93	Evergood, Philip 51, 154, 155 Ewald, Kurt 115
Delaunay, Robert and Sonia 75	exhibitions 195–96
DeLillo, Don 211	'Advancing American Art' (1946–47)
Demarco, Richard 46	154–55, 164
Demuth, Charles 141, 143	ahistorical 204-06
Denis, Maurice 12, 61	'American Sources of Modern Art'
Depression 138–42, 147	(1933) 160
Derain, André 31	Armory Show (1913) 141–42
Derrida, Jacques xxiii, 181, 194, 205 Descartes, René 71, 181	'Common Man: Mythic Vision' (1998) 164
Descartes, Refle /1, 101	1UT

'Cubism and Abstract Art' (1936) 7	Fusco, Coco 126
'Degenerate Art' (1937) 102	futurism 10, 73, 83, 109, 110–11, 173, 218
'Documenta 7' 46	20, 10, 10, 10, 11, 170, 210
'Indian Art of the United States' (1941)	Gablik, Suzi 30, 66
160	Gauguin, Paul 62–63, 63, 76, 77
'Machine Art' (1934) 114	Gautier, Théophile 99
Monet (1998–99) 212	Geddes, Norman Bel 135
Surrealist (1938) 190	Gehry, Frank 209
existentialism 66, 77, 152–53	gender
expressionism 7, 76, 98, 101, 117, 119,	and colour 52
119–20, 218	and division of labour 80
	and monuments 51–52
Farrell, 171, 171	Geneaur, Emily 154
fauvism 31, 76	generative art 129
Federal Arts Project (FAP) 139, 140	Géricault, Théodore 202
Feininger, Lyonel 155	Gibbs, Michael 189
female nude	Gibson, William 129
and black women 99, 102–03	Gilbert, Alfred 195
death, disease, dangerous 99–102	Gilman, Sander 99
and fin-de-siècle anxieties 99–100	Gombrich, Ernst H. 2, 31
formal 97–98	Goncharova, Natalia 11
gendered view of 95–97, 98	Goodyear, A. Conger 140
genealogy of 86–91	Gorky, Arshile 73
postmodern 102–07	Graham, Dan 131–32
and primitivism 100–02, 103	Graham, Martha 139
representing 91–94	Gramsci, Antonio 26, 125, 126
and sexuality 100	Grand Tour 76
see also nude	Great Depression 115
feminism/postfeminism 218	Greenberg, Clement 10–11, 20, 27, 34,
Fernandez, Armand 55, 57	43, 60, 67, 117, 136, 145, 151, 152,
Ferren, John 147	155–56
figurative art 78	Greenbergian formalism 10–12, 20, 163
film 3, 56, 60, 64, 123, 159	Greenway, Peter 213
and communist threat 147	Greer, Germaine 184, 185
feminist theory 95–96	Greyworld 129, 129
First Machine Age 114, 116	Grimonprez, Johan 211, 212
Flanagan, Bill 179	Gropius, Walter 115, 119, 121
Flaubert, Gustave 89	Gropper, William 154
Flint, R. W. 115	Grosz, George 155
Flügel, Karl Alexander 79	Grunenberg, C. 208
Fluxus 5, 127, 173, 207–08, 219	Guilbaut, Serge 136
Ford, Henry 125, 126, 134	Gurdjieff, George I. 67
formalism 10–12, 39, 64, 97, 98, 102,	
155, 159, 218	Habermas, Jürgen 9
Foster, Hal 16, 28-29, 57, 173	Hah, Trin T. Minh 211
Foucault, Michel 92, 100, 161, 174,	Hall, Doug and Fifer, Sally J. 127
197–98	Hamilton, George H. 43, 44
Frascina, Francis 70, 115, 143, 155	Happenings 173
and Harrison, Charles 117, 153	Haraway, Donna 132, 133, 134, 187
Freud, Sigmund 80–81, 99, 181, 193	Harris, Jonathan 140, 211
Fried, Michael 24, 156	Harrison, Charles 31, 151
Frith, William 15	Hart, Frederick 54, 54
frontier art 154, 159	Hatoum, Mona 103, 104
Fry, Roger 9, 11, 12, 16-17, 23, 24, 66,	Hawking, Stephen 128
144	hegemony 219
Fukuyama, Francis xxiii, 35	Henderson, Linda D. 62, 73

Henning, Emmy 206 Hepworth, Barbara 43 hermeticism 72 Hicks, Edward 159 high art xxi, 23, 219 Hill, Gary 211	Jong, Erica 169 Jopling, Louise 28, 29 Jugendstil 70 Jung, C. G. 73 Kandinsky, Wassily 7, 67, 68–70, 70, 75,
Hill, Oliver 135	119, 168, 206
Hiller, Susan 193	Kant, Immanuel 12
Hilliard, John 104-05, 104	Kaplan, Janet A. 72
Himid, Lubaina 103, 103	Kaprow, Allen 163
Hirst, Damien xv, xvii, xviii, 192, 193	Kent, Sarah and Moreau, Jacqueline 92
history painting 86	Kerouac, Jack 77
Holshawm, Eric 38, 150	Kesey, Ken 77 Kirchener, Ernst Ludwig 101–02
Hockney, David 170	Kirchener, Ernst Ludwig 101–02 kitsch 34, 220
Holzer Jenny vyjij	Klee, Paul 206
Holzer, Jenny xviii Homer, Winslow 148	Klein, Yves 171
and the second s	Klimt, Gustav 64
Hopper, Edward 155 Horn, Rebecca 172	Kooning, Elaine de 163
Hudson, Richard 165	Kooning, Willem de 81, 136, 138, 163
Huelsenbeck, Richard 206	Koons, Jeff 34
Hughes, Robert 28–29	Kosuth, Joseph 205
Hugo, Victor 31	Kozloff, Max 52
Hulten, Pontas 199	Krasner, Lee 163
humanism 64, 219	Krauss, Rosalind 59
Hunt, Ian 195	Krishnamurti, Jiddu 81
Huysmans, J. K. 77, 96, 97	Kristeva, Julia 174, 178
	Kruger, Barbara 27, 28, 34, 35, 107, 107,
idealism 149	208
identity see self/identity	Kubota, Shigeko 164, 185
identity politics 186–87	Kuniyoshi, Yasuo 154, 155
ideology 219	Kupka, František 62, 67, 68, 69
illusion 219	1 1 101 102 105 06
imagination 17, 62–66	Lacan, Jacques 181, 183, 185–86
defined 62	land art see earth art
as privileged 62–63	language 2, 185
imperialism 219 impressionism 28, 41, 62–63, 76, 83,	Lasch, Christopher 189 Le Corbusier 45, 60, 111, 113, 135
220	League of Revolutionary Artists and
individualism/individuality 33, 175, 176,	Writers (Mexico) 142–43
204, 220	Leary, Timothy 77
installation 220	Léger, Fernand 115, 116-17, 120
internet 131, 188, 210	Leja, Michael 162
Irigaray, Luce 95	Lenin 26, 37–38, 123
Itten, Johannes 135	Lennon, John 84
2	Leverhulme, Lord 28
Jackson, Michael, statue of 33-35, 36, 56	Lévi-Strauss, Claude 71
Jameson, Frederic 59	Levin, Harry 31
Janco, Marcel 24, 206	Levine, Jack 154, 155
Jansen, H. W. 31	Levine, Sherrie 1, 30, 137, 163
Jeanneret, Charles Edouard see Le	Lewis, Dave 194
Corbusier	Lewis, Reina 94
Jerichau-Baumann, Elizabeth 93	Lin, Maya 52–54, <i>53</i> , 55
Johnson, Ellen H. 153, 161	Lippard, Lucy R. 50–51, 65, 70, 71, 172
Joly, Françoise 211	Lipsey, Roger 66
Jones, Steven G. 133	Lissitzky, El 120

Lodder, Christina 38, 39	commodity 26-28
Loewy, Raymond 135	and content 20
Loos, Adolf 45, 113, 117	existence of 9–10
Lorenz, Pare 139	flatness of 152-53
Louis, Morris 163	and focus on the artist 15
Lumière, Auguste 3	as French 7
Luna, James 179, 180	and isolationism 76-77
Lyotard, Jean-François 130, 135	as movement 1–2
	objects of 12–15
McCarthy, J. 146–47, 150	received genealogy of 2-5
machine aesthetic 7, 109, 110, 113-19, 200	regressive/primitive connection 78, 83
dystopias 124–26	and rejection of academy values 12-13
as egalitarian 123–24	schism 119–24
gendered view 133-34	systematic approach to 7-8
individual/universal paradox 124	timespan of 5–7
as separatist 119–23	modernity/modernisation 221
Maciunas, George 207	Modersohn-Becker, Paula 76, 77, 78, 79
McLuhan, Marshall 127, 128, 132	Modigliani, Amedeo 88, 89
Mailer, Norman 169	Modotti, Tina 142, 144
Malevich, Kasimir 2, 5, 73, 135	Moffitt, J. F. 83
Malraux, André 206–27	Moholy-Nagy, László 75, 109, 111, 117
Manet, Edouard 5, 6, 14, 18-20, 27, 88,	121, 122, 124, 125, 135
98, 110, 138	Mondrian, Piet 7, 66, 78, 119, 120
'Manifeste Dimensioniste' 75	Monet, Claude 16, 25, 25, 63
'Manifesto: Towards a Free Revolutionary	monuments
Art' 144	absence of 45-46
Manzoni, Piero 92, 185	agitational 37–38
Mapplethorpe, Robert 105	communist 37–38
Marcuse, Herbert 45	and the community 46
Marin, John 155	counter-monument 47–50
Marinetti, Filippo Tommaso 10, 110, 114	fugitive state of 33–34
Marx, Karl 76	gendered 51-52
Marxism/post-Marxism xxi, 14-15, 25, 36,	Holocaust 48, 49
38, 126, 144, 145, 220	Lebanese 55
Masson, André 190	memorial 33-37, 47-48
Matisse, Henri 31, 76, 84, 98, 168	negative 48
Mauriac, François 150	and politics of representation 46-47
Mayakovsky, Vladimir 123	and the public 42–44
Mazdaism 67	public/private change 40-42
Mead, Margaret 164	to Korean War 54–55
mechanthropomorphism 116-17, 132-33	to Vietnam veterans 50-51, 53-54
Meijers, Deborah J. 206	and truth 48
Menzies, William Cameron 135	unintentional 50-51
Merleau-Ponty, Maurice 175, 179–80	unrealised 38–40
Mexico 142–45	and virtual reality 57–59
Michelangelo 42, 86	and war 50–57
Michelet, Jules 31	in the west 40–42
Miller, Catriona 31	Moore, Henry 98
minimalism 60, 71, 220	More, Thomas 124
Miró, Joan 75	Moreau, Gustave 63
mixed medium art 179	Morimura, Yasumasa 183
modern art xv-xvi	Morris, Robert 46
modern period 220	Morris, William 124
modernism 220	Motherwell, Robert 51
aesthetic autonomy 21–22	Mukhina, Vera 38, 39
central paradox of 4	Mulvey, Laura 95, 108
-	· ·

Mumford, Lewis 60 Munch, Edvard 63, 64 Muniz, Vik 163 mural-painting 145 museum alternatives to 206–07 and art 208–10	O'Connor, Francis V. 140, 166 O'Keeffe, Georgia 142, 155 O'Neil, John 36 Oldenberg, Claus 51, 52 Olitski, Jules 163 Ono, Yoko 84, 207–08 Oppenheim, Meret 213
'aura'/sacred space of 'white cube' 203–04 building of 196–98	Orchardson, William Quiller 23 orientalism 93–94, 221 Orlan 174
collection, classification, surveillance, ordering of other 192–93 curators/ahistorical exhibitions in 204–06	Orozco, José Clemente 141 Ouspensky, P. D. 75 Owens, Craig 188
function of 191–92 modern 198–99	Ozenfant, Amédée 111–12, 112
and taxonomy of anthropology 194–96 and technology 210–11 Museum of Modern Art (MoMA) 7, 114,	Paik, Nam June 127 Paine, Thomas 159 painting 4–5
140, 146, 160, 199–203	truth in 42
music 2, 68, 119	Papadakis, Andreas C. 205, 209 Papanek, Victor 135
Naifeh, Steven and Whitesmith, G. W. 148, 189	Paris 33, 41–42 Parker, Rosika and Pollock, Griselda 92
Namuth, Hans 58, 159, 160, 168, 174 National Gallery 196–97	Parkin, 171, 171 Pater, Walter 83
nature/naturalism 77-80, 78, 206, 221	patriarchy 80
Nauman, Bruce 170	Peace Movement 51, 52
Nead, Lynda 86, 88	Pearce, Susan 213
negro art 206	Penny, Simon 130
neo-Dada 127	performance art 131, 163, 171, 171-73
neo-plasticism 66, 78	and body as social/political model of
new art 54	behaviour 176
new art history 221	and decentred subject 183–84
New Deal 138, 153, 221	as female 184–86
and art 139-40	as provocative 177–79
new public art 46	see also artist
New York School 147	Philippi, Desa and Howell, Anna 99, 101
Newman, Barnett 5, 5	philosophy
Nicholson, Ben 75	and dualism 71–72
Nochlin, Linda 18, 184, 185	neo-platonic 73
Noland, Kenneth 163	photography 122–23, 139, 163, 171, 180–81
Notarius, David 185 nude	Picasso, Pablo viv. 23, 24, 63, 84, 89, 98
anxious 99–102	Picasso, Pablo <i>xix</i> , 23, 24, 63, 84, 89, 98, 103, 105, 134, 154, 168, 200, 206
as art form 92	Picon, Gaeton 13–14
distinction from naked 87–88	Piles, Roger de 9
formal 97–98	Piper, Keith 133, 135, 186–87
gender differences 84-86	Pisarro, Camille 41, 76
genealogy of 86–91	Plato 12, 124
performance art 177–78	pluralism 221
representation/alienation 85	Pointon, Marcia 189, 208
subject/object discourse 94–97	Polcari, Stephen 72, 164, 167
see also female nude	Polhemus, Ted 173, 179
	politics of representation 221
O'Brian, John 11, 20	Pollock, Jackson 44, 81, 145, 148, 154,
O'Brien, Elaine 167	156, 158, 160–61, 162, 163, 168, 174

pop art 35, 51, 170 popular culture 221 pornography 104–06 positivism 194 post-impressionism 4, 7, 17, 222 post-painterly abstraction 4 postcolonialism 221–22 postmodernism xxii–xxiii, 1, 30, 35, 222 and abstract expressionism 163–64 critique of abstraction 162 and fiction of self 65–66 and the human body 133 and the nude 102–07 and representation 102–07 and self 183 and spirituality 67	Rockefeller, Mrs J. D. 200 Rodchenko, Aleksander 20, 21, 121–23 Rodin, Auguste 43 Rodman, S. 161, 163 Romanticism 10, 31, 64, 78, 156, 223 Rose, Barbara 140 Rosenberg, Harold 151–52, 156–57, 158, 168–69, 170, 171, 174, 189 Rosicrucianism 67 Rosler, Martha 60, 126, 135 Rossetti, Dante Gabriel 17, 17 Rothko, Mark 161, 161, 162, 169 Rousseau, Jean-Jacques 110, 170 Rousseau, Théodore 78 Rubenfeld, Florence 167 Rubin, William 101
poststructuralism 71, 94, 161, 175, 184–86, 222	Rush, Benjamin 171 Rush, William 87
Pousette-Dart, Richard 72, 73, 164	Ruskin, John 13
Pre-Raphaelite Brotherhood 16-17, 23,	Russolo, Luigi 109, 128
83	Ryder, Albert Pinkham 147–48, 148
precisionism 114	C:1 E1 102 04 440 475 404
primitivism 78, 83, 100–02, 103, 222	Said, Edward 93, 94, 149, 175, 186
pseudo- 191 productivism 114, 122	Saint-Simon, Henri de 18
Proletkult movement (Russia) 26, 27	Sanderson, Lesley 103 Sandler, Irving 159
protest art 177	Sant'Elia 111, 128
proto-surrealism 112	Sartre, Jean-Paul 152
psychoanalytic theory of art 222	Satie, Eric 2
purism 111–13, 114, 120, 145, 153	Saussure, Ferdinand de 181, 183
queer politics 84	scene painting 154 Schapiro, Meyer 118, 151, 157
D 1100 0 452 450	Schatzki, Theodore 179
Ratcliff, Carter 153, 158	Schechner, Alan 210, 212
Rauschenberg, Robert 136–38, <i>137</i> , 163	Schlemann Ochon 11(121
Ray, Man 190	Schlemmer, Oskar 116, 121
ready-made art xv, 3–4, 56–7, 222 realism/realist 33, 34, 50, 59, 149, 151,	Schlesinger, Arthur Jr 150, 167 Schoenberg, Arnold 2
222–23	Schomberg, Thomas 56
Rebay, Hilla 70, 200	Schwarzkogler, Rudolf 171
Reinhardt, Ad 42, 51	Schwitters, Kurt 173
Remington, Frederic 154	science 109
Renaissance 223	scopophilia 96
Renoir, Jean 97, 99	sculpture 5
retreat 62, 64	essentials of 44
and ascent to nature 77–80	heroic/non-heroic 40-42, 43
dualist 70–72	and the public 42–44
into unconscious 80–83	scaling down of 40
physical 75–77	self-expression 223
spiritual 66–70 transcendent 72–73, 75	self/identity 63–66, 121, 153–55 American construction of 159
revolution 142–45, 147	and autobiography/authenticity 169–71
Richter, Hans 3, 25	body politic 175–79
Rilke, Rainer M. 32, 42	forms of 186–87
Ringgold, Faith 30	obsolete body 187–88
Rivera, Diego 117, 118, 119, 141, 143, 160	phenomenal body 179–81
	÷

subjective 173–75 unitary selfhood/decentred subject 181, 183 - 84semiotics 89-91 Senie, Harriet F. and Webster, Sally 56 Serra, Richard 46, 48, 209, 210 Seurat, Georges Pierre 110 Severini, Gino 114, 123, 134 Shahn, Ben 150, 154, 155, 164-66 Shapiro, David and Shapiro, Cecile 157, 158, 159 Shaw, Jeffrey 58, 59 Sheeler, Charles 115, 116, 134, 141 Shelley, Mary 110 Sherman, Frederic F. 147–48 Shonibare, Yinka 191 Shuffenecker, Claude E. 175 Simmel, George 27 Siqueiros, David Alfaro 141, 142, 156, 160, 166 Sirato, Charles 75 situationist/situationism 5, 27, 223 Sloan, John 155 Smithson, Robert 41, 50, 65, 70-71 Smyth, William Henry 113 social Darwinism 64, 102 socialist realism 34, 38, 79, 107, 144, 150, 152, 154, 223 Sontag, Susan 194 space/time 73, 75, 129 Spence, Jo 180-81, 182 spirituality, influence/movements 66–70 Sprinkle, Annie 105, 107 Stalin, Joseph 33, 35, 143 Stearns, Carol Z. and Stearns, Peter N. Stein, Gertrude 2, 170 Stelarc 187-88 Stepanova, Vavara 121 Stieglitz, Alfred 1 Stieglitz School 142 Still, Clyfford 159, 167 Storey, John 58, 59 subjective/objective division 174-75 subjectivity 223 sublime 128-29, 135, 209, 223 Suleiman, Susan R. 94 Sullivan, Mrs C. J. 200 suprematism 114 surrealism 5, 7, 26, 27, 43, 72, 76, 81–82, 98, 101, 112, 133, 145, 162, 190, 224 gendered 80 Suvero, Mark di 51 Swedenborg, Emanuel 67 symbolism 62, 63-64, 70, 113 Szeeman, Harold 213

Tamayo, Rufino 155 Tanning, Dorothea 76 Tarabukin, Nikolai 114, 117 Tatlin, Vladimir 38-40, 117, 135 Taylor, Brandon 213 Taylor, Frederick W. 125 technocracy 113, 120-21 technoculture 133-34 technology 109-10, 126, 128-29, 130, 132, 134 and the museum 210-11 TechnoSphere 131 television 127-28 Tenier, David (the Younger) 201 theatre 2-3 Theosophical Society 66, 67, 81 theosophy 67-68 Thoreau, Henry David 42, 77, 159 Timms, Edward and Collier, Peter 26 Tingueley, Jean 199 Tomkins, Calvin 83 transcendence 72-73, 75 Trodd, Colin 197 Trotsky, Leon 26, 143-44 Turkle, Sherry 130 Turner, Bryan S. 173 Turner, Frederick 167 Tzara, Tristan 206

unconscious 80–83 United States Information Agency (USIA) 154 universal 224 utilitarianism 64 utopian 24, 27, 35, 36, 124–25, 149, 224

Van Gogh, Vincent 76, 82 Varo, Remedios 72, 76, 80 Veblen, Thorstein 113 video art 103, 126–28 video installation 131 Vinci, Leonardo da 80, 81 Viola, Bill 178, 211 Virilio, Paul 130, 132 virtual reality 57–59, 129–32 Vlaminck, Maurice de 31

Warhol, Andy 28, 35, 107, 137
Warner, Marina 52
Watkins, Franklin 155
Watson, Peter 26
Weber, Max 73, 74, 75, 77, 155, 160
Weiemair, Peter 183
Weinman, Adolph A. xv, xvi
Weston, Edward 137, 163
Wheale, Nigel 58

246 INDEX

Whistler, James McNeill 13, 13, 17 Whiteread, Rachel 46, 48–49, 49 Whitman, Walt 153, 158–59 Williams, Raymond 4, 15, 18, 22, 23–24, 31, 32, 101, 212 Williamson, Judith 59 Wilson, Martha 168 women cultural designation of 177 as performance artists 184–86 representation of *see* female nude Women's Movement 52 Woolf, Virginia 184 Wordsworth, W. 170 Works' Progress Administration (WPA) 139 Worringer, Wilhelm 78 Wright, Frank Lloyd 200

Young, James 33, 48, 49, 60

Zola, Emile 31, 89 Zorach, William 160